MW00817671

JEWISH PRIMITIVISM

Stanford Studies in Jewish History and Culture
David Biale and Sarah Abrevaya Stein, Editors

JEWISH PRIMITIVISM

Samuel J. Spinner

To Scott,
With thanks for sharing with
me your wonderful collection and
home. They are a marvel! I know
my sister Sarah Liska also enjoyed
the visit. Sam Spinner, Dec '22

P.S. Chapter 6 maybe the
most relevant to your interests.

STANFORD UNIVERSITY PRESS
STANFORD, CALIFORNIA

Stanford University Press
Stanford, California

Printed in the United States of America on acid-free, archival-quality paper

Library of Congress Cataloging-in-Publication Data

Names: Spinner, Samuel J., author.
Title: Jewish primitivism / Samuel J. Spinner.
Other titles: Stanford studies in Jewish history and culture.
Description: Stanford, California : Stanford University Press, 2021. |
 Series: Stanford studies in Jewish history and culture | Includes
 bibliographical references and index.
Identifiers: LCCN 2021011013 (print) | LCCN 2021011014 (ebook) |
 ISBN 9781503628274 (cloth) | ISBN 9781503628281 (epub)
Subjects: LCSH: Jewish arts—Europe—20th century. | Jewish
 aesthetics—Europe—20th century. | Jewish literature—20th century—
 Themes, motives. | Jewish art—20th century—Themes, motives. |
 Primitivism in literature—History—20th century. | Primitivism in
 art—Europe—History—20th century.
Classification: LCC NX684.E85 S65 2021 (print) | LCC NX684.E85 (ebook) |
 DDC 700/.4145—dc23
LC record available at https://lccn.loc.gov/2021011013
LC ebook record available at https://lccn.loc.gov/2021011014

Typeset by Newgen North America in 10/14 Minion Pro
Cover background: zoomstudio | iStock

To my parents, my teachers
Miriam Spinner
Nahum Spinner ז"ל

CONTENTS

ILLUSTRATIONS

ACKNOWLEDGMENTS

Without my teachers, I would have had nothing to fill these pages. Peter Queck, my high school German teacher, was my first guide on the path that led to this book. As an undergraduate at Johns Hopkins, I was privileged to have professors who were remarkable teachers, especially Richard Macksey and Vernon Lidtke, who showed me the fun and the value of intellectual seriousness. I have the rare and special privilege of being able to thank a professor who is now a colleague: Rochelle Tobias advised me when I was an undergraduate, and now that I am her office neighbor, she is still my mentor.

Thank you to Jeremy Dauber and to Mark Anderson, my advisors in graduate school at Columbia, for their staunch support of my work on both Yiddish and German; this book's scope is due to them. Liliane Weissberg took a student from a different university under her wing and has kept me there. Thank you to Fred Stern for accompanying me from the first word to the last.

My colleagues at Hopkins have been extraordinarily helpful interlocutors and readers; working with them is a great privilege. Special thanks to Ken Moss for sharing with me his enormous knowledge of Yiddish literature and for reminding me at one point what my book is about. Neta Stahl has been a model colleague (and neighbor), always ready with advice and encouragement. Anne Eakin Moss helped me shape an important part of the book. I also owe thanks to many other colleagues at Hopkins, including Laura Di Bianco, Evelyne Ender, Jennifer Gosetti-Ferencei, Peter Jelavich, Brukhe Lang, Pawel Maciejko, Douglas Mao, Yitzhak Melamed, Katrin Pahl, Derek Schilling, and Bécquer Seguín

for feedback and advice on various aspects of my project. Gabrielle Spiegel is another professor turned colleague; I am grateful to her for welcoming me back to Hopkins by inviting me to join the Mellon Seminar, where I received productive feedback on my work.

My thanks to the many colleagues at UCLA who helped make my first academic position so productive, especially Carol Bakhos, David Myers, and Todd Presner.

I have benefited from feedback, comments, guidance, and support from many friends and colleagues around the world, including Elizabeth Brown, Marc Caplan, Madeleine Cohen, Ofer Dynes, Ben Etherington, Jay Geller, Raphael Gross, Jeffrey Grossman, Matt Handleman, Roni Henig, Iris Idelson-Shein, Alex Kaye, Lynn Kaye, Eitan Kensky, Andreas Kilcher, Barbara Kirshenblatt-Gimblett, Jessica Kirzane, Josh Kotin, Andrea Krauss, Mikhail Krutikov, Agi Legutko, James Loeffler, Caroline Luce, Daniel Magilow, Hannah Pollin-Galay, Na'ama Rokem, Gabriella Safran, Daniel Schwartz, Rachel Seelig, Scott Spector, Elisabeth Strowick, Josh Teplitsky, Josh Walden, Daniel Wildmann, and Tamar Wolf-Monzon. To any others I may have forgotten: you have my sincere gratitude (and I owe you a drink).

Some of my dearest friends were also my most assiduous readers; I am indebted to them. Jordan Bear has supervised the writing of this book since before its beginning; he also introduced me to the work of Moyshe Vorobeichic (and most of the other interesting things I know about). I am grateful to have had a writer and thinker as gifted as Emily Beeny improve every draft I sent her way. Ben Sadock helped me puzzle through every obscurity I encountered while researching the book and read every word once I wrote it. Kerry Wallach has been my guide; her no-nonsense advice and unstinting generosity have accompanied me every step of the way. Sunny Yudkoff coached me through thinking and rethinking, writing and rewriting; I'm lucky to be on her team.

Thank you to Margo Irvin and Cindy Lim of Stanford University Press for their careful guidance of my book through the publication process. Thank you to the series editors Sarah Abrevaya Stein and David Biale for inviting me to join such a distinguished club. And thank you to the anonymous readers, whose generous feedback helped make my book better. Speaking of generosity, the research and writing of this book was supported by the Gerald Westheimer Career Development Fellowship of the Leo Baeck Institute—New York and the Stulman Program in Jewish Studies at Johns Hopkins. I am grateful to Dr. Philip Myers, who made my position at Hopkins possible by endowing the Zelda and

Myer Tandetnik Chair in Yiddish Language, Literature, and Culture in memory of his parents. Thank you to Yossi Raviv for sharing with me stories and information about his father, Moyshe Vorobeichic, and for granting me permission to reproduce Vorobeichic's photographs. Thank you to Uri Zvi Grinberg's son, David Grinberg, for granting me permission to reproduce his father's drawing.

Thanks are due, most of all, to my family. Thank you to my siblings Josh, Ben, Ruth, my twin Sarah, and my twin-in-law David, for their unrelentingly high standards—professional, intellectual, and familial. Thank you to my parents-in-law, Norm and Toshka, who have been gracious hosts and trusted advisers.

My parents raised me in a house filled with books, watched over by a portrait of Kafka on the wall. They taught me how to read and what reading is for. My mother, Miriam Spinner, showed me by her uncompromising commitment to her profession and dedication to her family that it might be possible to write a book while raising my children. I hope she will remain my teacher and the teacher of my children, *biz hundert un tsvantsik*. My father Nahum Spinner *z"l* was born in Czernowitz in 1936, a time and a place in which the works I write about in this book still meant what they were supposed to mean. I learned to love German, Yiddish, and Hebrew from my father; I learned to love learning from him; and I learned that those books and that culture are still here and still mean something. This book is dedicated to my first teachers, my parents.

Finally, thank you to my children Tova and Menashe; I love you. And thank you to my wife, Hanna, for making it possible to write this book, and most of all for making it worthwhile. The biggest projects (books, life) seem doable with you here.

JEWISH PRIMITIVISM

Introduction

SAVAGE JEWS

"Looked at precisely, it was something like a savage African tribe," commented Franz Kafka after visiting a Hasidic Jewish gathering in Prague in 1915.[1] The statement is startling. Kafka seems at first to disparage Jews by combining a flatly racist estimation of Africans with a condescending attitude toward Jewish migrants from eastern Europe. But we also know that Kafka actually viewed Hasidim in an admiring light. He participated in what Gershom Scholem would later call a "cult of Eastern Jews" that lay at the heart of a contemporary cultural renaissance among German-speaking Jews.[2] This positive valuation of eastern European Jews and their language, Yiddish, led Kafka, for example, to declare that "Yiddish is everything" and is something one can "feel the true unity of."[3] In this light, the tribal "savagery" Kafka saw in these Yiddish-speaking Jews, with their superstitions, circle dances, and repetitive chanting, presented an exciting repudiation of the hollowed-out, Westernized Judaism that Kafka identified with his father.[4] This is Jewish primitivism; in fact, this is primitivism across European modernism: a critique of modernity activated by the positive evaluation of a purportedly premodern society. Primitivist critique typically takes an object that is distinctly "other"—and definitively not European. Hence the people generally enlisted, whether by force or by fantasy, to play the role of primitives are defined as everything Europeans are supposedly not: dark-skinned, illiterate, uncivilized, superstitious, prelogical.[5] Jewish primitivism—by Jews, of Jews—should therefore have been impossible: European Jews were often stereotyped—by themselves and others—as too modern, too urban,

too political, too literate. And even if Hasidic and other eastern European Jews superficially resembled more distant so-called primitives, why would European Jews valorize as vital and free a people actually among the most vulnerable in Europe? After all, neither Jews nor so-called primitive peoples had a place as equals in modern, civilized Europe, and Jewish primitivists were certainly not arguing for the exclusion or subjugation of Jews. On the contrary—Jewish primitivism was a product of the effort to create and consolidate identity and nationhood through Jewish culture.[6] European modernity depended, however, on the creation of ineradicable difference—between the Jew and the Christian, between the *Volk* and everyone else, between the civilized and the primitive. In imagining European Jews as primitive savages, European Jewish writers and artists used Jewish primitivism to undermine the idea of ineradicable difference by blurring the border between savage and civilized. Jews turned the ethnographic lens on themselves not so much to salvage or study the premodern vestiges of their own culture,[7] and certainly not to denigrate themselves, but instead to critique the distinction, so starkly drawn in modern ethnography and aesthetic primitivism, between subject and object.

Jewish primitivism exposed the fixed poles of identity holding in place Europe's political and aesthetic regimes. Only in this inherently destabilizing manner could the impossible situation of European Jews be analyzed and reimagined. The result was a discourse that recognized its own impossibility: a powerful critique of the necessity of Jewish inclusion that began from the premise of inclusion. This meant that it was a broader critique, too—of European modernity and its claims regarding collective identity and individual subjectivity. It was also a critique of the aesthetics that emerged from the binary construction of identity in European ethnographic modernity. In other words, Jewish primitivism generated an aesthetic paradox by interrogating the vulnerability of the Jewish subject—the literary and visual conflation of subject and object. This aesthetic paradox was a pointed critique of continental European modernist primitivism.

Jewish primitivism is found in an idiosyncratic array of works of art and literature. Else Lasker-Schüler, the German-Jewish poet and artist, introduced herself and signed her correspondence as Prince Jussuf, chief of the "Bund der wilden Juden," the Society of Savage Jews. These fearless warriors featured in her poetry, prose, and visual art, narrowing the gaps between genres and media and bridging the chasm between art and life. Although Lasker-Schüler was a

bohemian and famously claimed to be "unpolitical,"[8] her fantasy of unfettered primitivity revealed that the politics of Jewish primitivism were not only emancipatory; they could also be about domination, as in the Hebrew and Yiddish poetry of Lasker-Schüler's onetime friend Uri Zvi Grinberg. While Prince Jussuf wore a dagger in his belt inscribed with the word "ve'ahavta"—and thou shalt love—Grinberg's radical right-wing Zionism sharpened the sword of the "Society of Savage Jews," turning it into a poetic vision for the settlement of Palestine.

Despite its immediate communal and political resonance, Jewish primitivism was also always about the self—the Jewish self, the European self, the human self. In 1914, Kafka asked in his diary, "What do I have in common with Jews? I have hardly anything in common with myself; I should stand quietly in a corner, happy that I can breathe."[9] Here he rejects the premise of an exoticizing, ethnographic gaze and turns the lens on himself. Relative to the distance he feels from himself, the primitiveness of the Hasidim he would later compare to Africans is beside the point. Kafka understands that true difference can lie much closer to home. Asking what he has in common with himself does not mean that he no longer seeks commonality with Jews, with Hasidim, or, indeed, with African tribesmen; it shows, rather, that in relation to a primitive other, Kafka becomes other himself. Kafka's primitivism and his radical self-alienation exist in relation to one another, oscillating continuously between looking outward and looking inward.[10]

Another example of Jewish primitivism brings Kafka's two elements together: when the leading Yiddish literary critic Bal Makhshoves described his encounter with the Jews of Warsaw, he remarked that he felt "like someone from a foreign people with a more elevated culture. . . . I studied them like Aztecs; but they were close to me, like children from one father."[11] Bal Makhshoves turned what may seem like an ordinary instance of exoticizing objectification into something more intimate and more complicated.[12] He pushed the object of his commentary as far as exoticism would allow but then undercut the chasm of difference with a claim of similitude. But not just a claim: he himself was a Jew from Warsaw. Here we see a recalibration of primitivism's distancing effect: the "other" is not placed across an unbridgeable civilizational chasm but is a sibling. Rather than turning the alienation onto himself, as Kafka does, Bal Makhshoves emphasizes a kinship and closeness that complicate—without renouncing—his own primitivism.

In the examples of Lasker-Schüler and Grinberg, we see that Jewish primitivism shared a purpose with primitivism more broadly: it was a search for vitality and immediacy. In the examples from Kafka and Bal Makhshoves, we see clearly the primary distinction of Jewish primitivism and why it is that all of the above examples may seem so strange and self-contradictory. Unlike European primitivism more broadly, which sought to replace the European subject with the primitive object, Jewish primitivism was the struggle to be both at once—European and foreign, subject and object, savage and civilized.

While Jewish primitivism's currency was determined by its social relevance, it was above all, as Ben Etherington argues regarding all primitivism, an aesthetic project.[13] The connection between the two aspects emerges in a 1910 speech by Y. L. Peretz, the dominant figure of turn-of-the-century Yiddish literature in eastern Europe: "Two paths lie before us, one path to Europe where Jewish form will be destroyed, the second path back."[14] By Jewish form, Peretz meant specifically, recognizably Jewish art and literature. But where was back? His answer: the "Bible" (*bibl*); "Hasidic" (*khsidish*); "folklorism" (*folkstimlekhkeyt*). Forward and backward were not the only directions Peretz used to orient his thinking on art; he also went up and down: "Art is a staircase, and the ground floor is the primitive of the folk."[15] Peretz's compass of Jewish art pointed back (to the folk) and down (to the primitive): the cardinal points of primitivism. *Bible, Hasidic, folklorism*—translation flattens the strangeness of this trio in the original Yiddish, particularly the middle word, Hasidic. *Bibl* is a European Christian word; the Yiddish word is *toyre*, from the Hebrew *torah*. *Folkstimlekhkeyt* is another strange word, derived from an eighteenth-century German neologism and meaning something like "folkishness"; why not simply say "folklore"?[16] *Khsidish* is the strangest of all—it is an adjective, nominalized not grammatically but by the force of Peretz's literary vision. But what is the noun this adjective replaces? "Hasidic" . . . what? These odd and ambiguous words, chosen over more typical and grammatical alternatives, betray the ambiguity of Peretz's aesthetic project, which had a direction—back or down—but no destination, a process without a fixed method or goal.

The lack of fixity was shared across the various versions of Jewish primitivism. It allowed for ideological flexibility: it could be assimilationist or Zionist, revolutionary or reactionary. It allowed for linguistic flexibility: written in German, ostensibly the language of modern civilized Jews; in Yiddish, ostensibly the primitive language of benighted, backward Jews; and in Hebrew, a language creating a present between a biblical past and a still-to-be-determined future.

And it allowed for aesthetic flexibility: neo-Romantic and modernist; literary, graphic, and photographic; based on models of orality and visuality; realist and abstract.[17]

On the varied map of Jewish primitivism I will draw in the coming chapters, two landmarks are unmistakable. First, by turning primitivism on its head and reversing its direction toward the self, Jewish primitivism recalibrated one of modernism's central elements. This was so destabilizing and so counterintuitive that it has been excluded from the story usually told about primitivism.[18] A new assessment of the place and function of primitivism in general within European modernism is called for.[19] The second major contribution of Jewish primitivism was its radical challenge to the central cultural project of European Jewish modernity. Romantic nationalism—the effort to create a Jewish *Volk*— has been seen as the basis of modern Jewish culture. In this view, Jewish culture was meant to reflect the Jewish *Volksgeist* and to substantiate the social and political claims of a Jewish nation in the modern, European sense. But Jewish primitivism, which emerged from the Herderian aesthetics of the Jewish cultural project, issued a profound challenge to this project. It did so because its object—European Jews—did not fit the model of a *Volk* promoted by Romantic nationalism and the associated discipline of folklore studies.[20]

I will elaborate on each of these aspects in turn—first, the place of Jewish primitivism in European modernism, and second, the place of Jewish primitivism in modern Jewish culture.

The Difference of Jewish Primitivism

Primitivism in European modernism was the belief that a better way of making art and a better way of living were to be found among those people considered by Europeans to lack civilization. Before humans were corrupted by modernity, so the line of thinking goes—indeed, before they were corrupted by any civilization at all—they were truly free, truly creative, and truly alive. For civilized (read: white, Christian, European) peoples, this time of freedom, creativity, and vitality ended before recorded history. At the turn of the twentieth century, however, many European ethnographers and artists believed that such a state could still be found among "primitive savages" who lived in a permanent state of prehistory.[21]

In the first scholarly study of primitivism, George Boas and Arthur Lovejoy sought to account for all the varieties of primitivism from antiquity to the

present and found that it was everywhere: "The unending revolt of the civilized against something, or everything, characteristic of civilization, has been prompted by diverse tempers or impulses, and it has been directed against diverse objectives; and this diversity compels us to recognize a number of significantly distinct primitivisms."[22] Despite their recognition that primitivism is protean, they reduce it to two types: chronological primitivism ("a kind of philosophy of history, a theory, or a customary assumption, as to the time—past or present or future—at which the most excellent condition of human life, or the best state of the world in general, must be supposed to occur")[23] and cultural primitivism ("the discontent of the civilized with civilization").[24] Each type has numerous subcategories; most interesting, cultural primitivism is divided into "soft" and "hard" primitivisms. Soft primitivism is the adulation of primitives for the leisurely simplicity of their lives; hard primitivism admires the contentment of primitives with brutal lives of struggle and scarcity.[25]

Robert Goldwater's *Primitivism in Modern Art* (1938) identified primitivism's most hospitable terrain and set the terms for a sympathetic scholarly assessment of primitivism that would last close to fifty years. Like Boas and Lovejoy, Goldwater sought to impose a schema on the manifold varieties of primitivism he saw even in his drastically reduced time frame. He proposed that modern art featured the following types of primitivism: romantic, emotional, intellectual, and subconscious. Goldwater likewise understood that primitivism was variable in essence but pushed further by insisting that primitivism had no particular object, that it was "more psychological than formal, it was a quality read into the objects rather than objectively observed, and so it was bound to vary with the orientation of each group."[26] For Boas and Lovejoy, primitivism had been an idea; Goldwater argued that it was no longer just an idea in European modernism, becoming instead a question of perspective or orientation. Among his definitions of primitivism, Goldwater maintained that primitivism depended on "the fact that the primitives of the twentieth century are not part of the artist's own tradition."[27] Yet he also noted that the trajectory of primitivism was toward "endemization," wherein "children's art and folk art were at first mixed with the African and the Oceanic and similarities were found between them; and then, with the addition of subconscious art considered under its primitive aspects, they entirely replaced the aboriginal productions."[28]

Goldwater's insight about the trajectory of primitivism toward the endemic prompts a comparison of Jewish primitivism to other forms of primitivism as practiced by artists belonging to ethnic and religious minorities on the

European continent and in the Americas or who were subjects of European empires in the first half of the twentieth century. Some of these primitivisms were distinct from Jewish primitivism because they still operated on the assumption of binaries of distance and otherness. For example, the valorization of Gaelic culture in Ireland opposed the center to the periphery, the urban to the rural, dominant language to dying language, the ascendant to the declining.[29] These binaries were often organized around the contrast of English dominance—political and linguistic—with the forms of Irish social, political, and aesthetic expression possible in Great Britain's shadow.[30] A further important distinction between the Celtic revival and Jewish primitivism is the fact that the former was undertaken, according to Gregory Castle, "by intellectuals who were not, strictly speaking, 'native.'"[31]

Gauging the similarities and differences between the primitivisms deployed by writers and artists of the African diaspora (and indeed African colonial subjects) and by Jewish writers and artists requires more nuance. A century's worth of scholarship on European primitivist modernism, largely focused on European painting (mostly on Pablo Picasso and German expressionism), has taught that the critique of Western modernity offered by primitivism stemmed from the purported discovery of alternative aesthetic and epistemological models in the art of so-called primitive peoples.[32] The reinterpretation of this history in the last generation has shown that European primitivism is also an aesthetic ideology of domination of non-European others by means of the appropriation of non-Western art as source material and the objectification of the people who produced it.[33] Both versions are true.

Paul Gauguin, arguably the first artist of modern primitivism, is a good example of both accounts. He wrote of "two kinds of beauty: one that results from instinct and another which would come from studying."[34] He traveled all the way to Tahiti to find people he viewed as sufficiently uncivilized to know the kind of beauty that comes from instinct. But studying this instinct was not enough for him; to produce the kind of art he admired, he needed to become "savage-in-spite-of-myself."[35] Only then would he "forget all the misfortunes of the past" and be "free from all artistic jealousies and with no need whatsoever of lowly trade."[36] And only then could he become an artist by instinct. His paintings show a world of unfettered sexuality and spirituality and a lack of material want. The composition and subjects of his paintings also reveal that he wished to possess—the bodies and the freedom—perhaps more than he wished to belong. What's more, he was never able to free himself from his "lowly trade"

as a painter, and he depended on the modern machinery of colonialism to sub-sist.[37] His critique of Western art and society was based on a fantasy and was fed by his exploitation of Tahitian people and art. The European primitivists after him, including Picasso, followed suit, deploying one or all of the following, regardless of the particularities of their project: prurient and often racist depic-tions of "primitive" people, facile representations of their society and beliefs, and interpretations of their art only within Western models and for Western purposes.

While the goal of most European primitivism was, as Gauguin put it, to be-come "savage in-spite-of-myself," Jewish primitivism asserted a savage identity for Jews not in spite of themselves but because of themselves. Jewish primitiv-ism was therefore much closer to the primitivisms that flowered in the shadow of Europe's empires, like that of Négritude at the fringes of the Francophonie and that of the Irish revival off the continent's coast. Such valorizations of primitiveness, produced by people who belonged to groups objectified by "ma-jor" primitivism, challenged European dominance over identity formation, artistic creativity, and political identification. Jewish primitivism brought this challenge to the heart of metropolitan Europe and into the midst of European modernism.[38]

There can be no doubt that primitivism's colonial context determined its aesthetic agenda and possibilities: the inspiration claimed by white European artists, in the light of its material and social underpinnings, is clearly also ap-propriation.[39] But this important realization has made it difficult to appreciate that other primitivisms, like those of Négritude and the Harlem Renaissance, could be something other than an internalization and replication of the racist terms of primitivism more generally. Sieglinde Lemke has argued that "black primitivism"[40] is obscured by seeing primitivism as a binary matter, with Black art always objectified and subordinate.[41] In clearing a space for the examina-tion of Black primitivism, Lemke and others have revealed the ways it diverged politically, and indeed aesthetically, from "white" primitivism.[42] For example, Claude McKay, Jamaican-born and a central figure of the Harlem Renaissance, could write a character in *Home to Harlem* (1928) who, according to Tracy Mc-Cabe, "attempts to repress the 'savage' image of Africa and Haiti" only to have it "surface when he contemplates his own educated, civilized self."[43] The binary opposition in "white" primitivism of civilized and savage is taken apart in Mc-Kay's primitivism. Lemke further argues that "black primitivist modernism"[44] stages a "double encounter, with European primitivist modernism and African

design," by which an African American artist could discover "the legacy of her ancestors through her cultural other."[45] This observation reminds us that although Black primitivism shared an object with white primitivism[46]—African art and African people—it had drastically different political meanings and social consequences.

This was possible because, contrary to most understandings of primitivism in the last generation, primitivism was not created by hegemonic voices only. As Ben Etherington has argued, the framework of major versus minor identity and the idea that primitivism had a stable object can lead to a misunderstanding of how primitivism actually worked.[47] Etherington notes that *what* primitivism wanted is far less important than the wanting: "'The primitive' is more like a dialectical principle of aesthetic exploration than something that can be nailed to any particular conception."[48] This is why, argues Etherington, primitivism could be a major part of the literature of Black colonial subjects who were themselves already objects of primitivism.[49] This insight is also crucial for understanding Jewish primitivism, a phenomenon of metropolitan Europe, not the colonial hinterland.

Yet the inconsistency and seeming impossibility of an ever-shifting object and identity did not mean that identity was unimportant. For European Jews, as for African Americans, identity could be a matter of life and death. However vaguely construed, it was central to culture, society, and politics and accordingly introduced a set of pressing social questions to an aesthetic discourse that was otherwise concerned, as Robert Goldwater puts it in his foundational definition of primitivism, with "the basic elements of human experience" (which precede or obviate identity) or "the fundamental factors of external form."[50] The precariousness of the safety and status of European Jews, together with the unification of subject and object, did not change the orientation of aesthetic primitivism but raised its stakes: Jewish primitivism was no longer an abstract critique of modernity but an urgent response to the urgent challenges of European Jewish life.

The scholarly assessment of primitivism as an aesthetic mode that envisioned the infiltration of Europe by the savage other is therefore inadequate. In Jewish primitivism, the savage was already there, and so too was the capacity to turn primitivism against the aesthetic order and ideological regime that generated it. In other words, while primitivism was grounded in difference, Jewish primitivism disassembled that difference, because, from the perspective of European art and society, Jews were plausibly primitive but also plausibly

European. This was the source of Jewish primitivism's ability to expose and critique the presuppositions undergirding modernism at large.

Jewish Primitivism and Modern Jewish Culture

Jewish primitivism has similar confounding consequences for the understanding of modern European Jewish culture. The central project of European Jews in the last decades of the nineteenth century and first decades of the twentieth was the reinvention and elaboration of Jewish peoplehood, centered around the modern discourses of the folk and the nation. Jewish art, literature, and music operated under the terms of this social and political project. Primitivism posed two related challenges to the project of modern Jewish culture. First, if primitivism emphasized the gap between savage and civilized, wouldn't the savage Jew compromise Jewish claims to European identity? Second, by interrogating the self, Jewish primitivism disassembled the collective that was so painstakingly created in the notion of the Jewish folk.

The idea of the Jewish folk was meant to solve the problem that despite the fact that Ashkenazic Jews and their language, Yiddish, were as old and as European as the Germans or French and their languages, the possibility of being European—whatever its definition—was always denied them. The Jews could solve this problem by substantiating their claims to rights, status, and nationhood with folklore, the glue that binds together a folk and is the basis for a folk's most significant product—culture. For Herder, the Jews had already accomplished this: he maintained that Hebrew poetry (i.e. the Bible) was the greatest proof of the essential nationhood of the Jewish people.[51] The modern Jewish culture project attempted to offer an updated proof in the face of new definitions of culture in the latter half of the nineteenth century. The first was Matthew Arnold's famous definition of culture as "the best knowledge and thought of the time," which worked seamlessly with a nationalism centered on folklore—a folk simply required a lore that met those standards.[52] The other central definition of culture challenged the syllogism of folk-culture-nation. In his seminal work *Primitive Culture* (1871), Edward Tylor proposed that culture was a "complex whole" and was manifest in "the lower tribes" just as it was in "the higher nations."[53] This definition was crucial for the formation of primitivism but inimical to the project of Jewish culture, which pivoted on the Jewish claim to belonging among the "higher" nations.

There were many ideological and aesthetic versions of the modern Jewish culture project. Yiddishists, who claimed that the Yiddish language was the glue that held together the Jewish nation and proved Jewish belonging in Europe, argued that folklore was a manifestation of the Jews' deep roots on the continent.[54] Cultural Zionists claimed Jewish folklore as proof of Jewish nationhood.[55] It was a tool of the Jewish "culturists," as Kenneth Moss has called them, in the early Soviet Union, whose project to create a "new Jewish culture" drew unabashedly on the nineteenth-century notion of high culture.[56] These ideologies all saw folklore as the "ground floor," in Peretz's words, of national creativity and accordingly as the linchpin of national identity. As Marc Nichanian memorably put it in his discussion of similar processes in Armenian culture, "nationalization is an aestheticization."[57] What else could it be, after all, when there was no possibility of self-government? The creation of folklore, of a national literature, is thus a type of what Stathis Gourgouris calls autoscopic mimicry,[58] which Nichanian sees as central to the formation of the "ethnographic nation" and leads inevitably to "self-colonization."[59]

But since, in Tylor's terms, folklore belonged as much to the lower as to the higher nations, not only was it a tool of nationalization—as it was, for example, among cultural Zionists—but it was also a gateway to primitivism, that is, the subversion of nationalization. If autoscopic mimicry results in self-colonization, then Jewish primitivism is a technique of decolonization.[60] And so the practices of collecting and of narrating the folk generated by Romantic nationalism laid the groundwork for a discourse that would undermine it.

Primitivism worked against the nationalizing aesthetics of folklorism and orientalism because it rejects a stable national or folk identity and consequently rejects a stable archive of artistic themes, texts, or subjects. Without a folk, there is no canon; without a collective other, there is no collective self. This distinction between folklorism/orientalism and primitivism is important: the former category is essentially concerned with the creation of a group defined through folk culture, while the latter engages primitive culture for the refinement of individual subjectivity. It is important to note that when Jewish primitivism makes use of folk culture, it does so *as* primitive culture: primitivism can draw on the domestic as much as the exotic. In fact, the Yiddish word most often used to identify these sources is *folks-primitiv*.[61]

To characterize the aesthetic ramifications of this distinction, it is useful to distinguish between exoticism and primitivism. According to Klaus Kiefer,

an exoticist work is one that incorporates the source material into one's own representational aesthetic.[62] This is, as Carlo Severi argues, not a new style but a kind of quotation, in contradistinction to primitivism, which generates "a reciprocal tension between two styles of representation. Through this tension, one of the two visual languages becomes definable through the other."[63] This is the essential dividing line between the exoticist and the primitivist engagement with ethnographic or folkloric material: exoticism (of which folklorism is therefore the domestic form and orientalism the form pointed toward the Near East, North Africa, central Asia, and India) quotes and incorporates; primitivism seeks synthesis and produces tension. To be clear, since the preexisting terminology overlaps: primitivism can draw on domestic and foreign sources, and exoticism can do the same. To avoid terminological confusion, when exoticism draws on domestic sources, I refer to it as folklorism.

Finally, though it may seem obvious, it is important to distinguish Jewish primitivism from primitivisms practiced by Jews looking to Slavic peoples, Siberian peoples, African Americans, or Native Americans.[64] It is the self-directed element of Jewish primitivism that renders it so richly complicated: the effort to synthesize a subject and object that are impossible to distinguish fully and, in fact, are inextricably joined.

Media of Jewish Primitivism

Since my treatment of the media of Jewish primitivism and its languages diverges from disciplinary models for the study of both primitivist modernism and modern Jewish culture, I will address each in turn.

Art historian William Rubin has noted that primitivism began as an art-historical term describing a painterly phenomenon.[65] But I have addressed so far mostly literature; where I have touched on visual art, I have not made any special distinction from texts. This is because Rubin's point deals with a scholarly genealogy; but to the primary actors of primitivism, the separation of text and image was not a foregone conclusion. In fact, the German-Jewish avant-garde writer and art historian Carl Einstein, an early (arguably the first) theorist of both primitivism and cubism, wrote: "I've long known that this thing that we call 'Cubism' goes far beyond painting. . . . I've long known that not only is a transformation of vision possible . . . but also a transformation of its verbal equivalent."[66] Einstein's theory of African art was imbricated with his

understanding of cubism: the visual principles he extracted from the former were at work, as he saw it, in the latter. But how could visual principles be transferred to a work of literature? Einstein acknowledged that his own attempt to answer this question was insufficient.[67] I will argue in Chapter 5 that this challenge—the transfer of the visual to the literary—was compellingly met by the Yiddish writer Der Nister. Der Nister's stories show how verbal rhetoric—particularly Yiddish rhetoric—could be deployed in a way that built on and exemplified visual principles while nevertheless being derived from Hasidic and Yiddish literary folk traditions. This is an example of how Jewish primitivism addressed the theoretical analogy of visual primitivism and literary primitivism. Else Lasker-Schüler, by contrast, developed themes that she reinforced reciprocally across her drawings and writings, while the artist Moyshe Vorobeichic (Moï Ver) used the avant-garde engagement with semiotics to explore the textuality of photography and to ironize the supposed bias in Jewish culture toward the textual.

My insistence that there were no meaningful distinctions between literature and art in Jewish primitivism beyond the obvious ones of genre and medium goes against the grain of much scholarship on primitivism, which neatly sorts the literary from the visual. Indeed, in all the vast scholarship on primitivism, literature seems barely to exist as a subject. In one of only a handful of books[68] that redress this imbalance, Nicola Gess offers a sensible explanation for why visual art has been privileged: "Comprehension of foreign-language literatures was hindered, for European readers, by a language barrier. Hardly any writers knew the foreign languages, there were few translations, and those that existed paid no attention to semantic thoroughness let alone stylistic particularities."[69] Erhard Schüttpelz goes so far as to say that literary primitivism on the model of visual primitivism is impossible for this very reason; he sees primitivism as a question of the anthropological definition of the category of the primitive.[70]

But this all depends on what, exactly, constitutes a "foreign" language and whose comprehension is at stake. The categories used in this argument do not take into account Europe's own minority languages, let alone those in Europe's colonies. The problem is related to the inapt idea that primitivism can only draw on foreign sources.[71] But this approach—which admirably expands the field—also bypasses the question of identity as it played out in the period, that is, as a social problem. When the domestic and the foreign can be equally primitive, as they were in Jewish primitivism, untranslatability is moot and identity

is brought to the foreground. Yiddish- and Hebrew-speaking writers could work with Jewish folklore as easily as with folk art—perhaps more easily, since the literary sources were more readily available, by far.[72]

Since there was no linguistic impediment to the formation of Jewish literary primitivism, and the question of transfer between media was itself part of the technical and theoretical agenda of the primary creators of Jewish primitivism, there is no need to separate art and literature in this study.[73] This is yet another example of the scrambled categories and definitions that result from Jewish primitivism: it stretched across media, from literature, to graphic art, painting, photography, and, indeed, music.[74]

Languages of Jewish Primitivism

How did Jewish primitivism find purchase in German, Yiddish, and Hebrew? German was a civilized tongue: the language of Goethe and of science. But Yiddish was a so-called *Jargon*, thought to have no substance, no importance, no literature—to be essentially a primitive language.[75] And Hebrew was a fossil, unsuited for the work of modern literature. Although language posed a crucial cultural and social question for European Jews of the period (at least for the intelligentsia), it did not interfere with the agenda of Jewish primitivism. Jewish primitivist aesthetics encompassed the primary literary languages of Jewish central and eastern Europe, that is, German, Yiddish, and Hebrew. Yet the literatures of the three languages have rarely been examined under a single lens. Scholars of European Jewish literature have instead mostly focused on the relation of Yiddish and Hebrew, which was, after all, a central concern of many writers and ideologues of the period.[76] Only recently have scholars turned to the relation of Yiddish and German, approaching the question as one of a social interchange between languages, literatures, and cultures that largely took place in Berlin between the world wars.[77] Seeing literature and art as things transmitted or negotiated between networks centered on language or geography foregrounds social interpretations, especially histories of reception, that can obscure a phenomenon like Jewish primitivism, which operated similarly across its contexts. This is because Jewish primitivism was a phenomenon more closely tied to the aesthetic and cultural agendas of its producers than to its social contexts.[78]

Working within the existing paradigms of Jewish cultural history, it would be all too easy to separate the above-cited examples of Kafka and Bal

Makhshoves, one writing in German and the other in Yiddish. Kafka's percep-
tion of Hasidim slots into a ready-made and widely accepted narrative about
the German-Jewish relation to eastern European Jews, the so-called *Ostju-
den*. The discourse around *Ostjuden* in turn-of-the-century German-Jewish
culture has deep roots: Gershom Scholem famously reminisced about what
he called a cult of Eastern Jews among German Jews around the First World
War;[79] Steven Aschheim's historical study of the phenomenon complicated the
picture, showing how the so-called Eastern Jews functioned as both positive
and negative stereotypes in German-Jewish culture and society, as "brothers
and strangers," following Aschheim's title.[80] On the one hand, by showing how
foreign Jewishness could be, *Ostjuden* served as prompts to assimilation. On
the other, these real and imagined eastern European Jews were also foils for
what Shulamit Volkov has called "dissimilation," reflecting the positive asser-
tion of a supposedly authentic Jewish identity in the face of a hollow, artificial
German-Jewishness.[81] The discourse surrounding the *Ostjude* has been seen
as quintessentially German: the word, of course, is German;[82] and the carto-
graphic orientation of the term requires a Western—that is, German—starting
point. Furthermore, the social debate surrounding *Ostjuden* was informed by
self-conceptions of German Jews regarding their culture and religion, catalyzed
by a massive influx of Jewish immigrants to Germany from eastern Europe. The
Ostjude has thus been seen as central to the German-Jewish navigation between
the poles of assimilation and dissimilation, self-hatred and self-affirmation.[83]
It is easy enough to read Kafka's pejorative dismissal of Hasidim in this light,
namely, the history of German-Jewish culture.

But the fact that Bal Makhshoves, himself an *Ostjude* (if only insofar as
Kafka was a German Jew), displayed the same attitude and deployed a similar
trope must rebalance our understanding of both cases. It is no longer tenable to
argue that Kafka's approach to *Ostjuden* was typical of German-Jewish culture
and that Bal Makhshoves—a Yiddish writer from eastern Europe—was neces-
sarily doing something else; rather, both Kafka and Bal Makhshoves engaged
in Jewish primitivism.

That is to say, the powerful social and linguistic distinctions between West
and East, between German and Yiddish, do not obtain in the aesthetic context
of Jewish primitivism. The seemingly German phenomenon focused on Hasi-
dism and Ashkenazic folklore was equally Yiddish: Martin Buber's first collec-
tion of Hasidic tales in German (*Die Geschichten des Rabbi Nachman* [*The Tales
of Rabbi Nachman*], 1906), which helped catalyze the *Ostjuden* fad in Germany,

postdated Peretz's Hasidic stories, which began appearing in the 1890s and were collected in 1903 in Yiddish (*Khsidish* [*Hasidic*]). In other words, projects with differing social contexts bore a striking aesthetic resemblance to each other. This was not mere coincidence. One important goal of this book is to demonstrate that Yiddish, German, and Hebrew were enlisted in the same aesthetic project of Jewish primitivism. Bal Makhshoves's insistence that Yiddish and Hebrew are, according to the title of his Yiddish essay "Two Languages, One Single Literature," expands in this study to three languages, one literature.[84]

In this book, I balance the claims of Jewish primitivism: its claims about aesthetics and its claims about politics; its claims about Jewish art and its claims about Jewish identity. I identify two primary areas in which primitivist art and literature operated: identity and aesthetics. In the case of the former, the unique position of the Jew within European society granted artists a simultaneous identification as subject and as object in a way that opened up social and political possibilities that were largely inaccessible in the landscape of European modernism and modern Jewish culture. The turn to primitivism was an escape from—and a critique of—the omnipresent politics of Jewish identity formation.[85] But Jewish primitivism was also an aesthetic enterprise. By uncovering alternative artistic traditions, primitivism provided the tools to reconceive the formal possibilities of art and literature. Artists and writers in Yiddish, German, and Hebrew capitalized on these new developments not only to thematize ethnographic and folkloric notions of Jewish identity but, above all, to transform their works as such.

How was this transformation to be accomplished? The proclamations of its practitioners can be frustratingly vague. Peretz again offers a good example. In the 1910 essay in which he described the primitive of the folk as the ground floor beside art's staircase, he continued as follows: "It seems clear what one has to do: collect, make notes, transcribe. Come together and learn to read, sing together, recite, enjoy yourselves, create the atmosphere for art. . . . Genius will come later and create."[86] Though Peretz meant this somewhat ironically, he offered nothing more concrete. With no clear goals, the actual manifestations of primitivism—the works created by genius—varied drastically. This book charts the landscape of those works in art and literature, but not in order to compile an exhaustive list, which would be very long and of seemingly endless variety. My aim is to begin the task of drawing the map of Jewish primitivism and to point out some of its most notable features. The chapters of this book analyze literary and visual manifestations of these claims—the literary and artistic use

of folkloric and ethnographic sources not only as subjects and themes, that is, as content, but also in pursuit of new forms—aesthetic forms and forms of identity; forms of objecthood and forms of subjecthood.

Chapter 1 describes the Jewish literary folklorism from which Jewish primitivism emerged and against which it reacted. It takes as its subject the works of Y. L. Peretz, the seminal author of folklore-inspired literature in Yiddish and simultaneously the bête noire of others in the Yiddish avant-garde for whom his work was politically reactionary, insufficiently formally inventive, or both. I show that Peretz, and Jewish folklorism more broadly, drew on Johann Gottfried Herder's technique of *Nachdichtung*, or translational adaptation, most characteristically represented in his Hasidic tales. Peretz's project initiated the primitivist project of undermining neo-Romantic aesthetics and ethno-nationalist politics. He did this in spite of himself, affirming the project of folklorism in his short stories while in his essays critiquing the very aesthetics his works embodied. An overt aesthetics of Jewish primitivism would finally emerge as a backlash to Peretz's Hasidic stories: the *Nachdichtung* of Peretz and his epigones was cast as mere "stylization" by members of the avant-garde, who called for his aesthetic to be discarded and his subject to be refashioned in a new way.

Chapter 2 analyzes the conflicted primitivism of writers who attempted to stage their encounter with the primitive other in travelogues while also describing being or becoming primitive in works of fiction. Writers like S. An-sky in Yiddish and Alfred Döblin and Joseph Roth in German could not square the primitivist fantasies of their belles lettres with the reality of Jewish life they depicted in travelogues. This conflict emerged because, while major forms of primitivism objectified the "primitive" by suppressing subjectivity and insisting on otherness (racial and/or geographic), Jewish primitivism had to face the nearness and accessibility of its object, the European Jew. The effort to engage in primitivism with a subject that refused objectification and insisted on its similitude resulted in works that both suppressed and revealed the potential for equality between the civilized writer and the savage Jew. The writers examined in this chapter felt obliged to adhere to a model of primitivism dependent on ethnographic description, which meant that the very tool they used to approach the primitive foreclosed access to it. Jewish primitivism was what I call a "plausible" primitivism, in which the conflation of subject and object was not hindered by daunting geographic, racial, or political distances. This chapter shows how the paradox of plausible primitivism manifests in two opposing literary orientations. On the one hand, a range of belletristic genres presented an

idealized vision of Jewish primitivity; on the other, travelogues foregrounded the reality of European Jewish life. Plausible primitivism could not help but trip over itself.

Chapter 3 reads Kafka as a Jewish primitivist. This runs counter to the prevailing view that sees Kafka apart from broader trends in European Jewish literature. Instead, as I demonstrate, Kafka connects the contradictions of Jewish primitivism to his own ambivalence about his Jewish identity, which in turn reflects back onto several of Kafka's core texts, including "Vor dem Gesetz" ("Before the Law") and "Ein Bericht für eine Akademie" ("A Report to an Academy"). In these works, Kafka comments on the allure of identity. In this light, Kafka's presumed avoidance of introducing Jewishness into his aesthetics is actually a manifestation of the instability and critique of authenticity at the heart of Jewish primitivism.

Chapter 4 explores the politics of Jewish primitivism, which ranged from the radical Left to the radical Right, from Berlin to Jerusalem—all within the aesthetic of the avant-garde. I explore this political breadth in my description and analysis of the unlikely poetic relationship between the German-Jewish poet Else Lasker-Schüler and the Yiddish and Hebrew poet Uri Zvi Grinberg, the former ambivalent toward Zionism, the latter a proponent of the movement's most radical wing. The idea of an originary, authentic Jewish identity rooted in an ancient but geographically unspecified East was nevertheless central to Lasker-Schüler's poetry and visual art, if not her politics. Where her trope of the "Society of Savage Jews" was a utopian community of writers and artists that existed only in her work, Grinberg deployed this trope to very different ends—his savage Jews were Zionist pioneers, creating a nation-state. This chapter explores the political flexibility of primitivism, showing how it could marshal the same aesthetics in pursuit of opposing politics.

Chapter 5 considers the ways ethnography motivated bold formal and generic experiments that brought to literature innovations that were otherwise limited to the visual arts. I examine the avant-garde short stories of the Yiddish writer Der Nister, whose abstracting primitivism fractures the narrator-ego into a kaleidoscopic and disorienting landscape, disassembling Western forms of narrative production that privileged a stable subject. I use the work of the German avant-garde theorist of primitivism Carl Einstein to clarify Der Nister's own innovative solution to the problem of abstraction as a visual and spatial phenomenon in literature. Einstein noted that primitivist abstraction was in principle achievable in literature but in practice absent; I argue that

this was because, unlike visual sources, which, since immediately perceptible, seemed to be readily comprehensible, the literary sources of primitivism were obscured by multiple layers of translation. Der Nister's intimate familiarity with Yiddish folklore served as the ground of his literary abstraction; from the particularity of Yiddish textuality he was able to spring to the visual principles of modernist painting.

Chapter 6 examines visual culture, focusing on a little-known photobook by the Bauhaus-trained photographer Moyshe Vorobeichic (Moï Ver). In *A Ghetto in the East—Vilna*, published in three bilingual editions (German/ Hebrew, German/Yiddish, and English/Hebrew), Vorobeichic refracted the peddlers and rabbis of Vilna through the lens of avant-garde photography. Specifically, he used an avant-garde visual idiom, including montage and distorted perspective, to depict subjects usually portrayed with sentimental naturalism. Vorobeichic's skepticism toward notions of primitive authenticity diverged strikingly from the mainstream of Jewish modernist art in the period, which was dominated by Marc Chagall and his imitators, an aesthetic the Yiddish avant-garde artist Henryk Berlewi dismissed as "Chagallism."[87] Employing an approach similar to what James Clifford has termed ethnographic surrealism, Vorobeichic's photobook critiques the trope of the primitive Jew even as it ostensibly reifies this trope. In ironically but sensitively taking as his subject supposedly primitive Jews, Vorobeichic restores their subjectivity.

Jewish Primitivism concludes with a chapter that connects the Jewish primitivism explored in the preceding chapters with the persistence of Jewish primitivism after the Holocaust. I do this through an analysis of two short prose texts by the Czech-German-Jewish journalist Egon Erwin Kisch. One, a story about searching for the Golem of Prague, written shortly after the First World War, mournfully describes how incommensurate folklore is with the violent disenchantment of modernity. The next describes Kisch's search, during the years of the Holocaust, for a village of "Indian Jews" in Mexico, where he had fled to escape the Nazis. As in Kafka's encounter with Hasidim, Kisch's quest leads to a radical confrontation with himself. Kisch's alienation was not voluntary—he was alone because his family, his friends, so many of Europe's Jews, were gone. But he does not experience his loss alone; he joins with the Indian Jews—his fellow Jews—to pray and to mourn. The distinction between European and primitive disappears.

This book shows that Jewish primitivism encompassed a range of techniques and possibilities conditioned by both the aesthetics of primitivist modernism

and the politics of Jewish identity in Europe but was ultimately responsive to its own internal aesthetic agenda. The texts and images that promote a vision of Jews as primitives take their origins in any number of familiar locations on the map of European modernism and Jewish cultural and political history. The ends of these textual and visual journeys are, however, unexpected and even unprecedented in the versions of Jewish identity and Jewish art and literature they generated. In literature, graphic art, and photography, Jewish modernists developed a series of distinct primitivist aesthetics that, by locating the primitive present in Europe, troubled the boundary between observer and observed, cultured and savage, colonizer and colonized, subject and object.

Chapter 1

THE BEGINNINGS OF JEWISH PRIMITIVISM
Folklorism and Peretz

Bravo, long live Jewish art! . . . All according to the custom of Europe—Jewish poetry in a frock coat and white gloves![1]

Y. L. Peretz

Y. L. Peretz described art as a staircase, with the "primitive of the folk" as the ground floor.[2] He also described what to do with that primitive folk material: "Collect, make notes, transcribe. Come together and learn to read, sing together, recite, enjoy yourselves, create the atmosphere for art. . . . Genius will come later and create."[3] What he did not describe is what genius would create. His own oeuvre offers a possible answer: the group of short stories collected in two landmark volumes titled *Khsidish* (Hasidic) and *Folkstimlekhe geshikhtn* (Folkloric stories). He began to publish these stories in periodicals in the 1890s and first collected them in 1903 and 1906, respectively. Peretz's stories are among the best-known examples of the folkloristic aesthetic that was at the heart of modern Jewish cultural production during that period. These works were intended to play central roles in a Jewish cultural renaissance that was a necessary stage in the larger project of nationalization. According to Marc Nichanian, "nationalization is an aestheticization."[4] So the recognition that folklore played a central role in the nationalization projects across Europe in the nineteenth century is also a recognition that this was a literary project. Folklore was not strictly scientific, and nationalization was not strictly political. The place these two categories overlapped was in the literary creation of folklore. To the degree that folklore is a linchpin of nationalization, the identity of a nation is at stake in the aesthetics of folklore. This explains the importance and centrality of folklore as literature in the period. We know well the history of the

idea and ideology of Jewish folklore as a project of nationalism,[5] but what were the aesthetics of Jewish folklore as a literary project?

In answering that question, this chapter uncovers a paradoxical dynamic: the aesthetics of Jewish nationalization, that is, folklore, laid the groundwork for primitivism—a project directly at odds with it, politically and aesthetically. There would be no Jewish primitivism without the process of creating a Jewish subject around the literary concept of folklore. For that reason, to arrive at Jewish primitivism, we must first pass through Jewish folklorism.

The primary folkloristic elements of the modern Jewish cultural project, across central and eastern Europe and in German, Yiddish, and Hebrew, were Hasidic stories. Hasidic stories catalyzed folklorism into an agenda of renewal. In 1900, the same year that Peretz published the Yiddish "Oyb nisht nokh hekher" ("If Not Higher"), one of his landmark Hasidic stories, Micha Yosef Berdichevsky, an author who wrote in all three languages, proposed Hasidic literature as the basis of an aesthetic program.[6] In an anthology of Hasidic stories and reflections on Hasidism in Hebrew called *Sefer Ḥasidim* (The book of Hasidim), Berdichevsky claimed Hasidism as central to Jewish renaissance—a word he inserted in Latin letters in the Hebrew text, as a translation of *teḥiya ḥadasha* (a new revival).[7] Just a few years later, in 1906 Martin Buber published the German *Die Geschichten des Rabbi Nachman* (*The Tales of Rabbi Nachman*), an adaptation of *Sipurei ma'asiyot* (*Tales*) by Rabbi Nachman of Bratslav (1815), the second-ever book of Hasidic stories. Buber's book initiated his lifelong project of adapting Hasidic stories and established Hasidism as central to the German-Jewish project of Jewish renaissance, which he described in his 1901 article "Jüdische Renaissance" (Jewish Renaissance).[8]

The prominence of Hasidic stories in modern Jewish literature generated a name for the trend, neo-Hasidism.[9] Peretz was its central figure:[10] he was widely read (even in German)[11] and was the key figure linking folklore as science and folklore as literature in the Yiddish-speaking world.[12] Indeed, the importance of his literary salon helped him put folklore at the center of the modern Jewish cultural project.[13] This chapter will describe the ways in which he set the agenda for Jewish folklorism in his essays and short stories, even as his broader oeuvre displayed ambivalence, even skepticism, toward the project of folklorism. Indeed, as Dan Miron has argued, while the overall objective of Peretz's varied oeuvre was "retying the knot with the folk,"[14] he also composed works that considered "the possibility of failure of the Jewish revival project."[15] Peretz

in fact went further, explicitly rejecting the aesthetic premises of folklorism in several essays that draw out the pessimism and sharpen the implicit critique in his fictional works. Peretz's critique of his own project went a good way down the path that would lead to primitivism; this is most readily evident in how close certain of his critical terms and viewpoints were to explicitly primitivist critiques of folklorism among the Yiddish avant-garde. Yet Peretz—a folklorist who was ambivalent about folklorism—was also an incipient primitivist deeply skeptical of primitivism. While some of his essays opened the door to primitivism, others shut it. None of his fictional works exemplify Jewish primitivism, as I have defined it, even if they broadly share its themes and topics. Ultimately it was Peretz's folklorism, despite his ambivalence toward it, that provided grist for the mill of his avant-garde critics. As these critics saw it, Peretz's works were mere "stylization," the term they used to indicate a superficial aesthetic assimilation to the European standard. In typical fashion, they never proposed clear alternatives. These become legible only by investigating the individual projects of the writers and artists who picked up the threads unraveled by the critique of folklorism. In other words, the critique of Peretz, of stylization, and by extension of folklorism was the theoretical basis for Jewish primitivism, rather than a full-fledged aesthetics of primitivism. Nevertheless, their theoretical linkage and Peretz's wide influence on both sides of the issue meant that without Jewish folklorism there could not have been Jewish primitivism. And so my account of the latter must pass through the former.

The Aesthetics of Folklorism

From its beginnings in German Romanticism, folklore was a matter of identity and of aesthetics. Both as a scientific discipline and as a literary project, folklore was catalyzed by Johann Gottfried Herder's *Volkslieder* (Folksongs) of 1787–88, the first folklore anthology. For Herder, collecting folktales and folksongs was a literary and national project—the revitalization of literature was linked directly to the revitalization of the *Volk*.[16] Following Herder, folklore's dual purpose of fashioning national identity and shaping literature was accomplished in two linked ways: the collecting, ordering, and defining of national "folk" heritage, and the transformation of that heritage into modern aesthetic products. The former task was performed through the anthology. The latter was accomplished through a process Herder called "Nachgesang" or "Nachdichtung,"[17] later

emulated in the Yiddish context as *iberdikhtung*,[18] meaning a kind of translational adaptation. Both aspects—collection and adaptation—quickly came to shape nationalist literary projects across central and eastern Europe.[19]

But folklore in Jewish literature did not initially perform these tasks of nation-building and literary self-definition. The early nineteenth century was still the moment of the Haskalah, or Jewish enlightenment, which promoted the secularization and modernization of Jewish thought, religion, and identity. The development of a national consciousness—the idea of a Jewish *Volk*—as part of a literary project was a process that would only accelerate toward the turn of the twentieth century. While ethnography and folklore found pride of place in broader European literature and culture, evidenced by the popularity of the tales of the Brothers Grimm and the rise of the *Kunstmärchen*, the universalizing perspective of the Haskalah viewed Jewish folklore as a reminder of the backwardness of a still-benighted eastern European Jewry. Where it appeared in Yiddish and Hebrew literature, it was marshaled, in Dan Miron's term, as "antifolklore," in order to expose its inherently ridiculous nature.[20] Barbara Kirshenblatt-Gimblett named a subgenre of this tendency "ethnographic burlesque," capturing the unscientific, polemical aspect of the deployment of ethnographic detail and folkloric thematics in Jewish literature throughout much of the nineteenth century.[21]

It was only near the turn of the twentieth century, over a hundred years after the publication of Herder's *Volkslieder*, that the project of nationalization through folklore finally fully arrived in central and eastern European Jewish society.[22] This vision of identity through literature by way of folklore rapidly became a central feature of many Jewish political and cultural projects, from Zionism to socialism and from Germany to Russia.[23] Many of the most significant figures in German-Jewish, Hebrew, and Yiddish literature in the first decades of the twentieth century either wrote "folkloric" works or collected folklore in anthologies, or both.[24]

The primary aesthetic technique these writers used was *iberdikhtung*. Susan Stewart aptly describes the parameters of this technique in her discussion of the "distressed genre," her term for the rhetorical and formal toolkit of folkloric literature, which she calls distressed because of its artificial antiquity.[25] Stewart defines distressing as the "literary imitation of folklore" in the creation of a "new antique," which involves "an attempt to bypass the contingencies of time" and "an attempt to recoup the voice of orality."[26] The quest for orality is significant: the opposition of folklore as an anonymous collective oral production to modern literature as the written construction of an individual became a basis

of the discipline of folklore studies and an epistemological foundation of the ethnographic construction of (Western) civilization.[27] But the irony was that, starting with Herder, orality was derived from textual sources. Herder's anthology relied on printed sources and included such manifestly textual artifacts as excerpts from Shakespeare. The Brothers Grimm famously collected their fairy tales not only at the kitchen tables of old women in remote villages but through correspondence with city-dwellers.

This textuality of oral literature was particularly pronounced in the Jewish context, where the primary sources were the Talmud and Hasidic legends. The Talmud—at least the legendary and narrative parts of it—would seem to be perfect for repurposing as folklore: because it was transmitted orally before it was transcribed, it is called in Hebrew and in Yiddish the "oral Torah," while the Hebrew Bible is called the "written Torah." Yet the Talmud had been written down and canonized more than a thousand years before the neo-Romantic anthologists began their work—it was, after the Bible, the basis for the Jews' text-based religious culture. This posed no problem for Jewish folklorists, whose awareness of the continued centrality of the Talmud in traditional Jewish life meant that an intrinsic distinction between orality and textuality was not constitutive of their notion of Jewish folklore the way it was of folklore more broadly. For example, the Yiddish writer M. Vanvild approvingly described contemporary efforts to consider "primitive" oral literature according to the same standards as written literature and explicitly referred to folklore—including that of South Seas islanders—as *toyre shebalpe* (oral Torah).[28] The other main source for modern folklore anthologies was Hasidic legends, which had begun to be collected, transcribed, and published very soon after Hasidism was founded.

Martin Buber's Hasidic stories are the quintessential expression of the distressed genre in Jewish folklorism. He was clear about the writer's task in relation to the sources: "That which the Hasidim related . . . could not be associated with any form. . . . It remained raw ore—the most precious ore. So it came to me, from hundreds of folk-books and personal communications."[29] What, then, to do with this raw ore? "I simply smelt them down into their pure narrative form."[30] This procedure consists of "giving the stories . . . the form appropriate to them—nothing more and nothing less." Yet Buber claimed that this is not a poetic transformation—"I do not poeticize" (*Ich "dichte" nicht "weiter"*)—and he adds nothing new to the motifs he finds in the stories.[31]

Elsewhere Buber explicitly acknowledged deploying the very same technique. In the introduction to his first Hasidic collection, *Die Geschichten des*

Rabbi Nachman, he presented his approach as follows: "I did not translate the stories of Rabbi Nachman, but retold them [*nacherzählt*] with complete freedom, but in his spirit."[32] The stories, he goes on, are preserved in a distorted form; his book is an effort to retain the "elements of the original," elements that he identifies through discernment.[33] Buber's task is to turn them into literary folklore (what he calls "fables" and elsewhere "legends"). This is a process that entails a kind of re-creation. Once again, in describing his technique he disavows Herderian *Nachdichtung* while essentially describing it. In the introduction to his second Hasidic collection, *Die Legende des Baalschem* (*The Legend of the Baal-Shem*, 1907), about the founder of Hasidism, he writes:

> The Hasidic legend does not possess the austere power of the Buddha legend nor the intimacy of the Franciscan. It did not grow in the shadow of ancient groves, nor on slopes of silver-green olive-trees. It came to life in narrow streets and small, musty rooms, passing from awkward lips to the ears of anxious listeners. A stammer gave birth to it and a stammer bore it onward. . . . I have received it from folk-books, from notebooks and pamphlets, at times also from a living mouth, from the mouths of people still living who even in their lifetime heard this stammer. I have received it and have told it anew. I have not transcribed [*übertragen*] it like some piece of literature; I have not elaborated it like some fabulous material [*Fabelstoff*]. I have told it anew as one who was born later.[34]

"Telling it anew" means removing the traces of its origins, correcting the stammer, and polishing its rough edges. In a sense this would seem to remove distressed features from the text. But the distressed genre was meant to be literary folklore; the distressing it deployed was therefore not a replication of the features of "raw" folkloric sources but a replacement for them.

Peretz's Aesthetics of Folklore

The ethnographer and Yiddish writer S. An-sky echoed Buber when describing Peretz's technique of converting folkloric sources into literary products. An-sky described what would happen when he shared with Peretz Hasidic stories he collected in the field:

> While I was still telling the story, Peretz had already grasped it, assimilated it, cast off the unartistic bits, added in new ones, and bound it all together with details from another story. And I had hardly finished when Peretz had already

begun to tell me the same story, transformed into a folktale [*folkstimlekhe geshikhte*] which was as far from the original version as a cut diamond from a just-unearthed diamond in the rough. The next day, the story would already be written down, and a few days later published with a dedication: "To An-sky, the collector."[35]

The writing of folklore, of Hasidic stories, was a process of regulating the relationship of source material to its final literary product. As An-sky saw Peretz's practice, this entailed a clear hierarchy. The work of ethnography and folklore collecting was the starting point for a project with a definitive end: the publication of a literary product.

Peretz himself was not only a practitioner of this technique but a theorist of it. He saw the relationship of folkloric sources to modern literature not only as a limited matter relating to a handful of genres but one addressing the entire history of Yiddish literature. The emergence of Yiddish literature, for Peretz, was not a process of secularization through the adoption of European forms like the novel. Peretz turned the literary history of Yiddish inside out, pinning its origin not to its first secular writer, Ayzik Meir Dik (1807–93) but to Hasidic stories: "Yiddish does not begin with Ayzik Meir Dik. The Hasidic tale is its Genesis. *Shivkhey bal-shem* and other wonder tales are the literature of the folk [*folksdikhtungen*]. The first folk poet was Reb Nachman of Bratslav."[36] *Shivkhey bal-shem* refers to the *Shivḥei habesht* of 1814; Rabbi Nachman's book, *Sipurei ma'asiyot*, was published in 1815, four years after his death; these were the first two books of Hasidic hagiography and lore in Yiddish.[37] Peretz thus contradicts the conventional wisdom that sees in the secularizing, antifolkloric works of Dik and the early Yiddish novels of Yisroel Aksenfeld (1787–1866) the beginnings of modern Yiddish literature. In the conventional history of Yiddish literature, folklore is a catalyst for the emergence of modern Yiddish literature—it is present in it but is not of it. Peretz saw the history of Yiddish literature as growing out of folklore rather than in opposition to it.[38]

Additionally, in rejecting the anti-Hasidic and antifolkloric works conventionally seen as the beginnings of modern European Jewish literature in favor of Hasidic literature, Peretz was also redefining the generic history of Jewish literature. The writers he rejected wrote novels—the quintessentially modern, secular literary genre; he replaced them with anthologies with complicated and mediated authorship, comprising the traditional genres of hagiography and legend. Although anthologies as such were just as modern as the novel, their

orientation was toward the formation of a collective (both formally and in its ideology) rather than the novel's promotion of individual subjectivity. Herder (1744–1803) was the first German folklore anthologist; Peretz made the early Hasidic rebbes the first Yiddish folklore anthologists. Yet Rabbi Nachman's (1772–1810) precisely identified historicity ought to disqualify his work from the category of folklore, since he was the author of his book's stories, not the collector of tales with anonymous, collective authorship.[39] Additionally, Nachman was relatively recent, undermining the claims to antiquity usually made by folklore. Calling Rabbi Nachman the first folk poet, Peretz conflates the oral and the textual, the antique and the modern, at the heart of Jewish folklore. Peretz's folklore was a self-consciously modern and written product.

The very title *Folkstimlekhe geshikhtn* (Folkish tales) gives another indication of Peretz's approach to folklore. Both words in the title, while not neologisms, were also not anchored in the Yiddish language, nor were they quite colloquial.[40] Both derived from German: but while *geshikhtn* had an obvious Yiddish alternative in *mayses*, there was none for *folkstimlekh*, a recent adaptation from the German *volkstümlich*, which itself was an eighteenth-century neologism.[41] Indeed, the entire discourse of the "folk" was a matter of German influence,[42] and using German words to designate his stories unambiguously marks the discursive context of the works, namely, Herderian neo-Romanticism. Peretz's clear etymological distinction between his literary works and their presumed sources serves also to sever the filiation claimed for them. This is also accomplished by the adjectival rather than the nominal form: *folkstimlekh*—folkish or folkloristic. Peretz positions his stories as equivalent to folklore rather than derivatives of it.

Accordingly, Peretz was opposed to mimicry—of rhetoric or form. In his 1902 essay "In folk arayn" (To the people), he critiqued his contemporary Berdichevsky's attempt at the mimetic representation of colloquial speech—for Peretz, this is mere vulgarity.[43] His alternative to mimicry was *iberdikhtung* into polished prose.[44] Paradoxically, however, this rejection of aesthetic mimicry in favor of a universalizing style led directly to a consequence that Peretz also critiqued, namely, the mimicry of European identity.

In his 1910 essay "Vos felt undzer literatur?" (What does our literature lack?), he rejects mimicry but observes that embracing Yiddish alone will not solve the essential problem, which is that Yiddish literature is immature and has borrowed its contents from non-Jewish literature. "If you have nothing to say, you

can speak Yiddish from cradle to grave and everywhere—at home, in the street, in the study house during prayer services, and at the philharmonic. . . . But what you say will be *goyish*. And on top of that—banal, mimicked, dead."[45] This is because, he argues, mimicry inhibits true "intuition." To explain the point, he makes recourse to an image critical of colonialism:

> African children [*neger-kinder*] who study in European schools show great abil-
> ity in the early grades—as long as it is enough to hear what the teacher says and
> learn it by heart, to remember and repeat what it says in the book . . . for that,
> they are the best. In the fourth or fifth grades . . . stop [*stop*]! You need your
> own, living intelligence; you need intuition; drive [*vilns-kraft*]—and in a foreign
> school, the African child has lost those things. He has studied and mimicked
> for so long [*azoy lang oysgelernt un nokhgemakht*] that his own well has dried
> up. The processes beneath consciousness—intuition—have stopped, and what
> emerges from school is a spiritual dwarf, spiritually depressed and impotent [*a
> shvarts-gaystike impotents*], dressed in the European fashion: frock coat, top hat,
> gloves, a European curtsey, but withered and empty. Our literature is also cursed
> by this dwarfness.[46]

This amounts to a primitivist manifesto, in what it seeks—intuition; what it condemns—the strictures of European modernity; and in its object, possessors of the intuition destroyed by mimicry—African children. In rejecting European forms of thought and representation, Peretz returned to his customary alternatives, in this essay focusing on the Bible: "We want to return to the Bible [*bibl*], but first we need to stop looking at it through Wellhausen's eyes."[47] But here again, even following his most pronounced denunciation of mimicry, he arrived at the core paradox of his aesthetics: it was, of course, the influence of Wellhausen's so-called higher biblical criticism that made it possible to speak of the *bibl* instead of the *toyre* in the first place.

The return to the Bible or to folklore (which went hand in hand with the Bible for Peretz) needed to be done with a different compass and a different map. Peretz was clear about that much. But he does not quite say what that would entail—what it would mean to reject "goyish."

A speech from the same year reiterates the critique of mimicry and points toward a model solution. In "Vegn der yidisher literatur" (On Jewish literature) he declaimed, "Our house is built of foreign stones, yet it still stands empty."[48] How to solve the problem? He explained:

> If Jewish literature wishes to be Jewish, it needs to be it in more than language, in
> the exterior form of the word—it needs to be Jewish[49] in essence, in its soul. . . .
> It must stop mimicking Europe. . . . If we remain European copycats, creators of
> books just for entertainment, for ladies—we are in service of the very same as-
> similation we are fighting against. . . . But instead of developing ourselves to let
> our own souls shine, we have become imitators.[50]

The danger is mortal, but there is a way out: "We have two paths before us.
One leads to Europe, where Jewish form will be destroyed. The second leads
back—to what was, to our past." Unsurprisingly, the way back is folklore:

> In Jewish life we find the folkloric [*dos folkstimlekhe*]—what the folk tells about
> itself, Hasidic works [*dos khsidishe*], and so on. If the Jewish poet would take
> these riches and work through them according to his own spirit (not Euro-
> pean!), if the Jewish musician would seek out and beautify the melodies of the
> folk, all will be well. We would have the beginnings of a Yiddish literature. . . .
> What we aspire to can only be found in our Bible [*bibl*], in *khsidish*, in folkloric
> works [*di folkstimlekhkeyt*].[51]

But *bibl*, as the Europeanized version of *toyre*, seems to be precisely the op-
posite of what Peretz called for.[52] This choice of a Christian, or perhaps secular,
word conveys the paradox: Peretz sought authenticity not through mimicry of
authentic sources but in a modern European manner. The other two options he
cited, *dos folkstimlekhe* and *khsidish*, were, of course, borrowed from the titles
of his two best-known collections. He consciously (and without irony) held up
his own works as a model, introducing the above passage by saying, "I am talk-
ing about myself." Despite their broadly European aesthetics, Peretz felt that
his own works were the best example of how to restore "a Jewish style [*shnit*]
to our form."[53]

Why should Jewish literature follow a path back to the folkloristic (*dos folk-
stimlekhe*) and the Hasidic (*khsidish*)? Because, as Peretz wrote elsewhere, "art
is a staircase: the ground floor is the primitive of the folk."[54] Creating art re-
quires finding the primitive within the folk; the next stage would be to take it
upstairs. The risk, as Peretz himself described in the same essay, was that the
next stage would result in art "according to the custom of Europe: Jewish po-
etry in a frock coat and white gloves!"[55] But the aesthetics of Peretz's folkloristic
project forced him toward that very result; his works were an amalgamation
of a European folkloristic sensibility with the Jewish sources he identified as

primitive. While his aesthetic program presaged what would be sharpened into primitivism, his literary works leaned in the other direction, toward European-ization, *iberdikhtung*, and stylization.

Peretz in Practice

Folklorism

"Oyb nisht nokh hekher" ("If Not Higher," 1900), from *Khsidish*, is one of Peretz's best-known "Hasidic" stories and offers a good illustration of how this conflict worked in practice. On the one hand, the story's narration is marked by a folksy orality matching its subject—a miracle tale of a Hasidic rebbe. On the other, the narrator is not the rebbe, and not even a Hasid but a skeptic of Hasi-dism. The skeptic has come to town to test the veracity of a story the Hasidim tell. Every morning, they say, at the time of the predawn penitential prayers that precede the High Holidays, the rebbe ascends to heaven to intercede di-rectly with God on behalf of his people. The skeptic is a Litvak, a Lithuanian Jew—stereotyped as a cold rationalist endowed by geography with immunity to Hasidism. His mission is part ethnographic—he is curious about the legends of this foreign place—and part detective—he hides under the rebbe's bed to see where he goes each morning. What he sees is the rebbe dressing up as a non-Jewish peasant, chopping down wood, and giving it to an impoverished, sick woman at no charge. The story ends as follows: "Later, whenever a Hasid would tell how the Nemirover [Rebbe] gets up early every morning during the High Holiday season and goes up to heaven, the Litvak would not laugh, but quietly agree: 'If not higher.'"[56] The skeptic has been convinced of the rebbe's holiness and converted into a Hasid. But he is not really a Hasid—he does not value the rebbe's deed in the same way the actual Hasidim do, in a religious framework. Instead, he sees the rebbe's holiness in the universal religious value of char-ity. Nevertheless, he stays with the Hasidim, participates in their storytelling, and agrees with their moral. By accommodating their mystical and magical religiosity to his seemingly secular worldview, he becomes a Hasid and yet not a Hasid. On the one hand, this resembles the conflicted positioning of the Jew-ish primitivist. On the other, the Litvak has not actually moved at all from his original position. He has, rather, accommodated the Hasidic legend to his own values; so too, argued the leading Yiddish literary critic Shmuel Charney (1883–1955),[57] Peretz has accommodated the Hasidic source material of this story to *his* own values—secular humanism, rather than religious belief.[58] Rhetorically

and formally, although parts of the story resemble Hasidic sources,[59] the volte-face of the ending[60] gives the final word to someone other than the rebbe or even one of his "actual" Hasidim. The text thus operates outside the sphere of folk and Hasidic literature.

"Oyb nisht nokh hekher" also has its cake and eats it too: the spiritual power of the rebbe is shown to derive not from magic or mysticism but from modesty and charity, virtues not exclusively religious or Hasidic. David Roskies calls this "the romantic betrayal of Hasidism [and] the aesthetic betrayal of folklore."[61] This "betrayal," of course, was the essence of *iberdikhtung* and was the point of folklorism. The fact that Peretz, foreshadowing critics both then and later, would elsewhere castigate this type of aestheticization does not remove these works from the project of folklorism. In other literary works, however, he did articulate parts of the critique found in his essays.

Against Folklorism

While Peretz's iconic *Khsidish* stories slightly temper their valorization of Ha-sidism with shifts in emphasis to external narrators and values, other literary texts directly criticize folklorism in general and Hasidim and Hasidic storytell-ing in particular. Dan Miron, in a lucid reading of what he calls the decon-struction of the classic image of the shtetl across Peretz's oeuvre, argues that this contradiction is not a paradox. On the contrary, argues Miron, the texts that seem most folkloristic (or in Miron's terms, that seem to propagate the classic image of the shtetl) serve, in fact, to illustrate its demise.[62] In order to circumvent Peretz's own comments in his essays that support folklorism, Miron attributes them to a "strange lack of sensitivity to his own work."[63] I argue, how-ever, that Peretz's critique of folklorism—like his folkloristic works—is based on an ambivalence toward it rather than a wholesale dismissal of it. The two facets of his work do not reflect alternating commitments, much less a critical self-awareness about his own masterworks. On the contrary, Peretz's folklorism and his critique of it are a kind of dialectic attempt to exhaust the resources of neo-Romanticism and find out what lay beyond it. For this reason, what Peretz critiques is not folklore per se—which was to remain an aesthetic resource after the disassembly of folklorism—but the literary institutions of folklore, that is, storytelling as a process and the negotiation of folklore between the modern writer and his sources. Peretz does this with two different ironic depictions: of Hasidic storytelling and of the literary activities of a modern writer, namely, collecting and retelling folklore.

An example of the first kind comes from *Bilder fun a provints-rayze* (*Impressions of a Journey*, 1891). In the chapter "Fartseylte mayses" ("Twice-Told Tales"), the narrator allows a Hasid to take the narratorial reigns and tell a story.[64] Dan Miron implies that Peretz called the story "Fartseylte mayses" because he "had not yet invented the word *folkstimlekh*."[65] This would mean that the chapter shares a favorable outlook on folklore and Hasidim with Peretz's later stories. But although the narrator relinquishes the ethnographic reins and allows the Hasid to tell the story, a strong ironic critique is activated in moments of unwitting bathos. First, the Hasid attempts to illustrate his rebbe's sanctity and wisdom; the anecdote, however, clearly displays the opposite, and the Hasid's attempt to spin the story is laughably weak: presented with a Talmudic problem by a Litvak, the rebbe is unable to solve it, but according to the Hasid, he offers the incorrect solution on purpose. The anecdote doubly skewers the teller: he is stupid enough to believe this logic, and his rebbe is so stupid as to be unable to answer a simple Talmudic question.

The remainder of the chapter is occupied by a story the Hasid tells that is ostensibly about how he nearly became rich because of his rebbe. Peretz achieves his distinctive combination of sympathy and scorn with bathos. The Hasid lives in a town near his rebbe but avoids visiting him so as not to disturb him with petty concerns like his livelihood. So he waits for the rebbe's periodic visits to town. Once during such a visit the Hasid's daughter was in the midst of a difficult childbirth, and the Hasid belatedly realized that she was on the brink of death. He decides only at the last minute to trouble the rebbe and races across town to plead for his help. Reaching the house where the rebbe is, he becomes frantic:

> "I reach the first window of the house. I don't want to wait till I get to the door, I'll break through the panes. I look and the rebbe is there, pacing about. I'm going to go in like a robber. . . . I summon my last reserve of strength, and I leap."
>
> He had difficulty breathing, so he rested for a moment. With the tears thick in his eyes, he resumed, his voice low and broken.
>
> "But it wasn't meant to be. In front of the window was a pile of manure mixed with stones, so I fell and almost broke my neck. I still bear the scar on my forehead. When I was allowed to see the rebbe, he made light of the matter."[66]

Not only does he land in a pile of manure at the moment of crisis, and not only is he mocked instead of helped by the rebbe, but when he returns home he finds his daughter has died. And none of this relates to the point he was ostensibly

making, about nearly becoming rich. He finally turns to that subject: after his daughter died, so did his wife, who was the family's breadwinner. The Hasid decides to climb out of poverty by imploring the rebbe for wealth. He does so, and, as he narrates, "That was it. I barely escaped alive from the encounter and he, may his merit shield us, passed away the week after. So I didn't get rich, but I missed by no more than a hairbreadth."[67] His faith in the rebbe is preposterous, as is his pratfall. Yet the tragedy of his life—his poverty, the loss of his daughter and his wife—is undeniable. As a person he is rendered sympathetically; as a Hasid, specifically a storytelling Hasid, he is ridiculed. It is not his human suffering that is subject to Peretz's irony but his particular Hasidic method of transforming it through a kind of moralizing storytelling.

In other works, Peretz made the folklorism of modern writers a target. "Mayses" ("Stories") depicts the ongoing failure of a writer's attempt to seduce a woman with his storytelling prowess.[68] He tells her fairy tales, and she keeps coming back to hear them; at times he forces a kiss on her over her clear objections. His use of folklore leads to an erotic dead end but is also connected with nostalgia for the small town he has left behind for the big city. Realizing that it is Passover, the writer is filled with a conflicted homesickness—yearning for his parents and the traditions they represent but also aware that the last time he went home for the holiday, his visit ended with his angry denunciation of the small-minded obscurantism of his parents' traditional beliefs. But in the city he uses the resources of the tradition—stories—he has left behind in a futile quest for erotic fulfillment. He is adrift. Peretz's story about storytelling is bleak.

Shtet un Shtetlekh (Cities and towns), a collection of weekly newspaper columns from 1902 on the goings-on in towns and cities across Jewish eastern Europe, is unsparing in its critique of traditional Jewish society and particularly of Hasidim. But two columns stage a conflict between Peretz's critique of "real" Hasidim and his adulation of invented Hasidim. The conflict between these two images of Hasidim creates an opening in which Peretz presents a rabbi voicing his own defense, targeting Peretz and his literary aims. In one article, the actual Bialer Rebbe (whose forebear featured in Peretz's story "Tsvishn tsvey berg" ["Between Two Mountains"]) comes under heavy fire for depending on the generosity of ordinary Jews to subsidize what Peretz characterizes as an indolent and luxurious lifestyle. "Where will he get his livelihood?" Peretz asks. "He can't be a town rabbi, because he is, heaven forfend, no great scholar; he can't be a schoolteacher, after all a soft man can't hold a whip—and he's never even slugged a single Zionist! He obviously can't be a soldier—first, he's too old,

second, he limps—God protect you!"[69] At any rate, his rabbinic heritage ("the merit of his fathers in all his limbs, in every drop of blood") dictates the only profession he is suitable for.[70] And making a living in this manner means traveling to his followers and bilking them out of their money.

But in a later chapter Peretz stages a rebuttal. A rabbinic judge visits Peretz to complain about the nasty portrayals of rabbis in his weekly newspaper columns. Peretz refuses to concede that his depiction of one rabbi's method of kosher certification is unfair. The rabbinical judge who confronts him voices his frustration: "You love rabbis and saints [tsadikim] who cut their own wood and use it to heat the stoves of poor widows . . . but a rabbi needs to eat, and if you want to eat, you have to—."[71] Whereupon he is interrupted by Peretz, who accuses the certifying rabbi of not only selling his certificates but also selling the Torah itself. The judge was referring, of course, to Peretz's story "Oyb nisht nokh hekher," which rationalized a rebbe's miracle-working as an example of the humane value of charity. The rabbinical judge complains that Peretz's fantasy doesn't match the real world. But Peretz, of course, will not concede the point. The only Hasidic rabbis he approved of were, in fact, fantasies—he castigated the actual Bialer Rebbe but lionized his fictionalized forebear.[72]

Peretz reuses the rabbinic judge's accusation and similarly turns the tables on a narrator with a secular interest in folklore in one of the two chapters appended to the 1904 edition of Bilder fun a provints-rayze. In the chapter "Dos vaserl" ("The Pond"),[73] the narrator, a Westernized Jew on a mission to collect demographic and economic information about ordinary Jews in the provinces, is dressed in non-Jewish clothing and riding in a non-Jewish coachman's wagon when a voluble Jew named Moyshe hitches a ride with them. The narrator suspects that there may be an interesting story related to a pond in the area, but Moyshe is reluctant to tell it. He explains his reluctance as follows: "A German Jew, for example, becomes religious, and has, for example, a yortsayt,[74] so he goes into a Jewish restaurant and orders kugel, for the benefit of his mother's soul. His Judaism is kugel. Is your Judaism maybe stories? Do you have a yortsayt?"[75] Moyshe astutely identifies the narrator's interest in storytelling as a project informed by nostalgia or even politics (he precedes this comment by noting that German Jews find their religion in Zionism). He is right, of course, both about the narrator's interest and regarding the larger discourse of folklore in Jewish culture. The narrator suspects that stories have as much use for an outsider as kugel in a restaurant does for a religious observance—possibly symbolic and definitely frivolous.

Peretz shows the limits of folklorism and the broader traditional folk culture from which it was derived most fully in *Bay nakht oyfn altn mark* (*A Night in the Old Marketplace*, 1907)—a disjointed drama that is his most demonstratively modernist work.[76] Its narrative frame includes a theater director and a playwright; its primary action is contained in the dream of a nameless wanderer who crosses into the frame narrative; its plot, such as it is, is fragmented by the innumerable voices mediating it—a cast of dozens of characters, which is its most distinctive characteristic. These characters include the living and the dead, stock figures from Jewish folklore, and stereotypes from Jewish society, including a folk poet. The deployment of folkloric themes is satiric, and is central to the play's "vision of despair," as Khone Shmeruk puts it. Avraham Novershtern similarly comments that *Bay nakht* is "a vision of decline rather than revival"; accordingly, it is opposed to the project of national revival of neo-Hasidism and folklorism. Indeed, the futility of the project of folklorism is summed up by the play's final sounds: a factory whistle drowning out a call for the characters to go to synagogue. The authority of the synagogue—and the demands on Jews it metonymically represents—is undermined by industrialized modernity. Significantly, it is a jester who issues the inaudible call to prayer. As Dan Miron argues, this central character in the play is "the quintessential representative of a failed secular Jewish renaissance and of a tragically deluded renaissance-oriented modern Jewish literature."[77] Jewish tradition is doubly condemned, negating the viability of folklore—the folk's repository of tradition—as an instrument of renewal.[78]

Against Peretz, against Stylization

Most readers, including Peretz's early readers, ignored his critiques of folklorism and in fact read him as the major proponent of this discourse. Peretz's *Khsidish* stories in particular became the focal point of a critique of folklorism that combined an ideological and an aesthetic critique. This critique targeted Peretz as a stand-in for the entire neo-Romantic strand of Yiddish literature, which was its most prominent and popular element. Peretz's critics did not seek to do away with folklore as an object or tool for artistic creation; it was rather the aesthetics of neo-Romanticism that had, in their view, run its course. Their critique was thus not only a disassembling of Peretz's project (as they saw it) but an effort to set the stage for an alternative, indeed opposed, aesthetic discourse. The aesthetic project that would match their goals was Jewish primitivism.

One of the questions that sparked a critical reception of Peretz was how "Hasidic" his *Khsidish* stories actually were. S. Y. Agnon (1888–1970)—a Hebrew writer and author of Hasidic-inspired works himself—put the matter most acerbically:

> Peretz was a great artist and produced wonderful works. But his magical eyes saw neither Hasidim nor Hasidism. The ideas that embellish his images and the images that encircle the ideas—none of them contains anything of Hasidim or Hasidism. If you searched all the places where there have ever been Hasidim, from the time of the Ba'al Shem Tov till now, and you asked every one of the Hasidim to speak, you wouldn't hear a single thing remotely like what the Hasid in the story "Between Two Mountains" says. And as for his other Hasidic stories? The appearances may change, but it's a distinction without a difference.[79]

Although the debate may seem to be about authenticity and accuracy, these are actually beside the point. As Joseph Dan has demonstrated, and as is readily apparent to anyone who has encountered Hasidic stories produced by and for Hasidim, *none* of the writers who drew on such sources dealt with Hasidim or Hasidism in a manner that reflected intra-Hasidic values.[80] The object of the debate is actually *iberdikhtung*, identified by Dovid Bergelson in a 1925 article as a misnomer for Peretz's works: "It is an error to think that Peretz was merely a transcriber [*iberdikhter*] of Hasidic spirituality, that in using its content he had nothing more in mind than the adulation of its forms."[81] In fact, argues Bergelson, Peretz "secularized" Hasidic literature.[82] Bergelson misreads *iberdikhtung*, since what he describes is exactly what it is. He does this in order to void Peretz's technique of its Romantic nationalist genealogy in favor of a revolutionary ideology. It is astonishing that Agnon and Bergelson should make the very same point to diametrically opposed purposes— Bergelson to praise him and Agnon to bury him. But their central observation is shared, namely, that Peretz's stories are not mimetic and his goal was not verisimilitude.

The implications of this debate were identified by a fictional character, the teenaged Hasidic genius in Yankev Glatshteyn's 1940 novel *Ven Yash iz gekumen* (When Yash arrived). The autodidact immodestly opines:

> I have read all of Jewish literature, I know everybody and everything. But what is there except rhetoric? Peretz's Hasidic stories are anecdotes with a moral. He looks at things through a keyhole and then blows them up. I want to see things

from within. I want to renew Jewish thought. To begin with, you understand, we must do away with Gentile forms. A Jewish creation must be everything—poetry, prose, philosophy, drama, psychology, astronomy, epigrams—everything.[83]

Glatshteyn, ventriloquizing a Hasid, made clear that the debate about how Hasidic Peretz's works were missed the point. All were in agreement that Peretz's works were, as Yiddish literary critic Nakhmen Mayzel admiringly put it, a model of "Jewish content together with refined form; Jewish plot with a worldly point of view."[84] The word Mayzel used to capture this aesthetic was synthesis: "[Peretz] deepened, refined, and synthesized the raw folkloric [*folkstimlekhe*]."[85] In asking "What is there except rhetoric?" Glatshteyn's character articulates the core critique of Peretz and the broader project of folklorism: What was the point of it? And the teenaged Hasid offers what might be a condensed manifesto of primitivism: "to see things from within."

The avant-garde Yiddish poet Peretz Markish, for example, noted in a 1921 essay, "For practically the last ten years of the nineteenth and first ten of the twentieth centuries, the best Yiddish writers, artists, and musicians have been occupied with the excavation, display, restoration, and stylization of folklore, folk-art, and folk-music—the so-called '*folks-primitiv*.'"[86] He goes on to issue the critique clearly:

And what have we gained from such tricks and stunts? . . . Where is our menorah in the worldwide Holy Temple of art? . . . What have we brought to the great market of art? Sketches of tombstones, descriptions of terrifying fairytales, stylizations of *badkhonishe* melodies. . . .[87] The primitive? . . . The primitive is only useful in art in its form. Only in that regard can artists make use of it. And only if they forgo this yearning for it [the primitive], because the primitive itself yearns for, and is immersed in, true art. And if art encounters, affects, and combines with the primitive on the path of synthetic harmony, it is not because it is indebted to it for its past.[88]

Markish acknowledges that primitive art has a vital role to play in contemporary Jewish art. But he argues that "we [should] take from it only what the heart wants—determined by aesthetics. . . . The remainder? That's a task for historians and archivists."[89] Primitivism, for Markish, must be motivated by aesthetics, and it entails synthesis in the realm of form. This demand emerges from his excoriation of the folkloric, specifically its reflexivity to its own antiquity, which, he argues, produces only stylization.[90] In short, what Markish objects to

is a neo-Romantic instantiation of the distressed genre that, he wryly notes, "is a little bit late for our century."[91]

Markish's critique of "stylization" and by extension of folklorism was echoed in the 1921 Yiddish manifesto *Skulptur*,[92] by the sculptor Yoysef Tshaykov.[93] Describing the recent accomplishments of Jewish avant-garde sculptors, he asked what connection their innovations—relating to abstraction, the depiction of mass in space, the interrelations of pictorial planes, and so on—might have to Jewish art of the past. His answer? There is no connection. Jews have no tradition of sculpture. There can therefore be no Jewish sculpture. The Jewish sculptor is thus fortunate to have unfettered access to the range of developments in the plastic arts from futurism to cubism to constructivism. But one of these major trends troubles Tshaykov: "We consider the approach of the young artists of the Left incorrect. They wish to solve the problem by recourse to the archive of our past and our folk-primitive style. This leads to stylization, and stylization to aestheticization; that is, a lie given the present circumstances and capricious individualism in service of beauty."[94]

Markish and Tshaykov almost certainly took the word "stylization" (*stilizatsye*) from the Russian context, where it was a common critical term. According to Alexander Ogden, the word has two senses in Russian criticism, one of which is "a critical value judgment, the opposite of 'authenticity' and a quick way of dismissing works artificially modeled on folk sources."[95] A more succinct definition of stylization offered by Ogden clarifies Markish's intervention in this particular discourse: mimicry.[96] Here the resemblance of Markish's critique to Peretz's becomes clear, as the broader terminological and theoretical landscape becomes muddled: mimicry (Peretz) and stylization (Markish) are to be avoided, while these same features are also called synthesis (Mayzel) and praised, while Markish sets synthesis and stylization in opposition to each other.

To clarify the terms and stakes, I will draw out the distinction between folklorism and primitivism that I made in the Introduction and that has been implicitly in play so far. First, a brief restatement of my definition: folklorism is a type of exoticism; primitivism is opposed to both, even if they all take the same object. Folklorism (exoticism) is the assimilation of folkloric/primitive source material into one's own (Western) aesthetic. Primitivism entails a critique of this process and concurrently an attempt (even if it is unachievable or not even properly articulable) to synthesize its sources with the aesthetic vernacular in pursuit of something new. As Yve-Alain Bois has argued, the critical step that led to modernist primitivism was the rejection of what he calls morphological

primitivism (i.e., the copying of external features of primitive art) in favor of structural primitivism (using an interpretation of primitive art to reconceive the representational principles of one's own work).[97] Thus, following Bois and as I have been arguing here, the beginnings of primitivism lie in the rejection of the approach to folklore that was dominant in Jewish literature of the period. The desire to produce an art essentially (or structurally) transformed by folklore and ethnography, rather than simply quoting its morphology or style, is reflected in Markish's demand that primitivism be based on encounter, affect, and synthesis.

Markish's description of primitivism is not unique to the Jewish context; in fact, it is one of the premises of modernist primitivism writ large. As such, it has been described by scholars as an expression of affinity,[98] a moment of catalysis,[99] or a relation of empathy.[100] Anthropologist Carlo Severi argues that a primitivist work is one "with a reciprocal tension between two styles of representation."[101] Conversely, "cultural imitation" of foreign or primitive sources *without* a synthesis between the "models of visual rhetoric" is mere juxtaposition.[102] The elements of neo-Romanticism (the folklore anthology and the distressed genre) constitute such a cultural imitation—quoting, so to speak, Jewish folklore within a European aesthetic paradigm.[103]

The range of Peretz's engagement with folklorism had limits. As Markish put it regarding folk sources, "[artists] restore, stylize, photograph—but they don't create." Shmuel Charney, the literary critic, issued the same complaint in his own critique of folklorism:

> Do not find the folk around you—look for it within yourself. . . . If the folkloristic primitive will be an ersatz for the folk, which arouses us and drives us to find the folk within ourselves, to find its mighty antiquity together with its youthful strength, then Jewish folklore . . . will be a bridge that leads us from our newest, most refined experiences to the ancient but still not extinguished creative energies locked up in our blood and hidden from us.[104]

To unleash creative energies; to create . . . but what? Peretz had no concrete answer, and in fact reverted throughout his career to a critique of folklore as creative resource. Ironically, Peretz's critique established the theoretical basis of primitivism, even though his works were never fully primitivist. Primitivism developed in part to address the limits of folklorism; its shape would be worked out in practice by the writers and artists considered in the remainder of the book.

Chapter 2

THE PLAUSIBILITY OF JEWISH PRIMITIVISM
Fictions and Travels in An-sky, Döblin, and Roth

While the search for the primitive led some writers to mine the archive of Jewish literature for folklore, others turned to ethnography and its quintessential genre, the travelogue.[1] Travel was the ready alternative for those who, like the critics cited in the previous chapter, felt that folklore, along with the national aesthetic project of which it was a part, had reached a dead end. Shmuel Charney's command to seek "the folk, not only folklore" was thus the pivot from philology to ethnography, from neo-Romantic folklorism to the travelogue. Charney clarified that this meant looking within the self; one simply needed to start with the "folkloristic primitive" to get there.[2] But the allure of finding difference outside the self was powerful. Jewish writers were attracted by difference, especially the most visible and audible kinds of difference, found in the distinctive dress and speech of Hasidic Jews, which were markers of a presumed primitive religiosity and vitality.

But an image of Hasidism that could validate a primitivist agenda could not be validated by travelogues that relied on realistic descriptions. Primitivism was a matter of fantasy. Reality was more complicated, and European Jewish reality was too near to be fabricated. As Robert Goldwater noted in his definitional work on primitivism: "The fact that the primitives of the twentieth century are not part of the artist's own tradition is in itself of value because it frees the individual and so makes his desired return to a single underlying intensity that much easier."[3] This chapter examines the work of primitivism when the "primitives" were, in fact, part of the artist's own tradition, when the "journey to the

Jews,"[4] as Joseph Roth described the travelogue of his contemporary German Jewish writer Alfred Döblin, was as straightforward as a trip across the Polish border. In short, the "desired return to . . . intensity" became counterintuitively harder as access to its source became easier. This paradox derived from two facets of Jewish primitivism: first, it could be a plausible call for an experiential and performative shift in identity, not only an aesthetic or philosophical gambit; and second, it was anchored in a prosaic reality that often ran counter to primitivist fantasy. "Going native" in Africa or in the South Sea islands was implausible at best—despite his stated desires, Gauguin, for example, remained a European artist, enmeshed in colonial economic networks.[5] But becoming Hasidic? A European Jewish man would not need to change the color of his skin or move to a distant island. He needed only grow a beard, change his clothes, and practice a religion into which he had already been born. For a Yiddish speaker language was no obstacle, and the high degree of mutual intelligibility between Yiddish and German meant that any German speaker had immediate linguistic access to this ostensibly exotic culture. Becoming Hasidic was not easy, to be sure, but it was possible.[6] Ahron Marcus, a German and the greatest popularizer (after Martin Buber) of Hasidism in Germany did it; Jiří Langer—Czech poet, Hasid, and friend of Kafka—did as well.[7]

For the Jewish writer, the propinquity of the primitive subject did not elide its difference but suggested that the desirable qualities the primitive object was thought to possess were in fact acquirable. Yet when the awareness that both writer and object inhabit the same position—or at least that they could—came up against the powerful fantasies about primitive Jewish identity, an irresolvable conflict was created that rippled throughout the works of the writers who staged this confrontation. The challenge to primitivist fantasy did not cause these writers to scuttle their primitivist literary projects. On the contrary: the writers examined in this chapter all wrote distinctly primitivist fictional works *after* having written travelogues that presented the challenges reality posed to Jewish primitivism. The disappointment of primitivist fantasy in the face of the reality of Jewish life and culture would be redressed by a retrenchment expressed in primitivist works of fiction. Each part of these writers' oeuvres is only properly understood in relation to the other. Jewish primitivism is thus not a matter of the opposition of primitivist fantasy and its negation but of the sometimes purposeful and sometimes oblivious obviation of this distinction.

This means that Jewish primitivist travelogues do not proceed through the orderly expression, testing, and then undermining of primitivism. Rather, the

travelogues anticipate their own challenges by attempting to negate the evidence they find of Jewish modernity by emphasizing Jewish primitivity along the way. Second, the writers follow these ambivalent or abortive primitivist travelogues with texts that are insistently and unambiguously primitivist. This is not a dialectic so much as a sleight of hand, in which Jewish primitivism is pulled out of a hat already shown to be empty. This peculiar, dual and dueling literary project was only possible because of the social, geographic, and cultural conditions that allowed German and Yiddish modernist writers to selectively—sometimes simultaneously, sometimes alternately—emphasize aspects of Jewish identity as either modern or primitive.

The slippage between primitive and modern identities compromised the traditional aim of the ethnographic travelogue, which was meant to redress this slippage by fixing identities. Jewish primitivism resisted stable identities and points of origin. As a result, these travelogues could not guarantee the primitivity of their object or the modernity of their writer. Instead, such writing presented the primitive object as sometimes primitive, sometimes modern—or as both at once. This self-awareness made some works of Jewish primitivism tend toward "ironic meditation . . . on the limits of primitivism," as Gabriella Safran has argued about S. An-sky.[8] Others, however, bypassed irony for an unambivalent primitivism. Confoundingly, the two options are found within the oeuvres of individual writers, including that of An-sky, the subject of Safran's argument. When the exploration of limits was paired with the strong primitivization of Jewishness found in other texts, the story becomes one not of irony but of paradox.

In combining opposing trajectories—toward and away from primitivism, whether in a single work or in a body of work—Jewish modernists were exploring a terrain of aesthetics and identity not accounted for by scholarly models stemming from the study of colonial systems. In those contexts, the intense urge to become primitive was kept in check by the distance between the writer and the desired object, whether it was an emotional state or a social identity. This gap between subject and object could never actually be bridged, creating what Homi Bhabha has called "the disturbing distance in-between."[9] Bhabha argues that the hybrid identities that emerge from this in-between space make impossible the fulfillment of the colonial project—the remaking of the colonized in the image of the colonizer. Similarly, Mary Louise Pratt calls such a space a "contact zone" which generates a genre with emancipatory potential—autoethnography. As Pratt defines it, "Autoethnographic texts are

not, then, what are usually thought of as autochthonous forms of expression or self-representation. . . . Rather they involve a selective collaboration with and appropriation of idioms of the metropolis or the conqueror."[10] Stathis Gourgouris, however, sees this kind of mimicry (which he calls autoscopic) as less inherently emancipatory, since it is not only a mimicry of forms but also one of discourse and thus replicates other hegemonic forms.[11]

All of these accounts are premised on a basic polarity of identity at work in ethnography and empire. But the shifting social and aesthetic considerations around Jewish identity in the period reflected a different set of conditions; the presumed polarity of the colonial encounter did not apply in the world of central and eastern European Jewry.

Coming somewhat closer to what we see in central and eastern European Jewish modernism is John Zilcosky's account of the colonial encounter in German literature. Zilcosky describes the "uncanny encounter," a feature of German modernism that stages "the unsettling confrontation with one's mirror image in a world that ought to contain wondrous, inscrutable strangers." What follows is "the disappointed, angry reaction to this surprising sameness."[12] This uncanny recognition produces, contrary to Bhabha, a fear "not of difference but of similarity."[13]

There are certainly resemblances in these accounts of the colonial encounter and the literature it produced to the Jewish modernist travelogue. But in distinction to colonial hybridity, the texts examined in this chapter show that the question here is not about "disturbing distance" or a fear of difference but about the primitivist desire for difference. Further, the Jewish desire for difference may correlate to a fear of similarity, as in the "uncanny encounters" described by Zilcosky, but they do not evince an "angry reaction" to sameness. Instead, Jewish primitivist texts evade and undermine similarity; such texts either deny similarity outright or use it as a foil for difference that is once again discovered. The psychological implications of both hybridity and the uncanny encounter— anxiety, fear, dread—already indicate a crucial difference of these colonial discourses from Jewish primitivism that is highlighted by Zilcosky's treatment of the place of the Jew in relation to these encounters. According to Zilcosky, the feeling that "the Jew is not as strange as he ought to be" is inevitably anti-Semitic because it insists on a core degree of otherness, whether recognizable or not.[14] Indeed, the problem for many anti-Semites, Zilcosky notes, was that Jewish difference was not recognizable. In this anti-Semitic discourse, the placement of the Jew in the position of the object with an uncanny resemblance to the

subject remains one of otherness.[15] The fear, which is ultimately related to the fear of the colonizer in the postcolonial account of hybridity and mimicry, is that the sameness will encroach upon one's own identity and eventually obliterate it. But this is precisely what primitivism desires: it subsumes a Westernized, Europeanized identity in a savage one. Jewish primitivism expresses the desire for one's own Western identity to be replaced by a Jewish, primitive identity. Though fear and dread certainly shadow this discourse, they do not predominate; ultimately Jewish primitivism is characterized by fascination and desire. But this is by design: the ever-changing measurements of difference demand a constant recalculation of distance, in order to continuously maintain primitivist fascination and keep the forces that might challenge primitivism at bay.

The constant calculation of distance in these travelogues means that the gap between primitive and civilized, between writer and object, is opened and closed at will. Max Brod recorded Kafka's comment that a Hasidic group they had visited in Prague "was just like a savage African tribe."[16] But Kafka's comment was addressed to Brod and to the person who brought them there, Jiří Langer. Langer was from the same assimilated Jewish milieu as Kafka and Brod but became a Hasid—at the age of nineteen he went to Belz, in eastern Galicia (then still in the Austro-Hungarian Empire) to join the followers of the Belzer Rebbe.[17] He returned to Prague wearing a caftan, with beard and sidelocks, and dismayed his friends and family. His newfound piety did not diminish, and likely strengthened, his friendship with Brod and especially Kafka. So Kafka, who was brought to a Hasidic gathering in his hometown, was speaking to a Hasid when he compared them to a savage tribe. The identities in play were negotiable, even fungible. While Kafka's comment betrays an irony spiked with hostility, the dynamics of the encounter were based on attraction and interchange. *Ostjuden* in Mitteleuropa on one side, assimilated Jews turned into Hasidim on the other. Even if Langer's path was relatively rare, it was possible, even plausible. Its plausibility underscored the geographical, cultural, and linguistic proximities that catalyzed travelogues about eastern European Jews even as they complicated them.

Texts that moved between the imagined primitive and the "actual" primitive (as opposed to works that simply denied the opposition of these two categories) were inherently conflicted.[18] The conflicts in these texts, the specific problems they generate, and the ways in which their authors attempt to resolve them are the subject of this chapter. These travelogues stage the subversion of their premises but do not abandon them. They pit depictions of Jewish life as

prosaically modern against tenacious assertions of primitive Jewish identity together with literary explorations of how to experience that primitiveness. If such an interesting conflict were not enough, each of these writers of conflicted ethnographies wrote works of fiction that—at least in part—offer an unambiguous picture of Jewish primitivism and wrote these either simultaneously with or following their travelogues. These creative works, in this light, are answers to the particular challenges to primitivism raised by the travelogues. A scene from the very beginning of Alfred Döblin's masterwork *Berlin Alexanderplatz* (1929), Joseph Roth's novel *Hiob* (*Job,* 1930), and S. An-sky's renowned play *Der dibek* (*The Dybbuk*, 1919) all respond to the version of Jewish primitivism that is proposed and challenged by the travelogues of their respective authors.

Alfred Döblin presented his powerful desire to find "the core" of the Jewish people among the eastern European Jews in the travelogue *Reise in Polen* (*Journey to Poland*, 1925).[19] His primitivism is stymied again and again by the difficulty, sometimes impossibility, of communicating with the objects of his primitivism. The language barrier plays a role, but the more significant obstacles are his resistance to comprehending what the Hasidim he meets with have to tell him and their difficulty in understanding what exactly he wants from them. *Berlin Alexanderplatz* presents, in its very first pages, a model of translingual German-Yiddish communication that claims the power of stories to generate meaning, to be comprehended intuitively, and to change their listeners. The parables told by a Hasid to the novel's protagonist, Franz Biberkopf, provide the gauge by which his reintegration into society is to be measured and the means by which his reintegration ought to be accomplished.

Joseph Roth, the journalist among this trio of writers, describes in his book *Juden auf Wanderschaft* (*The Wandering Jews,* 1927) the powerful challenge posed by modern politics, by migration, and by secularization to the traditional culture that fostered the object of his primitivism. If Hasidic Jews stand no chance in the face of modernity, neither by extension does Roth's Jewish primitivism. His novel *Hiob* therefore presents a hero who maintains, indeed refines, his naïve, pure, and powerful belief in God in the face of every hurdle and disappointment modernity throws in his path.

An-sky's travelogue, *Khurbn Galitsiye* (The destruction of Galicia; based on diaries from the First World War),[20] stages the salvage work of an ethnographer who is faced with the fact that, while his subjects are in grave danger, their culture is not on the brink of disappearance but is alive and productive; they are endangered as humans but not as ethnographic objects, thus skewing the

dynamics of primitivism that An-sky, as ethnographer, attempts to put in place. His play *Der dibek* (first drafted in Russian in 1913–14, the revised Yiddish version was published in 1919),[21] written in roughly the same time period, presents a static image of Jewish culture, full of exotic and antiquated details. The play's ethnography is the catalyst for the star-crossed romance at its heart. An-sky's primitivism, in other words, is focused on the vital eros that not even death can stop, embellished by an apparatus of early modern Jewish beliefs and customs.

Together the conflicted travelogues and the unconflicted fictional texts produce a body of work that is primitivist: holding itself in suspension, mutually negating and confirming itself. One half of these dual and dueling oeuvres by itself would not constitute primitivism; together, they show the challenge that Jewish primitivism posed to itself. Finally, for all three authors, the fictional work (which for Döblin and Roth followed the travelogue and for An-sky was composed in the same period) presents a version of primitivism that specifically rejects the challenges posed to primitivist fantasy by the Jewish reality presented in the travelogue. The decreasing primitivity of the Hasidic Jew makes the desired increasing primitivity of the civilized Jew impossible. Resolving this dynamic falls to works of literature that could fabricate a Jewish primitivity immune to the social forces that made such primitivity impossible.

The Travelogue

Alfred Döblin—*Journey to Poland*

Alfred Döblin wrote, "I feel as if I've come upon an exotic tribe."[22] He was describing Hasidic Jews, a focus of his travelogue *Reise in Polen* (1925). But he didn't even need to go as far as Poland to see such "primitives"—the Jewish primitive was as near as Berlin's Scheunenviertel, where his magnum opus, the novel *Berlin Alexanderplatz*, begins. Though Döblin had a long-term interest in Jewish identity,[23] it made relatively little mark on the part of his oeuvre that has captured the most critical attention: his fiction, especially his novels. Yet the very first pages of his most important work—a novel that has come to define the city of Berlin as well as German modernism—are occupied by a Yiddish-speaking, storytelling Hasidic Jew. Though the scene has garnered limited critical attention[24] (it is, after all, just a small part of an enormous book), it is crucial to understanding both the novel's larger argument as well as Döblin's understanding of Jewish identity. But this novelistic vision of primitive Jews was preceded by a conflicted primitivism in his travelogue.

Döblin's book-length reportage, *Reise in Polen*, shows that the conflict between primitivist fantasy and Jewish reality was irreconcilable. But the travelogue does not portray disillusionment with and abandonment of Jewish primitivism; rather, it presents his vacillation between the affirmation of a primitivist fantasy about Jews and his confrontation with a prosaic reality that deflated his primitivist hopes. The book represents both experiences; it neither solely affirms nor solely undercuts Jewish primitivism. But while the work as a whole reveals the ambivalence at the core of primitivism, the work itself is not ambivalent—the passages that affirm, promote, and reify primitivism do so powerfully and with conviction.

Reise in Polen is one of Döblin's most sustained treatments of Jewish subjects. The book is an account of a long trip Döblin took around Poland; the most notable topics to emerge in the book are his exploration of Jewish life and his incipient interest in Catholicism (to which he ultimately converted). The descriptions of Jews predominate and are characterized by Döblin's primitivist desire to make them into a rejoinder for the modernity he despises. Döblin's primitivism here is motivated both by an exoticist fascination with Hasidic Jews and by his repudiation of modernity: "I decisively dismiss and reject classicism [*Klassizität*], Hellenism, and humanism. They are bourgeois armchairs, easy chairs for the lazy. . . . I'm a natural enemy and adversary of lucid classicism and too-beautiful Grecism [*Griechentum*], an adversary of their mimicry and of their entire doctrine, because it is perishable."[25] He needed to come to Poland to learn that there is a Jewish culture immune to these dangerous Western values: "What an impressive people, the Jews. I didn't realize it. I believed that what I saw in Germany were the Jews: those driven people, the merchants . . . the nimble intellectuals, the countless insecure, unhappy, gentlemen. Now I see: those specimens are degenerating, cut off, and far from the core of the people [*Kern des Volkes*] that lives here and is preserved here. And what a core—it produces people like the . . . Baal-shem, the dark flame of the Vilna Gaon. The things that took place in these ostensibly uncultured Eastern regions. How everything flows around the spiritual."[26]

Döblin relished the iconoclasm of his position and used it as a further cudgel against modernity:

> I know what the enlightened gentlemen, the Jewish Enlighteners, will say. They laugh at the "stupid backward" people of their own nation [*Volk*], they're ashamed of them. . . . To tell the old fairy tales that the stupid backward people

occupy themselves with—what nonsense, what naïveté! None of that is real. I, belonging neither to the Enlighteners nor the hoi polloi [*Volksmasse*], a Western passerby—the "Enlightened" ones seem to me to be like Negroes [*Neger*] who parade around with the glass beads given to them by sailors, with dirty cuffs on their swinging arms, with brand-new top hats on their heads. How poor, how shabby, unworthy, and soullessly devastated is the Western World that gives them those cuffs.[27]

He analogizes the Haskala to the "civilizing" process that compelled Africans to give up their authenticity in favor of the worthless frivolities of Western culture. Among the Polish Hasidim he finds Jews who have resisted the malign influence of western Europe and of the Jewish Enlightenment. He immediately contrasts the top-hat-wearing Africans with the Jews he finds in Kazimierz, who dressed "in low shoes, in white stockings, enormous fur hats down to their ears—the *shtrayml*."[28] Their commitment to their customs is a powerful rejoinder to modernity.

The contrast between the two types of Jews is revealed strikingly in a comparison of synagogue services on Yom Kippur. On the morning of Yom Kippur, Döblin goes to a small congregation of Hasidim. Even before entering he anticipates strangeness: "We begin to climb up the dark stairs, along worn steps between crumbling masonry, this is a very special place." His hunch is immediately confirmed: he hears "loud, indeed shrill singing, no not singing," and "a wild confused shouting, then a murmuring with individual cries, a sonorous tangle that sometimes fuses into a single noise and roar."[29] The service is chaotic and strange:

> The worshipers here rock in a peculiarly sharp and expansive way. At one point in their prayers, one man suddenly kneels, then, tumultuously, all the others; they get back on their feet, slowly and chaotically. The simple brown-bearded man next to me prays strong and loud. Now his voice changes; I can't follow what he reads: he weeps. The others also have broken voices. Now their voices rise in a chorus, an ecstatic tangle begins, a shrill chaos. Mute rocking, then sudden shrieks. And now, what's this; a singing, in unison, a joyous song. The place livens up, it's like a dance, an exuberant rejoicing. It starts with words, then, like laughter, ends as lalala.[30]

This mode of worship is contrasted with a visit to a liberal "Temple": "These prayer rooms reveal a difference of worlds."[31] In the temple, "well-dressed

gentlemen and ladies step into various doors. . . . The man with the prayer shawl in the vestibule is wearing a real doorman's cap, and it even says 'portier.' . . . Total silence. The bright clear singing of the choir. . . . Only occasional whispers in the throng behind the benches. . . . The room is a large wide circle, and lo, it has three genuine tiers with a balcony, it's built like a real theater."[32] Döblin wanted to leave immediately, "for I despise what the liberals of all persuasions call 'divine service,'" but he is captivated by the cantorial singing, which he finds to be "the finest artistry."[33] It is not merely an artistry appropriate for a so-called temple built like a theater: "It's not mere art, the art of concert halls; there is such a thing as religious art, even if it's not as sublime as religious non-art."[34]

This distinction encapsulates one of the fundamental differences Döblin sees between Hasidic Judaism and "Europeanized" Judaism—the former is able to consistently, as a part of the daily lives of its practitioners, evoke religious "non-art." The appeal of religious art is not its refinement but its proximity to non-art, its approximation of the worship of Hasidim: "The praying begging praising emotions express themselves here with a thin veneer of civilization."[35] Beneath this veneer is true culture, the culture of ecstatic prayer and chaotic worship. The primitive core emerges when the veneer is stripped away: in response to the cantor's singing, "the doorman becomes wild."[36]

Döblin's primitivism is motivated and undermined by a paradox: "I want to see the dead, the vanished, which lives. I don't want renovations [Ich will das Tote, das Entschwundene sehen, das lebt. Ich will nicht die Renovationen]. Those people in black coats and fantastic fur caps on the sidewalk! Don't I recognize them? The Jews!"[37] This strange paradox—the dead that lives—is quintessentially primitivist,[38] but it is also typical of Döblin's particular struggle in this text. That is, he both implicitly and explicitly acknowledges that the principle of his primitivism is paradoxical. Later in the text, describing the Catholic imagery he admired in Krakow, he writes, "The most ancient is always the newest" (Das Uralte ist immer das Neueste).[39] This comment was in response to a power plant that he admired; he acknowledges the apparent contradiction: "These machines here are real, strong, living steel. They have my heart. I don't care how they're connected to the Hanged Man, the Just One [i.e., Christ]."[40] Earlier he writes, "Is it a dead world and a new world? I don't know which is dead. The old one isn't dead. I feel intimately and violently drawn to it. And I know that my compass is reliable. It never points to anything aesthetic, it always points to living, urgent things [Lebendiges, Drängendes]."[41] In other words, his compass points to living things, but the things he believes are most alive must

also be those that are dead. Yet, of course, these objects of primitivism were alive. Döblin has three responses when he encounters actual Hasidic Jews. The first is the response typical of primitivism more broadly, that is, the imposition of imagined features on a real object. He sees what he wants to see. Second is finding that, surrounded by so many living, real Hasidim, he is stymied: he cannot understand their language; he feels uncomfortable observing their prayer; he is mystified by their behavior. In other words, when they conform to his primitivist expectations, he does not actually appreciate them. Third, and most confoundingly, he finds that when they conform least to his primitivist expectations, he admires them most. This heterogeneous dynamic in which he asserts his primitivism only to unwittingly undermine it or implicitly retract it becomes the defining feature of the vision of Jews he expresses in the text.

For example, a key section of the book is a lengthy description of a visit to the court of the Gerer Rebbe, the leader of the largest Hasidic group in Poland. Döblin had prepared this section to be a stand-alone piece for publication elsewhere, setting it off in his manuscript with the title "With the Spiritual Prince of the Jews of Gura Kalwarja."[42] Formally a typical travel vignette, it begins early in the morning with the beginning of the voyage—Döblin seeks the railroad station to travel from Warsaw to Gura Kalwarja. His interest at this point is not, however, in travel but in the Hasidim, and he quickly begins accruing local color, describing "men in long black coats and black skullcaps" and "young, old, black-bearded, red-bearded Jews."[43] In seeking the primitive, Döblin balances ethnographic particulars with universal generalities, for example by juxtaposing a praying Jew and a nursing peasant woman who are near each other in the train carriage. Both are offered as examples of purity, bound by the ease and naturalness of their actions, but whereas the natural behavior of the Jew is spiritual and rarefied in nature, that of the peasant is corporeal and mundane. This tableau on the way to the rebbe indicates the dichotomy of Jew and other, spiritual and mundane, on which Döblin's primitivism is premised.

As he approaches the rebbe's court in Gura, the Hasidim are shown to be paradoxically urban and of the natural world, even animal-like:

As we turn into the broad main street, a fantastic and unsettling image is revealed. This swarm of black pilgrims—those who came with us and others—with bag and baggage, going up the long street. The up and down of black caps. The yellow trees stand on either side, the sky above is pale gray, the soil tawny—between, an almost frighteningly bustling blackness [*eine fast entsetzlich regsame*

Schwärze] moves, packed together hundreds of heads, shoulders, plods, drags along, a mass of ants.[44]

Condensed into this short sequence is fascination mingled with terror: the Jews are unruly; they are insects; they form an undifferentiated mass that was "much worse, much worse, than any urban crowd that I have ever experienced."[45] This veers into ethnographic description colored by enthusiasm:

> But the men and the boys who await the travelers and come to meet them are of a very special sort [*Art*]. They have long hair, their curls shake; the curls, twisted as tight as corkscrews, drop sideways from under the skullcaps and dangle in front of their ears, next to their cheeks, on their throats. I get a picture of what earlocks are; what a proud adornment. How proudly these men, youths, boys stride along in clean black caftans, in high shiny black caps.[46]

This enthusiasm demands that the Jews he sees be of a very special sort indeed—in the next paragraph Döblin writes, "I feel as if I've come upon an exotic people [*eine exotische Völkerschaft*]."[47] This is Jewish primitivism in its most condensed form. The invocation of this foundational trope is reserved until a crucial moment—just before Döblin's entry into the rebbe's house and the critical encounter with the rebbe himself.

Döblin's excited anticipation sets up his inevitable bitter disappointment. He makes his way past foreboding and unfriendly men in the vestibule. He describes the growing crowds flooding the rooms; his initial efforts to negotiate a way in to the rebbe are fruitless. Finally, his guide manages to make his way through the crush into the rebbe's study. After a few minutes a doorman pulls Döblin into the room: he has finally gained entry to the inner sanctum. His description of the rebbe bespeaks his expectations. With a face completely covered by hair, the rebbe seems like an animal: "His head is completely wreathed in a tremendous mass of curls. . . . Thick sheaves of curls tumble over his ears, over his cheeks, along the sides of his face all the way down to the shoulders. A full fleshy face surges out from the curls. I can't see his eyes."[48] The rebbe also lacks normal civilized comportment: "He keeps rocking to and fro, incessantly, now less, now more. . . . He doesn't look at me, doesn't look at my companion. . . . His expression is ungracious, he never looks up for even an instant."[49] Nevertheless, he has been conversing the entire time in Yiddish with Döblin's companion, who relays to him the rebbe's offer to answer a question.

Döblin writes: "I think to myself: Impossible, that's not what I'm after; I want to speak to him, not question him."[50] The pompousness of the reaction reflects his misapprehension of what a rebbe is and does. In his moment of hesitation the experience begins to slip toward banality and disappointment: "But the rebbe is already speaking again, softly: I can't understand a single word of this very special Yiddish. Then, suddenly, I have his hand, a small slack fleshy hand, on mine. I am astonished. No pressure from his hand; it moves over to mine. I hear a quiet "*Sholem*," my companion says: 'We're leaving.' And slowly, we leave."[51]

Döblin attributes his lack of comprehension to the rebbe's Yiddish. But he has not only failed to understand the rebbe's words; he has also misunderstood the purpose of such a visit. He claims he was interested in the rebbe as an interlocutor, but this imposes a role external to the rebbe's own conception of himself and bespeaks the deeply primitivizing character of Döblin's wishes: his ostensible desire to engage the rebbe as a subject transforms him into an object. Döblin's linguistic inadequacy is recast as the rebbe's inscrutability—the rebbe remains fully other.

Döblin's failure to comprehend is so complete that, leaving the room, he wonders, "What happened?"[52] He may not have understood what transpired, but the rebbe did. Döblin learns that the rebbe asked who he was, what he wanted, and if he was a lawyer, concluding, "'I won't be interrogated. He has nothing to ask me, and I have nothing to answer.'"[53] The rebbe has accurately seen that Döblin has misjudged his role. A conversation or interview with a rebbe would have been out of the ordinary; words of blessing (which Döblin received in the end) or advice were the norm. The reality of a rebbe's pastoral role was incommensurate with Döblin's lofty expectations.

What Döblin hoped for is encapsulated in his description from later in the book of the Baal Shem Tov, the founder of Hasidism:

A Jewish "heresy" cropped up in the Ukraine. It was spread by a lone man, poorly acquainted with Talmud and Torah. He began to say all kinds of things to the poor Jewish masses. . . . He didn't go inside the *bes-medresh*, the synagogue, he remained outdoors, studying, people said, the voices of the birds and the speech of the trees. "Ah," he said, "the world is full of light and wonderful secrets. . . . Anyone can be great and righteous without knowing the Talmud." The uneducated ran to him. He must have been an imposing, elemental [*urwüchsig*] person. This wonderful man taught the vast power of the soul, the omnipotence of

the soul. They made him a tsadik, a superhuman, a mysterious being who saves others, works miracles. . . . He taught joy and merriment, ardent prayer; sorrow struck him as reprehensible. Pure thought, feeling were everything for him.[54]

In this light, it is easy to understand Döblin's disappointment in the relative ordinariness of the Gerer Rebbe. The Baal Shem Tov was *urwüchsig*, which can be translated as primitive. The Gerer Rebbe, by contrast, was underevolved and like an animal, covered in hair and in constant motion. Döblin's primitivism turns negative in light of his disappointment. The social framework shaping his encounter—the doorman, the crush of visitors—and the banal, modest exchange with the rebbe, underlined by the rebbe's refusal to participate in Döblin's project, exploded his primitivist preconceptions—the fantasy cannot coexist with reality. Döblin represents both the fantasy and its undoing, his high expectations and their disappointment.

The challenges to Döblin's primitivist hopes do not dampen his enthusiasm or mitigate his persistent attempts to confirm them, which some encounters in fact do—up to a point. For example, at the end of the Sukkot holiday, Döblin wanders among the sukkahs in the courtyards of Warsaw with his guide and meets a Hasid who invites him into his sukkah.[55] Here is his opportunity to ask about what he saw the previous day in Gura, including the *tish* (the ritual Sabbath and holiday gathering at the rebbe's table) he attended after his audience with the rebbe. He asks, in particular, about the *shirayim*—morsels of food from the rebbe's plate that are distributed among the Hasidim in attendance, who sometimes jostle for position. His host's teenage son offers a secular opinion on the ritual: "In that crush, some people faint and they could catch consumption; they have to be carried out," while the father offers the Hasidic explanation.[56] The teenager's comment is related by Döblin with indirect speech, the father's with direct—the contrast indicating differing levels of authority. The teenager's comments are relatively obvious and lack interest for Döblin, so they do not need the authority lent by a direct quotation. The father's explanation quoted by Döblin is as follows:

> "Eating and drinking: our attitude toward them is different from yours. You believe that you eat for the sake of your bodies. We do not believe that. We see eating and drinking as something spiritual, something that contributes to the mind. . . . When the tsadik touches the fish or merely looks at it on his table, something of his spirit goes over to the fish. And if someone else partakes of that fish, then he absorbs something of the rebbe's spirit."[57]

In contrast to the son's banal observation, the father gives an explanation with deep detail of precisely the sort that Döblin would want: mystical, strange, exotically spiritual. This rich ethnographic source material moves Döblin to an interpretive reverie:

> How does a democratic nation come up with saints? An old vestige: the kingdom collapsed; the structure that people cling to is religion, cult, and its chief carrier is the rabbi. He can be understood in national terms: rabbis are the leaders, kings, dukes, princes. And they actually ruled until the past century. But that's not all. The Jews brought the Middle Ages along. They have their Torah, a single book, but it is accompanied, namelessly, by magic and by faith in witchcraft. In this respect, Judaism resembles Buddhism, which has its own teachings but tolerates the survival of ancient deities. Behind the backs of the rabbis, the populace attributed these illegitimate magic powers to these Jewish leaders, these spiritual rulers. Especially once the mystical Hasidic movement brought back magic. The magicians became rulers, became rebbes. . . . The rabbinical dynasties still exist—although their great era is past—and they hand down a mysterious chosenness.[58]

The scope here is broad and comparative—he looks back to the beginning of the exile as well as to Buddhism—marking the kind of ethnographic synthesis popularized by James Frazer's *The Golden Bough*. Significantly, Döblin indicates that the institution of the Hasidic rebbe is a "vestige" of magical belief brought from the Middle Ages, an explanatory model favored in contemporary ethnography and known as the doctrine of survivals.[59] This doctrine dictates that the best way to understand the past is through the examination of contemporary practices that are "survivals" of earlier periods; they are identifiable by virtue of their oddity or attested antiquity. Similarly, primitive peoples are felt to be survivals of prior stages of human evolution.

But sometimes survivals weren't quaint or inspiring. Sometimes they were inexplicable and frightening, as in Döblin's visit to a cemetery before Yom Kippur:

> From all over the meadow, even where I see no people, I hear chanting, shrieking, wailing, moaning. . . . Now and again, something emerges from the green, a back, a head, a face. . . . [More women] lie on the graves, weeping, lamenting, accusing themselves, calling, appeasing the dead, [they] huddle in the grass, lamenting, moaning, emitting the shrill singsong.[60]

The cemetery terrifies him: "Cold shivers run up and down my spine when I see and hear these things. . . . This is something horrible. It is something primordial, atavistic."[61] He contrasts this primitive behavior with a Christian cemetery, where "everything is so soothing," and wonders where the Jewish customs come from.[62] He explains it using the concept of survivals: "These are living vestiges of ancient notions! These are vestiges of the fear of the dead, the fear of wandering souls. A feeling handed down to the members of this nation with their religion. It is the remnant of a different religion, animism, a cult of the dead."[63] Instead of characterizing the behavior of Jews in a cemetery as an admirable rejoinder to modernity, he retreats into ethnographic discourse, soothing himself, as it were, with the explanatory models generated by the Western institutions of knowledge he claims to despise.

Claudia Sonino has argued that Döblin's travelogue is characterized by an attempt to overcome the depersonalization of the New Objectivity.[64] While the ethnographic nature of the above-quoted and similar passages show that this is not the case for the entire book, it certainly characterizes those moments where Döblin's primitivist expectations are confounded. In other words, in giving voice to his own subjectivity, Döblin allows the subjectivity of his objects to emerge. This process inevitably displays the challenge to his own primitivism that emerges from his pursuit of it; it is most strikingly displayed in the final pages of the book's penultimate chapter.

In this episode, Döblin once again visits a rebbe, this time one of minor stature. He begins his vignette with a primitivist image: "Once again I am summoned to the dark lanes. A rebbe lives here, the Rebbe of Strickow."[65] The rebbe lives amid winding and mysterious streets, not modern, well-lit avenues; a place that mysteriously draws one in. On admittance to the rebbe, Döblin is favorably impressed: "The great Rebbe of Gura Kalwarja wouldn't accept me; this one sits down with me at the table. He lives in a tenement, his *bes-medresh* [study and prayer hall] is small."[66] Whereas Döblin described the Gerer Rebbe as unkempt, he notes the Strickower Rebbe's civilized garb, as the Hasidim "take his wet umbrella and silk overcoat."[67] He is impressed by the rebbe's appearance, which he equates with his superior character: "He has deep, very calm eyes, which do not gaze out of him, but are turned inward. They are windows peering inside him. . . . He's modest, kindly. . . . This rebbe has almost an excess of softness and gentleness."[68] Döblin draws the comparison explicitly, saying, "What a contrast with that rich autocrat, the Rebbe of Ger," whose hairy, animalistic appearance belied an inferior character.[69] The experience itself is also more satisfying: "It's

not easy for me to ask questions. But I take heart when the rebbe, that tremendous figure with a gray beard, responds calmly and kindly, in a highly intelligible way."[70] Döblin also notes that when he attempted to ask a question, the rebbe quieted down the bystanders, letting him speak.

But although the experience was so different, it remains motivated by his drive to see the Hasidim as primitive and therefore opposed to Western, "civilized" Jews. This opposition leads Döblin to pursue binaries throughout his final characterization of Hasidic Jews. He shows a dichotomy between the spiritual and the worldly: "While the mild, lovely words resonate within me, the men sometimes get into violent, chaotic disputes."[71] Döblin carries these binaries into the realm of politics, asking the rebbe's opinion on Orthodoxy and Zionism, seemingly assuming that the rebbe would affirm the anti-Zionist position of the Orthodox political party Agudas Yisroel. The rebbe, however, offers a response that in its moderation breaks apart the binaries inherent in the categories to which Döblin refers. The rebbe says that "he is no enemy of Zionism. But in the eyes of God, a man is a Jew if he keeps nation, country, and Torah together. Without this there is no Zion."[72] He also supports the study of secular subjects, albeit only after an education in Talmud and Torah. Döblin pushes at another binary, asking, "How do the old sacred writings relate to modern science and scholarship; can they be made compatible with one another?"[73] The rebbe's response, again moderate, delights him: "The Torah is the source that makes everything fruitful. Science is only a single body of water deriving from it."[74] Döblin calls his meeting with the rebbe "a wonderful conversation, completely refreshing" (*wundervolles Gespräch, vollkommenes Labsal*).[75] And indeed, in its contrast to the expectations he brought to it, expectations formed by his rudimentary knowledge of Hasidism and the contemporary situation of Polish Jews, as well as his prior experience with the Gerrer Rebbe, it was refreshing. The schemas, tropes, and binaries that had governed his understanding and description of Hasidic Jews throughout the book give way to the rebbe's modesty and moderation. Döblin's quest for primitivism produces something different: a final vignette of religion moderated by the overtones of humanism. On the one hand, his primitivist conceptions of Hasidim have failed to withstand their confrontation with the reality of Hasidim. But on the other hand, his primitivism has succeeded: he had outsize expectations about the wisdom and authenticity of Hasidic rebbes, and these expectations were finally confirmed in his encounter with the Strickower Rebbe. Döblin's primitivism is malleable enough to adapt to his own depiction of a Hasidic primitive

who counters many of the stereotypes he had earlier deployed. Nevertheless, both rebbes, each in his own way, deflate the primitivism that motivates Döblin's excitement about them; this is because he actually has contact with them and has given each the opportunity to speak and to disappoint or delight him with their humanity. Only the Jews with whom he does not speak—whether he observes them at prayer or in the cemetery—allow him to create primitivist representations that confirm his primitivist expectations.

Joseph Roth—*The Wandering Jews*

Joseph Roth's politics and literary agenda diverged sharply from Döblin's. While Döblin leaned left, Roth eventually ceded—after the First World War—his revolutionary politics to an anachronistic, nearly irredentist, devotion to the Austro-Hungarian Empire. While Döblin's novels were testing grounds for at times strikingly modernist techniques, Roth's novelistic modernism was less aggressive: his journalism was often stylistically inventive, but his fiction was more restrained. Yet he shared Döblin's primitivist fascination with Hasidic Jews and struggled with the same tension between primitivism and reality in his travelogue. Roth's Jewish primitivism is the centerpiece of two of his works: a short book of essays, *Juden auf Wanderschaft* (*The Wandering Jews*, 1927), and the novel *Hiob* (*Job*, 1930). *Juden auf Wanderschaft* is part travelogue and part ethnography; in valorizing eastern European Jews, Roth is also condemning western European Jews and the West more broadly.[76]

In some of his works, *Radetzkymarsch* (*The Radetzky March*, 1932), for example, eastern European Jews, especially Hasidim, were part of the landscape of diverse ethnicities that Roth cherished and championed as part of his adulation of the Hapsburg monarchy. But *Juden auf Wanderschaft*[77] and *Hiob* are entirely about eastern European Jews. Andreas Kilcher, in pairing these two works, has noted that they reveal the relationship between journalism and literature, specifically in their capacity to create ethnographic text. Kilcher argues, however, that both texts—the journalistic book-length essay and the novel—seek to describe their objects with "artistic creativity, or poetic storytelling."[78] According to Kilcher, *Juden auf Wanderschaft* is part of Roth's effort to work past the New Objectivity and the limits of realism through a prioritization of empathy, similar to Sonino's observation regarding Döblin's travelogue.[79] Kilcher writes: "Empathy suspends the conventional boundaries between subject and object, thus making it possible to describe Eastern European Jews beyond Western European cultural differences and colonialist tendencies, from an insider's view."[80]

Yet Roth idealizes the eastern European Jews, as Kilcher also notes; the essay is thus limited by the possibilities of its genre. Kilcher sees *Juden auf Wanderschaft* pointing the way toward what he identifies as the increased empathy (and concomitantly decreased realism) of *Hiob*. But Roth's ambivalence and his pitting of identification and objectification against each other—his struggle to defamiliarize things that remain stubbornly familiar—are not so easily resolved. The text works ultimately at cross purposes with *Hiob*, where the defamiliarization and exoticization of the eastern European Jews is complete. Together, the works reveal Roth's version of the problem of Jewish primitivism and his resolution. *Juden auf Wanderschaft*, with its travel reports and social and political descriptions of eastern European Jews, explains their migration westward across Europe and eventually across the Atlantic Ocean. It also contains ethnographic descriptions of the *Ostjuden*, particularly in a chapter on the shtetl, describing Jews before they have moved to the places (Paris, Vienna, Berlin, America) described in the remainder of the book. Roth's primitivism in the book emerges from his attempt to defamiliarize European Jews, to retrieve the exotic from what has become unjustifiably familiar:

> Even if their naiveté and their hospitality had been as great as those of other people who have suffered at the hands of our desire for knowledge, even then it would be hard to persuade a European man of learning to embark on a voyage of discovery among the Hasids. The Jew, because he lives everywhere in our midst, has ostensibly already been "researched" ["*erforscht*"; Roth's quotation marks].[81]

Remarkably, even as Roth acknowledges the terrible destructive powers of European ethnography, he laments that Jews have not been turned into an object of this science.

There is a further irony in the fact that the Hasidim—the appropriate objects of ethnography—have been preempted by the west European Jews who live among the researchers and by virtue of their familiarity prevent European scientists from recognizing the ethnographic importance of the Hasidim. Yet it is precisely their proximity that makes them of even greater interest than the exotic inhabitants of the Himalayas: "In fact they are even more mysterious [than Himalayans], because, being more prudent than those other helpless objects of European inquisitiveness, they have already come to know the superficial civilization of Europe."[82] Despite this mysteriousness, Roth immediately denounces the very same exoticizing impulse: "The notion of an Eastern Europe in which all the Jews are either wonder-rabbis or traders . . . is just as

ridiculous as the Eastern Jew's dream of the humanistic West. In the East po-
ets and thinkers [*Dichter und Denker*] are actually more commonly met with
than wonder-rabbis and traders. Apart from which, it is perfectly possible for
wonder-rabbis and even traders to moonlight as thinkers and poets."[83] Here
he not only objects to the separation of these two types of Jews but rejects the
premise of their separation.

Yet Roth continues to toggle between stereotyping Hasidic Jews and reject-
ing such stereotyping. The reason he is unwilling to come out definitively on
one side or the other—at least in this text—is related to his uncertainty regard-
ing how special such Jews, especially "wonder-rabbis," really are, whether the
border between poets and wonder-rabbis, as a cipher for the border between
savage and civilized, did in fact exist.

He struggles over this problem in his extended ethnographic description
of Hasidic rebbes, which precedes his own meeting with one. He introduces
the extended passage with a claim to genuine exoticism: "The things that hap-
pen at the court of a wonder-rabbi [*Wunderrabbi*] are at least as interesting
as with your Indian fakir."[84] This German name for Hasidic rebbes, which lit-
erally means "miracle Rabbis," reflects derision for the belief among Hasidim
that rebbes possessed supernatural powers. Roth reclaims this word, as it were,
turning the object of derision into one of celebration.[85]

For Roth, the rebbe is emblematic of the rejection of modernity implicit in
Hasidism; Roth's ethnography of the rebbe culminates in a critique of modern
scientism:

> Day after day people come to him with a dear friend who has fallen ill or a
> mother who is dying, who are threatened with imprisonment or are wanted by
> the authorities. . . . Or by those whose wives are barren and who want a son. . . .
> Or by people who are faced with a great decision and are uncertain what to do.
> The rabbi helps and intercedes not only between man and God, but between
> man and his fellow man, which is still harder. . . . The rabbi has wisdom and
> experience in equal measure; he has as much practical common sense as he has
> confidence in himself and his mission. He is able to offer advice or prayer. He
> has learned to interpret the sentences of Scripture and the instructions of God
> in a way that does not bring them into conflict with the laws of earthly life, and
> he leaves no little chinks anywhere through which a liar might manage to slip.
> Since the first day of Creation, many things have changed but not the will of

God, which expresses itself in the basic laws of the world. There is no need of any compromises to prove that. Everything is just a question of understanding.[86]

This is a description less of a shaman than of a social worker; this rebbe mediates between belief and contemporary knowledge. Nevertheless, Roth sees him as an embodiment of irrational belief and thus as a rejoinder to secular modernity: "[The rebbe] has left the stage of wisdom behind him. The circle is unbroken. Man is once more a believer. The arrogant science of the surgeon kills the patient, and the empty knowledge of the physicist leads his students into error. One no longer believes the knower. One believes the believer."[87] Roth prefers the witch doctor to the medical doctor. Yet the rebbe's ability to avoid bringing belief "into conflict with the laws of earthly life" is ultimately the source of Roth's appreciation of him; the dilution of the rebbe's primitiveness paradoxically allows Roth to maintain him as an embodiment of primitivism. Roth depicts here a reconciliation with modernity garbed in the trappings of a primitive rejection of modernity.

Roth's ethnography of the Hasidic rebbe is centered around a travel report, set off narratively from the surrounding text. He immediately adds to this visual separation a stylistic push away from ethnography toward fiction. He begins with belletristic rather than ethnographic detail: "It was on a day in late autumn that I set out to call on the rabbi. A day in late autumn in the East, still warm, full of humility and a golden forbearance."[88] Roth travels with locals but gains admittance to the rebbe by looking foreign, that is, like a non-Jew: "I had on a short fur coat and high riding boots. I no doubt looked like one of the feared local officials, a signal from whom was enough to get someone thrown into prison. Therefore people let me pass."[89] He describes the crowds outside the rebbe's house and the rebbe's gatekeeper, whom he convinces to let him cut in line. He enters the house through the back entrance and finally gains admittance to the inner sanctum. Roth's narrative contains a physical description of the rebbe: "His left elbow rest[ed] on the table. He had black hair, a short black beard, and gray eyes. His nose jutted powerfully from his face, as though on a sudden impulse, widening and flattening a little at the tip. The rabbi's hands were bony and thin, and his fingers had sharp white nails."[90] The rebbe's lackluster appearance sets the stage for the disappointing and brief encounter that follows. The rebbe asks the reason for Roth's visit, and Roth replies that he "had heard much about his wisdom and had wanted to meet him."[91] The rebbe's

response could hardly be less dramatic, although, in an unprepossessing way, he does manage to address Roth's request. "'God is wise!' he said, and looked at me again. He beckoned to me to come to the table, shook my hand, and, with the heartfelt tone of an old friend, bade me: 'Farewell!'"[92] The domesticity of the scene—Roth had entered through the kitchen—compounded by the plainness of the rebbe's room and the ordinariness of his appearance, precedes a response that confirms the conventionality of the experience. Roth ends the episode by describing his conversation with the doorkeeper on his way out: "He wanted to hear what news I had, wondered whether the Japanese were once again preparing for war. We talked about wars and about Europe."[93] Though Roth has promised a culture as exotic as that of the Himalayans or Indian fakirs, he might as well have been in a cafe in Berlin or Vienna; though he has criticized Western scholars for neglecting this culture because of its resemblance to the culture of Western Jews, he has shown just how familiar and ordinary it is. Roth is struggling here with the peculiar task of directing the primitivist gaze at European Jews: what exactly is it that is primitive about them? Which predominates—their European or primitive aspects? Roth is unable to separate the one from the other, much as he would like to.

Continuing his ethnographic report of holiday observances, he says of the holiday Simchat Torah:[94] "I saw Jews losing consciousness . . . not on the anniversary of a battle but out of joy that God had chosen to share his knowledge and his law with them."[95] Here the difference of the *Ostjuden* is calibrated vis-à-vis non-Jews. Pivoting back to the baseline critique of Western Jews, Roth writes, "I had seen them [*Ostjuden*] losing consciousness once before, but that was through prayer. It was during Yom Kippur."[96] This, again, is in contrast to the western European observance of Yom Kippur, where the holiday, which Roth insists ought to be rendered "Day of Expiation," is nevertheless "translated as 'Day of Atonement,' a phrase that reflects the Western Jew's whole willingness to compromise."[97] He then describes a model Yom Kippur among the *Ostjuden*:

> The streets suddenly go dark as candlelight breaks from windows. . . .
>
> [People] hasten through the lanes quite transformed, making for the prayer-house, dressed in the heavy black silk and dread white of their funeral suits, in white socks and loose slippers, head down, their prayer-shawls bundled under their arms. . . .

> All the fathers now bless their children. All the women now weep in front
> of the silver candelabra. All friends embrace one another. All enemies beg one
> another for forgiveness. The choir of angels blows a fanfare for Judgment Day.
> Soon Jehovah will open the great volume in which this year's sins, punishments,
> and destinies are recorded.[98]

Oddly, despite the ethnographic presumptions of the text, there is no change
of any kind to indicate that we have traveled from an objective description ("all
enemies beg one another for forgiveness") to a ventriloquizing of subjective
religious values ("Soon Jehova will open the great volume . . .").[99] A strange kind
of free indirect discourse is at work here, moving the voice of authority from an
external observational position to an internally situated, actively participatory
position. Roth plays on the same dynamic that vitalizes participant-observer
anthropology, paradoxically evoking authority from within and without. To
know what the Jews believe, Roth writes as if he were one of the believing Jews;
to describe what they look like, he writes as if he were observing them dispas-
sionately. The balance between objectivity and empathy, to use Kilcher's charac-
terization of this dynamic, does not tilt in favor of one or the other side.

Roth offers a description of Yom Kippur observances that foregrounds its
primitiveness:

> From a thousand windows there breaks a wailing prayer, interspersed by soft,
> mild, otherworldly melodies. . . . In all the prayerhouses, the people stand,
> crowded together. Some prostrate themselves on the ground, lie there for a long
> time, then get up, sit on footstools or flagstones, hunker there, and suddenly leap
> to their feet, sway back and forth from the waist, and run around incessantly in
> the tiny space like ecstatic sentries of prayer. . . . A giddiness comes over them,
> they reel, they rant, they whisper, they hurt themselves; they sing, shout, wail.[100]

In his portrayal of Yom Kippur, Roth has more than made up for the banality of
his visit with the rebbe; but in order to do so he has abandoned the ambivalence
of his literary ethnography, fully mobilizing the primitivist elements he wishes
to see in the Hasidim. He ignores the personal encounter with real Hasidim in
favor of a distanced portrayal of anonymous people.

But Roth is also aware of the ironic tension at work in invented authen-
ticity. He finishes his ethnographic vignettes with a paragraph on the Yiddish
theater, saying that "it's become almost more of an institution of the Western

ghetto than the East."[101] In the term "Western ghetto" and in locating the Yiddish theater there, Roth has identified the way in which a performed authenticity undermines itself: how authentically *ostjüdisch* can something really be if it has become, as Roth says, an institution of the West? This is a perception that many viewers of Yiddish theater in central and western Europe—Kafka famously among them—missed in seeing the Yiddish theater as an expression of unalloyed eastern European Jewish culture.[102] Roth, however, in his depiction of Jewish primitivism reveals a *mise en abyme*: the Western Jew looks at the Eastern Jew who has become a Western Jew, performing an Eastern Jew.

Throughout Roth is aware of the malleability of the categories "Eastern" and "Western," primitive and modern; yet he remains undecided on whether to valorize the things that promote the stereotype of "Eastern Jews" or to critique the stereotyping itself. He would resolve this tension unambiguously in the novel *Hiob*, published just three years after *Juden auf Wanderschaft*. In it, he gives free rein to a primitivist vision of eastern European Jewish life uncompromised by his knowledge of its reality.

S. An-sky—*The Destruction of Galicia*

S. An-sky's life, according to David Roskies, traced an arc—first away from and then back to the Jewish people and Jewish issues.[103] After a traditional Jewish education in childhood, he became a *Narodnik*, a populist, working among Russian miners and collecting their folksongs. He began his literary career writing in Russian and spent years around the turn of the century in Paris involved in radical politics. Eventually he began to write in Yiddish in addition to Russian and finally returned his energies and attention to Jewish issues, turning away from the non-Jewish causes to which he had devoted so many years. He would therefore seem to be a likely candidate for an effort to imagine Jewish life that would be distant from its lived reality—in other words, a likely primitivist. Indeed, in the same period in which he returned to Yiddish, he turned his attention to Jewish folklore, having decided that Jewish folk culture was the key to creating a viable and vibrant contemporary secular Jewish culture. In pursuit of this project, he became an early organizer of Jewish ethnography.[104] Ultimately, he would write *Der dibek* (*The Dybbuk*), a play with strong primitivist elements that were subsequently highlighted by a striking avant-garde staging.[105]

In 1909, in a letter to his friend the publicist Chaim Zhitlowsky, he announced that he was turning his attention away from writing: "I have decided

to devote the rest of my life to the Jewish task, which I consider colossally important for the creation of a Jewish culture. This is the creation of Jewish ethnography, the collection of objects of Jewish folklore, etc."[106] This turn to Jewish ethnography presumably entailed leaving behind his engagement with Russian folklore as well as his literary activities, whether in Yiddish or Russian. An-sky's decision intimates a triage between literature and ethnography. Initially it seemed that ethnography would dominate the remainder of his career: from 1912 to 1914 he organized and led the first major Jewish ethnographic expedition in the Pale of Settlement, collecting folklore, sayings, ritual objects, folk art, and the like.[107] But he would quickly reject the dichotomy he had imagined between literature and ethnography, going on to produce his most important literary works, the modernist play *Der dibek* and his war travelogue *Khurbn Galitsiye* (The destruction of Galicia). These two literary texts, the most substantial since his turn to Jewish ethnography, illustrate in divergent but complementary ways the possibilities for a nonscholarly, ethnographically informed and engaged literature in Yiddish.

Khurbn Galitsiye is a wartime travelogue that takes as its dual subjects literature and ethnography, placing them within the context of an engagement with Jewish culture that privileged, by necessity, the concerns of the present, rather than a scholarly past or an ideological future. That present was the First World War, and An-sky's primary response to it, unifying the ethnographic and the literary, was to salvage—salvage folklore and salvage people. *Khurbn Galitsiye* is a document sprung from these interests as well as a record of these interests in action. The two salvage projects, however, were at odds with each other, at least in their underpinnings and their consequences. Salvaging folklore was predicated on the idea that a folk and its culture—at least a folk and a culture subject to academic folklore and ethnography—were static. Humanitarian relief turns frozen objects of ethnography into human beings; moreover, the interpersonal contact generated by this work together with the chaotic and unpredictable context of the war weakened the framework of expectations and allowed an actual, living folklore to emerge. That is to say that An-sky's ethnographic technique was based on the method of collecting epitomized by questionnaires (he was an author of the first Yiddish ethnographic questionnaire, composed for his earlier expedition): his interlocutors were actually subjects and could speak and provide information, but only in response to the ethnographers' expectations. An-sky's humanitarian work, by contrast, had no ethnographic preconditions; so while he exploited the opportunities to collect folklore from the

people he met, he did not condition aid on ethnographic or folkloric products that matched his expectations. And so, instead of frantically saving the dying remains of a primitive Jewish culture, what he actually found, amid the death, destruction, and chaos of a war zone, was the generative power of Jewish culture, still producing folklore—new folklore—in the midst of and in response to the war.

The travelogue's full title is *Der yidisher khurbn fun Poyln, Galitsiye, un Bukovine, fun tog-bukh, 1914–1917* (The destruction of Jewish Poland, Galicia, and Bukovina: From diaries, 1914–1917). It was first published in his collected works in 1923 and was based on his travels during the First World War throughout the region of the Eastern Front dispensing humanitarian aid, salvaging Jewish artifacts, and collecting folklore.[108]

Salvage was a key justification for ethnography. Jewish culture was not exempt. In 1915, three of the most prominent Yiddish writers of the period—Peretz, An-sky, and Yankev Dinezon—published a call to Jewish laypeople to collect. They cautioned that if left for others to record, the experiences of the Jews during the war would either not be preserved at all or would be recorded with malice:

> We turn to our people, which is now and evermore being dragged into the global maelstrom, to all members of our people . . . with the following appeal:
>
> BECOME HISTORIANS YOURSELVES! DON'T DEPEND ON THE HANDS OF STRANGERS!
>
> Record, take it down, and collect!
>
> See to it that nothing is lost or forgotten of all that happens in our life during and because of the war: all the upheaval, the sacrifice, the suffering, the acts of valor, all the facts that illuminate the attitude of Jews to the war and of others toward us; all the losses and philanthropic efforts—in short, record everything. . . . Whatever can be recorded should be recorded, and whatever can be photographed should be photographed. Material evidence should be collected, and all this should be sent . . . to the Jewish Ethnographic Society.[109]

An-sky's book is a response to this call as well as an investigation and record of the state of the Jews along the front and the extent of their suffering. Of course, he did not miss the opportunity to continue his work as an ethnographer and collector—he gathered folklore and saved artifacts when and where he could. *Khurbn Galitsiye* records his experiences in pursuit of both salvage objectives, which fused together the humanitarian and the ethnographic.

Over the course of the book, An-sky toggles between examples of contemporary wartime folklore and the desire to find the traditional folklore his prewar ethnographic expedition sought. Early on, he discusses the phenomenon of contemporary folklore:

> The Jews, frightened and cowed, had no way of fighting—neither the cruel, murderous persecutions nor the harmful lies. And so they wove their sighs and tears into legends, as they had done in the past, from which they drew comfort and courage. In one place it was rumored that the local Rebbe was writing a saga about the war, "which would surpass anything ever written. When he finishes, the redemption will come." Jews talked about the Messiah in many places; they consulted ancient texts and believed that the Messianic age was finally dawning. . . . Of course, these legends, like all folktales, were filled with deep optimism, with the faith that in the end truth will out.[110]

His drive to collect was not inhibited by scruples; he describes exchanging monetary aid for folklore. In Khorostkov, An-sky gave the local cantor a donation and asked if he knew any Hasidic tales.[111] To An-sky's delight, he did: "And what a storyteller he was! Filled with rapture, teeming with marvelous details like a true poet. Each tale he recounted was a work of art!"[112] Haunting this exchange, as with all of An-sky's other ethnographic endeavors, is the fear of loss. Referring to the stories, he writes: "I felt true pain that I couldn't write them down word for word."[113] The joy of discovery is mitigated by the oral artifact's ephemerality and its imminent loss—indeed, An-sky writes that he was only able to remember one of the cantor's stories, about an early Hasidic rebbe. This—the classical Hasidic story—motivates An-sky's fear of loss, since it validates his primitivist expectations more so than the examples of contemporary folklore, which do not prompt such anxiety.

An-sky's evening in Khorostkov seems to have been something of a shtetl pastiche: he meets an old woman who boasts of her distinguished rabbinic lineage while demanding a handout; he meets the storytelling cantor; and finally another figure enters the scene:

> While the cantor was sitting and telling his story, I suddenly heard a quiet, doleful violin emitting an ancient and deeply plaintive melody. I looked around and saw in the doorway a famished, tattered, embittered Jew in his fifties, playing an old, poor, violin. And both were weeping. Tears poured from the musician's eyes, and a quiet, heartrending cry poured from the fiddle.[114]

This sequence is a revue of sentimental archetypes. An-sky has cast these living people as tropes, even as he mines them for ethnographic material. He transitions seamlessly from regarding these figures as literary archetypes to ethnographic informants: "It was very touching to hear his violin weeping and to see the hungry man's tears. When I was engaged in ethnographic research, I had noticed that so many folk songs and folktales are full of grief and lament: 'So they began to weep and wail,' 'Woe and sorrow,' and so on."[115] Although this passage is unambiguous in its depiction of An-sky's relationship to potential ethnographic subjects and sources, it is not as heartless as it may seem. An-sky continues on the subject of the sorrowful folksongs, writing that he "had always seen this as merely a rhetorical figure. But now, in Galicia, I realized that it is true to life. I saw people 'shedding torrents of tears.'"[116] It is not his experience as an ethnographer that has enabled him to be more compassionate in his aid work but the opposite: his experience as an aid worker has provided him with the opportunity to elucidate a problem from his fieldwork. He realizes now that folklore "is true to life."

The intertwining of literary, humanitarian, and ethnographic concerns comes to fruition just following the above episode. Still in the same town, An-sky met the owners of a Jewish antiquarian bookshop, Lipe Shvager and Rabbi Frenkel. An-sky describes their store as Galicia's largest for rare Jewish books and manuscripts. It was destroyed in the pogrom, and the owners had saved very little. What they did salvage An-sky says he took back to St. Petersburg. He then relates a story that Shvager told him. Shvager met the rebbe of Kopitshinits in a spa in Hamburg at the beginning of the war. After the Russians had invaded Galicia, the rebbe asked Shvager to go to Kopitshinits and save an extremely rare handwritten letter and autograph by the founder of Hasidism, the Baal Shem Tov. For a Hasidic rebbe, the spiritual value of these artifacts determined their value, which was such that they warranted a trip into the war zone. An-sky writes that the rebbe said to Shvager:

> Please go to Kopitshinits immediately and save these letters. If you're not able to come back here, store them in a safe place. You ought to know that your trip will be very perilous. You could be shot, or someone might kill you because of a rumor . . . but these dangers should not keep you from performing your sacred mission and saving those letters.[117]

Shvager asked the rebbe about his property and other valuables, worth millions. The rebbe responded, "All that stuff is expendable . . . but the Baal-Shem-Tov's

letters must be saved."[118] Shvager made it to the town but wasn't able to escape with the manuscripts, so he buried them deep in the basement of the rebbe's house. Months later, after an initial failure to retrieve the letters, Shvager finally found them and saw that the writing had disappeared from the letter (although the autograph was still intact). After relating this story, An-sky writes:

> Frankly, I didn't put much stock in Shvager's tale. It was one of the usual legends that emerge during such tumultuous times. So I asked to see the letters. He said they were at the inner sanctum in Kopitshinits and refused to show them to me. But when I met him there a few weeks later, I urged and prodded him, and he yielded, though very reluctantly. He brought the letters to the synagogue. They were wrapped in several sheets of paper. With great reverence he unfolded the letters without touching them directly. I saw two small sheets of ancient paper, both of them dated 5513 [1753]. One was covered on both sides with a dense and tiny handwriting . . . [with] a barely perceptible signature in long, sharp, single letters: "Yisroel Baal-Shem." The second sheet, half decayed and with faint spots left by moisture or tears, was completely blank, with no trace of writing.
>
> Shvager, gazing at both letters with dreamy, mystical eyes, said: "I was told that the script vanished because of the dampness and that it can be chemically restored. . . . But we Hasidim have a different view . . . a very different view."[119]

It is the cultural value of the letters, not their monetary value, that is of concern to the rebbe—he tells Shvager not to try to save any of his other property.[120] Since Jewish law prohibits endangering one's own life[121] with only rare exceptions, including the possible exception of saving another's life, the rebbe has implicitly ascribed to these artifacts a value equivalent to human life. Shvager's "sacred mission" of cultural salvage is worth his life. But it is neither the war nor the journey that proves to be the greatest danger to Shvager. Instead, when Shvager goes to retrieve the letters and cannot find them, "he almost died of shock."[122] It is the loss of the artifacts that is configured (though hyperbolically) as coming closest to killing him—cultural salvage, even more than war, is a matter of life and death.

But the collector's work is not done. An-sky turns Shvager's story about salvaging an artifact itself into a narrative artifact, reasserting himself as the primary collector and legitimator of enterprises bordering on the ethnographic: "Frankly, I didn't put much stock in Shvager's tale. It was one of the usual legends that emerge during such tumultuous times."[123] Like the earlier stories that An-sky collected, he categorized this as a newly minted folktale, with the

difference that this folktale has something to say about the act of collecting itself. Moving from an external analysis back into a participatory mode, An-sky asked Shvager to show him the letters. Shvager, now the native informant, his role as collector having been taken up by An-sky, resists, protecting the religious mysteries that the ethnographer seeks, claiming they are in the "inner sanctum" of the rebbe's court. Shvager finally relents and displays the letters with, as An-sky writes, the "flown-off letters" [*opgefloygene oysiyes*]. The Baal Shem Tov's letters in turn remind An-sky of a different scene, loaded with its own allusions: "I recalled the shard of the Ten Commandments that I had found at the profaned and shattered synagogue in Dembits. All that was left on the fragment were the words *kill* and *commit adultery*."[124] This image echoes the shattered tablets of Moses. An-sky kept the fragment of the Ten Commandments with him for the rest of his life, attesting to his impulse to salvage and his realization of its limits.[125] Together, writes An-sky, these two images—the broken tablets and the flying letters—reminded him of a phrase from the Talmud: "The tablets are broken and the letters are flying."[126] The chain of allusions gains its resonance of violence with its terminal point, since the Talmudic phrase An-sky quotes in turn echoes the Talmudic legend about the martyrdom of Rabbi Hanina ben Teradion, a story at the center of both the Tisha b'Av and Yom Kippur liturgies. It tells how the Romans wrapped Hanina in a Torah scroll before setting fire to him. His students asked him what he saw in the midst of the flames, and he responded, "The parchments are burning, but the letters are flying away."[127] This allusive network, writes An-sky, "summed up the life of the Galician Jews"—stripped of all material possession, on the brink of death, but unlike the Talmudic hero, the Galician Jews were eventually spiritually shattered: "These living corpses [*lebedike meysim*] trudged past me not as 'shattered tablets' but as tablets from which 'the letters had flown away.' These people had lost the supreme sanctity of human dignity."[128]

Finally, it is not the ethnographic value of the artifacts or the interest of the folklore that captivates An-sky but the humanity of his subject. Because An-sky's primitivist project ultimately remained inseparable from his humanitarian project, he could never fully objectify the Jews he met. Yet he was also unable or unwilling to distinguish between the two projects or even to determine which was more urgent. Balancing primitivist aesthetics and ethnography with humanitarian work is paradoxical: primitivism tends toward denying its objects human agency, while humanitarianism seeks just the opposite. In combining humanitarian and ethnographic elements, An-sky's project, most clearly

among Jewish primitivists, was dual: it was about the identity of Jews and the aesthetics of Jewish art. Aesthetics can be primitivist, but as An-sky found during the war, humans are simply people.

Fiction

The travelogues by An-sky, Roth, and Döblin expressed a primitivism inhibited by the recognition that its objects were not real but fantasies. In works of fiction, their imaginations were unrestrained by the demands of a real journey with actual encounters. These fictional texts, novels by Döblin and Roth and a play by An-sky, were venues for an emphatic primitivism[129] that not only represented primitive objects but demonstrated how primitivist aesthetics could reorder the works themselves.

Döblin: *Berlin Alexanderplatz*

As Franz Biberkopf, the antihero of Döblin's novel *Berlin Alexanderplatz*, makes his way back into the center of Berlin after his release from prison, he wanders near the train station at Alexanderplatz and veers into the Scheunenviertel, the Jewish immigrant neighborhood of Berlin. By the mid-1920s, Berlin had attracted tens of thousands of eastern European Jewish migrants, many of them poor, many of them pious, most of them Yiddish-speaking. The old, crowded neighborhood that housed many of these Jews, their prayer houses, their restaurants, and other businesses, came to be associated with the aura of Jewish authenticity that German Jews ascribed to the *Ostjuden*. The Scheunenviertel became an exotic locale in the middle of Berlin. But of course it was exotic more in fantasy than in reality, and for Biberkopf it arouses no special notice. He is disoriented by his newfound freedom to the point of illness; noticing his condition, a friendly *Ostjude* called *der Rote* (the redhead; his name is later given as Nachum) offers him a place to sit down and collect himself. More important, he tells him a story. The story, like this *Ostjude*'s language, is meant to seem very Jewish, indeed quintessentially Hasidic. Like the *Ostjude*'s language, however, there is nothing authentically Jewish about it; Döblin has invented both. The language is bad German peppered with Yiddish-sounding words; the story is a shaggy dog tale about the rise and fall of an adventurer and has no specifically Jewish content or themes.

The Jew tells a story to Biberkopf to edify him and to aid his reentry to society; a few weeks later, Biberkopf returns to thank him and hears a final story.

Just as the stories guide Biberkopf into Berlin and the events that are to come, they similarly aid the reader's entry to the novel. How and why are this Jew, his language, and his story the agents of reentry for Biberkopf? Equally significant, why are they the agents of entry into this novel? The stories are allegories, but their blunt didacticism is of limited use. If they are effective, however, it is not by virtue of their allegorical meaning but because they are stories. Stories—and storytelling—offer a way to master the primal psychic and spiritual forces secretly operative in modern humans and governing—and restricting—their integration into and functioning in society. Biberkopf lacks social and intellectual discretion, is erratic, is governed by uncontrolled thoughts and emotions, and is insufficiently "civilized." His disorder reflects the disorder of the city and by extension the disorder of modernity. The answer to this problem is not, however, to regulate the disorder, a function unsuccessfully performed by those institutions of civilization—prison (from which Biberkopf has just been released at the book's start, and which seems to have had no effect on him besides further contributing to his instability) and the insane asylum (from which he is released at its end, and which effects his integration into society as a "kleiner Arbeiter," a little worker, diminishing his humanity and restricting his freedom). A countervailing set of options is presented by Nachum—not those of civilized but of primitive culture and the role storytelling plays in it. He approaches Biberkopf openly and generously: he is unguarded in his approach to social interactions but also gives an impression of wisdom. He is simple but wise, much like the stereotypical "red Indian," and after all, Nachum is consistently described as "red" (*der Rote*). It is storytelling—in addition to Nachum's identity as an *Ostjude* and his language—that constitutes the primitivism of this episode. Oral storytelling is the center of Nachum's appearances in *Berlin Alexanderplatz* and is what both the character and Döblin offer as the medium for Biberkopf's transition back into society. Orality was the hallmark of primitive culture, since it implied pre- or nonliteracy, and literacy was the hallmark of "civilization." Insofar as oral storytelling persisted into European modernity, it was seen as a prehistoric survival and an expression of deep folk culture. Both Nachum and Franz have a nearly magical belief in the ability of storytelling itself to effect change in a listener.

The stories themselves are simplistic parables. Their function is didactic, but their significance lies in their very status as parables: they present themselves by definition as readily interpretable and thus present the world as comprehensible and navigable. Some critics have seen these parables as Jewish in a religious

sense, an identification stemming largely from the fact that they are told by religious Jews, Hasidim no less, for whom storytelling must be a religious act.[130] But the stories are completely devoid of Jewish content, and the storyteller does not provide them with a Jewish interpretation. Merely being told by a Jew, even a Hasid, does not make a story Jewish. On the other hand, parables are an important feature of rabbinic literature, and significantly, of Hasidic literature; the Hasidim therefore are plausible tellers of parables. Perhaps alone among the residents of the relentlessly, noisily modern metropolis of Döblin's novel, the Hasidic storytellers are embodiments of an alternative narrative tradition, having more in common with the supposedly universal language of myth and parable than with the fragmented newspaper headlines and billboards of urban modernity. For Döblin the parable and the *Ostjude* are the access points to a vision of the world at odds with urban modernity; as such they are primitivist par excellence. Their primitivism is underscored by the more overt associations of oral storytelling and *Ostjuden* with primitive culture. The parable offers an alternative to the modernist novel, or as Jonathan Skolnik has put it, the "kind of narrative that no longer seems possible in modernity."[131] Moreover, within the narrative, that is, in relation to Biberkopf, they have a direct function: Nachum tells the tales to educate Biberkopf, and for his part Biberkopf feels comforted and steadied by them. Their salutary effect is in spite of the fact that, as critics have noted, the parables resist ready interpretation and lack easily legible morals. It is belief in the power of storytelling that makes the stories powerful; this belief is transferred, so to speak, from the Hasidim to Biberkopf. In this sense, the Hasidim themselves, stubbornly clinging to outmoded narrative modes and to their religious belief in the power of storytelling, offer a counterpoint to Biberkopf, the quintessential product of urban modernity, whether he is the bewildered ex-convict lost in the city at the novel's start or the "kleiner Arbeiter" of its end.

Nachum's language also indicates his position outside of the civilized, urban order: while what Biberkopf speaks is recognizable as Berlin dialect, the dialect of the Jews is impossible to identify—because it is invented. The language they speak is German but retains some features of Yiddish, for example the Yiddish formal pronouns (rendered *Ihr* and *Aich*) rather than the German equivalents; the indefinite article is often replaced by both Nachum and Eliser with a Yiddish-sounding *ä*; they say "scheen" instead of "schön," and so on. This language, while clearly German, displays some features of Polish Yiddish, along with some words from the German Jewish lexicon. But if this is an

approximation of Polish Yiddish, why is the name of one Jew transcribed as "Nachum," rather than "Nukhem," as a Polish Jew would have pronounced it? Why does Nachum say "meschugge"[132] rather than "meshige" and "scheen"[133] instead of "shayn"? Of course, Döblin might simply not have known or noticed the difference. But his task in this work is not ethnographic; accurately transcribing the dialect of *Ostjuden* in Berlin would not necessarily serve the literary purpose of this episode. The purpose of this episode, as noted above, is to mediate Biberkopf's reentry into society by means of storytelling. The language of the Jews, their "Jewish" or Yiddish, is thus a language imagined by Döblin as an antidote to a particular type of urban malaise—the obsolescence of oral culture. Standing against urban modernity requires reclaiming the orality, the language, and the narrative forms preserved by the Hasidim in their Berlin enclave.

Roth: *Job*

Hiob presents a version of Jewish primitive religiosity not in spite of the depredations of the modern world but as a rejoinder to it. The primitivism of this novel, then, is not an avoidance of the challenge to primitivism suggested in *Juden auf Wanderschaft* but a direct answer to it. Kilcher sees this novel as the fruition of Roth's project to do away with the "cold order" (in Roth's terms, cited by Kilcher) of ethnography and journalism, "fulfilling ethnography's great promise . . . to venture deep into the innermost space of the exotic . . . and to participate in the magical actions of the fakirs among the Jews."[134] Yet as I have shown, Roth was unable to fully convince himself that there were, in fact, fakirs among the Jews. Roth's primitivist imagination in his fiction, then, is not a fulfillment of the promise of his journalism but a literary freeing from the reality to which *Juden auf Wanderschaft* was tethered.

 Hiob is a novel about the troubled life of the pious shtetl Jew Mendel Singer. In addition to the general difficulties facing any such Jew—poverty and a hostile world—Mendel is particularly challenged by the difficulty of raising his children. The novel is a blend of shtetl pastoral and dystopia: Mendel's daughter has sex with Cossacks and is ultimately hospitalized for nymphomania and hysteria; one of Mendel's sons desires nothing more than to join the Russian army, in whose service he will ultimately meet his death; another son moves to America and finds financial success; the final son, Menuchim, suffers from epilepsy, is mute, and has other developmental delays. After much agonizing,

the pious Mendel finally abandons his disabled son in Europe to join his son in America. This son has bewilderingly become Americanized and in Mendel's eyes has lost his Jewishness. Although Mendel has come to America hoping that his daughter's "condition" would improve, she continues to suffer from it in America and is ultimately institutionalized. His American son dies in the First World War. Then Mendel's wife dies. He feels that he has lost everything and begins to lose his faith in God, even contemplating burning his *tefillin*. But he doesn't and, like Job, is rewarded for the tenacity of his faith: at the Passover seder Mendel's disabled son appears. He has been fully healed and has become a world-renowned violinist with a family of his own. Although not all of Mendel's losses are made whole, his reward is especially meaningful because it validates his faith and his attachment to the religion and culture that other immigrants left behind. Menuchim's career as a violinist is an only slightly modernized version of a traditional shtetl occupation (think, for example, of Chagall's fiddlers). In joining Menuchim, Mendel does not abandon his traditional religious practice but accommodates it, deciding that he is permitted to drive on a holiday, contrary to the usual understanding of Jewish law. He brings his *tefillin* with him into the modern hotel lobby. He chooses to remove his skullcap, "for the first time in his life," and enjoy the sun on his bald head; the experience, though, is not a renunciation of religion but a deeply felt encounter with the miraculous nature of his new life. The novel ends with Mendel, enjoying the sunlight with his head uncovered and resting "from the weight of happiness and the greatness of miracles."[135]

Mendel's simple faith is underscored throughout the novel by Roth's narrative style, which is characterized by a fairy-tale-like simplicity. This is the greatest departure from the biblical Job, whose faith, though persistent, is anything but simple. Indeed, although the frame of the book of Job—its beginning and end—has left the greatest cultural imprint, its bulk consists of theological debate and poetic embellishment of this theology. Roth's *Hiob* has no such complexity. Its presentation of the beliefs and spiritual world of Mendel Singer reflects a primitivist notion of Hasidism, indeed of Jewish religiosity in general.[136] The subtitle of the novel is "Roman eines einfachen Mannes," a novel of a simple man, and Mendel Singer's faith is indeed simple.

The novel's presentation of eastern European Jewish religion is encapsulated by a scene featuring a Hasidic rebbe, to whom Deborah, Mendel's wife makes a pilgrimage on her sick son's behalf. The journey itself, though logistically

ordinary, is imbued with religious mystery: "She kindled the dry pine chips that lay on the stove, sought and found a pot. . . . It was as if she were acting in accordance with a mysterious rite."[137] There is, however, no context or reason that makes this entirely mundane behavior mysterious or redolent of ritual aside from its context—immediately before, and in preparation for, her visit to the rebbe. Indeed, her faith in the rebbe inspires wildness as she makes her way to his door: "With a sharp scream she plunged into the waiting crowd, with cruel fists she forced apart the weak. . . . With a single shrill cry, in the wake of which the terrible silence of a whole dead world ensued."[138] This early scene with its depiction of wild behavior prompted by intense belief colors every other aspect of Deborah and Mendel's behavior, no matter how prosaic. Their religious world is primitive.

Most significant is the fact that the narrative validates their primitive piety: The rebbe tells Deborah that "there will not be many of his like in Israel. Pain will make him wise, ugliness kind, bitterness gentle, and illness strong. His eyes will be far and deep, his ears clear and full of echoes."[139] First, the rebbe predicts that Menuchim will survive and become healthy, which does transpire; but he also predicts Menuchim's prominence and even, possibly, that he will be a musician. In fact, although Mendel and Deborah ignore the rebbe's interdiction against abandoning Menuchim and leave him behind in Russia when they go to America, their choice is shown to be a mistake—the rebbe was right. The narrative's structure and the premise of the plot are not determined, as in the biblical book, by God's willingness to test, punish, and reward, but rather by a Hasidic rebbe's prophetic intervention. The narrative itself submits, as it were, to the novel's understanding of Hasidic rabbinic power.[140] Against that vision of Jewish religiosity, modernity cannot prevail: persecution, poverty, immigration, secularization—all fail to undermine a rebbe's magical power and Mendel's primitive belief in it and in God. In spite of the depredations of the West, Mendel emerges with a measure of happiness. Roth is able to deploy a literary form so closely associated with Western culture—the novel—to capture and affirm the religiosity of Mendel's experience by virtue of a primitivist reimagining of the thematic and narrative possibilities of the novel focused through the lens of what Ritchie Robertson calls "radical nostalgia."[141] In other words, Western culture, in the guise of the novel, is no longer an impediment to the expression of a vital form of Jewish identity, as it is characterized in *Juden auf Wanderschaft*, but a potential conduit for this imagined identity—because, like this primitive Jewishness, it is fiction.

An-sky: *The Dybbuk*

Der dibek (subtitled "Between Two Worlds")[142] is heavily indebted to ethnography, as much of its material derives from the stories, legends, rituals, beliefs, and material objects that An-sky collected on his ethnographic expeditions. Nevertheless, it is much more than dramatized ethnography or a bricolage of folk practices. For An-sky, one of the primary tasks of ethnography was to revitalize Jewish culture with a secular foundation that could be a source of emotional engagement as well as artistic productivity.[143] As Gabriella Safran put it, "An-sky's aim was not at the past, but the future."[144] A literary work written from these premises is by definition primitivist: its object is vitalization, and its subject is the catalyst. *Der dibek* is an example—perhaps the only one in An-sky's oeuvre—of what such a cultural product might look like.

Der dibek is a story of star-crossed lovers, Khonen and Leah, who were betrothed to each other in childhood. Khonen is orphaned and becomes destitute; as a result the betrothal is forgotten and remains unknown to Khonen and Leah. Eventually Leah is engaged to be married to someone else, even though she and Khonen, now a young scholar and mystic, have fallen in love with each other. Khonen, overcome with grief, drops dead. On the day of Leah's wedding, she visits the grave of a couple who were murdered on their wedding day during the Chmielnicki massacres of the seventeenth century. She invites their spirits to her wedding and then indicates that she wishes to invite the spirit of Khonen. On her way to the ceremony, she shouts out "You are not my bridegroom"[145] and throws herself onto the grave of the murdered couple; Khonen's spirit has inhabited Leah's body, turning her into a dybbuk. Reb Azriel, a Hasidic rebbe, attempts to exorcise the dybbuk but fails. The town rabbi is summoned; he reports that he had a dream in which the spirit of Khonen's dead father summoned Leah's father to a rabbinical court to establish that they had agreed to marry their children. The court is convened, Khonen's father testifies, and the court rules in his favor, ordering Leah's father to pray for the souls of the departed and give his wealth to charity. Khonen (the dybbuk) remains unappeased, and as the unknowing townspeople rush to prepare Leah's wedding, she chooses to unite her soul with Khonen's and dies.

The play's reception has focused on its debt to An-sky's "actual" ethnography. Indeed, many contemporary critics accused An-sky of aimless ethnographic collection, causing the literary quality of the play to suffer. For example, Avraham Shlonsky called the play "an ethnographic museum strewn with bits

of folktales, religious rituals, etc.—all of it devoid of literary or dramatic neces-
sity."[146] Bialik—who produced the highly regarded Hebrew translation of the
play—had a similar impression and told An-sky to his face, "I have the im-
pression that you, as a folklore collector, went to all the garbage dumps and
gathered bits of folklore and like a tailor, you sewed together remnants of all
kinds of garments and patches into a multicolored blanket . . . the Dybbuk."[147]
Perhaps as an ethnographer An-sky was motivated by an indiscriminate urge to
collect, an urge motivated by the imperatives of salvage.[148] But as a writer, An-
sky by default selects and interprets his materials. His play, then, does not only
present ethnographic material—it performs the interpretation of this material.
Gabriella Safran was the first to note that the interpretation of Jewish culture
the play puts forward is essentially primitivist. In her view, *Der dibek* identifies
Jews "with a primitive people, specifically with Siberian natives," and creates a
"stylized, Siberianized representation of Jewish culture."[149] While Safran sees
the play's primitivism as one of analogy and of "stylization" (i.e., an aestheti-
cized mimicry of folk culture), it seems to me that An-sky also sees the Jew-
ish identity of his characters as distinctly primitive. The primitivism at stake is
thus a process of reclaiming something inherent in Jewish culture rather than
acquiring something from Siberian culture. Accordingly the play demonstrates
how this reclamation is to be accomplished.

Khonen and Leah, of course, are not models of An-sky's ideal armchair eth-
nographers, and what happens to them would certainly not encourage any neo-
phytes interested in following An-sky's lead. But they are the models of the link
that An-sky envisioned between culture, society, and folklore, a link he brings
to the foreground in his play but about which he is reticent in his essays on
folklore and ethnography. An-sky modeled the effect that folklore could have
on his audience on the characters in the play. Indeed, Safran writes that Leah
visits the synagogue as if it were a museum.[150]

In one of the scenes that doubtless annoyed critics of the play, rare objects of
synagogue Judaica are shown to Leah, with explanations proffered by her nurse
Frade and the synagogue attendant. Eventually Frade seeks to end the little eth-
nographic exhibition by turning it into a performance of piety—she asks to kiss
the Torah scrolls. As she approaches the ark to kiss the Torahs, Leah quickly
and shyly exchanges a few words with Khonen. At that very moment she is in-
structed by Frade to kiss the scrolls and does so with unseemly passion. She has
transposed her feelings for Khonen into a performance of traditional piety.[151]

The first act ends with another set of ethnographic "displays" that direct the internal narrative movement of the play. Leah's father, Sender, has just returned from arranging the engagement and wishes to celebrate with his comrades in the synagogue. While they wait for food and drinks to be brought, Sender, as if providing a caption, says, "Let's dance! Everyone join in! You don't think that Sender will marry off his only daughter without dancing and rejoicing? What kind of Miropolyer Hasidim are we?" Now that Sender has explained what will take place, An-sky immediately offers a stage note describing the dance in detail. He writes, "Sender, the three Batlonim [idlers], and Meyer place their hands on each other's shoulders and in a circle, their eyes rolled up in an expression of ecstasy, they sing a repetitive tune while they move slowly in place."[152]

As has been the case repeatedly throughout the first act, this ethnographic tidbit does not sit alone as if in a display case—it precipitates the dramatic climax of the act, namely the discovery of Khonen's death. In the midst of the dance, an old man calls for Khonen—and others—to join, whereupon Sender also comments on his absence. His unconscious body is thus discovered. So, from the moment that Sender enters the synagogue, a swift series of actions is set into motion, beginning with Khonen's death and ending with its discovery. The domino effect of this climax is halted by the ethnographic display of Hasidic dancing. Earlier the ethnographic vignettes served to move the action of the play forward; here it ends the act. Though An-sky may be documenting the rites he chronicles, this is not his primary interest. Folklore, throughout the first act, has been a dramatic mover, a kind of deus ex machina that marks and also produces the key moments of dramatic movement in the act. Within the context of modernist literature and modern Jewish lives, the place of folklore can no longer be as "natural" as it was in the places and periods evoked by the setting of *Der dibek*. The first act presents a vision of Jewish life that, while to a certain extent preserving an imagined past in which the folk and their culture were one, also manages to mirror the present in which folk culture no longer naturally emerges from the people and is not a seamless part of their lives—things must be introduced, explained, elaborated. But without folk culture, which drives the plot, the play's action—and thus the lives of its characters—would halt. The characters in the play need to understand folk culture because it still directs their lives and organizes their world. The process by which they learn to understand and to live with their folk culture mirrors An-sky's vision for the revival of modern Jewish culture on the basis of folklore. As

Safran argues, the composition history of the play—written first in Russian—reflects the degree to which educating a Jewish audience ignorant of their folk culture was, in fact, An-sky's aim.[153] Like his modern audience, Leah needs to be taught the meaning of the objects and beliefs that will determine her fate. This is, perhaps, the most primitivist of all of An-sky's gestures: the idea that disenchantment does not preclude reenchantment and that attachment to an enchanted world of dybbuks and exorcists can be acquired.[154] This happens to Leah in two stages. First, as a museum visitor, in Safran's words, she identifies and learns about the primitive object. This enables the next and final step, in which she becomes subject to the primitive beliefs in possession and exorcism. Her alienation becomes irrelevant as she is forcefully pulled into this world; in fact, it is forcefully inserted into her. The primitivist project is enacted on her: prepared by study, she is then swallowed up by a powerful primitive culture.

The limits of primitivism that An-sky probes in *Khurbn Galitsiye* and elsewhere[155] are made moot here. His late primitivist oeuvre, then, split between travelogue and fiction, as with Döblin and Roth, seems ambivalent. On the one hand, the proximity of actual Jews to "primitive" Jews introduced hard limits to the primitivism of the travelogues, because the genre's aesthetic aims and its social aims could not coincide. On the other hand, these travelogues, tripping over their limits, were followed by works that defiantly ignored or rejected any limits to primitivism. In these works of fiction, the ostensibly primitive and defunct beliefs of the characters are turned into the organizing principles of the works themselves. And so despite the fact that primitivism as an aesthetic tool does not function when it confronts its social resonances, Jewish primitivism did not fail as an aesthetic project. The duality of primitivism, caused by its plausibility, generated a productive power. To one degree or another, this duality characterizes all forms of Jewish primitivism, ranging from works that are immobilized by ambivalence at one pole to works that create a primitivism without limits at the other. Some writers, like Franz Kafka, as I will show in the next chapter, put the paradox of Jewish primitivism at the heart of their work. The book's remaining chapters will explore the writers and artists who dared deny this paradox and created examples of Jewish primitivism that leap over its essential paradox.

Chapter 3

THE POSSIBILITY OF JEWISH PRIMITIVISM
Kafka's Self and Kafka's Other

"Looked at precisely, it was like a wild African tribe. Sheer superstition."[1] So Kafka described Hasidic Jews in Prague. Based on that sentence, Kafka scholar Ritchie Robertson wrote: "Kafka is not a primitivist."[2] To arrive at this conclusion, Robertson had to believe that primitivism must be unambivalently positive and that Kafka's statement is negative. But Kafka's characterization of Hasidic practices as superstitious does not undermine the primitivist nature of the statement; in fact, it makes the statement primitivist. After all, it is their superstition that immunizes the Hasidim from the hollowed-out, rationalized, and Westernized Judaism familiar to Kafka. Moreover, Kafka's appreciation of Hasidim is more complicated than the above citation from Max Brod would indicate; situated within the corpus of texts that engage Hasidim, Kafka's primitivism and its particular form become clear. A simplistic exoticizing primitivism is the wrong standard here; the ambivalences of Jewish primitivism allow, even demand, the oscillation between affirmation and disavowal in Kafka's engagement with Jewish identity. Moreover, it is the capacity of Jewish primitivism to expose its own limits that allows Kafka to produce his form of Jewish primitivism—to turn his encounters with the "other" inward.

Kafka's Jewish primitivism extends from his diaries to his most analyzed stories, though some of these texts have not been identified as dealing with primitivism, in part because they do not contain distinctly primitivist formal elements or even explicitly primitivist themes. Mark Christian Thompson, in his study of racial Blackness in Kafka's works, notes the absence of an

approximation of African art and the lack of African characters, arguing that "what we find at work in Kafka are aspects of primitivism that are not formal or characterological but tropological and taxonomic. . . . His primitivist discourse is more in the order of that of a cultural critic than an artist."[3] I am in agreement with Thompson that Kafka's primitivism is critical and tropological. Thompson's illuminating study also finds an engagement with racial Blackness that goes beyond the superficial types of primitivism that are clearly absent in Kafka's oeuvre.[4] But as I will show, there is another place to look for primitivism in Kafka, and that is in his engagement with Jewish culture and identity.

So while Kafka's primitivism, as Thompson notes, is "somewhat unique" in its lack of engagement with or borrowing from primitive art, this is perhaps as regards African art and identity. Jewish primitivism, as I have shown in Chapter 2, often leaves aside questions of aesthetics and engages instead with questions of identity and social critique. So in relation to Jewish primitivism, Kafka's primitivism is not unique. Yet it is not quite the same as that of writers like Döblin, Roth, and An-sky, who skirted the challenge primitivist plausibility posed to their elaborations of Jewish identity. This is because Kafka turned the plausibility of Jewish primitivism into the basis of a critique of the ethnographic construction of identity and ultimately of the construction of the self. Although Kafka's various interactions with and applications of ethnography and anthropology have been analyzed by a number of scholars,[5] they have not seen Kafka's engagement with Jews and Judaism in this light. Situating Kafka's comment recorded by Brod in the context of his oeuvre entails an exploration of a seemingly disparate array of texts, including his diaries, correspondence, several of his shorter literary works, the parable "Vor dem Gesetz" ("Before the Law"), and the *Brief an den Vater* (*Letter to His Father*). Together, these various pieces enable a shift in our understanding of Kafka's relationship to Jewish identity and to the *Ostjuden*, and demonstrate that his writings on Hasidim are a provocative example of Jewish primitivism.

The source for Kafka's comment quoted above is Max Brod, who records it in his biography of Kafka, describing a visit they took on September 14, 1915, to the court of the rebbe of Grodek, who had been transplanted from Galicia as a result of the First World War.[6] Why did Kafka visit a rebbe? We know that Kafka was dissatisfied with the mode of Jewishness he learned at home and that he shared an interest in Zionism, Yiddish literature and theater, and the *Ostjuden* with many others of his milieu, including the two friends with whom he went to the rebbe.[7] Hasidism offered a powerful example of the opposite of what

Kafka resented about the Judaism he learned at home. In *Brief an den Vater*, he castigates his father for foisting on him a Judaism devoid of meaning and belief: "I couldn't understand how, with the utter nothing of Judaism you had at your disposal, you could reproach me for not making an effort . . . to practice a similar nothing."[8] In a lecture on the Yiddish language, he spoke of Yiddish as something more than a language, something that could repair the alienation from the self and the timidity of the non-Yiddish-speaking (i.e., non–eastern European) Jew: "Once Yiddish has taken hold of you and moved you—and Yiddish is everything, the words, the Chasidic melody, and the essential character of this East European Jewish actor himself—you will have forgotten your former reserve. Then you will come to feel the true unity of Yiddish."[9] Kafka positions Yiddish as a metonym for the essence of the *Ostjude*—it is Hasidism, melody, even the character of its speaker; it is something that has a unity, that constitutes wholeness. These features are recognizable as the qualities of the primitivist object. Kafka's gestures toward a critique of western European Judaism and an affirmation of the culture of the *Ostjuden* lay the groundwork for an evaluation of his ethnography—his primitivism in practice.

A key distinction between Kafka's encounters with Hasidim and those of other German-language Jewish writers like Alfred Döblin and Joseph Roth is that they occurred on his home turf: in Prague and its environs. Gill Perry has argued that "the cult of 'the going away'" is a prerequisite of primitivism.[10] Primitivist writers and artists followed in the paths of anthropologists who themselves had followed colonial explorers and merchants: traveling to primitive peoples was the primary means of accessing, exploiting, and representing them. But by engaging in the "cult of the *Ostjuden*" and forgoing the "cult of the going away," Kafka condensed even further the special inner-European qualities of primitivism in the Jewish context: he did not go to the shtetl; he brought the shtetl to himself. As John Zilcosky has argued about the role of travel in Kafka's work, his travels were geographically limited, ultimately becoming a form of interior travel. This is certainly the case for Kafka's ethnographic journeys to the Jews, which took him to Prague and Marienbad but no further. Kafka's ethnography thus emphasizes the resemblance of Jewish ethnography to the *Völkerschau* (the nineteenth- and early twentieth-century entertainments that put "savages" on display in European cities), an analogue that becomes explicit in "Ein Bericht für eine Akademie" ("A Report to an Academy"), which I treat below.[11]

His ethnography of the Jews began in the well-documented period of his friendship with the Yiddish actor and Galician Jew Yitskhok Löwy. In 1911 and

1912, Kafka immersed himself in Yiddish literature and began an intensive study of Jewish history and religion.[12] He read scholarly overviews of the subject and recorded in his diaries the Talmudic legends and other tidbits that Löwy told him. In the world of Kafka's travels, this was a veritable ethnographic expedition, focused on Judaism and specifically on eastern European Jews. Exemplary of this "journeying" and of the collection of ethnographic information in his diaries are two passages, December 24 and 25, 1911. In these passages, Kafka describes two circumcisions: the first of his nephew in Prague and the second a hypothetical "typical" circumcision among Russian Jews. He attended the former, and his information regarding the latter came, presumably, from Löwy. Delphine Bechtel has read these two passages in opposition to each other—the description of the Prague circumcision characterized by its clinical briskness and that of the Russian circumcision by its extended attention to the various details and practices surrounding the main ritual.[13] In both passages, however, Kafka conveys a strong sense of the strangeness of the ritual, oscillating between careful description and unbridled judgment. On the Russian circumcision, he writes, for example, "The circumcision takes place usually in front of over one hundred relatives and friends."[14] Several lines later he records the feature of traditional circumcisions that continues to arouse prurient disgust, the oral suction of the wound: "It is not . . . appetizing when they [the circumcisers] suck the bloody member with [their] mouths, as it is commanded."[15]

Kafka's interest in *Ostjuden* peaked in 1915; it is recorded in his diaries and letters in a number of passages in which he assumes the literary stance of a kind of participant-observer *avant la lettre*. Though he claimed that the Hasidim seemed to him like "a wild African tribe," the distance between them and himself was actually not that great. He had a friend who was a Hasidic insider of sorts, the Czech writer Jiří Langer (1894–1943).[16] Langer was not raised a Hasid but came from a secular Jewish Prague family, like Kafka. He grew up in the same social and religious milieu and came to inhabit the same artistic and cultural world as Kafka—they were introduced to each other by Max Brod. But Langer, interested like so many others of his cohort in finding a more vital form of Jewish identity, turned to Hasidism. In 1913, he absconded to the court of the Belzer Rebbe in Galicia and remained there for several years. When he returned to Prague, it was in full Hasidic costume, complete with caftan, hat, beard, and sidelocks; he would have appeared to dignified, bourgeois Prague as a wild Hasid. As Kafka described Langer in his diary, he was "the *Westjude*

who assimilated to the Hasidim."[17] Or as Langer's brother later wrote, he "had not come back from Belz; he had brought Belz with him."[18] This, of course, is the same vector of translocation performed by the ethnographic showcase. The potential of Jewish primitivism was realized in Langer's transformation into a Hasid and reappearance in Prague. Langer's performance was echoed by the massive influx of Hasidim into central Europe as a result of the First World War. Entire rabbinic courts moved from the Eastern Front to the big cities: Prague, Budapest, Vienna, and Berlin. The ethnographic subject was brought close to hand—the *Völkerschau* had come to town. But though Kafka shared a religious background with these Jews and carried the same potential as Langer to become one of them,[19] he describes pure foreignness—African tribesmen—when he describes Hasidim.

His friendship with Langer, together with the increase in the number of Hasidim in Prague and its vicinity, enabled Kafka to embark on his first ethnographic expeditions beyond attending a local circumcision: together with Brod and Langer, Kafka visited a Hasidic rebbe in Prague in September 1915; in July 1916, he spent two evenings observing the Belzer Rebbe taking the cure in Marienbad.

In a diary entry from September 14, 1915, Kafka describes a visit with Brod and Langer to the court of a so-called *Wunderrabbi* in Prague the preceding Saturday.[20] It was this same visit that precipitated his comparison of Hasidim to African tribesmen, as reported by Brod. Interestingly, it is Langer, the insider, who initiates the ethnographic characterization of the Hasidim in Kafka's diary entry. Kafka comments that "the rabbi reflects a strong paternal character," emphasizing the rebbe's generalizable humanity.[21] Langer responds by telling him that "all rabbis look savage" ("alle Rabbi sehen wild aus").[22] Presumably it was precisely this quality that prompted their visit. Fathers can be seen anywhere—in fact, Kafka spent plenty of time thinking and writing about his own father—but savages must be sought out. The appeal of the Hasidic court is that of the *Völkerschau*, the rare opportunity to see primitives in situ. Kafka then describes how he and his friends are escorted to the rebbe's table, where they can do more than observe: they can interact. Kafka, however, chooses to watch passively, and records a description of the rebbe that is ethnographic, laced with zoological discourse that, like Kafka's story "Ein Bericht für eine Akademie," is suggestive of ethnography's uncomfortable proximity to the study of animals. Kafka describes the rebbe as follows:

[He is] in a silk caftan, beneath which his underpants are visible. Hair on the bridge of his nose. With a hat trimmed in fur, which he keeps pushing backwards and forwards. Dirty and pure, a feature of an intensely thinking people. He scratches the base of his beard, blows his nose through his hands onto the floor, reaches with his fingers into the food; but when he leaves his hand on the table for a moment, you can see the whiteness of his skin, the way one believes he has seen a similar whiteness only in childhood fantasies.[23]

He has a fur cap on his head, hair on his nose—like an ape, his entire head seems to be covered with fur. He persistently moves his cap around his head and constantly scratches his beard, as if caricaturing a monkey. These observations slide between the poles of an evolutionism that elides the difference between primitive man and animal. They are punctuated by an ethnographic note on how the rebbe eats. Following quickly is yet another type of anthropology—this time racialist, describing the extreme whiteness of the skin on the rebbe's hand. This passage condenses the standard primitivist tropes applied to eastern European Jews: the lack of table manners intimated by the rebbe's use of his hands to eat identifies him with primitive man; the animalistic depiction of the rebbe's appearance identifies him with apes; his whiteness is a racial signifier and also a sign of puerility. The rebbe's primitiveness is thus multifaceted: calibrated ethnographically (along the scale of Western civility later codified by Norbert Elias), zoologically, racially, and in terms of childhood. It is this overdetermined encounter that prompted Kafka to compare Hasidim to African tribesmen.

At the beginning of the description of his ethnographic expedition with Brod and Langer, Kafka writes, describing entering the room where the rebbe sat, "We squeeze into a corner [*Ecke*]."[24] This passage calls to mind Kafka's most famous statement on his own Jewish identity, from a diary entry about a year earlier (January 8, 1914): "What do I have in common with Jews? I have hardly anything in common with myself; I should stand quietly in a corner [*Winkel*], happy that I can breathe."[25] The corner is the place Kafka identifies in both these diary entries as the point of observation—in the former of ethnography, in the latter of introspection. In both cases his own identity is at stake, and in both cases it is an ethnographic modality that defines his perspective. In the former case, he concludes that he has nothing in common with Hasidim; in the latter, that he has nothing in common with himself. This structural (but not lexical) duplication once again puts the observer in the place of the observed;

Kafka performs on himself as on the Hasidim the same process of observation, categorization, and judgment. Here, in explicit reference to Jews, we have the collapse of subject and observer, of Jewish ethnography and Jewish identity, a move typical of Jewish primitivism and one that is a key feature in Kafka's reflections on Jewish identity.

Kafka's final ethnographic expedition consisted of two evenings on vacation in Marienbad observing the Belzer Rebbe. Following the custom of other European aristocrats, Hasidic rebbes (at least those who were rich enough) would spend the summer in the elegant spa town of Marienbad. Kafka's guide was, once again, Langer. He accompanied Kafka as they followed the rebbe on his evening stroll, surrounded by his retinue. In a letter to Max Brod (July 18, 1916), Kafka described what he saw, which contrasted an exoticist frame with ordinary contents. He wrote that the rebbe "looks like a sultan. . . . But not a masquerade—an actual sultan. And not only a sultan, but also a father, a schoolteacher, a professor, and so on."[26] The immediate deflation of orientalist fantasy corresponds to what he saw: although the rebbe carries a silver stick and his attendants hold an umbrella over his head and carry a chair in case he wishes to sit, all that occurs is a slow stroll, not a strange rite or procession. The rebbe points to buildings and architectural features and asks about them; though he appears wise like a teacher, his interest in his surroundings is that of the ordinary tourist. Nevertheless, Kafka gives even these ordinary observations ethnographic valences. For example, the rebbe blandly comments on "a nice building," which Kafka designates an "astonishment particular to the *Ostjuden*."[27] This startling assertion is a clear example of the paradox of Jewish primitivism, insisting on ethnographic exceptionality in the face of banal reality.

Perhaps the above considerations can allow for a new perspective on a story that has been analyzed from almost every direction.[28] Kafka's short piece "Vor dem Gesetz" ("Before the Law"), eventually published as part of his novel *Der Prozess* (*The Trial*, 1925), first appeared in print in the Prague Zionist periodical *Selbstwehr* in the issue of September 7, 1915. Although the diary entry of December 13, 1914, indicates that "Vor dem Gesetz" may have been drafted by then, its composition was certainly after the period of Kafka's friendship with Löwy and quite likely from the time when he met Langer and began his second round of intensive engagement with eastern European Jews. As such, I would like to propose a reading of "Vor dem Gesetz" that builds on Heinz Politzer's interpretation of the "man from the country" (*Mann vom Lande*)[29] by suggesting that the dynamics of the encounter between the man from the country and

the gatekeeper resemble the dynamics of an encounter with a Hasidic rebbe. Politzer has suggested that "man from the country" is a literal translation of the Hebrew *'am ha'aretz*, which means simpleton or ignoramus.

In "Vor dem Gesetz," a "man from the country" approaches a doorkeeper seeking entry to the law. When the man looks closely at the doorkeeper, he notices his "fur coat," his "big pointy nose," and his "long, thin, black Tatar beard."[30] He observes the doorkeeper so closely and for so long that he even recognizes "the fleas in his fur collar."[31] These descriptions do not explicitly evoke the stereotypes of the *Ostjuden*, but Kafka is careful never to offer rote descriptions or signifiers that are not overdetermined. The doorkeeper's fur coat and collar are reminiscent of the fur in which a rebbe is garbed. The doorkeeper is exotic, barbaric, and foreign; these features are enough to suggest a comparison between gatekeeper and rebbe.

Even more significant are the dynamics of the encounter. In what scenario does an unschooled ignoramus come to a bearded man with a fur coat, seeking information about or access to "the law" (*das Gesetz*, itself a possible translation of *torah*)? A visitor to a Hasidic rebbe.[32] Although Hasidim may have had many reasons, mundane as well as spiritual, to visit their rebbe, *Westjuden* who documented their own encounters were seeking something larger and vaguer, something like *das Gesetz*. Seen this way, the story is a critique of the cult of the *Ostjuden* in that it represents the high hopes and deep disappointment of those who came to Hasidic rebbes and to Hasidism expecting to sample a Jewish version of Gauguin's Tahitian paradise but instead found a reality that could not comply with their fantasies. This is why the most the doorkeeper can offer the man from the country are gnomic banalities: as we have seen so far, that is what non-Hasidic Jews usually got in the meeting of their primitivist expectations with the misunderstood reality of Hasidic rebbes. And like the man from the country, Jewish primitivism expected, with no substantiation save fantasy, an essential truth to be concealed behind the doorkeeper/rebbe.

Although the "man from the country" never gained access to the law, there is no reason to assume that it was not where he expected it to be. For Kafka, primitivism's difficulty does not bespeak its failure. In roughly the same period in which he composed "Vor dem Gesetz," he cautioned himself in his diary to refrain from examinations of difference and to "stand quietly in a corner, happy that I can breathe." But he preceded this clause with a question and answer: "What do I have in common with Jews? I have hardly anything in common with

myself."[33] Just as this comment is not a renunciation of the project of interior exploration, it is likewise not a renunciation of the project of exterior exploration (i.e., ethnography and primitivism). It is, rather, a simultaneous affirmation and destabilization.

Kafka expands on this contradictory interpretation of primitivism in "Ein Bericht für eine Akademie." This story is, in many ways, a satire of the Jewish project of acculturation and *Bildung*.[34] But how it gets there is a tricky question. Indeed, as the following will make clear, the primary force of its satire is directed at primitivism in its various popular and institutional guises, in particular the *Völkerschau*. I argue that Kafka's critique of Jewish identity formation is located within his satire of primitivism. Like all satires, the work performs that which it takes as the object of its satire; that object, however, emerges as a damaged but still viable means of understanding the position of the Jew in Europe.

"Ein Bericht für eine Akademie" is the monologue of an ape who has been invited to relate the story of his life to a gathering of academics. The ape, known as Rotpeter (Red Peter), tells of his capture in the wilds of Africa by a German expedition and his subsequent transformation, by his own efforts and with the help of some friendly humans, into a civilized European. Kafka does not specify what kind of scholars the members of the academy are, but it is safe to assume that they are zoologists or anthropologists of some sort. In his account, Rotpeter makes reference to his many appearances on theatrical stages around Europe, offering his story and his presence as popular entertainment. Thus, the exact nature of his report—somewhat scholarly, somewhat middlebrow, and in parts definitely lowbrow—is unclear and unstated. To make sense of this hybrid creature (man/monkey) and his performance, a different sort of hybrid creature must be postulated: anthropologist/theatergoer—in other words, a modern European.

Kafka's satire addresses itself not only to scientific lectures but equally, as Alexander Honold has argued, to the phenomenon of the *Völkerschau*, the ethnographic showcase. These showcases were a late nineteenth-century and early twentieth-century popular spectacle in which groups of native peoples from distant corners of the globe were transplanted to the middle of European cities.[35] For a fee, visitors could come and see these "savages" in purportedly authentic costumes and settings as they engaged in rituals and dances. The leading German impresario of these entertainments was Carl Hagenbeck, who began his career as a dealer in exotic animals.[36] In Kafka's story, the expedition

that captures Rotpeter is identified as a Hagenbeck expedition,[37] and indeed, as an animal *and* a human, Rotpeter is the ideal Hagenbeckian captive. When the reader meets him, however, he is on display for his own profit.

The ethnographic showcase is not the only clearly discernible anthropological object of ridicule in the story. The other is evolutionism. Under the influence of Darwin, late nineteenth-century zoology and anthropology were joined in their interest in evolutionary theory. Anthropologists attempted to reconstruct the cultural evolution of humanity by comparing so-called primitive cultures with their own Western cultures and drawing the evolutionary lines from the former to the latter. Kafka's Rotpeter holds himself up as an example of anthropological evolutionism: his transformation from ape to human is, so he implies, the story of mankind's evolution. But the ape has raced through millennia of cultural evolution over the course of five years. The principle on which the scientific utility of Rotpeter's lecture is based has been reduced to absurdity. Though he speaks with the correct affect and idiom, he says little of scientific value or interest.

Indeed, if he were actually a useful subject of study for the members of the academy, why is he lecturing them, instead of being lectured about? Kafka has transformed the scholarly venue into a space of performance, the lectern into a stage, the lecture into a *Völkerschau*. But this *Völkerschau* is a failure: its subject has nothing to say or show about primitive culture, about his identity as an ape. What he is putting on display is, in fact, the culture of his observers. Yet he remains an ape: though he wears Western clothes, he is still covered in fur; his face remains that of an ape.

The irony here is that the subject mirrors the desires of those who study him rather than satisfying them. The members of the academy must have had mixed feelings: titillated by the novelty of a talking ape, but disappointed by the nonspectacle of a droning, pompous speechifier. This inversion of the expectations of an ethnographic showcase has more than playful, satiric consequences, however: it also explicitly puts the ethnographic subject into the position of the ethnographer. Excluded by Rotpeter's first-person narration, the members of the academy are entirely subordinate to the ape, who assumes their role even as he performs his own.[38]

It is this dual positioning that resembles the positioning inherent in Jewish primitivism. As Sander Gilman has noted, "Ein Bericht für eine Akademie" is not about Jews.[39] This point hardly needs to be made, though—the story is quite clearly about a talking ape. But, as Gilman has it, it is also clearly about

Jews.[40] Reading the story this way requires a forceful imposition of the Jewish theme onto the story and then an immediate retraction. Gilman tries to have his cake and eat it too. This identity-oriented interpretation of the story's German-Jewish connotations is indeed compelling: Rotpeter speaks of his attempts to adopt German language, behavior, habits of eating and drinking—the very elements of embourgeoisement and acculturation that Jews throughout the nineteenth century attempted to acquire and did acquire, all the while, like Rotpeter, both agonizing and boasting about it.

I offer a different means of interpreting the story in a Jewish light, precisely by reading it as a satire of primitivism in the period—it is thus a metaleptic reading, separated twice over (from the ape to primitivism, from primitivism to the Jews) but nonetheless connected. And ultimately, the story suggests the very stance that Kafka has adopted in its production. Rotpeter, though he is displaying himself to and performing for an academic audience, is, in the final analysis, the scientist himself. He closes his speech with the following statement: "I wish only to share knowledge, I am merely reporting; even to you, esteemed members of the Academy, I have only reported."[41] But unlike the medical or ethnographic report, the report here is offered not by a scientist speaking on a subject external to himself but by the subject speaking about himself. Rotpeter is both the subject and the scientist, the savage and the ethnographer. It is this condensing of observer and observed that most clearly and effectively identifies Kafka's story as a comment on Jews. The text is Kafka's report—an ethnographic document charting the dynamics affecting Jewish identity; a report whose subject is on one level a talking ape, but on another is Jews, or perhaps even Kafka himself.

If Rotpeter, though he has adopted European dress and a refined manner, remains an ape, what will happen to the hairy, filthy Hasidic Jews who have arrived in Prague, Vienna, and Berlin? This question, of course, with its various permutations, was one of the most pressing for European Jews in the first half of the twentieth century. But it is not the metonymic exchangeability of ape for Jew that signals that this story is, in many ways, about Jewish identity. It is, rather, the fact that the collapse of observer and observed is a fundamental condition of Jewish modernity. The ape is Jewish because his experience is Jewish. For the Jewish writer who took Jews as his subject, the prerequisite of literary primitivism—ethnography—automatically became autoethnography.

By looking to the *Ostjuden*—their fellow Jews and Europeans—Kafka used an object freighted equally with similitude as with difference to engage in the

primitivism for which other Europeans created objects marked by overwhelming otherness. Jewish writers were able, instead of traveling to the South Seas, even instead of traveling to the shtetl, and ultimately instead of traveling to the Jewish neighborhoods of Prague or Berlin, to look inward. Since Jewish primitivism positioned the Hasid not in relation to the savage but as the savage, he was not only a metaphoric double—the Hasid's tenor to the tribesman's vehicle. The Hasid is also substituted for the savage, performing the same rhetorical task: they both become metaphors for the western European Jew who himself stands in a metonymic relationship to the non-Jewish European. The Hasid is the vehicle to traverse the entire distance between savage and European, between primitive and civilized.

Kafka's primitivism abuts many of the aspects of others' Jewish primitivism—from diaspora nationalism to cultural Zionism, from religious revivalism to Yiddishism, from popular ethnography to avant-garde cultural production. But Kafka arrives, finally, at the self. Through an interrogation of the distance between the ever-reversing roles of subject and object, between the they (the Hasidim, the members of the academy, the Jews) and the me (Kafka, Rotpeter, the individual), Kafka asserts the impossibility of any form of identification: "I have hardly anything in common with myself; I should stand quietly in a corner, happy that I can breathe."[42] The primitivist interrogation of the other thus passes through the existential interrogation of the self to the biological assertion of existence. This nearly paradoxical combination of humility and gnomic universality is a product of the nearly paradoxical combination of subject and object typical of Jewish primitivism.

It is also the textual site where Kafka departs from the mainstream of Jewish primitivism; most central and eastern European Jews in the period did not wish to forgo identification with others, let alone with their own selves. Jewish primitivism gave voice to a desire for a different kind of identity, but for Kafka it was something more, something he expressed in his short text "Wunsch, Indianer zu werden" ("The Wish to Be an Indian"), from the collection *Betrachtung* (*Contemplation*) published in 1912:

> Oh to be a Red Indian, ready in an instant, riding a swift horse, aslant in the air, thundering again and again over the thundering earth, until you let the spurs go, for there weren't any spurs, until you cast off the reins, for there weren't any reins, and you scarcely saw the land ahead of you as close-cropped scrub, being already without horse's neck and horse's head![43]

To ride like the wind with no reins, no spurs, and even no horse—in other words, to be free. Kafka's Jewish primitivism did not seek to replace the bourgeois Jewishness of his upbringing with something more authentic; but it was also not a critique of the project of seeking and crafting alternative Jewish identities. It was, rather, an attempt to be free of the entire problem of identity. Free of the anxieties and challenges of being Jewish, perhaps even of being human.

Chapter 4

THE POLITICS OF JEWISH PRIMITIVISM
Else Lasker-Schüler and Uri Zvi Grinberg

From among the group of Jewish writers and artists who gathered at the Romanisches Café in Berlin in the 1920s, one could hardly choose two more different poets than Else Lasker-Schüler and Uri Zvi Grinberg.[1] But they knew each other well, and the time they spent together in Berlin in 1922–23 was to prove poetically potent. Lasker-Schüler's influence led Grinberg to one of the most provocative images in his oeuvre, the "Society of Savage Jews" (*Berit hayehudim hapera'im*)—an image he took directly from Lasker-Schüler's invention "der Bund der wilden Juden." This epigonal relationship was unlikely, to say the least. Lasker-Schüler was a middle-aged, eccentric, nationally known and admired German poet; Grinberg a twenty-something Yiddish poet newly arrived from Poland, who had just begun to make his presence known in the Yiddish literary world and in the coming years would transfer largely (but not entirely) to Hebrew.[2] Lasker-Schüler crafted a persona for herself that challenged and exceeded the boundaries of ethnic, religious, and gender identities—she dressed up in orientalist garb and referred to herself as Prince Jussuf. Grinberg, on the other hand, released a volume of Hebrew poems in 1926 titled *Hagavrut ha'olah* (Manhood rising). Lasker-Schüler was from a well-to-do, barely observant family living in a middle-sized German city; Grinberg was the son of a minor Hasidic rebbe and was born in a tiny Galician village.[3] Finally, Lasker-Schüler famously declared of herself "Ich bin unpolitisch" (I am apolitical).[4] Though this was clearly a posture, behind which lay a wide-ranging, if subtle, political engagement,[5] it nonetheless pointed to an approach strikingly different

from that of Grinberg, the poetic mouthpiece of far-right Zionism, a member of the first Knesset, and a founder of the radical right-wing anti-British group Berit habiryonim (Society of Thugs).[6] It was Grinberg who invented the name of this faction, basing it on the Talmudic epithet[7] for the Sicarii, Jewish anti-Roman extremists in the period preceding the destruction of the second temple in 70 CE. As Rachel Seelig notes, Grinberg argued in his very first Zionist statement that thuggishness was the key to Jewish sovereignty (*malkhut* [kingship]) in the Land of Israel.[8]

The name Berit habiryonim is closely related to the Berit hayehudim hapera᾿im, which, as noted above, Grinberg took whole cloth from Lasker-Schüler.[9] This phrase was central to both of their articulations of Jewish identity and their visions of Jewish society. In exploring the meanings of this phrase, I will elucidate a tropic landscape that spanned the geographies of Berlin, Warsaw, and Palestine. I will track the "Society of Savage Jews" and its correlates through Grinberg's Yiddish and Hebrew poetry and examine these in unexpected relation to the visual art, poetry, prose, and correspondence of Else Lasker-Schüler.[10] Grinberg appropriated this trope to his own ends, fundamentally redefining the meaning of Lasker-Schüler's *Bund*. For Lasker-Schüler, the *Bund* was a form of community grounded in social bondedness—bonds of friendship and physical proximity. For Grinberg, the social *Bund* became a much thicker *berit*, a covenant—social, but also political and messianic; for him the bond of friendship is replaced by the bond of blood—the blood of the covenant, which is the blood of circumcision and thus the blood of Jewish communal identity. Where Lasker-Schüler envisions community grounded in a political entity that in its strongest form is, as Sylke Kirschnick writes, an artists' city-state, Grinberg aims at an ethnically grounded nation-state.[11] From the common ground of the avant-garde critique of modernity and a particular conception of the Jewish primitive, they traveled in different political directions. As Yaacov Shavit notes, Grinberg harnessed a Spenglerian *Kulturpessimismus* to a "messianic-historic vision" of a kingdom, "transcending 'the state' or even 'the nation.'" It expressed a concrete vision: as Shavit further argues, "[Grinberg's] poetry was not intended to be a kind of 'literary,' 'poetic' world, and was not read as such by his followers. Its intention was to translate the idea into political terms."[12] Lasker-Schüler, by contrast, refused to acknowledge a distinction between a poetic and a political, or real, world. Her politics could thus be activated entirely within her poetics. Grinberg sought to use poetry to create national sovereignty; Lasker-Schüler created personal sovereignty within

poetry. But despite these differences, their applications of the "Society of Savage Jews" reflect a shared attempt to connect past to present, Jewish history to lived experience.

Savage Jews

Lasker-Schüler's trope of *wilde Juden* (savage Jews) constitutes a strong primitivist strain in her work, a strain often obscured by an insistence, in modern scholarship, on her orientalism.[13] Lasker-Schüler's oeuvre is characterized as orientalist with good reason: turbans, scimitars, and flowing robes appear in many of her visual works; her literary and personal pseudonym was at first Tino of Baghdad and later Prince Jussuf of Thebes; she gave her friends and correspondents Arabic (and sometimes Arab-ish) names—for example, the Yiddish poet A. N. Stencl[14] was Hamid (likely a play on the German version of his first name, Abraham). Lasker-Schüler was not alone in her orientalism. As Paul Mendes-Flohr established, orientalism was a critical component of turn-of-the-century German-Jewish culture—it offered the basis for an "aesthetic affirmation" of Jewish culture, specifically including the culture of the *Ostjuden*.[15]

Further, there is overlap between the early twentieth-century notion of "Hebrew" identity, which focused on ethnicity and language (rather than religion) by valorizing the ancient forebears of the Jews, and orientalism.[16] Lasker-Schüler participated in this form of orientalism too, evident in the collection *Hebräische Balladen* (*Hebrew Ballads)* and most famously in an anecdote Grinberg later related: when he once offered to translate Lasker-Schüler's poems into Hebrew, she insisted that they were written in Hebrew to begin with.[17]

In focusing on Lasker-Schüler's savage Jews, this form of orientalism emerges as a kind of primitivism. Edward Said commented that "the Jews and the Muslims, as subjects of Orientalist study, were readily understandable in view of their primitive origins: this was (and to a certain extent still is) the cornerstone of modern Orientalism."[18] But recognizing that Lasker-Schüler's primitivism is also a type of orientalism should not cause us to conflate her figuration of Jewish identity with adjacent ones. For example, although Ritchie Robertson has argued that Hebrews and savage Jews are one and the same in Lasker-Schüler's works,[19] "Hebrew" is not the only word she used to denote the people she sees as savages: she also used "Jew." Although savage Jews often fall under the rubric of Hebrews (e.g., in *Hebräische Balladen* or *Das Hebräerland* [The land of the Hebrews]) and thus constitute a subset of that group, Jew and

Hebrew in fact mean different things for Lasker-Schüler.[20] But while Hebrew as a theme in Lasker-Schüler's work has been treated by scholars,[21] the trope of the savage Jews has never been the subject of extended analysis.[22] By focusing on this particular aspect of Hebrew/Jewish identity—the savage—new light is shed on Grinberg's Hebrew and Yiddish poems of the late 1920s and early 1930s, and in particular the primitivist and orientalist valences of his politics as they emerge in his poetry. Despite the opposing extremes of politics they occupied, their momentary convergence of aesthetics proved powerfully resonant for Grinberg's conception of Jewish and Zionist identity. Of all the possible influences that Grinberg, arguably Lasker-Schüler's most astute reader among twentieth-century poets, could have drawn from her, it was the motif of the savage Jew that he identified, extracted, and adapted.

Lasker-Schüler's version of primitivism was decisive for Grinberg. Her innovation was in pushing beyond Jewish primitivism's undermining of the presumed unbridgeable chasm between the civilized and the savage. Lasker-Schüler went further, springing over the gap between the European subject and the primitivist object and insisting on their conflation and their reversal. She not only coveted the presumed vitality and wholeness of the "other" as the sole potential agent for the recuperation of European and/or Jewish civilization; she also took great pains to make what she identified as the primitive or savage Jew a core component of her *own* identity. For Lasker-Schüler, the primitivist object is neither an object of dispassionate study nor an instrumentalized source of formal inspiration. The primitivist object is the self. Although other writers and thinkers of the period were able to identify the theoretical possibility of such an identification, only Lasker-Schüler was able to capitalize on it and incorporate it into the center of the repertoire on which she drew to perform her identity.

The geographic, onomastic, and gender map she used to plot herself, her friends, and her entire world of writers, publishers, and activists radically reduced the space separating their European identities from their adopted exotic ones. Uri Zvi Grinberg joins Lasker-Schüler in the select (and suspect) group of writers able to productively capitalize on the plausibility of primitivism, although the political ends to which he turned his poetics of savagery make it difficult to place him beside Lasker-Schüler, the "unpolitische" naïve. Indeed, these two writers do not merely attempt to fuse together "modern" and "primitive" Jewish identities; they do not only collapse the spatial and chronological distance of the primitive object—they assert its reality.

This stands in opposition to the notion of the primitive in the history of ethnography. Describing the way that the primitive object was strictly conceptual—despite the human beings on whom it relied—the contemporary anthropologist and theorist Johannes Fabian cites one of the founders of nineteenth-century German anthropology, Adolf Bastian, as follows: "For us, primitive societies [*Naturvölker*] are ephemeral, that is, as regards our knowledge of and our relations with them; in fact, inasmuch as they exist for us at all."[23] Fabian argues that not only is the ephemerality of primitives a Western construct but their entire existence—as "primitives"—is as well. So we can see that from its inception, the modern category of the primitive was consciously understood as an instrumentalized construct: primitives had no substance or reality—they were always a discourse, a poetic conceit, a trope. But Grinberg and Lasker-Schüler insisted that this was not so, reversing Bastian's dictum: the very constructedness of the category enabled these writers to identify as primitives themselves. The primitive need not be ephemeral. Primitives are real because the poet is real. The implications of this self-identification were not only poetological but social, as both Lasker-Schüler and Grinberg would argue in their different ways.

Lasker-Schüler's *Bund*

Lasker-Schüler's *wilde Juden* typically appear as a collective, either the *Bund der wilden Juden* (figure 1) or a group called both the *Häuptlinge* (chieftains) and *die wilden Juden* (the savage Jews), (figure 2). In a letter addressed to "the Blue Rider" (Franz Marc, founding member of the expressionist group Der Blaue Reiter) in *Briefe und Bilder* (Letters and pictures, serialized 1913–17), she described a letter she would write to the noted satirist and journalist Karl Kraus, proposing the founding of a magazine on art and politics (*kunstpolitische Zeitschrift*)[24] to be called "Die wilden Juden."[25] The first individual savage Jew appeared in her work the following year. He is the biblical Joshua, who figures in the second edition of *Hebräische Balladen* from 1914, in the poem "Moses und Josua":

> When Moses' age equaled the Lord's
> He took the savage Jew Joshua
> And anointed him king of his horde.[26]

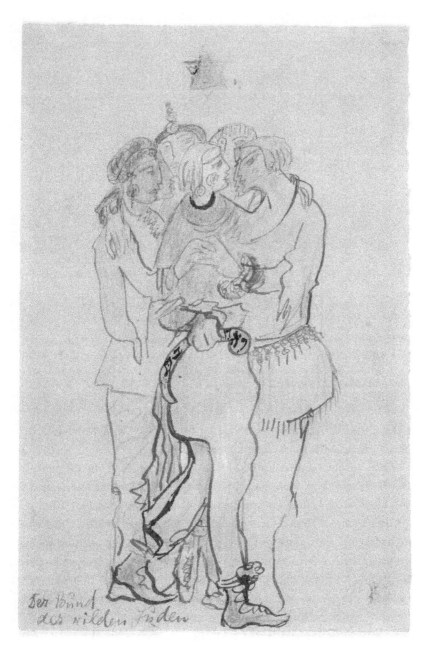

Der Bund
der wilden Juden

FIGURE 1. Else Lasker-Schüler, *Der Bund der wilden Juden* (The society of savage Jews), 1920. Courtesy of the Else Lasker-Schüler-Gesellschaft, Wuppertal.

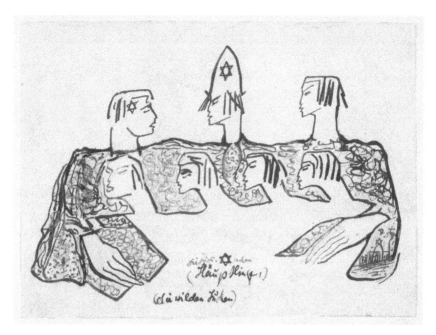

FIGURE 2. Else Lasker-Schüler, *die jüdisch=✿schen (Häuptlinge:) (die wilden Juden)* (The Jewish chieftains; the savage Jews), 1913. The title is handwritten on the work by Lasker-Schüler, complete with symbols and punctuation. Courtesy of the Else Lasker-Schüler-Gesellschaft, Wuppertal.

I will return to the essential point that this first savage Jew is the biblical figure who led the Israelite conquest of the land of Canaan.

The savage Jews return in *Briefe und Bilder* (later turned into the epistolary novel *Der Malik* [The king, 1919]). She writes to Ruben (her pseudonym for Franz Marc) of Prinz Jussuf's efforts to secure the release of Sascha, the prince of Moscow. Sascha was her name for Johannes Holzmann, the activist and writer who had been incarcerated in Russia in 1907 for aiding and abetting an anarchist group. Lasker-Schüler in reality went to great lengths to secure his release, raising money and traveling to Russia in 1913, but to no avail. Holtzmann died in a Russian prison in 1914. But in *Briefe und Bilder* she reports the following: "I selected seven chieftains [*Häuptlinge*] and placed myself over them as their ruler. We eight savage Jews [*wilde Juden*] now form a society [*Vereinigung*]. . . . With these savage Jews of mine I shall make my way over the Alps to Russia."[27]

But "wild" here is not only a coloring adjective—it has a specific genealogical claim, one at work in her corpus at large and specifically in this text. She

signs one letter, just a few pages before, "Dein Jussuf Abigail der Wildstämmige" (Your Jussuf Abigail, the savage-born).[28] Hence, by her own definition, Lasker-Schüler is not *like* a savage; she *is*—genealogically—a savage. This is crucial and distinguishes her brand of primitivism from the broader phenomenon of primitivism, including the practice of the artist to whom these letters were addressed: her friend Franz Marc. With Wassily Kandinsky, Marc coedited the influential *Der Blaue Reiter Almanach* (The Blaue Reiter Almanac), published in 1912. In that volume, Marc, otherwise mainly a painter, penned an essay titled "Die Wilden Deutschlands" (the savages of Germany).[29] In it he articulates a nongenealogical notion of savagery, one centered around aesthetics and ideology. He opens his essay as follows:

> In our time of great struggle for a new art, we fight as savages [*Wilde*]— disorganized against an old, organized Power. The struggle seems unbalanced, but in matters of the spirit victory is won not through numbers but through the power of ideas. The feared weapons of the savages are their new ideas.[30]

When the noun *Wilde*, or "savage," appears in this essay, it is in quotation marks. And just as Marc is explicit in the aim of the struggle—to create a new art—he also later specifically identifies the savage combatants, the foremost contingent being Brücke, the expressionist group to which Emil Nolde and other primitivist painters belonged. He writes "we fight *as* savages," *not* "we are savages." The slight distinction between a simile and a metaphor here opens a chasm; Marc's claim, unlike Lasker-Schüler's, is that savagery is analogical, not genealogical.

Another difference is that where Marc's savages are disorganized, representing a Romantic individualism, Lasker-Schüler's savage Jews form a primitive collectivity—a *Vereinigung* (union) of chieftains or the *Bund der wilden Juden* (the Society of Savage Jews). This latter appellation appears more frequently and is most notable in a number of drawings on the subject by Lasker-Schüler, including the one shown in figure 1, from around 1920. It is here that the intertwined poetics and politics of the trope emerge most fully. Jussuf stands in the middle, surrounded by his friends, who embrace him and form a circle as if in a dance. The *Bund* of their association is represented as a physical bond. The military component of this association of savages has not been neglected—Jussuf carries in one hand a long, curved dagger. But the dagger bears Hebrew letters, reading "ve'ahavta," a reference to Leviticus 19:18, "*ve'ahavta lerei'akha kamokha*" (Thou shalt love thy neighbor as thyself). The basis of this *Bund* is thus

comradely dedication, or perhaps friendship. The word *ve'ahavta* also alludes to another biblical verse, Deuteronomy 6:5: "And thou shalt love [*ve'ahavta*] the Lord thy God with all thine heart, and with all thy soul, and with all thy might." And here we have the second central component of Lasker-Schüler's notion of *Bund*, one that comports closely with the fundamental *Kulturkritik* of primitivism: these savage Jews are endowed with a selfless and total devotion; they perform their work with all their heart, soul, and might. The two most prominent features that emerge from this image are its representation of the bodily, physical forms of social bondedness as the paramount form of loving friendship and its identification of a unity of spirit, not only of body, in the fulfillment of a spiritual mission. In the 1913 drawing (figure 2), we again have both elements: the chieftains form a seamless block, physically undivided. The figures of the front row gaze in the same direction, united in focus on the task at hand; the outer figures of the top row both turn to look at their ruler, Jussuf, whose gaze joins that of his chieftains in the front row. These two aspects— the physical bondedness and the all-encompassing dedication—reflect Lasker-Schüler's reorganization of community around the notion of Jewish savagery.[31]

This is not to say that she was immune to the dangers of primitivism or that her form of it is innocent. A drawing (figure 3) from around 1930 shows the hazards of her approach: Lasker-Schüler employs derogatory visual stereotypes, and the title conflates identities while using a hateful American racist epithet—the image is captioned "The indianer niggers of the prince of Tiba." The faces are in anthropological profile, as were those in the preceding image, *Häuptlinge*; however, unlike the organized and dignified Jews, the Africans and Indians in this image form a chaotic crowd—a central conceit of negative notions of primitive identity.[32] Significantly, Jussuf is absent from this group. When he is present, he reorganizes the primitive chaos around himself into an organized group of which he is the linchpin.

Savage Language

Grinberg adopted the trope of the savage Jews from Lasker-Schüler, first presenting it in a 1926 essay written in honor of Lasker-Schüler's (purported) fiftieth birthday and published in the Labor Zionist Hebrew-language daily newspaper *Davar*.[33] Titled "Devorah beshivyah" (Deborah in captivity), it is a meditation on the qualities of Lasker-Schüler's poetry that, according to Grinberg, render it a premier example not only of modern Jewish verse but of modern *Hebrew*

FIGURE 3. Else Lasker-Schüler, *The indianer niggers of the prince of Tiba*, 1927–33. Lasker-Schüler wrote this title on the drawing in a mix of German and English. From Erich Lessing / Art Resource, NY.

verse. As it turns out, however, for this poet acutely conscious of the specificity of the Jewish languages Yiddish and Hebrew—a consciousness expressed in his transition from the former to the latter, not to speak of the rhetorical sensitivities of his work—Hebrew could be as devoid of linguistic specificity as both Yiddish and Hebrew were for Lasker-Schüler. Grinberg opens his essay citing Lasker-Schüler's autobiographical piece from the expressionist poetry collection *Menschheitsdämmerung* (Twilight of humanity, 1920), in which Lasker-Schüler famously wrote of herself: "I was born in Thebes [Egypt], though I came to the world in Elberfeld, in the Rhineland."[34] In truth, writes Grinberg, Lasker-Schüler was born in Jerusalem. This contention, which stands opposed to both Lasker-Schüler's real biography and her invented one, is based on Grinberg's understanding of her poetics, specifically her language. Her verses consist of originary Hebrew; the word he uses for originary (*giz 'it*) comes from the root meaning trunk or race and thus has botanical and anthropological connotations. Later in the essay he makes the same claim, this time using the word *meqorit*. As Rachel Seelig notes, this is a pun meaning both scriptural and original.[35] Of course, for Grinberg the two are not opposed—original Hebrew is accessible through the idiom of biblical Hebrew. The central point is that this is a "Hebrew alive in the twentieth century," although it is an originary language and thus a kind of *Ursprache*.[36]

Grinberg does not deny the fact that Lasker-Schüler wrote in German. In both places cited above, he immediately acknowledges this fact. After calling her language originary Hebrew (*giz 'it*), he continues to describe it as composed of "the twenty-two letters of the Song of Songs, Ecclesiastes . . . our very own phrases and verses in their spirit and their meter, but composed in Gothic letters."[37] In the latter example, he repeats himself, writing that these are "in the script and the language of Germany—verses of the Song of Songs, of Eretz Yisrael-ness (*erets yisra 'eliyut*)."[38] He hammers home this point by repeating the same rhetorical flourishes: earlier in the essay he had already declared that "she pours out the stuff of the Holy Language in Gothic letters";[39] "she is one of the planets of our Hebraism ['*ivriyuteinu*] that wanders yearningly through various shapes, guises, and incarnations and various countries";[40] "[*Hebrew Ballads*] is the intersection of the pain and yearning of a Hebrew woman, a woman of the Land of Israel, of the Tanakh."[41] Interestingly, Stencl made the very same argument in an article he wrote in honor of Lasker-Schüler's birthday for the Warsaw Yiddish daily *Haynt*: "She writes in the German language but in reality her language is Hebrew."[42]

In the lines preceding the above-quoted statement on originary/scriptural Hebrew, Grinberg argues that Lasker-Schüler's work must be considered Hebrew not only because of its "obvious oriental elements and moments" but also because of its rhetorical and poetic qualities. He writes that

> the diction of her phrases; the way her depictions are expressed in rhymed verse; her mastery of the emotional shock to see things and to sense their reflections from within are all proof that this poet was not born in Elberfeld and that she is not a German poet. In the script and the language of Germany—verses of the Song of Songs, of Eretz Yisrael-ness. . . . The reader of foreign tongues reads, in these verses, originary Hebrew."[43]

Once again, Stencl argues the identical point, claiming that her Hebrew is based on "Hebrew pathos and Hebrew rhythm"; what makes it Hebrew is its "dreamy and languorous Oriental atmosphere." "Not only is it Jewish through and through," he writes, "but it is also biblical and oriental."[44] Everything aside from lexicon contributes to this understanding of Hebrew,[45] and at its core is the element of expressivity, a central feature of primitivist conceptions of language and art, not to mention of expressionism.[46]

Grinberg's essay also treats the most significant aspect of their joint elaboration of Jewish primitivism, namely, the intersection of savagery and sovereignty I described above. In the second section of the essay, he describes his incredulity at the opulence of Prince Jussuf's world that Lasker-Schüler envisioned amid the poverty, privation, and hunger of their bohemian lives in Berlin. He remembers how he and his fellow cynics made fun of Lasker-Schüler and her various pseudonymous identities, but the non-Jews (lo 'azim) did not. The non-Jews, writes Grinberg, took part in a strain of Western civilization that saw art as being a consummation of sovereignty, whereas Western cynicism—in which he and his cohort participated—could speak only "to the individual life of the intellectual, not to the collective life of the nation."[47] In other words, earlier he failed to see Lasker-Schüler—or rather, Abigail, Tino of Baghdad, and Prince Jussuf—as anything more than the conceited fantasy of an individual. This section of the essay, appropriately, is titled "Nicknames." In section 7, titled "Above Kingship" (lema 'alah mimalkhut), he describes how he came to see Lasker-Schüler's fantasies of sovereignty in light of her Jewish identity rather than her identity as a bohemian poet. Walking together late one night along the Kurfürstendamm, Lasker-Schüler said to Grinberg, "We should inscribe on the flesh of our lips— Jerusalem."[48] That night, writes Grinberg, was "above kingship."

This very subsection is where Grinberg first makes known his familiarity with Lasker-Schüler's *Bund der wilden Juden*. In describing the contrast between Lasker-Schüler's fantasy of Prince Jussuf and the reality of poverty and hunger Grinberg recalled, he notes the table at which Lasker-Schüler sat, "shading in with *tekheilet*-gold-and-blood[49] [*tekheilet–zahav–vadam*] the 'Society of Savage Jews' on the pages of [her] album . . . with hands swollen from poverty."[50] This form of aesthetic, personal community is the background against which Grinberg sees Lasker-Schüler's potential to transcend her impoverished (to him) notion of kingship and assume one of solidarity with the Jewish people and their homeland in Eretz Yisrael. This solidarity is expressed by Lasker-Schüler in allusively covenantal terms—the engraving of the lips transposing into the rhetoric of poetry the progenitive symbolism of circumcision. This is also evinced homonymically: the word Grinberg uses for "inscribe," *laḥrot*, is close to the biblical word for the sealing (*likhrot*) of a covenant (*berit*). Grinberg thus implies a turn from her idiosyncratic art as a venue for a solipsistic *Bund* between herself and her associates—inscribed on a page—to her lips (and metonymically her poetry) as a venue for a *berit* with the people who long to return to Jerusalem.

This is the basis on which Grinberg reinterprets and transforms Lasker-Schüler's *Bund der wilden Juden* into his own *Berit hayehudim hapera'im*. The beginning of his new vision of this *berit* emerges in the penultimate section of the essay, in which he appropriates Lasker-Schüler's *Bund* to describe the settlers of Palestine, at the same time reintroducing a notion of kingship that fits with his vision of Jewish identity: "Now, sister, there is a small Israelite (*yisra'elit*) kingdom of poverty in Canaan. And these few poor people work for the vision of the End of Days, for the fulfillment of your painting in *tekheilet*-gold-and-blood: 'the Society of Savage Jews.'"[51] Grinberg has transferred the scene of privation from Berlin to Palestine, and on that basis he claims that Lasker-Schüler's image of the "Society of Savage Jews" is no longer a fantasy on paper but one that is being drawn into reality. The words he uses to describe the colors in her images capture his vision: gold and purple are the colors of kingship, blood is the color of life. In the next lines, the transfer is complete: "Woe that we have no comfort, not even the least. Were it not so, a messenger from among your brethren would come to you in Berlin and tell you: 'In the name of the Society of Savage Jews, I have been commanded to bring you to the Land of Israel.'"[52] Here, at the end of the essay, Grinberg's appropriation

of the "Society of Savage Jews" is complete—it has been transferred from the pages of Lasker-Schüler's sketchbook to Palestine; its members are not the fantastic alter-egos of Lasker-Schüler's friends but the Zionists working to build and settle Israel; it is a fantasy that has become real—at least, almost real. It is the political context that catalyzes the *Bund*, rendering it able—in theory[53]—to save Lasker-Schüler and thus mediate her quintessentially Jewish poetry. Grinberg makes literal Lasker-Schüler's metaphors of sovereignty and kingship and thereby turns politics into the basis—and the safe haven—of poetry, rather than simply an element within the poetry.[54] The transformation of artistic to political community articulated in the translation of *Bund der wilden Juden* to *Berit hayehudim hapera᾽im* corresponded to a social choice Grinberg made on arriving in Palestine. As Tamar Wolf-Monzon comments, faced with "the choice between belonging to the elitist literary community or joining the pioneers, Greenberg clearly opted for the latter."[55]

Grinberg's Covenant

Like Lasker-Schüler, Grinberg created an orientalist alter ego—the pseudonym Yoysef Molkho, with which he signed a sequence of Yiddish poems published in the Warsaw Revisionist weekly *Di velt* (which he edited) in 1933 and 1934. Wolf-Monzon notes that his use of the pseudonym goes back to 1923, when he signed several texts in his Yiddish avant-garde journal *Albatros* with the name.[56] But here it is used after the fault line of his embrace of Revisionism in 1929, catalyzed by his rage at the Zionist establishment for its weak response (as he saw it) to the violent attacks on Jews.[57] The pseudonym was clearly an attractively flexible tool for Grinberg, tracking here with what Hever identifies as his shift from a political messianism centered on the pioneers in the 1920s to a depiction in the 1930s of "a solitary messiah."[58]

One version of this solitary messiah was Yoysef Molkho, an allusion to the historical figure Solomon Molcho, a Jewish messianic aspirant of the sixteenth century. Born in Portugal as Diogo Pires, Solomon Molcho came from a family of Marranos, or conversos; despite his background he seems to have attained a dignified status as some kind of court official.[59] His interest in Judaism was piqued by the arrival in Portugal of David Reuveni, a Jewish adventurer claiming to represent his brother Joseph, ruler of a purported Central Asian kingdom with hundreds of thousands of Jews. Reuveni had political aspirations:

he sought audiences with the pope and various kings in order to pitch to them the idea of joining forces with his kingdom of Jews to expel the Ottomans from the Holy Land. Molcho was eager to join Reuveni and apparently circumcised himself to prove his seriousness. He was rebuffed by Reuveni but began wandering and preaching; eventually he claimed to be the messiah. Molcho and Reuveni finally joined their messianic and political aspirations and under a banner sought to meet the Holy Roman emperor.[60] This, finally, was too much, and they were turned over to the Inquisition: Molcho was burned at the stake in 1532, and Reuveni disappeared from the historical record, presumably meeting his end under the auspices of the Inquisition. Tamar Wolf-Monzon argues that the forename Yosef (pronounced Yoysef in Yiddish) in Grinberg's pseudonym is of indeterminate origin, most likely a combination of several disparate sources bound by an association with messianic nationalism. It seems plausible that it derives from David Reuveni's brother, the Jewish king Yosef, and is thus a conflation of a Jewish king and a false messiah.[61] It is the combination of Reuveni's and Molcho's political messianic pretensions—marching to meet kings and emperors under a Jewish flag—that inspired Grinberg. This nexus of politics and messianism suited Grinberg, whose messianism, argues Shavit, was meant to produce a "concrete program of immediate political relevance."[62] But he also used the name of this sixteenth-century false messiah in large part to vindicate a seventeenth-century false messiah whose sphere was religious— Shabbetai Tsevi, or in Yiddish, Shabse-Tsvi. A cycle of Yiddish poems signed "Yoysef Molkho" was printed 1934 in *Di velt*. It appeared under a heading drawn by Grinberg himself,[63] which reads "Meylekh Shabse Tsvi fun Yoysef Molkho" (The king Shabse Tsvi by Yoysef Molkho) (figure 4).[64]

FIGURE 4. Heading for poem, drawn by Uri Zvi Grinberg. The heading reads "Meylekh Shabse Tsvi fun Yoysef Molkho" (The king Shabse Tsvi by Yoysef Molkho). *Di Velt* [Warsaw], May 4, 1934, 9. From the Library of the YIVO Institute for Jewish Research. © Estate of Uri Zvi Grinberg, courtesy of David Grinberg.

This cycle of four poems (which constitute a major portion of the Molkho poems) is on the theme of Shabbetai Tsevi, the seventeenth-century Turkish kabbalist and messianic pretender whose claims about the imminent redemption of the Jews and their return to their homeland found many eager listeners among the Jews of Europe and the Near East. Though not accepted as the Messiah by most of the rabbinic establishment, he nevertheless had many adherents among the elites as well as the Jewish masses. Eventually it all came crashing down: coerced by the Turkish sultan, Shabbetai Tsevi converted to Islam, in a move that inevitably dealt a deathblow to his movement. Surprisingly, his conversion and even his death did not deter a hard core of Sabbateans from holding on to their faith. The movement dwindled to a mere rumor, a rumor that blended with a collective memory marked by the profound trauma of Shabbetai Tsevi's rise and fall on European Jewry. He was ultimately enshrined in Jewish folk wisdom as the preeminent apostate, whose messianic pretensions were part and parcel of his betrayal of the Jewish religion and people. But it was those very messianic pretensions that made him so attractive to Grinberg, whose encomiums to Shabbetai Tsevi concentrate the wide-ranging messianism in Hebrew and Yiddish literature of the period.[65] Grinberg complains in the second of the poems, "Gezang in opgrunt iber zayn gebeyn un zayne layt" (A song from the depths on his bones and his people):

> . . . in Hebrew revolutionary songs, they praise Bar Giora, they praise his
> heroism
> But you aren't in any songs: Thrown into the abyss. I descend into the abyss
> with praise
>
> And I raise you out of the depths with prayerful hands
> And I draw in Yiddish song, in messianic song,
> The letter "shin," crowned, and the letter "tsadik," crowned: Shabse Tsvi![66]

Grinberg's stated goal is to resurrect the reputation of Shabbetai Tsevi as an equal to the heroes of Zionist song, like Bar Giora, a military leader of the Judaean rebellion against Rome in the first century CE. But Grinberg's antinomian hero has been ignored in Hebrew revolutionary song, and so he must be recuperated in Yiddish messianic song. We see here the name Shabbetai Tsevi, drawn by Grinberg, with the crowned letters *shin* and *tsade*, features of traditional Jewish scribal practice typically used in Torah scrolls, not secular verse.

The poem, he claims, performs the same task as the letters: it crowns Shabbetai Tsevi as king, visually and textually investing in him the political power otherwise only extolled in Zionist Hebrew song and with a religious power implicit in Grinberg's messianic politics.

But why? Grinberg makes this clear in the first poem of the cycle, "Gezang iber Shabse Tsvis fal un der goyrel fun zayn kat" (A song about Shabse Tsvi's fall and the fate of his sect). The poem ends with a description of the sorry state of Shabbetai Tsevi's followers: threatened with death by the Sultan for "daring to tear out the . . . Judaean part of the Turkish kingdom" and excommunicated by the rabbis who drove them away and robbed them of their Judaism.[67] We can now understand the metaphoric use to which Grinberg puts Shabbetai Tsevi and his followers: Jews whose messianism entails national aspirations that butt up against the Ottoman Empire; Jews whose national aspirations entail a messianism that is reviled by the rabbinic establishment. These are Zionists, of course.[68] Grinberg's gleeful heterodoxy in associating his politics with the greatest Jewish folk villain recalls his early exuberant expressionism, also reflected in the vigorous inking and the ungainly, coarse letters of the heading of the Molkho poems.[69] This expressive aesthetics clearly expresses Grinberg's radical politics. Primitivism thus marks the aesthetic convergence of Lasker-Schüler and Grinberg, but it is also the point of their political divergence.

Where Lasker-Schüler describes a *Bund* of savage Jews, bound together by friendship and dedication to her and to each other, Uri Zvi Grinberg offers a *berit*. Like *Bund*, *berit* can mean association or society. And, like *Bund*, it also means covenant. But in Hebrew this is the paramount sense—the *berit* of circumcision is so called because of the covenant it affirms. We read in Genesis (King James Version, 17:8–10):

> I will give unto thee, and to thy seed after thee, the land wherein thou art a stranger, all the land of Canaan, for an everlasting possession. . . . This is my covenant [*berit*], which ye shall keep, between me and you and thy seed after thee; Every man child among you shall be circumcised.

The biblical covenant is God's promise to Abraham of all the land of Canaan, for all generations, and Grinberg appropriates this "berit as covenant" for his "berit as society." He achieves this by importing Lasker-Schüler's *Bund der wilden Juden* into his Hebrew poem cycle from the late 1920s titled "Bivrit hayehudim hapera'im" (In the Society of Savage Jews).[70] One of the poems, titled "Hanishba'im laberit" (Those sworn to the covenant), explicitly asserts his

claim of *berit* as covenant *and berit* as society: "Thus have we, the savage Jews [*hayehudim hapera'im*], made a covenant of the pieces [*berit bein habetarim*]."[71] The covenant of the pieces is God's covenant with Abraham in Genesis 15, alluding to the sacrificial animals that Abraham divided into pieces before God spoke to him.

The covenant of the pieces is the covenant sealed in the blood of circumcision. For Grinberg the covenant was transferred from the religious to the political sphere, but it was still to be sealed in blood. The title of a Yiddish poem printed in *Di velt* in 1934 makes this clear: "Got vet kumen tsu hilf tsum bavofntn folk" (God will come to the aid of an armed people).[72] Blood belongs to the aesthetic repertoire of primitivism and, of course, radical right-wing politics; these valences become clear in the way Grinberg brings together these strands of his poetics in the emergence of his vision of the savage Jew.[73] The first poem of the Hebrew "Society of Savage Jews" cycle, in fact, is called "Masa bamaḥaneh" (A vision in the camp) and begins as follows:

> My brothers in prayer shawls and *tefillin* have a prayer for all seasons. There is a Wailing Wall whose stones are like psalms in their mouths and cool their burning brows. There is a place for their tears in the highest heavens, even in the middle of the day. There is a God who listens to them and stills their aching hearts. But we—the savage Jews—we have no Wailing Wall for our foreheads or our sore mouths. We have no place to cry, and we don't always burst into tears . . . just like that—in the middle of the day.[74]

Grinberg goes on to challenge God to stand with him and the savage Jews knee-deep in the fetid swamps, paving roads. His savage Jews are clearly the *ḥalutsim*, the Zionist pioneers. Grinberg has thus remarkably inverted the typical identification of the traditionally religious Jew, bedecked in *tallis* and *tefillin*, with primitive authenticity. Grinberg's primitives are the pioneers, creating a homeland through the sweat of their brows, or as he demonstrated with the founding of his other *berit*, the *Berit habiryonim*, the Society of Thugs, through violence. The traditional objects of Jewish primitivism are beside the point, wasting their days in prayer and tears.

Another development of this theme emerges in a Yiddish poem from 1929 titled "Der sheyvet khalutsim" (The tribe of the *ḥalutsim*).[75] The title is a literal yoking together of the disparate elements—modern and biblical— that Lasker-Schüler had already joined in her form of orientalism. But Lasker-Schüler embraces their incongruence by insisting on their impossible

simultaneity—famously outlining her origins as follows: "I was born in Thebes (Egypt), though I came into the world in Elberfeld in the Rhineland" (*Ich bin in Theben [Ägypten] geboren, wenn ich auch in Elberfeld zur Welt kam im Rheinland*).[76] The word *wenn* expresses the paradoxical simultaneity, meaning (together with *auch*) "although," while by itself it carries a chronological connotation, cognate with the English "when." The two sections of her statement—birth in Egypt and birth in Germany—thus happened in chronological conjunction *and* in opposition to each other.

Where Lasker-Schüler turns the incongruence of ancient and modern identities into a pivotal paradox, Grinberg flatly asserts the incongruence, thus denying its paradoxicality: the *ḥalutsim are* the savages, the *ḥalutsim are* the tribe. Lasker-Schüler, adopting the supposed prelogicality[77] of the primitive, denies the necessity of resolving the contradiction. Grinberg, however, gestures toward a resolution based on a layering of the analogical and genealogical registers of savagery. His pioneers are savages because of what they do but also because of who they are: he thus resolves the contradiction of modernity and savagery by imbricating his genealogical primitivism with a politically charged orientalism. The *ḥalutsim* are not merely a tribe in the anthropological sense of the word but in its biblical sense—that of the twelve tribes of Israel—and they will inherit the land, as the tribes of Israel inherited Abraham's covenant with God. Accordingly, the first line of the Yiddish poem "Der sheyvet khalutsim" asserts this direct genealogy: "Ask our blood, it'll tell you—it's old . . . all the way from Abraham to today's pioneer. . . . Ask our hardworking hands—they'll tell you as clearly as a well-marked map about the rise of our conquest and our resettlement of the fields, the swamps, the sandy deserts." And later, most explicitly: "The tribe of pioneers emerged from the tribe of Abraham."[78]

It is worth remembering at this point that Lasker-Schüler's first individual savage Jew—Joshua—was the one who led the Israelites into the land of Canaan. So we can see in both Grinberg and Lasker-Schüler a doubled genealogical claim: a claim to Abraham's covenant but also to the strength and vigor of the ancient Hebrews. Jews inspired by the ancients would find redemption not by virtue of an exilic longing for the fulfillment of the covenant but by grasping their birthright with their hands and taking it for themselves. Although for Lasker-Schüler—unlike for Grinberg—this birthright was cultural and aesthetic rather than political, her savage Jew Joshua helps us locate the embedded politics of the Society of Savage Jews and shows how even from her insistence

on savagery as the basis for a community of poets and friends, the particular Jewish, and ultimately Zionist, implications emerge.

Lasker-Schüler was aware of what Grinberg could—and did—do with her vision of Jewish savagery. Yet she never disavowed him. Her ambivalence is evident when she wrote about him in correspondence and described him in prose. From the evidence of Avrom Nokhem Stencl's memoirs, a number of letters from Lasker-Schüler to Grinberg, and her brief characterization of Grinberg in *Das Hebräerland* (The land of the Hebrews, 1937), it seems that she enjoyed the way he conformed to her notion of savage Jewish identity—she relished his Hasidic origins and described him in primitivizing terms. But his politics clearly upset her; interestingly, her anxiety about him was expressed in similar primitivizing terms. Stencl, who wrote extensively about Lasker-Schüler in his memoirs,[79] describes Grinberg's appearance among the Jewish poets at the Romanisches Café in Berlin. During a quiet moment one evening (presumably in 1922), Stencl came to the café and found Lasker-Schüler sitting in terror at her table, claiming that "a red man from Poland came and wants to shoot me! Such red hair." Stencl writes that she called him "the redhead [*der Rote*] with flaming hair" and the "Indian."[80] Later that evening, reports Stencl, a red-haired man did indeed walk into the café, none other than Uri Zvi Grinberg. Lasker-Schüler told Stencl that she had a knife in her purse and would go over to Grinberg and stab him. Despite her palpable fear (Stencl describes holding her shaking hand), the evening passed without violence.[81]

Grinberg, however, seems to have found out; in a letter to him dated June 1, 1923, Lasker-Schüler begins by asking whether he really believes that she would poison him. She assures him that she would never harm the smallest animal, even if "there might be some people" she might like to kill. Nevertheless,

> like a brave and honorable Indian, I would shoot them with a gun, or a bow; but you, I love. And even though I would love to wear your bronze scalp on my belt—your hair; I would never earn it with poison, since poison is the most cowardly and treacherous way to kill. And never did an Indian of my Thebesean tribe give his enemy poison, much less his friend, and I would never do so to you. I would rather kill myself.[82]

The intense emotion that Stencl saw in her affect—the "hysteria," as he called it—was, as this letter shows, part of a self-aware (and funny) performance. Stencl, to his credit, sensed what few of his cohort did (including the poet

Moyshe Kulbak, who dismissed her as a "crazy old Jew [*yidene*]"),[83] namely, that this was a fusion of performance and life: "Inner duplicity was her game. . . . Fantasy? Imagination? And what is life?"[84] Grinberg, on the evidence of the assurances Lasker-Schüler offered in her letter, saw, like Kulbak, a crazy woman. Nevertheless, their relationship seems to have been one that included mutual respect; Lasker-Schüler's letter swiftly transitions to business (she attempted to connect him with people she thought might help him).[85]

Lasker-Schüler held on to this image of Grinberg as a threat, a dangerous Indian. This metaphor evoked alluring danger and power, fascination and simultaneous distaste. The fact that she did not disavow Grinberg despite his beliefs that ran counter to hers, may stem from the fact that she saw his politics less as ideology than as affect. In a letter on Grinberg's behalf to Ernst Simon, the thinker and public intellectual, she admitted to Grinberg's politics, characterizing it as posturing, and cultivated sympathy for him.[86] Twice repeating that Grinberg, though a committed Zionist and excellent poet, had been "neglected," Lasker-Schüler seems to be discreetly requesting an honorarium or other form of financial consideration for Grinberg in return for a lecture he was to give. Lasker-Schüler acknowledges the fact that Simon—binationalist, early member of Berit Shalom, and target of Revisionist ire and violence—was not the obvious choice to help Grinberg, who occupied the far-right fringes of Revisionist Zionism. She refrains from mentioning Grinberg's name in the letter, though she identifies him through various biographical and other markers, and asks Simon to destroy the letter after reading it.[87] Significantly, Lasker-Schüler uses primitivist imagery to both convey the dangers evoked by Grinberg and also to cast them in a positive light. She concedes that Grinberg "plays at being a soldier—is, in essence, a soldier," and that "we two often sparred when he blustered on the streets of Berlin," but maintains that he will nevertheless "take our side."[88] She also reassures Simon that Grinberg had no part in any attacks on him. Further, she tells Simon that Grinberg is a "childlike Indian" and calls him a "Wilderer." Though *Wilderer* means poacher, its root, *wild*, is what makes it an apt descriptive noun for Grinberg. *Wilde* is the word for savage; *Wilderer* brings a level of mediation and instrumentalization to the basic meaning—not a savage, but one who savages. One could argue that *Wilderer* as used here should be literally translated as "primitivist." At any rate, the root *wild* is one on which Lasker-Schüler plays two more times in describing Grinberg: in *Das Hebräerland*, she refers to him as "the idolized enfant terrible [*Wildfang*] of the youth of Palestine,"[89] and in a letter to him

she calls him "a wild [*verwildert*], ill-behaved creature."[90] *Wild* and the semantic field it occupies—including wildness, savagery, and so on—are, together with Indian motifs, the dominant descriptors for Grinberg in Lasker-Schüler's writings.

Although savagery is quite clearly a positive mode of being in Lasker-Schüler's imaginary, her attribution of aspects of savagery to Grinberg does not preclude discomfort—as demonstrated above—or outright condemnation of his politics. The angry letter (from September 16, 1941) in which she calls Grinberg "ill-behaved" was prompted by a date with her he had failed to keep, an affront to any human being, let alone the Prince of Thebes, as she notes.[91] The first line of the letter after the salutation reads as follows: "Brown is to your taste and suits you most naturally"; further on she calls him "Herr Hauptmann."[92] Writing in 1941 in Jerusalem, these are caustic words, even considering Grinberg's earlier fascist associations and sympathies.[93] It is important to note, however, that these insults are in response to a personal slight and are not part of a political exchange. There is a sense here that despite her strong leftward political leanings, she was willing to overlook Grinberg's politics as such; it is only in her articulation of a problem in their friendship that her disapproval appears.

Her fascination with Grinberg and its politically regressive implications is reflected in her application to Grinberg of Indian tropes, which are almost always deployed positively in her work. This is clearly an affirmative primitivizing. It requires reverse logic to see an undermining here: she must disapprove of Grinberg, thus the Indian imagery is critical. Seen the other way—that is, that the Indian is an exciting, transgressive, and positive trope for Lasker-Schüler—it becomes clear that she valorizes those aspects of Grinberg that coincide with the primitivist conception of Native American identity. In *Das Hebräerland*, a prose travelogue compiling impressions of several trips to Palestine, Lasker-Schüler describes spotting Grinberg in Tel Aviv: "Uri's copper-red hair flames up and his Indian eyes bleed like the daring dawn over the jungle [*Urwald*—literally, primeval forest]." Further on she writes that she was accompanied by him and "a posse of Indian-Jews [*Judenindianer*]." In the next paragraph she describes seeing "Jewish cowboys galloping" by on horseback.[94] The next time Grinberg appears in *Das Hebräerland*, the Indian imagery returns, and the root *wild*—absent early in the text—is reintroduced. Lasker-Schüler describes him as "the idolized, poetry-writing enfant terrible of the youth of Palestine," and a few lines later notes that his mother "loves her copper-redheaded Indian boy along with all of his savagery [*Wildheiten*]."[95]

In addition to his wildness and Indianness, Lasker-Schüler also noted the fact that Grinberg's father was a Hasidic rebbe. In both passages in *Das Hebräerland* where Grinberg is mentioned, his father is too: "the miracle rabbi [*Wunderrabbiner*] of Lemberg."[96] In a letter to Grinberg from 1925, she tells of a vision of his father she had.[97] Although Grinberg's father was a very minor rebbe, usually associated with Glina, the town of Grinberg's birth, Lasker-Schüler calls him the rebbe of Lemberg. As I have explained earlier in this book, the figure of the rebbe, particularly as the iconic primitive Jew, was pervasive. Lasker-Schüler was not immune to its power, deploying images of Hasidim and Hasidic rabbis in her visual work; she must have been delighted that the latest denizen of the Romanisches Café finally had a biography that she did not have to invent—Grinberg's father actually was a rebbe.[98] The term Lasker-Schüler employs for Hasidic rebbes—*Wunderrabbiner*—is close to the more common German term for rebbe, *Wunderrabbi*.[99] Interestingly, it is Lasker-Schüler's version that is more "correctly" German, *Rabbiner* being the standard German word for rabbi.[100] This swapping of the exotic for the familiar is a brilliantly subtle reversal of Lasker-Schüler's typical reversal of the vector of exoticism. Ethnography seeks to make the strange familiar, while Lasker-Schüler typically makes the familiar exotic (e.g., in assigning herself and her friends orientalist names and identities). Here, however, in the case of the central locus of Jewish exoticism in the period (Hasidic rebbes), Lasker-Schüler makes the strange slightly more familiar, turning the "rabbi" into the "rabbiner." Lasker-Schüler's new word for rebbe finds the familiar in the exotic. Yet there is nothing familiar about the two *Wunderrabbiner*s who appear in Lasker-Schüler's oeuvre—the titular hero of the story "Der Wunderrabbiner von Barcelona" ("The Wonder-Working Rabbi of Barcelona," 1921) and Grinberg's father. Grinberg's father is, for Lasker-Schüler, a cipher—he can be part of a mystical vision, as in her letter of 1925, or he can be the face of humanitarian sympathy, as in her letter to Ernst Simon, in which she forgoes mentioning that he is a *Wunderrabbiner* and calls him only a refugee.

Her fictional *Wunderrabbiner* is a more complicated case. Jonathan Skolnik argues that the story is a "transvaluation of . . . the nineteenth-century paradigm of 'Sephardic supremacy'" into a Buber-inflected fantasy on Hasidism, in consonance with the then-current "cult" of the *Ostjuden*.[101] As such, it is an example of Lasker-Schüler's conflation of orientalist and primitivist modes of representing Jewish identity; in this case they work in concert, and highlight the continuities from the nineteenth-century German-Jewish cult of the Sephardim to the

twentieth-century cult of the *Ostjuden* that Mendes-Flohr identified. But unlike almost every other German-Jewish writer from the nineteenth century to her time, Lasker-Schüler does not see the Hasidic rebbe as an archetype of savagery. On the contrary, her vision of the rebbe is even more rarefied than Buber's. For Lasker-Schüler, the rebbe is not a savage—the poet is. But the poet is not too distant from the rebbe—the other protagonist of the story is a poet, a young woman with the masculine Hebrew name Amram. Suggestively, in a letter from late 1922, Lasker-Schüler asks her correspondent to introduce a reading of one of her texts as the work of "Amram, the savage Jew-poet" (*die wilde Judendichterin*).[102] This, of course, was in reference to herself, but the allusion to Amram the *Wunderrabbiner*'s daughter—from a 1921 text—is unmistakable.

A final point worth noting: Lasker-Schüler's lodestar and overt reference point for the story is, of course, Heine's *Der Rabbi von Bacherach* (*The Rabbi of Bacharach*, 1840). Though neither this story nor the rest of her work is immediately evocative of Heine, Grinberg too thought of the comparison. In "Devorah beshivyah" he singles out Heine as the Jewish poet closest to Lasker-Schüler. He triangulates the two with Shabbetai Tsevi, writing that between the poems "An Edom" by Heine and "Mein Volk" by Lasker-Schüler reverberates "the echo of the cry of Shabbetai Tsevi."[103] For Grinberg, the cry of Shabbetai Tsevi is the failed claim to Jewish sovereignty. But this is clearly not what Lasker-Schüler sought to emphasize by turning to Heine as precedent.[104] Rather, she used the background of Heine's fragmentary depiction of Ashkenazic suffering and Sephardic success to imagine Jewish poetry in opposition to political considerations. The *Wunderrabbiner*, Eleazar, lives in a palace on a hill apart from the Jews; he travels to Asia for weeks at a time; upon belatedly realizing that his flock is being slaughtered in a pogrom, he sacrifices himself to effect by mystical means the destruction of the Christians of Barcelona. Amram, by contrast, meets her beloved, the non-Jew Pablo, after falling off a high ladder onto the ground; and though her father is the first victim of the pogrom and has his heart savagely torn out, she escapes. She and Pablo, "transfigured by love," remain undetected on a boat that "moved by love" sails over land through the city and out its gates.[105] The bond of love saves Amram, the poet; the bond of peoplehood, by contrast, isolates the *Wunderrabbiner* and leads ultimately to destruction.[106] We see once again the way that Lasker-Schüler's primitivism contains the potential for opposing valences—those she explicitly promotes and those that Grinberg reads into her work. For Lasker-Schüler, bonds (of love, of devotion) exist to secure the autonomy of the individual, her alter ego

the savage Jew; for Grinberg, the savage Jew catalyzes the bonds that secure the sovereignty of the collective.[107]

If we have considered discourses of orientalism and primitivism and their transfer into Zionist poetry, we must ask: Where are the Arabs? In his elaboration of politics and savagery, Grinberg does not ignore them entirely, although it might seem that way. In fact, Arabs haunt the *Berit hayehudim hapera'im*. I have probed the valences of the word *berit*. But what of *pere'*, the singular of *pera'im*? Like the others that describe savage Jews, this word also has a biblical origin, and one not nearly so obscure as its sole appearance in the Pentateuch would imply, for it was adopted into Yiddish as an idiom—*pere-odem*—meaning wild man, or savage. The source of this phrase is Genesis (King James Version, 16:12): "And he will be a wild man [*pere' adam*]; his hand will be against every man, and every man's hand against him; and he shall dwell in the presence of all his brethren." Who is he, the wild man of the Bible? Ishmael—the ancestor, according to Jewish tradition, of the Arabs.

Grinberg's development of the trope of savage Jews is thus a replacement for the savages he identified as already inhabiting the land being settled by the savage Jews. As Hannan Hever argues, Grinberg's poetry of the period evinces the violence of its politics as much through aesthetics as through explicit content.[108] Through the cipher of savagery embodied in the adjective *pere'*, Grinberg was able to smoothly enact a literary transfer that proved much more difficult politically. While people cannot so easily be replaced—something he chose to confront with an ideology that promoted conflict and violence—words are much more pliable. But Grinberg does not use his words to sweep the reality of his Zionism under the rug or to replace the reality of the Jewish settlement of Palestine with a poetic fantasy. Rather, he creates an internally consistent network of allusions reaching into both biblical antiquity and primitivist modernity, to Genesis and to Lasker-Schüler, to craft an image of the Zionist settler who is a natural replacement for the people already there.

Lasker-Schüler's Arabs, by contrast, are much easier to find—in fact, they are impossible to miss. Her alter egos, the pseudonyms she assigned to her friends, the landscape and local color of her imaginary are all shaped by orientalist understandings and configurations of Arab identity.[109] Fantasy is one thing, reality another, and Lasker-Schüler was familiar with the demographic, cultural, and political realities of Mandatory Palestine, having visited in 1934 and 1937 before her final trip in 1939, after which she could no longer return to

Europe. So where are her real Arabs? Certainly, there are none in the landscape inhabited by Jussuf and his chieftains; but what of the Land of the Hebrews? Palestine, after all, was a place that Lasker-Schüler not only visited and found refuge in but also wrote about. In the travelogue *Das Hebräerland*, she cannot avoid noticing Arabs as people outside her literary universe, but unlike Grinberg, she colors her observation of reality with her tropic vocabulary. In a draft for *Das Hebräerland* she writes as follows:

> If one wishes to meet the authentic descendants of Ishmael, go outside the city. There live savage Ismaelites in harmony with savage Jews; these vegetal Asiatics—still untouched by culture—were almost the greatest surprise and most interesting of all the inhabitants of Palestine. Ultimately, I felt freed of any feeling of revulsion to their slovenly outwardness. Just as a gardener overcomes the worms and snails and slimy earth around the roots of a plant, to take it lovingly in his hands, so do I look at my *Urvolk* and its stepbrother.[110]

This passage atypically confronts Arabs and Jews with one another rather than conflating them, but nevertheless overwhelms both groups with the same tropes. They are primitive, even vegetal. The author identifies genealogically with both groups but distances herself with the ethnographic process of initial surprise, foreignness, and repulsion followed by understanding. Indeed, she deploys a scientific metaphor to conclude the passage: "This natural science is only comprehensible in the land itself, in Palestine."[111] Ethnography becomes botany, thus tempering her connections to her *Urvolk* (ancestral people) and its relative and solidifying her assessment of the harmony in which the Arabs and Jews live, united in their savagery.[112]

The phrase "still untouched by culture" (*noch nicht mit der Kultur beleckt*) bears a satirical valence activated by an allusion to Goethe's *Faust*: "Auch die Cultur, die alle Welt beleckt / hat auf den Teufel sich erstreckt" (Culture, which has touched the entire world, / has even reached the devil).[113] The whole world—even the devil—contains culture, but not the savage Arabs and Jews; metonymically, Lasker-Schüler identifies herself with the devil. The cultured, privileged position of the Western observer is thus cast in a negative light. But given Lasker-Schüler's repeated and overwhelmingly positive depictions of savagery, this ironic allusion cannot serve to undermine the depiction of these Jews and Arabs as savage, or of living in harmony. It is, rather, sarcasm—directed at the author herself and her position as a German poet in the land of the Hebrews,

while for so many years she had cultivated an identity as a Hebrew poet in the land of the Germans. This is, perhaps, the strongest critique of primitivism in Lasker-Schüler's oeuvre.

She takes the representation of peaceful coexistence a step further just a few lines later in another fragment from the draft of *Das Hebräerland*, by referring to "savage Arabic Jews."[114] They are now unified, their identities fused. Where Grinberg uses the orientalist link between savage Jews and Arabs to poetically replace the latter with the former, Lasker-Schüler sees the link as representing a stable, peaceful, ultimately unifying relationship. As hopes for the future, one is clearly preferable; as poetic representations of a political reality, only one is serious; but both, as poetic visions of the present, fail to imagine agency for both parties, "secret sharers," as Said put it, in the dangerous and conjoined legacies of orientalism and anti-Semitism.[115]

Lasker-Schüler's presentist definition of the primitive and Grinberg's primitivist definition of the present thus approach each other without meeting. Biographically, the poets overlapped again as well, but never as consequentially as in Berlin in the 1920s. Lasker-Schüler spent the last years of her life in Palestine, where Grinberg also lived, although they seem to have had little to do with one another. They are buried not far from each other on the Mount of Olives in Jerusalem.[116]

Chapter 5

THE AESTHETICS OF JEWISH PRIMITIVISM I
Der Nister's Literary Abstraction

So I walked and walked, on the path and at sunset, which I looked up toward, and from time to time, from one time to the next, found the sun more set and more settled. A minute and two, slowly and more—and the sun already disappeared from the horizon completely. And suddenly . . . and I saw far-far away, facing me, and where the sun set, some kind of small and local animal appeared and illuminating and illuminated it revealed itself and stood still.[1]

These mystifying lines are by the Yiddish writer Der Nister. The repetition, the rhythm, the nonsequiturs are all hallmarks of his willfully obscure style. His pen name signals his resistance to accessibility: Der Nister—the Hidden One. Born Pinkhes Kahanovitsh in Berdichev (then the Russian Empire, now Ukraine) in 1884, Der Nister grew up in a pious household, finding his way, like others of his generation, first to Hebrew and then to Yiddish literature; he also eventually found his way, like so many of his peers, to Berlin in the early 1920s. By that point he had published a number of stories and short books staking his claim to a style typically associated with Russian symbolism. Although this was not a tack taken by many other Yiddish writers, and though his pseudonym makes it clear that he cultivated his status as an outsider, he was nevertheless in the center of the Yiddish avant-garde. By the time he came to Berlin in 1921, he had spent about two years in Kiev associated with the writers and artists of the Kultur-Lige group and had published books with illustrations by the already-famous Marc Chagall and the soon-to-be-famous El Lissitzky. But it was in

Germany that he was to publish the book that made his name and that remains his best-known contribution to the Yiddish canon: the collection of strange, folklore-inspired stories called *Gedakht* (Imagined), published in Berlin in two volumes in 1922 and 1923. Der Nister's avant-garde works culminated in a group of stories written during and just after his German period and published in Kiev in 1929 in a volume titled *Fun mayne giter* (From my estates). These stories all willfully resist interpretation. As Marc Caplan has pointed out, the way to make sense of a story by Der Nister is "by contextualizing the story within the larger body of his fiction, and by returning his work as a whole to an artistic community, a tradition."[2] The context in which I situate Der Nister's works is primitivist visual theory, especially that of the German-Jewish avant-garde theorist Carl Einstein. In the early stories of *Gedakht,* the connection to this context first becomes apparent. Two late stories from *Fun mayne giter* show his fully fledged primitivist aesthetics and their political consequences. Reading his works as literary examples of primitivist visuality reveals that they are only obscure if the standard of interpretation is in reference to measures of literariness such as thematics or style. But while Der Nister's prose was grounded in literary traditions both secular and Jewish, primitivist visual theory afforded him a way to vault over the political pitfalls of this genealogy. Soviet critics castigated him for his enmeshment in what they saw as a reactionary, ethnically particular, bourgeois tradition, because they did not see that his alternative aesthetic paradigm allowed him to use old building blocks for a radically new project. Der Nister's primitivism was based on visuality because it was the most effective—perhaps the only—way to write literature that achieved two interrelated and seemingly unattainable goals: the renunciation of the subject-centered tradition of Western literature and the avoidance of Jewish particularity in texts that remained distinctly Yiddish. The impenetrable obscurity of Der Nister's works is explicable as an aesthetics of paradox: literature built out of and against its precedents, Jewish yet universal, individual yet collective, traditional yet revolutionary, visual yet literary.

This paradoxical project, together with Der Nister's difficult style and convoluted plots, makes his works hard to understand. Critics from his time to the present have taken several tacks. Some have simply registered their confusion, with resignation or frustration. Shmuel Charney, the eminent Yiddish literary critic, wrote in a review of an early work, "After I read it and re-read it, the book remained foreign and wild."[3] Y. L. Peretz could not make sense of his putative disciple; after reviewing some of his works, Peretz angrily wrote to

Der Nister that he could not understand them. Der Nister's response—which he fortunately shared only with a colleague and not with Peretz—was to quote the Hasidic master R. Aron Karliner: "Konst; nor vilst nisht" (You can; you just don't want to).[4]

Critics have situated him in the context of Peretz's folklorism;[5] or Hasidic literature, particularly the stories of Rabbi Nachman of Bratslav;[6] or Russian symbolism;[7] or his politics.[8] These accounts have explained many of the peculiarities of his works, particularly their thematics and symbolism, with exegetical approaches being the most productive, plotting Der Nister's works in the field of symbol and allegory.[9] But they have had less success explaining his formal experimentation, which increased in complexity over the course of this phase of his career. Moving closer to a consideration of structure, Delphine Bechtel astutely documents certain important formal features of Der Nister's works, for example, what she calls "box structure," in which the frame story and the "told story" ultimately merge,[10] "creating an infinite and circular form of narration."[11] But her approach remains focused on an interpretation of the works' content. For example, Bechtel argues that this narratorial merging is a merging of fantasy and reality,[12] which is an interpretation of narrative content rather than form; or is a conflation of the levels of a parable or allegory, that is, of signifier and signified,[13] an approach that also interprets content.

As Dara Horn has argued, despite the scholarly focus on Nister's symbolism and the concomitant efforts to decode the meanings of his stories, "what really captivates and startles the readers of these stories . . . [is] not their symbolism, but their plots."[14] By this, Horn means the elements of the texts that operate over and above those elements that are subject to exegesis or semiosis—form, not content. Following Horn, I will focus in this chapter on explaining Der Nister's form. Doing so will show that his peculiar form is not independent of his stance toward the Soviet Union, or the revolutionary potential of art, or his use of folklore and Hasidism, or his symbolism; rather, it clarifies these elements. Indeed, Der Nister's use of visual principles in the creation of literary texts was his ingenious way of fusing these disparate elements of his agenda: his works managed to be universal and particularly Jewish, revolutionary and connected to tradition.

The connection between the various aspects of Der Nister's work is made through a distinctive primitivism at work in the form of the texts. At first glance, this primitivism seems to be of a more typical variety, restricting itself to matters of content—themes drawn from Jewish, Slavic, and other folk

literatures, as well as the archaicizing rhetoric with which they were conveyed. Such a "soft" primitivism,[15] which amounts to stylization,[16] was shared by other Yiddish writers in the period who also looked to forebears like the early Hasidic master Nachman of Bratslav or the more recent leader of this trend, Peretz. But none of these writers attempted or achieved anything near the formal complexity of Der Nister's works. As already noted, some of the strange features of Der Nister's works would also have been familiar to readers of contemporary Russian literature, specifically the array of styles and techniques called "symbolism."[17] For example, his works reflect the symbolist interest in the supernatural, the occult, and mysticism, as well as folk literature and mythology.[18] Der Nister also deploys aspects of the symbolist approach to language, often emphasizing the sonic over the semantic, including his characteristic repetitions, parallelism, and homophonous neologisms. Indeed, although Der Nister's debt to the Romantic *Kunstmärchen* as well as to Hasidic and Jewish folklore is often cited, his style also strongly reflects the universalizing tendencies of Russian symbolism, specifically by deploying rhetorical techniques that are generically archaic and obscure, evoking "Myth" with a capital M rather than any particular myth.

The concept of ornamental prose, described by Der Nister's contemporary the Russian literary theorist Viktor Shklovsky, is also apt.[19] Shklovsky defined this phenomenon as "a shift in favor of the image," resulting from the "general feeling that the old form has lost its resilience."[20] Ornamental prose deployed a range of rhetorical devices from the familiar to the obscure, including alliteration, various forms of repetition (including that of roots couched in different prefixes and suffixes), and the rhyming of similar grammatical forms.[21] Such rhetorical tactics, among others, are found again and again in Der Nister's stories. Yet for all their self-conscious complexity, a central element of ornamental prose is notably absent in the stories. Shklovsky writes that in ornamentalism we find "the loosening of plot structure" because "imagery prevails over plot." Indeed, in ornamentalist texts, the plot is often elided entirely.[22] But this absence of the narrative element is not a feature of Der Nister's texts. The ornamentalism of his prose can distract from what is actually an abundance of plot: his stories show an obsession with all elements of plot (loosely rather than narratologically defined): narration, structure, and the architecture of a story. Indeed, Der Nister's works contain an abundance of complex structural elements. For example, "Tsum barg" ("To the Mountain") from *Gedakht* is a story narrated in the first person, about a Wanderer, who, under the guidance of an Old Man, sets out from Granny's house to the Mountain. On the way, in the

forest, he meets a Hunter who tells him a tale. Later, in a steppe, he meets a Beg-
gar who tells him a tale. Then by a river he meets a Stork who tells him a tale.
Then, after years of wandering, he comes to a cave where he finds a conclave
of men clad in black robes. He then meets a Fox, an Eagle, a Mole, and a Skull.
None of them tells him a tale, but then he meets a Cuckoo who does. Finally, at
the end of the story, he hears a voice and sees the Cloud Man, who then para-
phrases to him some of the opening lines of the story, describing the Wanderer
in Granny's house. The degree of narrative complexity here goes beyond the
Romantic device of the simple framing narrative. But this does not approach
the complexity of Der Nister's most elaborate structures. In fact, it is relatively
straightforward, consisting of one narrative level that contains an extended se-
quence of horizontally embedded parallel narratives.

The conclusion introduces the greatest complication, fusing the primary
narrative level back to its own beginning, creating a kind of *mise en abyme*, or
endlessly regressing story-within-a-story. As the Wanderer nears the end of his
quest, he finds a scroll and reads it. When he finishes reading it, his experience
of wandering combines with the experience of reading, and he "sees" his own
story: "And just when I finished reading the scroll, a thought occurred to me,
as if from afar, behind me, and seemingly above me, a voice called out to me:
'Wanderer, wanderer.' And when I turned to the voice and to the Cloud Man,
I opened my eyes and *saw*: Quietly and at midnight."[23] And so the first-person
narrator reads, and hears, and sees the beginning of the text in which he finds
himself, puncturing the frame of the story in a way that Mikhail Krutikov notes
is typical of Der Nister's works.[24] The final paragraph is a near quotation of a
portion of the beginning of the story. This quotation is introduced with the line
"and I opened my eyes and I saw." The Wanderer thus *sees* the textual effect of
the narrative turning back on itself; the narrative metalepsis is accomplished
by means of a conflation of visuality and textuality that enables a confounding
textual recursion. It is not only described visually, but the very device—*mise en
abyme*—is by definition visual. Visuality opens up the conceptual possibility
for the formal techniques Der Nister employs. This is the basis of Der Nister's
primitivism: the use of principles of visuality to shape his literary works.[25]

Der Nister's "And"

What makes this primitivist? The dramatic ending of "Tsum barg," conflating
visuality and textuality to effect a complex narrative metalepsis, is a first-order

form of visuality—it describes a process of seeing that features as part of the plot and as an explanation for the narrative structure. In a sense, then, it is superficial. Its superficiality, however, offers an entry point to Der Nister's primitivism. It does this in two ways. First, the question of seeing and perception more broadly is, as we will see, a key issue in primitivist aesthetics. Second, the "surface" of a literary work consists, in a manner of speaking, of its rhetoric, which is the textual element closest to another primary theory of primitivist aesthetics, that of Wilhelm Worringer.

The opening lines of "Tsum barg" cited at the outset of this chapter are a good example of the rhetorical characteristics of Der Nister's works: "So I walked and walked, on the path and at sunset, which I looked up toward, and from time to time, from one time to the next, found the sun more set and more settled. A minute and two, slowly and more."[26] What stands out here is the extreme use of parataxis (many phrases linked together one after the other with little or no subordination) and of polysyndeton (the use of numerous conjunctions). The strangeness of lines like these prompted the first-ever scholarly study of Der Nister, an article by Ayzik Zaretski published in the Kiev Yiddish journal *Shriftn* in 1928. Zaretski, a grammarian, focused on a single rhetorical feature of a single story by Der Nister, indicated by title of his article: "Nisters un" (Nister's "and").[27] Zaretski was also a formalist, so instead of remaining astounded by the abnormally large number of "ands" in the story, he counted them. Zaretski's tally has the word *un* (and) appearing 1,226 times in 53 pages.[28] Moreover, he enumerates every grammatical category to which these "ands" belong and adduces every example from the text for each one. His painstaking, nineteen-page linguistic analysis of this single conjunction, or "coordinate," as he calls it, reaches the following conclusion: "One needs to study the genesis of Nister's unique 'and' and its linguistic and stylistic effects."[29] Zaretski's objective was to elucidate elements of Yiddish grammatical coordination, so this conclusion is sufficient for him. But he also revealed a much deeper insight into Der Nister's work that helps bridge the gap from his rhetoric to his form and from the peculiarities of his texts to the context that informed them. This insight stems from two of Zaretski's categories of conjunction. The first, perspectival coordination, includes the strange asymmetrical coordination (*nisht-simetrishe koordinirung*), which he defines as the coordination of syntagmas of different grammatical classes. Two of his examples from "Tsum barg" are *vayter un tsum vald* (further and to the forest) and *fun zitsn un fun barg* (from sitting and from the mountain).[30] Zaretski also offers an example of paranomastic coordination

(not from Der Nister): *er est fleysh mit apetit un mit khreyn* (he eats meat with appetite and with horseradish).[31] This kind of syntagmatic imbalance is not unique to Der Nister—it is a favored feature, for example, of Russian ornamental prose. A second major category Zaretski discusses is "aperspectival coordination" (*nisht-perspektivishe koordinirung*).[32] He defines this as the coordination of unlike parts of speech; an example from "Tsum barg": *plutsem un derzen hob ikh* (suddenly and I saw).[33] In this category, Zaretski introduces a visual metaphor—perspective. This metaphor illuminates a particular problem he had in describing this feature of Der Nister's prose, which becomes clear in another of his examples of aperspectival coordination: *a tish vos iz in groysn un in mitn kheyder geshtanen* (a table which stood in the large and in the middle of the room).[34] Something is off about this, but not in the relatively straightforward way of the above-cited asymmetrical type of coordination. Zaretski illustrates this new type of coordination with a diagram (figure 5). But introducing his discussion of the diagram he writes, "I find it difficult to schematize this. It ought to be something like this." In the diagram, the word "room" is off-kilter; making it appear, if one translates the diagram into an image, as if the table might slide out of the room. The organizing and descriptive power of linguistics has been disabled, and a visual aid is deployed to illustrate the visual metaphor

FIGURE 5. Grammatical diagram by Ayzik Zaretski. From "Nisters un" [Nister's "and"], *Shriftn* 1 (1928): 143.

of "aperspectival" coordination. For Zaretski the analogy of visual perspective is a powerful tool for understanding Der Nister's rhetoric.

From Formalism to Primitivism

The conflation of visuality and textuality, together with the seemingly ornamental qualities of the polysyndeton and parataxis analyzed by Zaretski, seems to resemble a type of literary abstraction famously identified by Joseph Frank in his 1945 article "On Spatial Form."[35] Frank argued that literary modernism was best understood in reference to the theory of visual art of the German art historian Wilhelm Worringer. Worringer's *Abstraktion und Einfühlung* (*Abstraction and Empathy*, 1908) charted a radically new course in the theory of art that was to be profoundly influential across the avant-gardes, especially in expressionism.[36] Worringer argues that the drive to art—*Kunstwollen*, a term he took from contemporary art-historical debate[37]—is psychological and posited two aesthetic categories that speak to two varieties of psychic need, abstraction and empathy. Empathy reflects a sense of being at ease in the world—indeed, being in the center of the world—and results in art that is mimetic, "the reproduction of organically beautiful vitality," in the tradition of classical antiquity and the Renaissance—Western art, in other words.[38] At the opposite pole is abstraction, which reflects "a great inner unrest inspired in man by the phenomena of the outside world"—a fear endemic to so-called primitive peoples.[39] Worringer, quoting the influential sculptor and theorist Adolf von Hildebrand, wrote of the "agonizing quality of the cubic," which is absent in abstract art because it is flat.[40]

This manifests in the primitive tendency toward abstract design. A concomitant feature of primitive style is its suppression of negative space, a proliferation of ornamentation meant to fill up any surface it occupies. And so Worringer posits—and canonizes—the idea that primitive art (together with the artistic traditions of advanced societies outside the lineage of classical antiquity, such as ancient Egypt and medieval Europe) tends toward abstraction. For Worringer, abstraction is nonmimetic, geometric, lacking depth, and ornamental. Abstraction is thus opposed to the empathy central to Western art, which is characterized by the representation of space through perspective, an illusion premised on a theoretical single viewer, on the centrality of the "contemplating subject."

Joseph Frank's insight was that this influence was not restricted to the visual arts but extended to literature, in which Worringer's theory manifested as "spatial form." Frank explained this transfer by analogy: just as modern art sought to overcome the traditions of representing space, so is modern literature "striving to rival the spatial apprehension of the plastic arts in a moment of time."[41] Neil Donohue explained that this could be achieved by "the turn from the subordination of clauses in sentences of continuous meaning (syntax) to parataxis, the discontinuous arrangements of word and phrase without depth of subordination."[42] We have already seen the importance of this particular rhetorical and syntactical technique for Der Nister. Yet there is something more than a flattening or ornamentalization going on in Der Nister's works. Despite their parataxis, Der Nister's stories are not flat; on the contrary, the conception of space in the stories reflects a sophisticated approach to narratorial form related to the theoretical association of cubism with primitive art.

This particular approach to the issues raised by Worringer, which fleshes out the picture of Der Nister's aesthetics, was offered by their contemporary the theorist and critic Carl Einstein. Einstein developed a primitivist aesthetic theory that applied to both visual art and literature without relying on analogy. Further, while Einstein built on Worringer's identification of abstraction, including primitive art, as an important area of aesthetic analysis, he disclaimed Hildebrand's rejection of the cubic and Worringer's psychological account of this rejection. In its place, Einstein offered a theory of form based on perception, the consequence of which was to be political and which was motivated by a startlingly new understanding of "primitive" art. Einstein's primitivism corresponds most closely to Der Nister's.

The relation of the visual to the textual was a core concern of Einstein's, who was among the first to produce a primitivist aesthetic theory and among the first to attempt to put it into practice. "I've long known that this thing we call 'Cubism' goes far beyond painting," Einstein wrote in a letter to Daniel-Henry Kahnweiler in about 1921.[43] Einstein was a German Jewish art historian and theorist who was one of the earliest champions and explicators of cubism. Kahnweiler was a German Jewish art dealer in Paris and the other principal expositor of cubism. At first glance, Einstein's claim makes little sense: cubism was an artistic movement begun by painters and developed by painters. Yet Einstein maintains that it must be transferable from one artistic realm to another. He went on: "I've long known that not only is a reformation of sight possible and

thereby of the effect of movement, but a reformation of the verbal equivalent is also possible."[44] The "thing" called cubism is a process of reformation; the reformation of sight occurs, naturally, in painting; accordingly literature should accommodate the reformation of the "verbal equivalent." And yet: "The literati limp along after painting and science, whining with their lyric and their little hints of film. . . . The literati think they're very modern, since they write about automobiles or airplanes instead of violets."[45] The problem is that the verbal equivalent of the reformation of sight is not at all obvious. It must start, Einstein posits, with the effort to express "events as experiences of time . . . not to paint [*malen*] them like most writers."[46]

So what would this look like in literature? In the letter to Kahnweiler, Einstein laconically (and flippantly) offered a handful of features such a text might have: "the loss of language; or the dissolution of an individual; or the disunification of the sense of time." "Simple themes," he concludes sardonically.[47] He claimed to have attempted these techniques in his short prose work *Bebuquin oder die Dilettanten des Wunders* (*Bebuquin or the Dilettantes of the Miracle*), published in 1907 and 1912 after he encountered cubism in Paris. In *Bebuquin* Einstein attempts these effects through a disjunctive narrative, gnomic utterances, and an embrace of paradox. "I am a mirror. . . . But has a mirror ever mirrored itself?" says Bebuquin, the protagonist and Einstein's alter ego.[48] Shortly thereafter Nebukadnezar—another character—examines the breasts of Euphemia, the third member of this strange group: "A mirror was hanging over him. He saw how her bosom divided and exploded in multiple strange forms in the finely polished precious stones of his head, in forms which no reality had previously shown him. The chased silver broke up and refined the sparkle of the shapes."[49] The chased silver refers to Nebukadnezar's skull. This passage describes striking visual effects including optical fragmentation and the deformation of shapes. But the form of the text, despite complications in chronology and other such effects, still reflected an attempt that was made, as Einstein admitted to Kahnweiler, "uncertainly and tentatively."[50]

Another effort was an anthology Einstein published in 1925 titled *Afrikanische Legenden* (African legends), based on French translations of various African sources. Yet the structure of the tales in this book more closely resembles the fairy tales of the Brothers Grimm than something like *Bebuquin*.[51] What made *Bebuquin* insufficient by its author's own estimation, and why in *Afrikanische Legenden* did he settle for traditional forms close to the source material? In short, it was difficult to do in literature what the reception of African

art had seemingly prompted in the visual arts. A visual artist who sought "primitive" inspiration for a painting could look at all the recently expropriated works of primitive art and material culture rapidly filling the ethnographic museums and private collections across Europe. But a similarly inclined writer would have a problem: not speaking any "primitive" languages, he would have to turn to translations, denuded of formal, linguistic, and cultural particularity by their interpreters and translators. Without access to the original text, how could a writer possibly emulate its primitive features?

Einstein identified a further problem. He argued that a key component of the formal workings of cubist painting was something called *simultané*,[52] or the "concentration of intersecting visual experiences."[53] *Simultané* is also found in myth and folklore: in a fable, for example, "the events . . . are given to us as if simultaneous; it is only that language is unable to convey them in one breath."[54] But if fable—which *did* possess this main feature of cubism—was inhibited by the restrictions of language, how could Einstein have claimed that a "reformation of the verbal" was possible? What did he mean by "the loss of language; or the dissolution of an individual; or the disunification of the sense of time," as he put it to Kahnweiler?

Einstein derived his claims about literature from his early visual theory, systematically if concentratedly elaborated in his 1915 book *Negerplastik* (*Negro Sculpture*), which offered a primitivist aesthetics flexible enough to be applied to literature. This short book—the first Western art-historical treatment of African art—promotes African sculpture as an antidote to the subject-centered pictorial illusionism of Western art. The book combines a short essay on African sculpture with 119 photographs. In essence, it was an inventive justification and explication of cubism based on an interpretation of African sculpture in which Einstein saw the same processes that were at work in the first phase of cubist painting. So while the book was ostensibly about African sculpture, it was also a theory of primitivist aesthetics. One of Einstein's main innovations in this work is his explanation of the organization of spatial elements in the sculptures: "Negro sculptures are marked by a pronounced individuation of their component parts; . . . the parts are oriented, not according to the beholder's point of view, but from within themselves."[55] The purpose of this reorganization is to eliminate what Einstein calls the "temporal function."[56] He writes, "The intuition of space evinced by this kind of work must totally absorb cubic space and express it in a unified way; perspective or the customary frontality are prohibited here. . . . The work of art must present the entire spatial equation;

for it is timeless only when it excludes a temporal interpretation based on kinesthetic mental images. It absorbs time by integrating into its form what we experience as movement."[57] What he means by the temporal function is the time it takes to move around a sculpture in order to see it all. African sculpture absorbs time because it absorbs space—it removes the need for movement. The equation of space and time is crucial for the transfer from visual theory to textual practice. It is important to note, however, that for Einstein removing the temporal function does not mean representing something frontally, which is an arrangement of "the foremost parts according to a single viewpoint," that is, traditional perspectival representation.[58] This "optical naturalism of Western art is not the imitation of external nature; the nature that it passively imitates is merely the vantage point of the viewer."[59] In African sculpture, by contrast, "the three-dimensionally situated parts must be represented simultaneously, which means that the dispersed space must be integrated into a single field of vision."[60]

There is more to this dense text, but the salient points are as follows. First, rather than representing a fixed image, African sculpture represents the *process of viewing*—a process in part physiological and in part cognitive. The dominant understanding of the visual fragmentation which characterized cubism and was thought to be found in so-called primitive art had been advanced by Kahnweiler in his short book *Der Weg zum Kubismus* (*The Rise of Cubism*, 1920). Kahnweiler famously argued that visual fragmentation was reassembled in the mind of the spectator in a process akin to the Kantian synthesis, thus solving the problem of what he called the "the piercing of the closed form" (*Durchbrechung der geschlossenen Form*).[61] Einstein insisted that achieving coherence is beside the point; the point is the experience of viewing itself, which produces its own kind of nonmimetic reality. Second, for Einstein the obviation of mimetic representation led to the rejection of what he regarded as the chief culprit in the illusionistic sham of Western pictoriality, namely, perspective. Third, the absorption of space involves the absorption of time by eliminating the need to move—through space and through time—around the sculpture. This means that the removal of perspective is reflected in the simultaneity suggested by the fragmentation and reintegration of the parts of African sculpture.

The Politics of Form

The "reformation of vision" extends far beyond painting not only as an epistemological or aesthetic matter but also because it is political. In fact, politics is

arguably the overarching agenda of Einstein's aesthetics. In short, the revolutionary effect of African sculpture is the destabilizing of the viewing subject, or as Einstein writes toward the end of *Negerplastik*, "all individuality is annihilated."[62] By annihilating the way that Western artworks fix their viewers in place, African sculpture creates a different kind of subjectivity.

This political aspect became the lever for Einstein's reformation of literature, which he came closest to in a sequel of sorts to *Bebuquin* called *Beb II*. As noted above, Einstein stated that his work *Bebuquin* attempted the following literary equivalents of the visual principles of cubism: the loss of language (which corresponds in the visual realm to the rejection of mimetic representation); the dissolution of the individual (the obviation of the stable viewing subject); and the disunification of the sense of time (the emphasis on the process of perception).[63] While Einstein himself admitted that *Bebuquin* was an insufficient expression of these principles, he came closer to fulfilling both the formal and the political promise of his primitivist aesthetics in *Beb II*, which he worked on throughout the 1920s and is preserved in his archives. Devin Fore argues that the structure of this text was modeled on Einstein's conception of myth, which he believed possessed "a circular temporal structure" akin to his description of fable.[64] Fore goes on to note that *Beb II* "overlays temporal strata on top of one another,"[65] as, for example, when the main character is murdered as a child and later on commits suicide.[66] This follows what Einstein wrote elsewhere, namely, that a "concatenation of words must fuse together contrasting temporal strata," and "the end overtakes the beginning."[67] The result of all of this temporal complication is what Fore calls "a necrologue of the ego"; the text achieves the goal that Einstein articulated in *Negerplastik*—the annihilation of individuality. With the elimination of individuality, the ground is cleared for revolutionary new forms of subjectivity and social organization.

This political goal was central to revolutionary aesthetics more broadly, not just Einstein's primitivism. The political valence of the destabilization of Western visuality is illuminated in a celebrated essay by El Lissitzky, who is also the biographical link between Einstein and Der Nister. The essay, titled "K. und Pangeometrie" ("A. and Pangeometry"—"K." is "Kunst" and "A." is "Art"), was published in 1925 in a volume edited by Carl Einstein.[68] By the early 1920s, Lissitzky had renounced visual figuration, but just a few years earlier he was illustrating Yiddish books, including one by Der Nister, and was centrally involved in the Yiddish avant-garde.[69] In his essay, Lissitzky articulates an artistic path forward five years after the Russian Revolution had "ripped A. off

FIGURE 6. El Lissitzky, diagram of planimetric space from his article "K. und Pangeometrie" (A. and pangeometry), in *Europa Almanach*, edited by Carl Einstein and Paul Westheim (Potsdam: Gustav Kiepenheuer Verlag [1924]), 104.

its sacred throne."[70] He enumerates various alternatives to Western perspective from around the world and throughout history, with a focus on archaic forms of perspective. The different kinds of perspective Lissitzky describes— for example, planimetric space (figure 6), recognizable from ancient Assyrian wall carving—are exemplified, he notes, by the suprematist transformation of space into relations of shapes and colors, as in his own "prouns" from the early 1920s. The rejection of traditional perspective, concludes Lissitzky, leads to "an a-material materiality."[71]

Both Lissitzky's objective—destroying the privileged position of the Western subject by taking art "off its sacred throne"—and the use of visual art to clear the way for an aesthetics uncoupled from the materiality that is the very basis of visual art, indicate that his project was not meant to be limited to painting, say, or sculpture. This aesthetics was not dependent on visuality, though it was derived from it; its foundational concern was a reconfiguration of representation that was independent of medium, even if it needed to be expressed in a medium and even if its most obvious media were visual. The goal of this primitivist rejection of Western aesthetic principles, whether visual or narrative, was revolution. As Einstein wrote in the essay "Zur primitiven Kunst" ("On Primitive Art"), "Primitive art: rejection of the capitalized art tradition. European

mediatedness and tradition must be destroyed, there must be an end to formalist fictions. If we explode the ideology of capitalism, we will find beneath it the sole valuable remnant of this shattered continent, the precondition for everything new, the simple masses, who are today still burdened by suffering. It is they who are the artist."[72] Restoring art to the masses required first annihilating the individual and the myth of individual creativity. Der Nister would take up all three challenges of Einstein's primitivism: (1) the transfer of visual principles to literature, (2) the destabilization of aesthetic norms, and (3) the fracturing of the "I." That his works also drew on Hasidic and other Ashkenazic traditions in the model of Peretz but were motivated by an altogether different type of primitivism meant that he was able to leap beyond the lingering exoticism and Herderian folklorism of Peretz and his followers. Der Nister's folkloric thematics promoted very different aesthetics and politics.

Situating Der Nister's works in the ideological landscape of avant-garde primitivism clarifies the relation of his stories to his politics, which has been seen as something of a mystery. After his return to the Soviet Union, his works were the subject of a critical debate about the matter of "Nisterism" and its politics.[73] His works were accused of being apolitical or, worse, reactionary; his defenders tried to portray his work as a bridge between the Jewish avant-garde and acceptable forms of Soviet literature. Among scholars there is no consensus on how to situate Der Nister's works politically. Khone Shmeruk discerned anti-Soviet critique in his work.[74] David Roskies has identified an evolving politics in Der Nister, ranging from an idiosyncratic utopianism interwoven in his symbolism to a contrite submission to Soviet aesthetics, with a measure of critique interspersed. Yet Roskies ultimately sees Der Nister's symbolism as irreconcilable with revolutionary politics, let alone the conviction with which Der Nister seems to have held such beliefs, evidenced by his return to the Soviet Union and the obvious political allegiance it signified.[75] By contrast, as Daniela Mantovan has shown, it is entirely possible to read Der Nister's symbolist works, especially the story "Nay-gast" from 1920, as expressing a mystical utopianism in sympathy with revolutionary ideals.[76] Nevertheless, his convictions, argues Mantovan, peter out in the last stories in *Fun mayne giter*, with the two stories first published in that collection—both stories that feature a character named Der Nister—evincing political ambivalence shading into critique.[77]

The strong tendency to claim an ambivalent politics for Der Nister seems to have two primary causes. First, his eventual conversion to socialist realism, as he poignantly put it in a letter to his brother, was "not a matter of technique"

but of turning "one's soul inside out."[78] This would seem to indicate not only an aesthetic conversion but also a political one—reluctant and belabored at that. Secondly, the overidentification of Der Nister with symbolism and the concomitant view of symbolism as at least apolitical and at most reactionary has generated the idea that Der Nister himself was apolitical and that his symbolist works certainly were.

Yet as I have shown, part of the ideological landscape of primitivist aesthetics could be inherently (if not necessarily overtly) revolutionary.[79] The political aspect of Der Nister's "symbolist" works becomes legible once we cease to search for it by decoding the meaning of his stories and instead pay attention to the questions of form, of space, and of vision that constituted primitivist aesthetics. Mantovan correctly identifies the "complete annihilation of human individuality" as the heart of Der Nister's late story "Mayse mit a lets" (A tale of an imp); she reads this as a form of social critique, aimed at the deleterious aspects of revolutionary collectivism.[80] Der Nister's annihilation of individuality should also be read as an aesthetic argument. In this light, his politics emerge secondarily but confidently: the narrative techniques used to deconstruct individualistic subjectivity do so by creating plural, collective forms of description and narration. This destabilization of both meaning and subjectivity is buttressed by what Delphine Bechtel identifies as a horizontality of meaning, that is, the interchangeability of signifier and signified in the late stories.[81] In this light, Der Nister's annihilation of individuality—Mantovan's phrase so suggestively echoing Carl Einstein—is primitivist and revolutionary. As with Einstein's primitivist aesthetics, the consequences are far-reaching; breaking down the individual's centrality clears the way for collectivity.

Der Nister's "I"

Der Nister's primitivism addresses the ego, so its most striking manifestations are found in his only two stories that feature a first-person narrator, both from the collection *Fun mayne giter* from 1929 and not previously published. These two late stories, "Fun mayne giter" ("From my Estates," which gives the collection its title) and "A mayse mit a lets, mit a moyz, un mit dem Nister aleyn" (A tale of an imp, a mouse, and Der Nister himself), mark the culmination of Der Nister's primitivism. The early stories, published in the collection *Gedakht* (1922–23, revised and reprinted 1929), mimic the features conventionally ascribed to primitive art. For example, "Tsum barg," from 1913, one of the earliest

stories in *Gedakht*, is characterized by extreme rhetorical manipulation, featuring parataxis, polysyndeton, pleonasm, and alliteration, all of which are associated with contemporary conceptions of myth and primitive literature and are also features of what Shklovsky called "ornamental prose." The formal features of "Tsum barg" are less extreme though still complicated: a proliferation of embedded tales, which contributes to a structurally ornamental effect, is enclosed by what seems to be an open-ended frame, where the end nevertheless circles back and fuses with the beginning, by means of *mise en abyme*. *Fun mayne giter* is less a break from than an intensification of the earlier collection. The introduction of stories that identify Der Nister by name as a character (in two out of the collection's six stories) and the formal complications that intersect with the first-person narrator mark the most significant change from the earlier to the later works.[82] In these two stories, Der Nister has found a way to generate the instability of authorial authority as part of the structure of the work, not merely described by it.

Raphael Koenig describes Der Nister's innovation in the story "Fun mayne giter" as the creation of an "unreliable author," which results in "deauthorization."[83] Koenig, echoing Mantovan, interprets this as a response to the attacks on Der Nister and his works by the Soviet critics.[84] Despite pointing to its origin beyond the text, Koenig nevertheless does not pin down the purpose of this new category outside the text. He leaves open a number of possibilities, that "Der Nister might merely be hinting at his dire fate in the Soviet Union" or that he might imply "a form of redemption."[85] Mantovan also associates the fate of the author figure in the story as a commentary on the dangers of "Soviet power."[86] These are compelling readings. But there is also a firmer, more thoroughly realized critique at work in Der Nister's deployment of the ego narrator, uncoupled from the superficial (if correct) opposition of the first-person narrator to stand-ins for the Soviet Union: the confusion of narratorial authority and the resultant destabilization of subjectivity appear more distinctly part of Der Nister's revolutionary aesthetic program.

The story "Fun mayne giter" begins and ends with a straightforward frame: a first-person narrator describes being hit in the head with a pat of mud that turns out also to be a coin; now with money to spend, he visits a book fair, where he finds a book titled "Shriftn fun a duln" (The writings of a madman) by Der Nister.[87] The remainder of the story, until the frame closes it, consists of a description of the story of this book. The frame may be straightforward, but it introduces an already dizzying complication: the story "Fun mayne giter" is

written by Der Nister; it features a first-person narrator who describes a book by Der Nister. Three separate authorial identities are thus muddled within a few lines. The narrative inside the frame introduces narratorial and plot complications that are even more confusing. The first-person narrator begins his description as follows: "I turned the pages, and the book begins."[88] As in "Tsum barg," which ends with the hero reading his own story from a scroll, the act of reading is the crux of the story—here it activates the narrative. The narrator then introduces an initial embedded narrative, which describes Der Nister's interactions with a group of ten ravenous bears who have taken up residence in his home, have eaten all his food, and demanding more, have eaten his fingers and are about to eat his heart.[89] Facing his seemingly inevitable death, Der Nister asks the bears if he might use his last moments to tell of his riches. There begins the secondary embedded narrative, which features several inversions of narrative and fusions to other narrative levels. First is a series of narrative metalepses by reference to the piece of mud, which was also gold, that the first-person narrator of the frame finds in the story's first sentence. Der Nister describes finding the mud/gold on his own forehead twice in the secondary embedded narrative. The second mention of the mud/gold is preceded by the introduction of the bears from the primary embedded narrative. The secondary narrative thus begins turning around and making its way toward the primary level. This process follows narrative logic, although the metaleptic reference to the mud/gold points beyond the story's frame. As we approach the fusion of the second level with the first, the narrator (Der Nister) describes being incarcerated in a madhouse, where he was beaten but found fellowship with two other inmates. He begins to tell them the story of his riches. This means that the narrative is now doubled: the same story is being addressed to the bears of the primary narrative and the fellow inmates of the secondary narrative. At that point, Der Nister describes how he was beaten, and "because of those blows my head is now empty; and in my head I walk around."[90] It is in the space of his own head (a space which is both metaphorical and literal) that the remainder of the now-doubled narrative occurs. The logic of the narrative flow toward the first level, already complicated, is disrupted, because the events are now described as occurring inside Der Nister's head. In other words, the primary narrative relates how Der Nister encountered ten bears demanding food and how in order to forestall his death he told them what brought him to that point. In the secondary narrative, Der Nister describes meeting fellow inmates in the madhouse and how he told them what had brought him to that point. At this

point, as he is about to narrate the entry (or reentry) of the ten bears, Der Nister describes how the events now take place inside his head. This is all confusing and essentially impossible to keep track of. The primary source of confusion is the doubled "backstory" of Der Nister's riches, moving toward the encounter with the bears: we now have a *mise en abyme* layered on the very same *mise en abyme*. But it is not a straightforward *mise en abyme*, which would simply repeat the same story, setting off the same story each time, endlessly recurring. What happens next is that the chronologies of the narrative levels fuse: the events that Der Nister is describing to the bears contain his description to his fellow inmates of what he describes to the bears, all of which are now told in the present tense, erasing temporal differentiation. Der Nister is describing how his fellow inmates brought him goods to give the bears: "And I gave them to you (if you recall, bears) . . . and you went away and afterwards you came back again. And once again we then gathered on my bed, and I again told my bedfellows how the bears have become frequent guests."[91] The embedded narratives catch up to the beginning of the primary embedded level as Der Nister tells the bears how they ate his fingers. The first-person narrator of the frame then returns and indirectly narrates the remainder of the story (while the preceding had been quoted by the narrator). The narrator describes how the bears forgave Der Nister and allowed him to live, and how he returned to the madhouse and finished telling his fellow inmates what had happened. They advised him to write down the entire story, which the narrator confirms he did.

In this summary I have focused on the narrative and temporal complications rather than the thematic elements of the story or even the events of the plot. This is because the complications of the text are, in fact, its primary feature, and all other elements, while offering details that might buttress one or another interpretation, are superfluous. Der Nister's accomplishment in this text is its remarkable and carefully constructed confusion. Deciphering it is not possible, since, as Bechtel points out, there is no classically constructed meaning here, allegorical or otherwise. What is at stake is the process of reading, a process that is modeled by the story itself, since the narrator of the frame is describing what he reads. And what the process of reading, which should enable the exploration of hermeneutic possibilities, creates is a tangle of temporal levels and plotlines. All of this forces perception to become deautomatized, in Shklovsky's terms. Another way of understanding Der Nister's objective here is through the subtitle of Lissitzky's article on pangeometry: "Seeing is another A.," (i.e., another type of art). Lissitzky's point—that the process of visual perception is just as

significant as the creation of meaning, is of course central to Carl Einstein's aesthetics. Setting aside interpretation in favor of the experience of perceiving the artwork, or the text, is, according to Einstein, the main lesson that "primitive" art has to teach European art. That experience, in the case of "Fun mayne giter," cannot be organized around the core features of modern literature: the single narrator grounded in a stable subjectivity.

Der Nister's other story from the collection featuring a character named "Der Nister" takes this set of techniques and its larger point even further. What he achieves in "A mayse mit a lets, mit a moyz, un mit dem Nister aleyn" is ultimately the disassembly of the author, the narrator, and the hero through their proliferation. As in "Fun mayne giter," this story achieves its formal complexity through a series of subtle shifts that amount to a narratorial structure that is difficult to determine and just as hard to describe. This is, of course, the point.

Der Nister (the character) acquires the pelt of an imp (a kind of demon) for a coat and is infected with a debilitating and life-threatening disease by an insect inhabiting the pelt. A doctor tells him he can only be cured by reuniting the pelt with the imp it came from. Surveying the charnel ground in search of the requisite imp bones, he is aided by a mouse who had formed a romantic bond with the imp. Der Nister restores the pelt to the correct bones, whereupon the imp is made whole again. The imp and the mouse then proceed to get married; for entertainment at the wedding, Der Nister, again hale and hearty, tells a tale—a story about Der Nister himself. All this takes place in the first three pages. The remainder of the text consists of the tale that Der Nister tells. Interestingly, although these first pages—the frame narrative—are told in the third person, there is no switch once Der Nister's embedded tale begins. The narration continues in the third person; in the first few lines this is accomplished through indirect speech, meaning that Der Nister's voice is approximated even as the third-person perspective is maintained. But the text slides promptly into quoted speech, assuming the typical contour of third-person omniscient narration. At first, this poses no problems. We are told how Der Nister travels to a city of glass people and teaches them to become flesh; how their newfound fleshiness and excess fattiness caused a mouse infestation and how they therefore wanted revenge against Der Nister; and how Der Nister was saved by the arrival of a mouse-catcher. So far, so good. But here begin the complications. The narrator intrudes to say that the mouse-catcher departed, because "staying there any longer made no sense, since the story would repeat itself again and again: mouse-catcher, mice, fat, and Nister; Nister, fat, mice and

mouse-catcher."[92] Note that this is not a direct repetition but a mirror image: mouse-catcher, mice, fat, and Nister; Nister, fat, mice, and mouse-catcher. But the departure of the mouse-catcher precipitates exactly that: the development of the story as a kind of fun-house mirror image of the first part of the story— generally inverted but containing disorienting disfiguration. Moreover, at this point the narration enters the realm of the impossible: we are still in the story Der Nister is telling at the wedding, but the narration now describes events at which Der Nister was not present. This impossibility is justified by the narrator once again in terms of the demands of storytelling: if the mouse-catcher's story had not proceeded, "we would not have had anything more to tell, and the story would have had to be cut off here, right in the middle."[93] The story then continues with the mouse-catcher until the narrator says that he cannot continue with the story of the mouse-catcher, "because there would not be enough paper or ink, and I only want to tell about Der Nister himself [*vegn dem Nister aleyn*]."[94] Remember that the story is meant to be told by Der Nister; here we finally seem to have a full disconnection of the narratorial voice from Der Nister's presumed voice.

And here, about halfway through the text's pages, we are given its proper beginning, learning how it is Der Nister became ill from a bug bite: a man on a star throws a coin to Der Nister, who uses it to buy an imp pelt for a coat. But when he begins to scratch and be tortured by his illness, "he saw his life backwards, in the reverse . . . direction."[95] What then proceeds is an inverted version of the first story: Nister and his donkey travel to a city of fleshy people and teach them to become glass people, devoid of fat. The difference between this and the first version is that this one is described as something Der Nister "saw." It is in this vision that the narration reverses course and mirrors itself, continuing in this vein until he and his donkey are again pelted with stones, at which point the text again notes that Der Nister *sees* the entire story proceeding backwards.[96] And then Der Nister "sees" (*derzen*) the beginning of the story again—the man on the star throwing him a coin. After he envisions all of this, he suddenly sees the insect that bit him, goes to a doctor who tells him the cure, and effects the cure. And so the structural and plot inflection points, the places where the narrative fragments, are marked by the verb "to see." The narrative metalepsis of the end of "Tsum barg" is also accomplished by means of a conflation of visuality and textuality, as the main character "sees" a quotation from the beginning of his story. It is visuality that determines, for Der Nister, the formal possibilities of his works.

The ending of "Mayse mit a lets" brings us back to the wedding at the beginning of the text, where Der Nister was telling his tale:

> and Der Nister was healthy again . . . , and
>> Mazl tov, and good fortune for all your days!
> And in thanks and for a wedding present I give you my insect . . . and again!
>> Mazl tov, and good fortune for all your days![97]

As the story ends, the narratorial voice returns to Der Nister and becomes, for the first time, first person. A measure of narratorial wholeness is achieved in the wake of the marital union of the mouse and the imp, the reunion of the imp bones with his fur, and Der Nister's own recuperation. A happy ending, in some ways. Yet in the wake of all the various forms of authorial and narrative metalepsis and inverted storylines, the gesture toward a proper resolution is strikingly ironic. It is just as destabilizing as the preceding pages of active narrative confusion. The closed form has been pierced, and as Einstein argued, it is not to be put back together again. The process of breaking apart and reconfiguring form and space (or in the case of literature, form and time) is a process of destabilizing the narrating—and the reading—subject. By amalgamating narratorial voices and eliding differences in perspective, Der Nister suggests that a unitary narrator named Der Nister does not and cannot exist.

I have described how the formal complications at work in Der Nister's stories reflect a primitivist understanding of visual and literary form. The form of his works, as much as the rhetorical tricks and thematic topoi, are related to avant-garde approaches to ethnographic and folkloric sources. What he produces is not *iberdikhtung*—a stylization of myth or folklore that remains fully in the grasp of the author. In Der Nister's folkloric stories, narration exceeds authorial control even as it is indisputably a product of authorial invention.

Jewish Primitivism

As I have shown by connecting Der Nister's aesthetics to Carl Einstein's, this is primitivism in general. But it is also Jewish primitivism. Only by starting from the ground floor—to use Peretz's term—of the folkloric tradition that Peretz had placed at the center of modern Yiddish literature could Der Nister climb away from it. In the 1921 Yiddish manifesto *Skulptur*, the sculptor Yoysef Tshaykov voiced a critique of primitivism that reveals by contrast just what

Der Nister accomplished.[98] Describing the recent accomplishments of Jewish avant-garde sculptors, he asked what connection their innovations—relating to abstraction, the depiction of masses in space, the interrelations of pictorial planes, and so on—might have to Jewish art of the past. His answer? There is no connection. Jews have no tradition of sculpture. Therefore there can be no Jewish sculpture. The Jewish sculptor is thus fortunate to have unfettered access to the range of developments in the plastic arts from futurism to cubism to constructivism. But one of these major trends troubles Tshaykov, and that is primitivism. He ends his manifesto with the following admonishment of a futile search for a usable past: "We consider the approach of the young artists of the left incorrect. They wish to solve the problem by recourse to the archive of our past and our folk-primitive style. This leads to stylization, and stylization to aestheticization; that is, a lie given the present circumstances and a capricious individualism in service of beauty." Although his disdain for primitivist "stylization" seems absolute, Tshaykov did admit, even if unwittingly, that the situation was not quite so simple. A few pages earlier, describing the achievements of the various schools of the avant-garde, Tshaykov notes the debt owed by cubism to African art.[99] If cubism is permitted, as it were, to draw on African art, then Tshaykov's refusal to admit that kind of relationship in the realm of Jewish art must be purposeful. His refusal to admit primitivism in Jewish art despite its presence at the heart of so much of the art he admires reveals his ideological stance: revolution, universality, the future, and abstraction were on one side; reaction, particularity, history, and figuration on the other. The masses on one side, the folk on the other. But Der Nister's stories show that Tshaykov's analysis is not quite correct, at least not regarding literature. Der Nister managed to encompass both universality and particularity, tradition and revolution, by structuring his literature visually.

The formal complexity of Der Nister's works takes up the challenge that Carl Einstein showed primitive art could pose to the subject-centered traditions—both literary and visual—of Western representation. If, in "Mayse mit a lets," it is difficult to locate the narrator in the chronology of the work; if it is challenging to distinguish the narrator's Der Nister and Der Nister the narrator, and indeed Der Nister the author, then we have identified a crucial step in the conversion from "I" to "we" and have identified the place where the Jewish folk and the universal masses overlap. Der Nister's answer to the struggle between particularity and universality, between Jewishness and whatever the alternatives were, was not "or" but "and."

Chapter 6

THE AESTHETICS OF JEWISH PRIMITIVISM II
Moyshe Vorobeichic's Avant-Garde Photography

In a 1923 article on El Lissitzky in the Hebrew and Yiddish journal *Milgroym*, the artist Henryk Berlewi dismissed the Jewish folk motifs that had character-ized Lissitzky's earliest works (mostly illustrations for Yiddish books).[1] Berlewi wrote that Lissitzky had moved beyond "Chagallism."[2] What was Chagallism? Berlewi did not say much beyond the remark that Lissitzky was able to over-come such "sentimentalism" thanks to his "analytical skills."[3] In a later article on Lissitzky, Berlewi wrote how just two years earlier, in 1921, he and Lissitzky had been in thrall to An-sky's *Der dibek*, which had played to great acclaim in Warsaw. "In every corner [of his studio] vibrated the distant echo of the *Dyb-buk*."[4] We can see Berlewi's association of the sentimentality of Chagallism with An-sky's play in his 1921 lithograph *Khonen and Leah*, a Chagallist depiction of the two main characters of *Der dibek* (figure 7). Berlewi's cavalier dismissal of Chagall so soon after he himself had left Chagall's shadow and abandoned both figuration and Jewish subjects was meant to clearly realign his allegiances.

Berlewi was not alone in associating Chagall and An-sky; the German-Jewish writer Arnold Zweig did the same in a review of a Hebrew-language production of *Der dibek* by the theater company Habimah. Zweig wrote that the characters "climbed up out of Chagall's pictures, painted like the masks of savage peoples, in costumes that looked like a fantasy of the clothing, paint-ing, and the magical implements of South Seas Islanders all at once."[5] Nor was Berlewi alone in pointing to Chagall as the figurehead, or perhaps the keyword, of an aesthetic. A more admiring assessment from the same period fleshes out

FIGURE 7. Henryk Berlewi, *Khonen and Leah*, 1921. From the collection of the
E. Ringelblum Jewish Historical Institute, Warsaw.

the picture of Chagallism. In the essay "Di vegn fun der yidisher moleray" (The
paths of Jewish painting), Yisokher Ber Ryback and Boris Aronson call Chagall
"the first with the right to bear the name 'Jewish artist.'"[6] This was because,
they wrote, "of all Jewish artists, Chagall is the only one who has understood,
appreciated, and in part creatively transformed [*ibergedikhtet*] Jewish plastic
folk-art [*yidisher plastisher folks-form*]."[7] Earlier in the text they had described
the "Jewish characteristics" of Chagall's work as being in part the "simplicity of

form and primitiveness of his approach."[8] But if this was primitivism, the keyword is *iberdikhtung*, a word Ryback and Aronson import from literary criticism to describe Chagall's innovation. In my discussion of Peretz in Chapter 1, I showed how *iberdikhtung* encapsulates the Romantic aesthetic of folklorism and its continuation into modernism. Ryback and Aronson—both artists, and both Chagallists—thus put Chagall directly in Peretz's shadow, associating his art with Peretz's folklorism. Although they describe him as a primitivist, what they are actually describing, in the terms I clarified in Chapter 1, is a type of folklorism. Even if they take the same object, folklorism and primitivism are distinguished by their stance toward that object. Folklorism wishes to assimilate it to the dominant Western aesthetic; primitivism criticizes such a process of assimilation, seeking instead a synthesis in search of something different from the dominant aesthetic vernacular. In this light, the comparison between Chagall and Peretz is apt. Like Peretz, Chagall's influence was enormous—he was instrumental in introducing Jewish folk-culture as a source for Jewish modernism. But, again like Peretz, while his innovations found wide appreciation, they also ran counter to avant-garde approaches to aesthetics and identity. This meant that the critique Chagall faced was related to the one to which Peretz was subjected, which is clear from the way Ryback and Aronson apply the literary term *iberdikhtung* to Chagall's painting. In the context of the visual arts, the critique was most clearly articulated by the sculptor Yoysef Tshaykov, who wrote: "We consider the approach of the young artists of the left incorrect. They wish to solve the problem by recourse to the archive of our past and our folk-primitive style. This leads to stylization, and stylization to aestheticization; that is, a lie given the present circumstances and a capricious individualism in service of beauty."[9] In 1919, Ryback and Aronson wrote admiringly of Chagall's *iberdikhtung*; in 1921, Tshaykov attacked such work as stylization; by 1923, Berlewi could succinctly dismiss it as Chagallism. While Chagall took the brunt of the criticism in the visual arts, An-sky played the same part for literature, and the two were tied together as focal points of a broader critique.

This does not mean that Chagallism had died out. Chagall himself made a career of it until his death. But the allure of working in the idiom Chagall was credited with inventing was so powerful that most eastern European Jewish artists of the period tried their hand at it. And this includes El Lissitzky, the master of pure abstraction. The talented artists who worked in the idiom of Chagallism never achieved the level of recognition of those two masters. But from Ryback to Yankl Adler, and even Berlewi himself—the impact of Chagallism

was deep. At the end of Chapter 1, I described Peretz's folklorism as a catalyst for Jewish primitivism by virtue of the critical reaction it engendered. Chagall did not prompt a similar response in art; the generation that followed him did not consist of critics seeking to transform or move beyond his innovations but of epigones seeking to replicate them. In fact, in the visual arts more broadly, there is (to my knowledge) only one example of Jewish primitivism of the kind I have described in this book, and that is a 1931 photobook by the photographer Moyshe Vorobeichic, the subject of this chapter.

The situation among contemporary Jewish photographers was, if anything, even more conservative, at least regarding the portrayal of "Jewishness." Two of the best-known photographers of European Jews in the period exemplify this trend, Alter Kacyzne and Roman Vishniac. Both can be said to have produced a kind of Chagallism in photography, but without any of Chagall's modernist techniques or interests. Kacyzne was a prominent Polish Yiddish writer but earned a living running a successful photographic portrait studio. In the 1920s, he was the European photographic correspondent for the *Forverts*, a Yiddish daily newspaper in New York. Around seven hundred of his negatives and prints for this long-term series have been preserved. His range of subjects is fairly broad but is marked by the valorization of poverty and the adulation of traditional religious belief and practice that is closest to literary folklorism in its assimilation of a subject to a preexisting dominant visual language. A 1927 portrait of Moyshe Pinchuk, a synagogue attendant, is typical (figure 8). The old Jew sports the *goles ponem*, a face marked by two thousand years of exile; he looks up from his sacred text with shining eyes, a result, presumably, of his pious and noble sorrow.

Roman Vishniac's photographs work much the same way. The iconic portrait from the cover of his 1947 book *Polish Jews: A Pictorial Record* resembles Kacyzne's. The image, like so many of his other photographs, is intense and focused but unspecific. The effect is to portray an essentialized purity catalyzed by poverty and religiosity. Modernity looms threateningly over the Jews; and it is only the old, bearded Jews who are strong enough to confront it with open eyes.

A further issue impacting photography is the fact that its implicit claim to the representation of unvarnished reality made it a key tool for claiming ethnographic authority.[10] This concentrated its ability to mediate a kind of soft primitivism or exoticism, and indeed photography was crucial to the popular dissemination of these discourses. But while photography was perhaps most

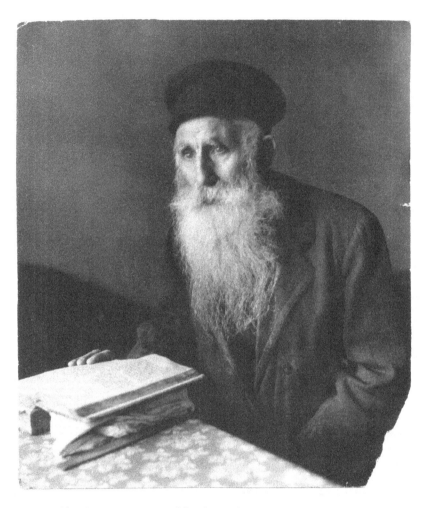

FIGURE 8. Alter Kacyzne, portrait of the *shames* (synagogue sexton) Moyshe Pinczuk, 1924. From the Archives of the YIVO Institute for Jewish Research, New York. ©YIVO / The Forward.

responsible for the blurring of the boundary between ethnography and art, it was not alone. For example, Chagall called his series of Vitebsk paintings from 1914 to 1915 "documents."[11] Indeed, the confusion between art and science was far-reaching and lay at the root of modernist primitivism. The canonical story of the origins of modernist primitivism in the visual arts places its inception in an ethnographic museum, the Musée d'ethnographie du Trocadéro in Paris, where Picasso first saw African masks. It was this encounter, Picasso later

claimed, that spurred his invention of cubism and offered a ready-made narrative for the historiography of primitivism.[12] The museum as the birthplace of primitivism is buttressed by Wilhelm Worringer's identification of the same ethnographic museum, the Trocadéro in Paris, as the place of his own inspiration.[13] Ethnographic museums were created as places of science but were also places of popular education and entertainment. The blurred boundaries between science, art, and entertainment in the period are more clearly revealed in the history of ethnographic showcases, which were simultaneously sites for ethnographic investigation and popular entertainment.[14] This conflation was fodder for Kafka's satire in "Ein Bericht für eine Akademie" ("A Report to an Academy"). This confusion underpins both the production and the reception of primitivist figurations of Jews in modern graphic art and photography.

A strange book from 1917 reveals this dynamic.[15] The volume *Kriegsgefangene* (Prisoners of war) features one hundred lithographs by the prominent German-Jewish artist Hermann Struck. Struck is perhaps best known now for his iconic rendering of Theodor Herzl; he was also a leading lithographer and wrote a textbook on the technique. Struck's wartime book is a lengthy series of soft-edged, rather sedate images of prisoners of war. Because of the diverse ethnic and national makeup of the British army, a representative sampling of whom were incarcerated in Germany, a smorgasbord of ethnographic types was available for study and artistic inspiration. The range of lithographs is accompanied by an introductory essay on anthropology by the leading German anthropologist Felix von Luschan. Luschan's essay contains photographs in the classical anthropological style, to illustrate his explanations. The contrast to Struck's lithographs is startling, and Luschan cannot avoid it. In the essay, Luschan notes that since artistically motivated photographs have limited ethnographic use, he was prepared for lithographs—even further from the kind of objective reality to which photographs lay claim—to be even less useful. But, he writes, "I saw this book and am happy to admit that I have seldom been so pleasantly disappointed. Of course, these pictures are first and foremost works of art and must be judged as such. But over and above their artistic value, they are indisputably of scientific significance."[16] By contrast, he writes that the photographs included in his introduction "are not intended as a counterpoint to the artistic illustrations and just as little are they intended to make this text an anthropological atlas. They are, rather, meant merely to unburden the text from bare descriptions."[17] Luschan's ambivalence is clear but does little to mitigate the claim to ethnographic authority of Struck's lithographs; on the contrary, the juxtaposition of works of

art with a "scientific" essay by Germany's leading anthropologist is itself what authorizes Struck's works as sources of scientific knowledge.

Of course, explicit scientific authorization was hardly needed for Struck's works to make a mark. This is clear from Struck's next major project, his illustrations for Arnold Zweig's 1920 quasi-anthropological, meditative book-length essay *Das ostjüdische Antlitz* (*The Face of East European Jewry*).[18] Struck's images, well within the current of the cult of the *Ostjuden*, together with Zweig's text, are a codification of primitivist tropes about eastern European Jews: soulful, deep of spirit, fully Jewish. Zweig and Struck's Zionism meant that they also injected a measure of modernity into their image of the *Ostjuden*, but the thrust of the work is unmistakable:

> The Jew of the West was on his way toward a kind of ossified denomination, toward an eviscerating, desperate piety which cut itself off from all tradition and was incapable of doing anything but cutting itself off. Due to fervent atheism and an exaggerated and totally false application of scientific objectivity, this denomination was declining from day to day, crumbling away, losing weight faster and faster, and in front of his own eyes, as if automatically and without resistance, the Jew of the West left these obvious losses to the mercy of the disaster.[19]

The counterpoint is the Jew of the East, as illustrated by Struck (figure 9):

> He turns his eye away from me and into the distance, a distance that is nothing but time. His profile leads like a waterfall into his beard, which dissolves into spray and clouds. The nobility of his posture and his nose, the spirituality of his pensive and furrowed brow, contrast the hard, defiant ear and meet in his gaze, a gaze that neither demands nor renounces, neither longs for nor laments what it is. And his gaze draws upon itself a distance about which we know that it is nothing but time.[20]

Zweig's is a soft-focus primitivism, in harmony with Struck's; both resemble Berlewi's Chagallism, but without the modernism.

A striking rejection of these discourses in the visual arts was the 1931 photo-book *Ein Ghetto im Osten: Wilna* (A ghetto in the East: Vilna), by Moyshe Vo-robeichic.[21] While the reception of his book, and even its introduction by the Yiddish and Hebrew writer Zalman Shneour, place it in the aesthetic context of Chagallism and the ethnographic claims of visual representations of Jews, the work itself is a powerful rejoinder to these tropes. The fact that it takes a critical stance toward the mainstream of representations of Jews in the visual

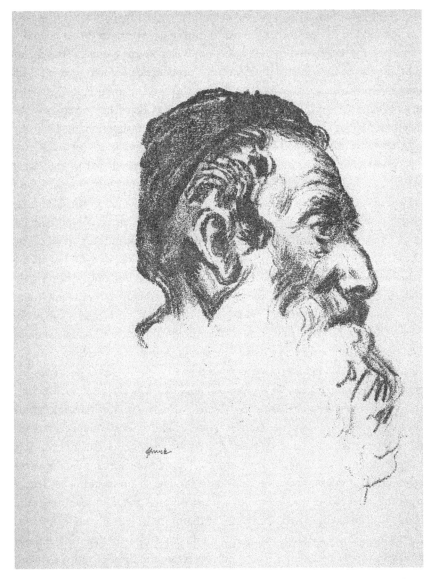

FIGURE 9. Lithograph of old man by Hermann Struck, in Arnold Zweig, *Das Ostjüdi-sche Antlitz* [The face of eastern European Jewry] (Berlin: Welt-Verlag [1922]), 12.

arts at the same time as it deploys that specific visual idiom qualifies it as Jewish primitivism of the kind examined in the literary works in earlier chapters. While the literary examples of Jewish primitivism swam against a strong current, they were not isolated; by contrast, Vorobeichic's accomplishment is all the more remarkable because his work may very well be unique. The influence of Chagall in this period was powerful, and beyond Chagall lay two options, the abandonment of Jewishness (of subject or style) and abstraction, the latter the path taken by Lissitzky and Berlewi.

Vorobeichic took a different path, seemingly unparalleled in the visual arts: the creation of a visual Jewish primitivism, simultaneously producing and critiquing the notion of Jewish primitiveness or authenticity. *Ein Ghetto im Osten*, containing both elaborate photomontages and "straight" photographs of the Jewish quarter of Vilna, was released in the Schaubücher series of the Orell Füssli Verlag of Zurich.[22] *Ein Ghetto im Osten* was, like the rest of the Schaubücher volumes, a small-format, mass-produced book of approximately sixty-five images. The series was an idiosyncratic combination of high and low culture, of avant-garde and straight photography. With titles such as *Befreites Wohnen* ("Living free"—on modern home architecture) and *Technische Schönheit* ("Technical beauty"—with images of factories and machines), it was clearly hospitable to modernist themes and tropes. The Schaubücher series encompassed another trend of the period: popular ethnography.[23] Such books, including *Negertypen des Schwarzen Erdteils* (Negro types of the dark continent) and *Nias: Die Insel der Götzen* (Nias: Island of idols), comprised a total of six of the Schaubücher titles.[24] *Ein Ghetto im Osten* seems to fit in this category.[25] Eastern European Jews and the shtetls from which many of them came were, of course, popular subjects in the Jewish press and belles lettres from the latter half of the nineteenth century onward. But the book forgoes the bland realism and prurient exoticism of the more generically popular series titles, embracing a striking avant-garde idiom that surpasses that of even those books on modernist themes. The book thus scrambles the dichotomy between realist and avant-garde, between high and low, that is represented by the other Schaubücher volumes. More significant, this tactic placed Vorobeichic at the center of a modernist approach to ethnography that had only just begun to take shape at large and was unprecedented in the photographic representation of eastern European Jews.[26]

The extent to which Vorobeichic's photographs went against the grain is revealed in the prominent Hebrew and Yiddish writer Zalman Shneour's

introductory essay to the book.[27] "[It is] a kind of museum [*beit osef*] for all the evening shadows of the street—shadows that tremble on the border of the traditional past and the modern present."[28] Shneour's understanding of the book emerges from the discourses governing the representation of eastern European Jews in modernity, discourses conditioned by the sentimentality of Chagallism and by ethnography. In the line quoted above, Shneour characterizes the book as a museum, the site par excellence for the popular mediation of ethnography.[29] For Shneour the images are perched on the border between sentiment and science, between art and ethnography. He concludes his introduction as follows: "This is not an aesthetic album for connoisseurs and gourmands of one kind or another, but has something for everyone: it is a collection of pictures for the masses; a delight for parents and children; a resource for researchers; a wealth of ethnographic material."[30] But, of course, these were works of art. The blurred border between science and entertainment was similarly at play in Struck's lithographs and in all visual representations of Jewish "authenticity."

Vorobeichic, however, crafted his work in opposition to these discourses, strategically capitalizing on the conflicting traditions his book drew on: popular ethnography, the valorization of the eastern European Jew, the modernist photobook, and the avant-garde engagement with ethnography. This multifarious genealogy creates taxonomical and interpretive problems: a book that capitalizes on a popular nostalgic trope of Jewish identity in an avant-garde idiom would seem to be a paradox. I situate the book in a network of discourses characterized by the collision of the avant-garde and ethnography and often called, using James Clifford's term, "ethnographic surrealism."[31] It is in this context that Vorobeichic's effort begins to become clear.

Ein Ghetto im Osten expresses an awareness of the opposed trajectories of ethnographic and avant-garde idioms in the photographic representation of Jews. The book is not, however, an avant-garde rejection of the ethnographic tradition but an exploitation of it, inherently reifying the underpinnings of the ethnographic project, namely, the creation of ethnographic objects out of subjects designated primitive or exotic. Vorobeichic's challenge to ethnography was to attempt to turn these objects back into subjects. But turning ethnography against itself creates an ambiguity of meaning that becomes the chief statement of the work. Rather than a standard example of the trope of the *Ostjude* or an all-out critique of ethnography, Vorobeichic's photographs suggest a multiplicity of interpretive possibilities without affirming any single one. The sentimental gaze and the ethnographic impulse are pulled back from the foreground

and removed as the only possible modes for representations of eastern European Jews. New possibilities are opened that direct the viewer away from the tropes and stereotypes that shaped the representation of eastern European Jews in contemporary culture.

It is, in fact, the metaphor of opening and the exploration of alternatives with which Vorobeichic introduces his work.[32] The image on the book's cover (figure 10) is a montage of numerous doors, some overlapping, all cluttered together in a jumble, suggesting a playful attitude toward a subject typically treated with heavy-handed sentiment but also evoking the interpretive conundrum of the work: Behind which door does the meaning of the book lie? Throughout the work, the very lack of an answer is articulated through Vorobeichic's characteristic techniques of repetition, doubling, visual puns, ironic captions and layouts, and use of negative space. All contribute to a work that points toward the semiotic status of photography while undermining the possibilities for interpretation through the proliferation of signs.[33]

The demand for multiple meanings is articulated not only through the polysemy of its images but also through its very materiality: the book had three editions, published together in 1931. Each edition was bilingual, featuring dual versions of the cover, the captions, and the introduction: one was in German and Hebrew, one in English and Hebrew, and one in German and Yiddish. The rather strange production of three bilingual editions sharpens the interpretive challenge posed by the image of doors: not only does the cover pose the riddle of which door is the correct entryway to the book, but we must now ask: For whom are these doors? With these four languages—German, English, Hebrew, and Yiddish—the target audience would seem to be the entire Ashkenazic diaspora.[34]

Although the duality of the three editions is primarily textual, with the various languages surrounding the same images, it is not entirely so. The book covers in Hebrew and Yiddish have the image of doors. But the covers in German and English have a different image—an unmanipulated shot with a slightly elevated perspective onto a crowded, filthy alley (figure 11). At the far end of the alley is a sunlit façade blocked by an archway, which in turn is obstructed by pedestrians and partially obscured by shadow. The face of the book presented to a "Western" audience thus displays the clutter and darkness of the ghetto with an only partly visible single point of egress at the image's vanishing point. For the eye that possesses this downward view onto the crowded alley, is the point of interest what is in the ghetto, or what is tantalizingly just visible outside its

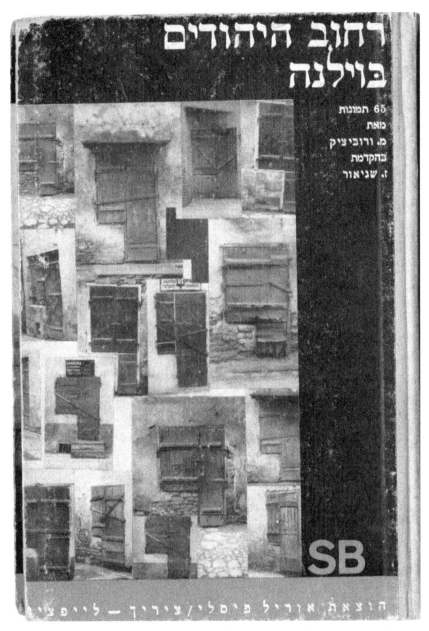

FIGURE 10. Moyshe Vorobeichic, *Ḥanuyot bireḥov hayehudim* (Shops in the Jewish street), Hebrew cover. From *Ein Ghetto im Osten* [A ghetto in the East] (Zurich: Orell Füssli Verlag [1931]). Special Collections, The Sheridan Libraries, Johns Hopkins University. © Raviv Family Archive, Israel.

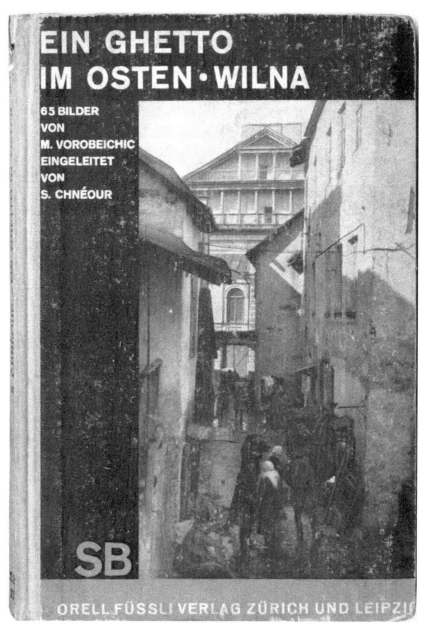

FIGURE 11. Moyshe Vorobeichic, *Judengasse mit Balkon der grossen Synagoge* (The Jewish street with the balcony of the Great Synagogue), German cover. From *Ein Ghetto im Osten* [A ghetto in the East] (Zurich: Orell Füssli Verlag [1931]). Special Collections, The Sheridan Libraries, Johns Hopkins University. © Raviv Family Archive, Israel.

gate? By contrast, the doors of the "Eastern" or "Jewish" cover are all closed but unblocked and lit evenly, seeming to offer many (too many) choices for entry but no clue as to what may lie behind them. To whom is interpretive access offered, and to whom is it denied? Which view is inside and which outside? Is the speaker of Hebrew and Yiddish—the returning *Ostjude*—barred from reentry? Is the speaker of English and German—the exploring European—trapped and prevented from exiting? The self-reflexivity of this question-asking is characteristic of the avant-garde approach to ethnography; it resists universalized approaches and produces no definitive answer.

Yet Vorobeichic's images were not primarily a response to the tradition of popular ethnography, though he exploits its tropes. *Ein Ghetto im Osten* emerges more directly from the avant-garde approach to photography—to which he was exposed during his studies under László Moholy-Nagy at the Bauhaus in the late 1920s—and its approach to ethnography, which had resulted most prominently in Georges Bataille's journal *Documents*, published from 1929 to 1930 in Paris, where Vorobeichic had settled after his time in Germany. Although he had begun his studies at the Bauhaus with a focus on painting, by the time he left he had switched his allegiance to photography. While in Paris he worked as a photographer for the press and produced the two signal achievements of his career, the seminal avant-garde photography book *Paris* and *Ein Ghetto im Osten*, both from 1931. Despite a long career—he emigrated to Palestine in the mid-1930s, where he was at first a leading graphic designer, eventually helped found the artists' colony in Safed, and had a successful career as a painter until his death in 1995—his reputation rests largely on *Paris*. For *Paris* he went by the pseudonym Moï Ver, which has become his most common appellation.[35] *Paris* is a consummate expression, a codification even, of high modernist photomontage. In one representative image, old and new collide in urban space as an automobile seems to drive right through a handcart and its driver (figure 12). In another, the superimposed—indeed, almost abstracted—forms of trees and the Eiffel Tower suggest a destabilized relationship between nature and machine.

Paris was an appropriate subject for a modernist photobook. It was, after all, a capital of the avant-garde and a destination for artists like Vorobeichic. Moreover, the formal composition of the images matches their content in attitude and orientation—the images dramatize the collision of tradition and modernity encapsulated by the idea of Paris. But his Vilna book seems far from appropriate—if Paris was a capital of the avant-garde, Vilna was not even on the map. On the map of Jewish Europe, however, Vilna was the so-called Jerusalem

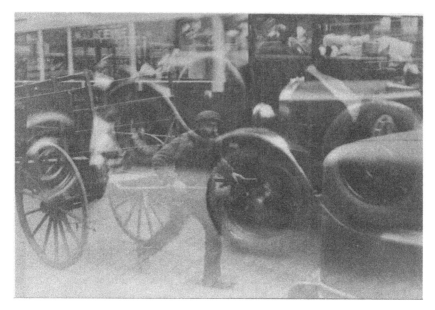

FIGURE 12. Moyshe Vorobeichic, handcart and automobiles from *Paris* (Paris: Éditions Jeanne Walter, 1931). © Raviv Family Archive, Israel.

of Lithuania, a major cultural center. As indicated by this moniker, it was also a focal point for stereotypes of eastern European Jewry—Vilna was the home of the saintly sage and the stooped peddler. Such characters, in fact, are the stock-in-trade of *Ein Ghetto im Osten*. Moreover, there are no cars, no steel structures, no cinemas: no traces at all of modern life. Nor is there any collision of nature and modernity, for nature is equally absent; the book represents the shtetl reduced to synagogue and Jew. But the images are composed and arranged in Vorobeichic's relentlessly avant-garde idiom, so much so that it demands to be read alongside *Paris* as a companion piece, the two books presenting two sites, or perhaps two kinds, of modernity. In this collision of form and subject, *Ein Ghetto im Osten* would seem at once to affirm and to interrogate the era's stereotyped picture of eastern European Jews. By engaging the idioms of ethnographic realism but also those of modernism, the book forces us to recognize that the visual representation of the classic eastern European primitivist subject is not an either/or proposition between realism and abstraction, or between critique and promotion of the authentic *Ostjude*.

Vorobeichic's instantiation of the dual—and often dueling—modes of ethnographic realism and avant-garde photography was sui generis for the

photographic representation of the eastern European Jew.[36] But, more broadly, he was not alone in his use of an equivocal stance toward the ethnographization of his subject. In fact, this move had become characteristic of (but not limited to) the Paris-based artists, writers, and ethnographers of the circle around Georges Bataille and his journal *Documents*, the special focus of which was the intersection of ethnography and representation. They produced the body of work that James Clifford termed "ethnographic surrealism." A focus of Clifford's analysis is Michel Leiris, whose *L'Afrique fantôme* (*Phantom Africa*) serves as the paradigm of a surrealist ethnography (an inversion of his category in discipline but not intention). Leiris's text was a diaristic ethnography resulting from his participation in the famous Mission Dakar–Djibouti ethnographic expedition of 1931–33. He gained his place on the expedition, so the story goes, owing to Luis Buñuel's decision not to take part. Instead, Buñuel returned to Spain from Paris and made *Las Hurdes* (also known as *Tierra sin pan* [Land without bread]), a thirty-minute ethnographic film that articulates many of the suppositions and enacts many of the forms of ethnographic surrealism.

As the debate that followed in the wake of Clifford's article made clear, ethnographic surrealism was neither ethnography nor surrealism, per se.[37] It was, rather, a posture—most frequently adopted by artists and writers associated with surrealism—that sought to expose and undermine the representational and subject-making capacities of ethnography. It was a posture that found a clear expression in Buñuel's engagement with ethnography and, I argue, in Vorobeichic's avant-garde Jewish ethnography. The substantial links between the formal and polemical approaches of the two works illuminate the stakes of Vorobeichic's book.

Las Hurdes is sometimes interpreted as a typically exploitative ethnographic film, sometimes as a powerful critique of capitalism, and sometimes as a profoundly self-aware parody of ethnography. It is all three, and perhaps more. The film is, according to James Lastra's analysis, fully in control of what he identifies not as an ambivalent posture but an "equivocal strategy."[38] Its subject, the remote Spanish region of Las Hurdes, is presented as hopelessly woebegone: mired in extreme poverty, filth, disease, and hunger. The residents of this barren, remote region are also presented as forlorn and without hope. But the film is also shot through with parodic elements, some of them undeniably humorous. Most notorious of these is the scene in which the narrator describes the scarcity of meat among the Hurdanos; one rare source of it is the mountain goats that occasionally plummet to their deaths among the sheer crags. Such an

eventuality is shown, but with an unmistakable puff of gunfire at the edge of the frame immediately preceding the goat's fall. For Lastra, this, together with other less obvious elements, is a purposeful tactic to draw attention to the essentially staged nature of the film. But Lastra argues that as with the goat, so with the Hurdanos: the result is a film that questions the tactics and motivations of ethnography while repurposing them for aesthetic ends. The film, writes Lastra, is "simultaneously a documentary and a dismantling of the documentary form" and "falls neither on the side of pure sympathy nor simple disgust but . . . insists on a constantly double movement embracing and repelling the Hurdanos at the same time, refusing a stable position."[39] This is a framing particularly apt in the representation of this group, which "resisted any homogenous representation as noble or ignoble. On the one hand they occupied a degraded place in the Spanish national body, while as Spaniards they were also said to *exemplify* Spanish identity."[40] They were, therefore, denigrated in order to raise the value of the other constituents of Spanish identity, a process that was "paradoxical, since the Hurdanos were no alien community, but citizens well within the heart of Spain itself, and therefore ineradicable."[41] Lastra argues that Buñuel thus "situates the Hurdanos on the border between the wholly inside and the wholly outside, as a group hostile to both classifications."[42] This paradoxical positioning of the partially alien subject is suggestively analogous to the position of the Jew in Europe, most particularly that of the Jew as ethnographic subject within Europe. More concretely, the formal aspect that this equivocation takes in Buñuel's film—the encroachment of subversive content at its edges and through the juxtaposition of words and image—is, I contend, recognizable in Vorobeichic's alternation between straight photographs and complex montages and multiple exposures, an alternation that he utilizes to toggle between the misery of the ghetto's inhabitants and their joy.

Lastra takes his argument one crucial step further. Through a series of subtle intertextual readings, he compellingly identifies the ultimate referent in the film's chain of equivocal signs. It is a referent only able to be present by virtue of its absence in the film and, indeed, its absence in *Las Hurdes*—the Jews. Lastra points out that all of the ethnographic and historical works on which Buñuel's film was based relate a local legend accounting for the expulsion of the Jews from the region during the Inquisition. A variant of the legend related by Buñuel has it that the original inhabitants of the region were themselves Jews displaced by the Inquisition.[43] The final piece of evidence for the Jewish subtext—or even context—of *Las Hurdes* is the title appended to Buñuel's

personal gift of a print of the film to the Museum of Modern Art in New York in 1940: *Unpromised Land*.[44] The Jewish subtext of the film is thus concretized. The picture Lastra has painstakingly painted makes clear the profoundly allusive potentialities for the representation of European Jews within the context of modernist ethnographic representation.

As is clear from Buñuel's film, the appearance of realism does not preclude a modernist underpinning. The same is true for the presence of documentary photography in surrealism. Ian Walker has shown how surrealists used straight photography "as a simultaneous exploitation and subversion of the standard realist frame," a manner akin to the equivocal dualism we have already seen in Buñuel.[45] This was particularly so in the avant-garde exploitation of ethnographic photography, a characteristic feature of *Documents* among other contemporaneous periodicals. *Documents* "was to offer a sort of ethnography of the everyday in which there was a two-way movement between the exotic and the commonplace. . . . The study of so-called primitive and exotic peoples was given no privileged status as ethnographic subjects. No methodological distinction was made between social facts taken from 'exotic' societies and those drawn from Western society."[46]

This two-way movement was also characteristic of the ethnographic and primitivist representation of eastern European Jews in Europe, in large part owing to the polyvalence of their constructed identities: Semitic (in "race") but European (in geography); Germanic (in language) but Slavic (again in geography); primitively religious but prone to excessive *Bildung* and assimilation. The collapse of exotic and mundane that was a signal achievement of the dissident surrealists was intrinsically present in the polyvalent identities of European Jews, which, however, was only capitalized on visually by Vorobeichic in his polysemic images. Whereas, for example, Buñuel's use of ethnography was simultaneously affirmative (in its reification of the conditions of production of ethnography) and critical (in the often jarring framing and contextualization that ethnographic representations were given), the tradition of visual representation of eastern European Jews was based on an unproblematized use of ethnographic representational modes, which easily accommodated the valorization of the poverty, traditional religiosity, and noble sorrow of shtetl Jews. Characteristic examples of such images include the works of Kacyzne and Vishniac.[47] Although their subjects embodied the binary of exotic and ordinary that avant-garde artists had to labor to achieve, the majority of photographers of eastern European Jews adhered to a mixture of sentimental and ethnographic

realism. It was Vorobeichic who brought an avant-garde form to a subject that was seemingly, in light of so many of its representations, quite distant from the avant-garde.

He did this either by contrasting manipulated and straight photographs, as with the dual covers of the book, or through the juxtaposition of the images with the words surrounding them. The latter tactic, a major element of the book, exploits the multilayered textual allusiveness of Yiddish to create captions that offer sarcastic commentary on images that on their own would appear to be in the typical sentimental mode. These witticisms are lost in the translation of the captions, but the multiplicity of versions—many so distant from one another that they can hardly be considered translations—means that we cannot think of this book as having three translations of one original. Rather, the book both visually and textually emphasizes its polysemy. Take, for example, an image of an empty room with blinding light reflecting off the flat surfaces of the benches and lecterns scattered about (figure 13). The image carries the following captions (my translations appear outside the quotation

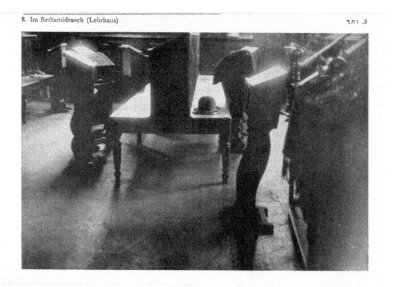

8. Im Bethamidrasch (Lehrhaus)

FIGURE 13. Moyshe Vorobeichic, German caption: *Im Bethamidrasch (Lehrhaus)* (In the study hall); Hebrew caption: *Zohar* (Brightness). From *Ein Ghetto im Osten* [A ghetto in the East] (Zurich: Orell Füssli Verlag [1931]). Special Collections, The Sheridan Libraries, Johns Hopkins University. © Raviv Family Archive, Israel.

marks): German—"Im Bethamidrasch (Lehrhaus)" (In the *bet ha-midrash* [school]); Yiddish—"In goens kloyz" (In the synagogue of the Gaon of Vilna); English—"In the *'Bethamidrash'* (Teaching House)"; Hebrew—"Zohar" (Radiance). The English is clearly a translation of the German (as is also clear from the mistranslation in a caption of *Talmudstunde*, or Talmud lesson, as "Thora Time").[48] But the Hebrew offers a pun independent of the other captions: *zohar* means brightness or radiance, but it is also the name of the central book of the Kabbalah. The light reflecting off the lecterns in bursts of radiance is thus metonymically (and humorously) reinterpreted as the light of the Kabbalah, which would normally be studied from books lying on the lecterns.

Other pages parody the earnest conventions of ethnographic photography: a spread featuring two versions of an image of a man and his drab surroundings is captioned on the left as "Architecture and Man" and on the right as "Man and Surroundings" (figure 14). The generality of the captions seems to promise a subject of greater interest, but all that is shown is yet another bearded man, the wet ground on which he stands, and an unadorned arch. Vorobeichic subverts the centrality of exoticism for ethnography by offering ordinary details that are in theory ethnographically satisfactory but that were all too often ignored in favor of prurience. He goes one step further than the conflation of the exotic and everyday found in ethnographic surrealism by making the everyday take the place of the exotic.

Yet it is only the subject of these images that is ordinary; their overtly playful form is, in fact, where their real interest lies. By means of an elaborate visual pun, the spread humorously foregrounds the semiotic character of photography: the image on the right is of a poor man, slightly compressed perspectively by the overhead camera angle; the image on the left duplicates the right-hand image in the form of an exclamation point. The transformation of image into typographic sign thus casts it as a caption for its facing image, as well as a caption for the textual caption below it, rather than the other way around. Reading the photograph becomes a matter of recognizing its legibility and understanding its textuality rather than only interpreting its visual subject.

The duplication of the image echoes a simultaneity of meaning consisting of a visual pun on the Yiddish phrase *dos pintele yid*.[49] Literally "the point of a Jew," it idiomatically means the essence of a Jew, an idiom that is itself already a play on words: the *pintele yud* is the point atop the letter *yud* in Jewish ritual script; when the letter *yud* becomes *yid*—Jew—the diacritic becomes a synecdoche for

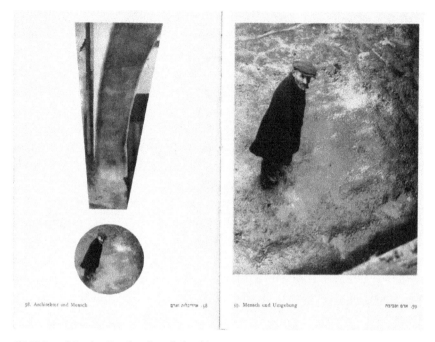

FIGURE 14. Moyshe Vorobeichic, (*left side*) German caption: *Architektur und Mensch*, Hebrew caption: *Adrikhalut ve 'adam* (Architecture and man); (*right side*) German caption: *Mensch und Umgebung*, Hebrew caption: *Adam usevivah* (Man and surroundings). From *Ein Ghetto im Osten* [A ghetto in the East] (Zurich: Orell Füssli Verlag [1931]). Special Collections, The Sheridan Libraries, Johns Hopkins University. © Raviv Family Archive, Israel.

the essence of Jewish identity.[50] In insisting on the semiotic legibility of photography, Vorobeichic has gracefully and wittily deconstructed the essence of this idiom, simultaneously pointing toward the essentialized identity underlying the idea of the *pintele yid* as well as the image of the *Ostjude*. Reading the image textually, we see how the transformation of subject (*yid*) into punctuation (exclamation point) critically mirrors the process by which ethnography turned Jew into *Ostjude*. This image/exclamation point is not an ostensibly realist documentary photograph ready for interpretation (like its companion on the facing page) but an instance of what Rosalind Krauss calls the "language effect," spelling out an interpretation in itself, of itself.[51]

Despite the unmistakable ways in which Vorobeichic calls attention to the fundamentally nonrealist stakes of his work, contemporary readers, beginning with Zalman Shneour, seem not to have seen it this way. In his introduction,

Shneour applauds what he sees as the documentary nature of the work, praising Vorobeichic for "doing without stereotypes, without sentimentality, without romanticism, leaving out everything that has no direct link to life in the Jewish street."[52] A few sentences earlier, in an opening paragraph present in the Hebrew and Yiddish but not the German, he focuses on their ability to evoke sentiment: "The pictures arouse curiosity, light streams from the shadows, and shadow from light. . . . How deep is Vilna; how mysterious her Jewish street."[53] What he does not comment on are the ways in which the photographs undercut both their status as documents and their sentimentality.

A review of the book from 1932 published in the German Jewish periodical *Menorah* similarly foregrounds the ethnographic dimension of the book while offering an answer to the question of its readership: the book, the reviewer writes, is "a delight for any aficionado of Jewish folklore."[54] This identification of the book as ethnographic echoes Shneour's reading, in which he calls the book a "museum in miniature" and a "handbook for researchers."[55]

Political agendas could also instigate a superficial reading of the book. In a review of *Ein Ghetto im Osten* from the New York Yiddish daily *Forverts* in 1931, the eminent scholar of Yiddish Max Weinreich takes issue with what he characterizes as Shneour's confused interpretation of the book, producing an interpretation that likewise takes a narrow view of the book. In the images, Weinreich sees not mystery but Jews who "want a chance to come out of the shadowy, permanently dank corners into the light of day." He further criticizes Vorobeichic for not including images of modern Jews:

> Where is the gym class in a modern Yiddish school? Where is a match between two Jewish football teams and the faces of hundreds of adult Jews who wait breathlessly for their team to score a goal? Where is a Jewish workers' demonstration? A political mass meeting? The Jewish technical school of the ORT? A troop of boy-scouts . . . ? Where is the Yiddish Scientific Institute [YIVO]?[56]

What these readings all have in common is the tendency to read Vorobeichic's photobook as if it were an entirely typical example of the representation of eastern European Jews and therefore an appropriate site for engaging the usual questions of ethnographic or political utility.

But even those photographs that appear as if they might have been taken by Alter Kacyzne or Roman Vishniac turn out to be destabilizing. For example, an image of a woman sitting in her shabby storefront seems to sentimentalize the poverty of such storekeepers while retaining a claim to documentary objectivity

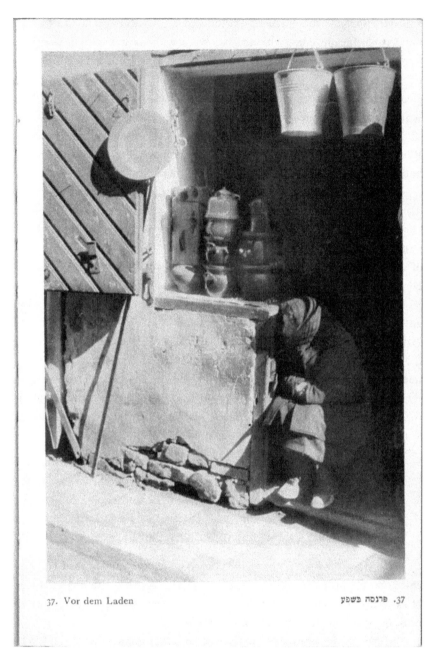

37. Vor dem Laden פרנסה בשפע .37

FIGURE 15. Moyshe Vorobeichic, German caption: *Vor dem Laden* (In front of the store); Hebrew caption: *Parnasah beshefa*ʿ (Abundant livelihood). From *Ein Ghetto im Osten* [A ghetto in the East] (Zurich: Orell Füssli Verlag [1931]). Special Collections, The Sheridan Libraries, Johns Hopkins University. © Raviv Family Archive, Israel.

32. „Dein Volk Israel ist reich!" .32 ,,עשירים עמך ישראל!"

FIGURE 16. Moyshe Vorobeichic, German caption: *Dein Volk Israel ist Reich*; Hebrew caption: ʿAshirim ʿamkha Yisraʾel (Your people Israel is wealthy). From *Ein Ghetto im Osten* [A ghetto in the East] (Zurich: Orell Füssli Verlag [1931]). Special Collections, The Sheridan Libraries, Johns Hopkins University. © Raviv Family Archive, Israel.

with the German caption "In front of the store" (figure 15). The Hebrew caption, by contrast, ironically subverts both the sentimental and the documentary readings of the image, offering instead "An abundant livelihood." Vorobeichic accomplishes a similar effect on the same theme with a formally challenging image (figure 16). Once again, the caption is sarcastic—"Your people Israel is rich"—but the image's heavily manipulated composition now participates in the commentary on the subject.[57] The premise of this commercial enterprise is cast as topsy-turvy; the disarray of the goods highlights their shabbiness, and the shopkeeper herself seems just another pile of fabric for sale.

Taking the book as a whole, it becomes impossible to separate the various registers of the images: the book traffics in both the avant-garde and the authentic. It is able to do so by virtue of its subversion of an ethnographic discourse, which was uniquely positioned to bridge avant-garde and traditional forms of representation and to imbricate, or perhaps even combine, realism and modernism. *Ein Ghetto im Osten* shows that although visual figurations of Jews typically associated the ethnographic with the authentic and both with realist forms, this equation was not an unbreakable rule—the borders could be

blurred. This blurring is the primary achievement of Vorobeichic's photobook, which, in its opposition to exoticized and abstracted notions of the primitive other, could foster a modernist engagement with ethnography that is more than an affirmation of ethnography's tropes. But it is also something less than the aggressive critique of ethnography of the surrealists, who, for example, organized an anticolonial exhibition in 1931—the year in which Vorobeichic's book was published—as a rebuttal of the massive French colonial exposition of the same year. This anticolonial exhibition, *The Truth about the Colonies*, reflected the maturation of the avant-garde engagement with ethnography and was of a piece with similar self-reflexive cultural products including Leiris's *L'Afrique fantôme* and Buñuel's *Las Hurdes*.[58] Vorobeichic's critique of ethnography was not as strident and did not share the resistance to the purported humanism of the ethnographic project percolating through such efforts. He did not have the luxury of distance that such a position required—distance from his subjects and distance from the stakes of his work. Vorobeichic, born in the city he depicted, speaking the same language and raised in the same religion as his subjects, sought to acknowledge the Jews he photographed as humans. Rather than critiquing the ethnographic basis of primitivism, as was typical in the avant-garde, Vorobeichic used the tools available to him—ethnography *and* primitivism—to recuperate the subjecthood of the Jews he photographed.

His task was urgent—the precarious situation of Jews in Europe in the early 1930s was clear. The "Jewish question" had an urgency for Jewish members of the avant-garde that the "human" question or the "ethnographic" question never had for the dissident surrealists, even considering the centrality of their critique of colonialism. These remained, ultimately, problems of other people. Not so for Vorobeichic, who immigrated to Palestine only a few years after the publication of his two seminal books in 1931. Whereas his political and artistic trajectory became increasingly clear and increasingly enmeshed in the formation of a Zionist visual idiom in Palestine and then in Israel, his stance was substantially less defined in the late 1920s and early 1930s. But this ambivalence was deeply motivated; it prompted an engagement with his subject and subjects without demanding an answer to the questions underpinning his work.

Ein Ghetto im Osten expresses a playful awareness of the uses and misuses of primitivism in the photographic representation of Jews. The book is not, however, a rejection of that discourse; it is, rather, an exploitation of it, which destabilizes the implicit ability of ethnography to create its own objects.

Vorobeichic's bringing together of ethnographic and avant-garde photography opens up the possibility that his subjects have value originating outside the discourses to which he was reacting. This ambivalence toward ethnography and toward the primitivizing of the eastern European Jew stems from the photographer's own identity. Jewish primitivism reckoned with a different set of stakes than other forms of European primitivism; *Ein Ghetto im Osten* is thus a rarity in primitivist visual art—it is personal.

Conclusion

THE END OF JEWISH PRIMITIVISM

"Take the D train to 55th Street in central Brooklyn, and you feel as if you have set foot in a different world. . . . The magical moment in Borough Park comes after sunset. The empty streets and the street lights create an almost surreal atmosphere, peopled by Jewish men in black coats heading home."[1] "The images here—knife-grinders on the street, bearded men in 19th-century frock coats—are not only vivid, they are also apparently lost to time."[2] "[T]he scenes among the Hasidim are essentially period pieces, meticulously designed and costumed. There's a sense . . . that the series takes places simultaneously in the past and the future."[3] A different time, a different place—this is how twenty-first-century Brooklyn Jews are described in the *New York Times*. These examples are particularly evocative but not at all exceptional. They echo Döblin's *Journey to Poland*, but there is none of Döblin's ambivalence. Around one hundred years after the modernist moment of Jewish primitivism described in this book, primitive Jews are still here, but the self-aware, critical posture of modernism is gone. Jewish primitivism has receded to bland exoticism.

Jewish primitivism has become a hollowed-out tradition in European and American culture, Chagallism warmed over, sometimes with a seasoning of postmodernism. In literature, for example, Michael Chabon's novel *The Yiddish Policemen's Union* describes a large enclave of Yiddish-speaking Jews in Alaska dominated by a gang of Hasidic criminals.[4] Their language and culture are reduced to caricature and literally, if superficially, primitivized: the novel's hero is an Orthodox Jewish Eskimo policeman named Berko, who has the qualities

of a bear. In real life, neo-Hasidic revivals turn Hasidic tradition and thought into sources for New Age or pop-psychological religious expression. A niche of American Jews has "rediscovered" Yiddish as an access point to authenticity, to a more rooted Jewishness or a Jewishness freed of the strictures of late capitalism.[5] These "new" versions of Chagallism, of Jewish exoticism, are the lingering echoes of a bell struck before the Holocaust. Chagall, in France, was successful as a purveyor of shtetl sentimentalism until his death. Vorobeichic, in Palestine, then Israel, reinvented himself as a painter of the subject he had once criticized—a sentimentalized vision of traditional Jewish belief and practice.

It is not surprising that the challenging, complicated primitivism of the kind described in this book dwindled and disappeared after the Holocaust. The Holocaust made it moot. Jewish primitivism began at the cultural and political moment in which its meaning was most productive: modernism turned neo-Romantic folklorism into a powerful aesthetic and political tool to challenge the terms in which Jewish culture, Jewish art, and Jewish identity were being defined. Jewish primitivism articulated a resistance to the Europeanization of Jewishness, even as it was inconceivable without the aesthetic and political ground of Europe. And then this ground was cleared of Jews. Beyond the murder of the people to whom it was addressed, the Holocaust meant that the social, aesthetic, and political questions that Jewish primitivism had asked and answered were drastically altered.

The limits of Jewish primitivism after the Holocaust are shown by Egon Erwin Kisch, a Jewish German-language journalist from Prague.[6] Two short pieces of reportage by Kisch illustrate what Jewish primitivism could mean in the aftermath of destruction. The first example of Kisch's primitivism was written after the First World War, in which eastern European Jews faced unprecedented devastation. This text, an article on the Golem legend, tests the relationship between folklore and modernity. The article was published twice in book form, first as "Dem Golem auf der Spur" (On the trail of the Golem), in Kisch's collection *Der Rasende Reporter* (The raging reporter, 1924), then slightly shortened as "Den Golem wiederzuerwecken" ("Reawakening the Golem") in the collection *Geschichten aus sieben Ghettos* (*Tales from Seven Ghettos*, 1934).[7] It is a first-person reportage describing the author's search for the Golem in the attic of Prague's ancient synagogue, the Altneuschul, where its dusty remains were laid to rest, according to legend. The text resembles Kisch's journalistic essays but retains a temporal and geographic looseness that gives it the cast of fiction. As Sigrid Mayer points out, the title of the first collection identifies the piece

as reportage, whereas the second book identifies it as a *Geschichte* (story).[8] Whether or not the events in the article can be verified is beside the point; Kisch's main subject is the meaning of his search for the Golem of Prague.

He uses the story to displace and reconfigure notions of Jewish identity based on east and west, tradition and modernity. He invokes the First World War as a metonymic representation of the violence of modernity;[9] his depiction of the tragic and destructive effect of the modern world on the life of a traditional Jew turns, in the final sentences of the article, to the impact of modernity on the lives of the working masses.

The article begins with an encounter with an *Ostjude* during the First World War. Writing from the perspective of an unspecified number of years after the war, Kisch recounts how his military company was stationed in a Carpathian village (Wola-Michowa, now in southeastern Poland), where he was quartered in the home of a Jew with a large pile of books behind his stove.[10] When his host saw that Kisch could read the Hebrew books, he struck up a conversation; upon finding out that Kisch was from Prague, he showed a great deal of knowledge about the city. It turned out that his interest was focused specifically on "the grave of the Great Rabbi Löw and the place where the Golem lay."[11]

This country Jew from a remote Carpathian village had learned about Prague from an old city guide he possessed, but his interest had nothing to do with the sights of Prague—he was interested in the grave of the Maharal and finding the final resting place of the Golem, located, according to tradition, in the attic of the Altneuschul, the medieval synagogue. His interest in Prague was freighted with almost excessive symbolism—he was interested in what was below and what was above, forgoing the intermediacy of the cityscape.

The same incompatibility of belief in the Golem and contact with the "real" world was expressed in the introduction of another book that the Jew kept behind the stove—a bilingual Hebrew and Yiddish book containing stories of the Maharal and his Golem. Kisch relays the text of the title page as well as its publisher and year of publication (1911), information that indicates it is likely the book by Yudl Rosenberg that was the source for most modern versions of the Golem legends.[12] Before describing the contents of the book, specifically the legends pertaining to the Golem, Kisch describes the introduction, which contained "an expert evaluation by Dr. A. Berliner, lecturer at the Berlin Rabbinical Seminary," who said that "this book is a hodge-podge of superstitions and should have been burned, not printed."[13] Abraham Berliner was a

neo-Orthodox philologist of the classic *Wissenschaft des Judentums* cast; his scholarly interests were in classical texts, not in folklore or anthropology. One of his publications was a defense against the blood libel; but his scholarly and rabbinic activities—typical of the German Orthodox elite—seem to qualify him for scorn in the eastern European Yiddish book that belonged to Kisch's host. The book's editor responded to Berliner's note as follows: "Whoever does not believe in established facts should be burned!"[14] This tussle between western scholar and eastern believer in the introduction parallels the dynamic that is initially performed by Kisch and his interlocutor. It is the classical interpretation of the nonprimitivist *Ostjude-Westjude* encounter: the *Ostjude* is regarded negatively by the *Westjude*, who dismisses him as primitive in lifestyle and beliefs; the *Westjude* is seen by the *Ostjude* to be so overly rational that he rejects accepted religious beliefs and established facts.

Kisch performs both conflicting roles of the outsider—ironic, deprecating observer as well as unquestioning admirer of the *Ostjuden*. Speaking German, wearing an Austro-Hungarian uniform as a member of the occupying army, and describing the filthy home of the Jew as well as his stunted (*kleingewachsen*) stature, Kisch initially expresses discomfort and even hostility. But then, contrasting himself to his fellow soldiers who throw the Jew's books back behind the oven when they see their foreign script, Kisch picks up a book and begins to read. This leads to a conversation with the Jew, who claims a measure of cosmopolitan identity by saying "Perhaps I know more about Prague than a native of Prague!"[15] He also reclassifies Prague as a place of piety as he reveals that his interest in Prague is not in any aspect of its contemporary existence but in its ancient legends of the Golem. Kisch, by contrast, needed to travel to a remote part of eastern Europe in order to acquire an interest in the Golem, which was part of the lore of his hometown.

Kisch and the Carpathian Jew meet up two years later in Vienna. His Carpathian host had turned gray and had fled the front: "A shell had torn his son to pieces in the lean-to of the synagogue in Wola-Michowa and shortly afterwards something terrible had happened to his wife, he did not say what it had been."[16] Kisch asked his former host whether he, the Carpathian Jew, would continue his quest for the Golem; he said no. Kisch then asked whether he himself should continue the search, and the man replied, "Do what you like."[17] Upon this relocation of their relationship to the west, the transfer is complete: the *Ostjude*, his life ruptured by the quintessentially modern war, abandons his

mystical, folkloric interests. The *Westjude*, who by virtue of the war had gone to the east and discovered there a western legend, chooses to possess it fully, both in following the historical traces of the legend and in writing an article about it.

In this meeting in Vienna, Kisch has subtly and movingly evoked the intersection of traditional Jewish lifeways and modernity, with the quest for the Golem synecdochally taking the place of the former and the war representing the latter. Slightly later in the essay, after Kisch describes his foray into the shaky, dusty attic of the medieval Altneuschul in Prague, the purported resting place of the Golem, he once again thinks of his Carpathian host, describing the conflict represented by his tragic life. Remembering a manuscript with further secrets of the Golem that the Carpathian Jew possessed in addition to the copy of Rosenberg's book, Kisch writes:

> He purchased it from a sage, from a sage. . . . It only cost him eighty Gulden. Those pages seemed to my naïve friend to contain all the secrets of existence. When he touched the book, it was as if he was caressing it.
>
> Poor, trusting, superstitious village Jew [*Dorfjude*]! There was nothing in your books to tell you that a shell would tear apart your child, and that your wife would be raped and killed. The books did not say that you would lose your belief in miracles, that you would be chased from your home [*Heimat*], that you would wander the streets of Vienna in despair.[18]

Kisch lays bare what he describes as the disenchantment of the "Dorfjude," the shtetl Jew. Previously, in the faraway forested mountain village of his "Heimat," he had found meaning and magic in what Kisch calls superstition. The poor man even spent a large sum of money on his Golem fantasies. But, according to Kisch, nothing in his traditional way of life and its folklore could prepare him for the crisis of modernity inflicting its tragedy on him. He shows that modernity has exploded the viability of folklore and traditional belief as a foundation for Jewish life. At that same moment, however, its viability for the secular Jew is ignited—Kisch picks up the thread of the quest, adopting it as his own.

Where could such a quest lead? Kisch concludes the article by describing the cemetery where, according to another legend, the Golem's body had been transported after unsuccessful attempts to revive him. Kisch observes the scene: "Here I am on the spot to which the Golem is said to have gone on his last journey. The grave of the Golem."[19] The mystical location of the Golem's grave is actually a modest, dirty hill. Kisch's focus then turns to the people in the area: he describes the factory horns sounding the end of the workday and

the people trying to relax on the grounds of the cemetery. He ends the essay with the following reflection: "People are going home to their apartments behind the city, tired, bent over, drained of blood. . . . And standing above the grave of the Golem, I know why it must be that the robot, unconditionally subject to someone else's will, working for someone else's benefit, must be buried irretrievably."[20] This moving reflection recasts the Golem as a symbol, not of tradition but of modernity; it is not a magical being but a mechanized robot. It represents the working people who have become, in their subservience and degradation under capitalism, robots themselves.[21] Kisch has found the Golem at the edges of Prague; but the story of the Golem is no longer folklore—it is reality.

The legend of the Golem was, as An-sky wrote, about protecting Jews from violence.[22] For the Carpathian Jew such folklore was enough to counteract the ordinary suffering of his isolation and poverty, living in a lean-to against the synagogue of his remote hometown. But the conditions of his life that made the Golem legends meaningful have been nullified by the war. And so Kisch takes up the search.

Kisch lays bare the way decontextualization, secularization, disenchantment, and violence are intertwined; he comes into possession of this piece of folklore only once it has lost its meaning, once its meaning has been destroyed. As Baudrillard wrote, "For ethnology to live, its object must die. But the latter revenges itself by dying for having been 'discovered,' and defies by its death the science that wants to take hold of it."[23] If primitivism relies on the authenticity and savagery of its sources to fend off the powerful ugliness of modernity, Kisch shows how modernity neuters that savagery and authenticity. Kisch shows the end of primitivism.

Jewish Primitivism after the Holocaust

Kisch evaded the war by fleeing to Mexico, where he lived from 1940 to 1946. In 1945 he published a book of articles on his experiences in Mexico, *Entdeckungen in Mexiko* (*Discoveries in Mexico*).[24] This collection contains an article titled "Indiodorf unter dem Davidstern" ("An Indian Village under the Star of David"),[25] which, in a fashion similar to his Golem story, juxtaposes personal tragedy with primitivist motifs. The article portrays a visit Kisch made to the tiny village of Venta Prieta, probably in 1945. This village is known for a Jewish community of indeterminate origin. It is thought that these Jews (who still live

in Venta Prieta but have now conformed to normative strains of Judaism) were descended from crypto-Jews who hid from the Inquisition among indigenous Mexicans, or perhaps from a group of Mexicans who had converted at some point in the somewhat distant past. Kisch goes to investigate, having ascertained that the Jews of the village hold Sabbath services early every Saturday morning. He had expected "something grotesque" and recalls an old comedy routine from Vienna, in which the comedian sings a ditty "all decked out in Indian feathers and Apache war paint, but with the side curls of an orthodox Jew from Eastern Europe and in the prayer shawl worn in the synagogue."[26] For "authentic information," he seeks out Señor Enrique Téllez, the head of the community.[27] Don Enrique does not answer the question of the ethnic origins of the community. Instead he tells Kisch a story of origins much more familiar: his grandfather had lived elsewhere in Mexico and was seized in a pogrom, ordered to convert to Christianity, and burned to death by a mob when he refused. The Jews fled the town, and Don Enrique's father came to the deserted area now inhabited by the two extended families that comprise the town's Jewish population. The rest of the villagers were Otomí Indians.[28] The story swerves into primitivist caricature (which nevertheless seems to be true), when Kisch, upon asking who will lead the Sabbath services, is told that none of the villagers are able to, and so they import a rabbi from nearby who is an "Abyssinian." The community's distance from familiar forms of Judaism, let alone from the grandeur and vaunted tradition of Kisch's native Prague, is further emphasized by the synagogue's lack of a Torah—instead they use a Spanish volume of the Old and New Testaments.

Unlike the primitivist encounters described in this book, which cast European Jews as tribesmen and as Africans, Kisch has met here a group of Jews who actually are indigenous and a rabbi who actually is African. Yet Kisch's encounter is a moment of failed primitivism. The difference of the Indian Jews dissolves in similitude. He writes that the worship was "in essence a Sabbath service like anywhere else."[29] Most poignantly and powerfully, Kisch joins the congregants who step forward at the end of the service to recite the "prayer for the dead."[30] He ends the essay with a meditation on the meaning of reciting this prayer in this place:

> My father and mother were born in Prague, lived there, and are buried there.
> It never could have occurred to them that one day one of their sons would
> be reciting the prayer for the dead for them amid a group of Indians, in the

shadows of the silver-laden mountains of Pachuca. My parents, who lived their entire lives in the Bear House of Prague's Old Town, never dreamt that their sons would sometime be driven out of the Bear House, one of them to Mexico, another to India, and the two who were unable to escape the Hitler terror, to unknown places of unimaginable horror. My thoughts roamed farther—to relatives, friends, acquaintances, and enemies, sacrifices of Hitler, all entitled to be remembered in the prayer for the dead.[31]

In his Golem story, Kisch represented the inability of the legend of the Golem—and by extension all folklore—to give meaning in the face of the violence of modernity. The story ends with a vision of a procession of workers, turned into robots by the calamity of capitalism. The story of his visit to the Indian Jews ends with an even bleaker vision of all those who were murdered in the Holocaust:

a procession of millions: men and women who their whole lives strove to nourish their families . . . ; employees and laborers who earned their daily bread by the sweat of their brows; doctors who were ready day and night to help the suffering. . . . Immense is the column; it drags on, as if mankind had never existed, as if the idea of mankind had never existed, never the aspiration to bring into the world more bread, more right, more truth, more health, more wisdom, more beauty, more love, and more happiness.[32]

Saying Kaddish with the Indian Jews, Kisch creates a moment of solidarity. In the face of genocide, primitive difference loses its significance. But Jewish primitivism has not been replaced by something more humane. Even the idea of humanity seems to have been lost. Sheer superstition, as Kafka said.

NOTES

Introduction

1. Brod, *Franz Kafka*, 188. All translations are my own except where otherwise noted. In some instances, I have slightly modified others' translations as needed.

2. Scholem described how many of his cohort felt drawn to the *Ostjuden* and that among the Zionists this feeling became "a cult of Eastern Jews." Scholem, *From Berlin to Jerusalem*, 44.

3. Kafka, "An Introductory Talk on the Yiddish Language," 263–66.

4. Kafka, *Letter to the Father / Brief an den Vater*.

5. The last was an ethnographic term invented by Lucien Lévy-Bruhl; see Lévy-Bruhl, *Primitive Mentality*.

6. Moss, *Jewish Renaissance in the Russian Revolution*; Gottesman, *Defining the Yiddish Nation*. There were also, of course, negative portrayals of Jews as primitive and uncivilized, including by other Jews. See Aschheim, *Brothers and Strangers*; Gilman, *Jewish Self-Hatred*.

7. This is a central component of primitivism according to Ben Etherington. More broadly, salvage was a major motivating factor for ethnography in the period. See Etherington, *Literary Primitivism*; Gruber, "Ethnographic Salvage and the Shaping of Anthropology"; Clifford, "The 'Others.'"

8. Qtd. in Bauschinger, *Else Lasker-Schüler*, 400.

9. Kafka, *Tagebücher*, 622.

10. Jonathan Boyarin calls this aspect of Kafka's works "minor ethnography." See Boyarin, "The Other Within and the Other Without."

11. Bal Makhshoves, "Bal Makhshoves vegn zikh aleyn," 35.

12. A more typical response is that of the Russian-Jewish composer Joel Engel, who participated in S. An-sky's ethnographic expedition among eastern European Jews in

1912 and found, according to James Loeffler, that "the closer he came to the shtetl, the more Engel sensed his own distance—linguistic, cultural, even spiritual—from the folk itself." Loeffler, *The Most Musical Nation*, 91–92.

13. According to Etherington, however, primitivism is an aesthetic project and *not* a set of assumptions about or representations of identity. As will become clear, I argue that Jewish primitivism is both. Etherington, *Literary Primitivism*, 9.

14. "Es lign far undz tsvey vegn. Eyn veg keyn Eyrope, vu di yidishe form darf farnikhtet vern, der tsveyter veg tsurik." Peretz, "Vegn der yidisher literatur," 381.

15. Peretz, "Gedanken in der velt arayn," 152.

16. Folklore would itself have been a neologism, of course. On the various terms in Yiddish, see Erlich, "Vos iz taytsh folkstimlekh?"; Kirshenblatt-Gimblett, "Di folkloristik."

17. This flexibility was related to that of Jewish ethnography, as Andreas Kilcher and Gabriella Safran have shown. They write that Jewish ethnography creates a paradox "by constantly posing the question of what it means to be Jewish, offering transnational and transcultural responses, positing the ethnographer as now on one side, now on the other side of the border between subject and object, Jewish and non-Jewish, exotic and familiar." By contrast, I argue that Jewish primitivism pushes the ethnographic situation further, positing not an either/or scenario in which the Jew is now on one side and now on the other but one in which the Jew inhabits both positions. Kilcher and Safran, introduction to *Writing Jewish Culture*, 10.

18. The disciplines and areas into which Jewish primitivism falls—art history, comparative literature, modernism studies—have also only seldom admitted Jewish topics into their purview. The reasons for this are presumably many and dispiriting.

19. Why it has not been included is less a question about primitivism than one about its scholarly reception; I will speculate about this below. A reassessment of primitivism along similar lines is undertaken by Ben Etherington in *Literary Primitivism*.

20. And Jewish primitivism set askew the goals and consequences of primitivism because European Jews also did not fit the model of primitiveness set by ethnography. According to anthropologist Thomas Hauschild, the history of anthropology and folklore studies reveals the disciplinary gap into which the study of Jews fell. Hauschild, "Christians, Jews, and the Other in German Anthropology," 748.

21. Fabian, *Time and the Other*; Wolf, *Europe and the People without History*.

22. Lovejoy and Boas, *Primitivism and Related Ideas in Antiquity*, 9.

23. Lovejoy and Boas, 1.

24. Lovejoy and Boas, 7.

25. Lovejoy and Boas, 9–10.

26. Goldwater, *Primitivism in Modern Art*, 252.

27. Goldwater, 254.

28. Goldwater, 264–65.

29. Garrigan Mattar, *Primitivism, Science, and the Irish Revival*; Castle, *Modernism and the Celtic Revival*; McCrea, *Languages of the Night*.

30. The alternative, sometimes complementary, identification of children and madmen as psychologically primitive was also different—their identities were not deter-

mined by nation, race, ethnicity, or language; in other words, they were in Europe but not of Europe. On children as primitives, see Goldwater, *Primitivism in Modern Art*, 192–214. On insanity in modernism, see Micale, *The Mind of Modernism*. On both categories, see Gess, *Primitives Denken*.

31. Castle, *Modernism and the Celtic Revival*, 7. On the other side of Europe, Russian "neoprimitivism" combined a focus on domestic peasant culture and heretical sects with an interest in the Siberian and central Asian tribes at the empire's farthest reaches. The dynamics of Russian domestic primitivism are roughly akin to those of Irish primitivism. In other words, the distance between subject and object was always clear. On Russian primitivism, see Bowlt, "Neo-primitivism and Russian Painting" and *Russian Art of the Avant-Garde*; Bowlt, Misler, and Petrova, *The Russian Avant-Garde*; Hansen-Löve, *Über das Vorgestern ins Übermorgen* and "Vom Vorgestern ins Übermorgen"; Weiss, *Kandinsky and Old Russia*.

32. Goldwater, *Primitivism in Modern Art*.

33. Torgovnick, *Gone Primitive*; Gikandi, "Picasso, Africa, and the Schemata of Difference."

34. Chipp, *Theories of Modern Art*, 86.

35. Chipp, 86.

36. Chipp, 79.

37. The seminal study on this subject is Solomon-Godeau, "Going Native."

38. For an account of the way that a broader view of primitivisms challenges the standard scholarly narrative about primitivism, see Etherington, *Literary Primitivism*.

39. See Gikandi, "Picasso, Africa, and the Schemata of Difference"; Lemke, *Primitivist Modernism*; Foster, "The 'Primitive' Unconscious of Modern Art"; Hay, "Primitivism Reconsidered (Part 1)."

40. Lemke, *Primitivist Modernism*, 18. Lemke uses the term "black primitivism" following Huggins, *Harlem Renaissance*, 126–27.

41. Lemke, *Primitivist Modernism*, esp. 47–58.

42. Lemke; McCabe, "The Multifaceted Politics of Primitivism in Harlem Renaissance Writing"; Kraut, "Between Primitivism and Diaspora"; Chinitz, "Rejuvenation through Joy"; Sweeney, *From Fetish to Subject*.

43. McCabe, "Multifaceted Politics of Primitivism," 489. A less nuanced approach to primitivism leads other scholars to see McKay as subverting primitivism, e.g., Peppis, *Sciences of Modernism*, chap. 2.

44. Lemke, *Primitivist Modernism*, 48.

45. Lemke, 51.

46. By contrast, the object of Jewish primitivism found no purchase outside its own precincts. While some non-Jewish artists and thinkers might have considered Jewish culture theoretically interesting (e.g., Herder, who wrote a book on ancient Hebrew poetry), with few exceptions (e.g., Leopold von Sacher-Masoch), only Jews employed Jewish culture as the basis of their creative work.

47. More specifically, minority primitivism: two of Etherington's case studies are on Caribbean-born black writers, Aimé Césaire in French and Claude McKay in English.

48. Etherington, *Literary Primitivism*, 7. Similarly, in her study of Irish primitivism, Sinéad Garrigan Mattar asserts that primitivism "is not a thing, but a process." This is to be distinguished from Johannes Fabian's contention that "primitive . . . is a category, not an object, of Western thought." Erhard Schüttpelz follows Fabian in his study of European ethnographic texts; his sources lead him to an implicit acceptance of a primitive object that is exotically other. He bypasses the possibility that minority primitivisms create primitive objects based on social realities, which are not exclusive of—and should not be excluded by—categories of thought. Mattar, *Primitivism, Science, and the Irish Revival*, 3; Fabian, *Time and the Other*, 18; Schüttpelz, "Zur Definition des literarischen Primitivismus," 18; Schüttpelz, *Die Moderne im Spiegel des Primitiven*.

49. Etherington, *Literary Primitivism*, xii–xiii.

50. Goldwater, *Primitivism in Modern Art*, 255.

51. Barnard, "Herder and Israel."

52. Arnold, *Culture and Anarchy*, 49.

53. Tylor, *Primitive Culture*.

54. Weiser, *Jewish People, Yiddish Nation*; Gottesman, *Defining the Yiddish Nation*.

55. Bartal, "The Ingathering of Traditions" and "The Kinnus Project"; A. Rubin, "Hebrew Folklore and the Problem of Exile."

56. Moss, *Jewish Renaissance in the Russian Revolution*, 4. See also Kiel, "A Twice Lost Legacy."

57. Nichanian, *Mourning Philology*, 8.

58. Gourgouris, *Dream Nation*, chap. 4. Gourgouris's term "autoscopic mimicry" is related to autoethnography, as defined by Mary Louise Pratt. According to Pratt, "An autoethnography is a text in which people undertake to describe themselves in ways that engage with representations others have made of them." Both terms presuppose a clear distinction between subject and object and entail the conversion of one into the other; Jewish primitivism can therefore not be autoethnographic (even though it is, of course, self-directed) because its subject and object are always already, so to speak, amalgamated. Pratt, "Arts of the Contact Zone," 35.

59. Nichanian, *Mourning Philology*, 75.

60. This decolonization can then be transformed into the recolonization of a new object, as I will show in Chapter 4.

61. The idea that domestic (i.e., folkloric) objects were fundamentally distinguished in European culture from ethnographic (i.e., primitive) objects is derived from the disciplinary development of the two branches of ethnology in the nineteenth century, *Volkskunde* (the study of European folk culture), usually translated as folklore studies, and *Völkerkunde* (the study of exotic peoples), typically translated as ethnography. But this fundamental epistemological and disciplinary split between folklore studies and ethnography—the split between the study of the domestic German peasant and the exotic, foreign savage—was not a meaningful distinction for Herder. Although he has gone down as the father of European folklore studies (*Volkskunde*), his interest in the subject was motivated by an "enthusiasm for savages [*Wilden*]," as he put it (*Schriften zur Ästhetik und Literatur 1767–1781*, 456). This enthusiasm for savages was expressed

in comments on the songs of Ossian—the purportedly ancient Scottish poet actually invented by James Macpherson (1736–96). In Herder we thus have the roots of a conflation—the exotic with the indigenous, the savage with the domestic—that underpins the cultural manifestations of folklore studies as the later development of primitivism in art and literature. The institutional development of the disciplines sublated this conflation, quickly dissociating Europeanness from primitiveness. Herder's conflation of the European and the "wild" only fully emerged again with the idea that an enthusiasm for Jews and an enthusiasm for savages could be one and the same thing.

62. Kiefer, *Diskurswandel im Werk Carl Einsteins*, 147.

63. Severi, "Primitivist Empathy," 113.

64. For studies of these phenomena, see S. Katz, *Red, Black, and Jew*; Krutikov, "Slavishe erd vehapo'etiqah hamodernizm beyidish"; Rubinstein, *Members of the Tribe*; Sundquist, *Strangers in the Land*. Gabriella Safran's important reading of S. An-sky's engagement with Siberian primitivism comes closest to articulating a version of primitivism akin to the one I describe. An-sky, writes Safran, "toyed with stylizing his Jewish folk culture after the model of the Siberian primitive," but ultimately "step[ped] back from primitivism itself." Safran, "Jews as Siberian Natives," 649, 651.

65. W. Rubin, *"Primitivism" in 20th Century Art*.

66. Einstein, *Werke: Texte aus dem Nachlaß I*, 153.

67. Einstein, 154. He referred to his early avant-garde novella, *Bebuquin oder die Dilettanten des Wunders*.

68. While there are certainly book chapters and articles that treat primitivism in literature, the following list contains most books in English or German that take literary primitivism as their primary subject, to my knowledge: Bell, *Primitivism*; Etherington, *Literary Primitivism*; Gess, *Literarischer Primitivismus* and *Primitives Denken*; Mattar, *Primitivism, Science, and the Irish Revival*; Pan, *Primitive Renaissance*; Schüttpelz, *Die Moderne im Spiegel des Primitiven*; and Werkmeister, *Kulturen jenseits der Schrift*.

69. Gess, "Literarischer Primitivismus: Chancen und Grenzen eines Begriffs," in Gess, *Literarischer Primitivismus*, 1–2. See also Gess, *Primitives Denken*, 19–22.

70. He allows for a literary primitivism on the model of *Persian Letters* (Montesquieu, 1721), i.e., a European text in the image of an imagined exotic perspective. Schüttpelz, *Die Moderne im Spiegel des Primitiven*, 361.

71. David Pan also charges Schüttpelz with implicitly identifying the primitive with the exotic. Pan, "Erhard Schüttpelz." Nicola Gess solves this problem by changing primitivism's purview, which in her definition takes primitive thought, not art, as its model and therefore includes children and the insane, in addition to ethnographic savages, among its objects.

72. The history of Jewish art was a brand-new discipline; Jewish art had only relatively recently begun to be collected by private collectors and was only sporadically exhibited. By contrast, Jewish folklore was broadly published in popular and scholarly editions.

73. Ben Etherington's *Literary Primitivism* treats literary texts but offers a theoretical approach applicable across media. See, e.g., Etherington, *Literary Primitivism*, xvii.

74. For relevant studies of Jewish music, see Loeffler, "Do Zionists Read Music from Right to Left?," "From Biblical Antiquarianism to Revolutionary Modernism," and *The Most Musical Nation*; Móricz, *Jewish Identities*; Walden, "'An Essential Expression of the People'" and *Sounding Authentic*.

75. Trachtenberg, *The Revolutionary Roots of Modern Yiddish, 1903–1917*, 48–53; D. Katz, *Words on Fire*, chap. 7; Goldsmith, *Modern Yiddish Culture*, 36–42.

76. Kronfeld, *On the Margins of Modernism*; Schachter, *Diasporic Modernisms*; N. Brenner, *Lingering Bilingualism*.

77. On Yiddish in Germany, see Alt, "The Berlin Milgroym Group and Modernism," "A Survey of Literary Contributions to the Post–World War I Yiddish Journals of Berlin," and "Yiddish and Berlin's 'Scheunenviertel'"; Bechtel, "Cultural Transfers between 'Ostjuden' and 'Westjuden' German-Jewish Intellectuals and Yiddish Culture 1897–1930" and "1922: *Milgroym*, a Yiddish Magazine of Arts and Letters, Is Founded in Berlin by Mark Wischnitzer"; Block, "The Dialectics of Jewish Author and Jewish Other in German-Jewish and Yiddish Literatures, 1886–1939"; Brenner, *Lingering Bilingualism*; Caplan, *Yiddish Writers in Weimar Berlin*; Estraikh, "Vilna on the Spree"; Estraikh and Krutikov, *Yiddish in Weimar Berlin*; Grossman, "The Yiddish-German Connection"; Schachter, *Diasporic Modernisms*; Seelig, *Strangers in Berlin*.

78. For example, despite the fact that the overlap between readers of the German works of Else Lasker-Schüler and the Hebrew works of Uri Zvi Grinberg was likely small, their aesthetic interchange was profound, as I will show in Chapter 4.

79. Scholem, *From Berlin to Jerusalem*, 44.

80. Aschheim, *Brothers and Strangers*. See also Myers, "'Distant Relatives Happening onto the Same Inn'"; Wertheimer, "'The Unwanted Element.'"

81. Volkov, "The Dynamics of Dissimilation: Ostjuden and German Jews." Jonathan Skolnik argues that dissimilation is less a negation of than a "dialogue with a majority culture." See Skolnik, *Jewish Pasts, German Fictions*, 9.

82. An entire discourse coalesced around the term, which was popularized in part by Nathan Birnbaum. See Olson, *Nathan Birnbaum and Jewish Modernity*.

83. Mattenklott, "Ostjudentum und Exotismus"; Mendes-Flohr, "Fin-de-Siècle Orientalism, the Ostjuden and the Aesthetics of Jewish Self-Affirmation"; Aschheim, *Brothers and Strangers*; Myers, "Distant Relatives Happening onto the Same Inn."

84. Bal Makhshoves, "Tsvey shprakhn—eyneyntsike literatur."

85. Wallach, *Passing Illusions*.

86. Peretz, "Gedanken in der velt arayn," 43–44.

87. Berlewi, "Yidishe kinstler in der hayntiger rusisher kunst."

Chapter 1

1. Peretz, "Gedanken in der velt arayn," 153.

2. Peretz, 152.

3. Peretz, 152. The description is admittedly ironic, not because Peretz does not think this was the appropriate task for people concerned with Jewish art, but because

he believed people treated this vital process as a trivial matter. Bal Makhshoves issued a similar command in his 1922 article "Der yidisher mitos," in which he writes: "What we are going through now cannot make us suited to stylizing and creating the Yiddish folktale. . . . Our task should only be the work of collecting alone. We must simply provide for our heirs." See Bal Makhshoves, "Der yidisher mitos," 10.

4. Nichanian, *Mourning Philology*, 8.

5. Kiel, "A Twice Lost Legacy"; Moss, *Jewish Renaissance in the Russian Revolution*; Weiser, *Jewish People, Yiddish Nation*; Gottesman, *Defining the Yiddish Nation*; Schweid, *The Idea of Modern Jewish Culture*; Aberbach, *Jewish Cultural Nationalism*.

6. Biale et al., *Hasidism*, 560.

7. Berdichevsky, *Sefer ḥasidim*, 14.

8. Buber, "Jüdische Renaissance."

9. Charney objects to the description of Peretz as neo-Hasidic, though he essentially describes what subsequent scholarship has designated neo-Hasidism. Niger, *Y. L. Perets*, 275.

10. Shmuel Charney notes that Peretz was not the first to "idealize" Jewish folklife and -lore. See Niger, 271. Itzik Gottesman identifies an 1889 article by Y. Y. Lerner as the first to connect the ideology of Yiddishism and folklore. See Gottesman, *Defining the Yiddish Nation*, xvii. What would have been the first anthology of Yiddish folksongs was prepared by Y. L. Peretz in 1894–95 but never published. See Gordon-Mlotek, "Y. L. Peretses zamlung yidishe folkslider"; Mayzel, *Y. L. Perets zayn lebn un shafn*, 171. Other collections of Yiddish proverbs and the like only appeared a few years earlier, with the major collection of folksongs by Marek and Ginsburg published in 1901. See Gottesman, *Defining the Yiddish Nation*.

11. Grossman, "From East to West."

12. Kiel, "Vox Populi, Vox Dei."

13. Werberger, "Ethnoliterary Modernity."

14. Miron, "Literature as a Vehicle for a National Renaissance," 39.

15. Miron, 46.

16. The literature on this aspect of Herder's thought is large. For useful overviews of the topic in English, see Bauman and Briggs, *Voices of Modernity*, 163–96; Bendix, *In Search of Authenticity*, 27–44; Koepke, "Herder and the Sturm und Drang"; Wilson, "Herder, Folklore and Romantic Nationalism."

17. Singer, *"Nachgesang"* and *"'Wie es in uns übertönet.'"*

18. Mark Kiel refers to this mode of translation among these Yiddish writers as *iberdikhtung* and asserts that the word was in common parlance, yet he offers no sources for any specific usage or the general assertion. A proper genealogy of the term is needed. See Kiel, "A Twice Lost Legacy," 7.

19. Gombocz, "The Reception of Herder in Central Europe: Idealization and Exaggeration"; Schulte, *Hebräische Poesie und jüdischer Volksgeist*; Nisbet, "Herder's Conception of Nationhood and its Influence in Eastern Europe"; Drews, *Herder und die Slaven*; Lehmann, Grasshoff, and Ziegengeist, *Johann Gottfried Herder*.

20. Miron, "Folklore and Antifolklore in the Yiddish Fiction of the Haskala."

21. Kirshenblatt-Gimblett, "Problems in the Early History of Jewish Folkloristics," 24.

22. On Herder's influence in the Jewish context, see Schulte, *Hebräische Poesie und jüdischer Volksgeist.*

23. Schulte; Shapira, "Buber's Attachment to Herder and German 'Volkism'"; Aberbach, *Jewish Cultural Nationalism*; Berkowitz, *Nationalism, Zionism and Ethnic Mobilization of the Jews in 1900 and Beyond*; D. Brenner, *Marketing Identities* and "Promoting East European Jewry"; M. Brenner, *The Renaissance of Jewish Culture in Weimar Germany.*

24. The list is long: C. N. Bialik, Berdichevsky, Buber, Peretz, S. An-sky, S. Y. Agnon, Itzik Manger, and others.

25. Although Stewart describes a phenomenon that was most prevalent in the eighteenth century, its enmeshment with the development of folklore studies meant that the distressed genre as aesthetic as well as ideological tool was operative into the twentieth century. Stewart, "Notes on Distressed Genres," 25–26.

26. Stewart notes, for example, the American folk festival and the contemporary amusement park. Stewart, 6–7.

27. On the centrality of orality in the construction of folklore and primitive culture, see Harbsmeier, "Writing and the Other"; Schüttpelz, *Die Moderne im Spiegel des Primitiven*; Werkmeister, *Kulturen jenseits der Schrift*. On the collective and anonymous nature of folklore (as well as its orality), see, e.g., Ben-Amos, "The Idea of Folklore."

28. Vanvild, *Bay undz yidn*, i.

29. Buber, foreword to *Der große Maggid und seine Nachfolge*, vi–vii.

30. Buber, viii.

31. Buber, viii. It seems to me that Buber's *weiterdichten* is synonymous with *nachdichten.*

32. Buber, *Die chassidischen Bücher*, 3.

33. Buber, 3.

34. Buber, *The Legend of the Baal-Shem*, x.

35. Qtd. in Mayzel, *Y. L. Perets zayn lebn un shafn*, 176.

36. Peretz, "Tshernovitser shprakh konferents," 371.

37. The compilers of both volumes are known: *Shivḥei habesht* was compiled by Dov Ber of Linits in the last decade of the eighteenth century, *Sipurei ma'asiyot* by Nosn Shternharts of Nemirov.

38. Peretz's position is premised on a misprision regarding the two early texts: despite their textuality, known authorship, and (relatively) recent provenance, he understands them as folkloric because they are Hasidic.

39. In fact, it is not even "fakelore" or "folklorismus," since Rabbi Nachman claimed authorship and never presented his works as folklore. Dundes, "Nationalistic Inferiority Complexes and the Fabrication of Fakelore"; Newall, "The Adaptation of Folklore and Tradition (Folklorismus)."

40. Schaechter, "Folkish un poshet-folkish," 52.

41. According to Schaechter, the first known usage of *folkstimlekh* is in Harkavy's dictionary from 1893. Schaechter postulates that Harkavy must have had evidence of the word's prior usage, since his dictionary is descriptive. Interestingly, the word "folklore" was a nineteenth-century English neologism transplanted to German and Yiddish. On the German word, see *Digitales Wörterbuch der deutschen Sprache*, s.v. "Folklore," www.dwds.de/wb/Folklore. On the Yiddish word, see Kirshenblatt-Gimblett, "Di folkloristik."

42. Schulte, *Hebräische Poesie und jüdischer Volksgeist*.

43. Peretz, "In folk arayn."

44. Berdichevsky, for his part, took the opposite approach, writing in a 1909 essay that the goal of literature in Yiddish ("the material of the folk") should be "to transmit it as it is" (*lemasro kemo shehu*). Berdichevsky, *Kitve Mikhah Yosef Bin-Gorion (Berdichevsky)*, 191.

45. Peretz, "Vos felt undzer literatur," 274.

46. Peretz, 275. Although opposed to colonial values, this image is still clearly racist.

47. Peretz, 277. Wellhausen was the most prominent early proponent of the documentary hypothesis of the Bible's origin and development. As such he was a hero to secularists and a foe of religious traditionalists. Peretz, by no means pious, deliberately takes a counterintuitive stand here.

48. Peretz, "Vegn der yidisher literatur," 381.

49. The Yiddish word for Jewish is the same as for the Yiddish language—*yidish*.

50. Peretz, 379. Peretz goes on to note that this travesty is noticeable when Yiddish writers are compared favorably to European writers: "a Yiddish Chekhov; a Yiddish Maupassant."

51. Peretz, 381.

52. He repeated the argument and the same rhetorical gesture in his 1910 essay "Vos felt undzer literatur" (279), in which he called for a return to the Bible, once again using the word *bibl*.

53. Peretz, 381.

54. Peretz, "Gedanken in der velt arayn," 152.

55. Peretz, 153.

56. Peretz, *Khsidish*, 102.

57. The pen name under which Charney published all his works is Shmuel Niger; most scholarship refers to him that way. Eli Bromberg has recently argued convincingly in favor of using Charney's legal name. I have opted to do so; all citations of his works, however, will use the name under which he published them. See Bromberg, "We Need to Talk about Shmuel Charney."

58. Niger, *Y. L. Perets*, 286. David Roskies makes a similar argument. See Roskies, "Rabbis, Rebbes and Other Humanists," 60.

59. Niger, *Y. L. Perets*, 287.

60. Ken Frieden calls this characteristic technique of Peretz's short stories "the Yiddish analogue of an 'O. Henry ending.'" Frieden, *Classic Yiddish Fiction*, 287.

61. Roskies, *A Bridge of Longing*, 120.

62. Miron, *Der imazh fun shtetl*, 111–12.

63. Miron, 112.

64. Peretz, "Bilder fun a provints rayze,"138–46.

65. Miron, *Der imazh fun shtetl*, 108.

66. Peretz, *The I. L. Peretz Reader*, 39–40.

67. Peretz, 41–42.

68. Peretz, "Mayses."

69. Peretz, "Shtet un shtetlekh," 198.

70. Peretz, 198.

71. Peretz, 272.

72. Interestingly, the Bialer Rebbe was the only Hasidic rebbe Peretz ever met. See Mayzel, *Briv un redes fun Y. L. Perets*, 321.

73. Peretz, "Bilder fun a provints rayze," 192–203.

74. The annual commemoration of the death of a close relative.

75. Peretz, 197.

76. Peretz, *Dramatishe verk*, 181–280.

77. Miron, "Literature as a Vehicle for a National Renaissance," 47.

78. David Roskies has made a similar argument, writing that "Peretz was too much the maskil, the modern . . . to credit the writing of mayselekh [folktales] with ultimate redemptive value." He derives this reading from across Peretz's oeuvre, including the story "Mayses" (Stories), which is a direct critique of the use of folklore as a social and literary practice. Roskies, *A Bridge of Longing*, 146.

79. Agnon, *Me'atzmi el 'atzmi*, 262.

80. Dan, "A Bow to Frumkinian Hasidism."

81. Bergelson, "Y. L. Perets un di khsidishe ideologye," *Literarishe bleter*, April 10, 1925. Shmuel Charney makes much the same point, wondering how a fellow critic (A. Litvin) could call Peretz's Hasidic stories *iberdikhtung*. Niger, *Y. L. Perets*, 274.

82. Bergelson, "Y. L. Perets un di khsidishe ideologye." His argument is a politically motivated rereading of Peretz, positing that his objective was to call for revolution.

83. Glatstein, *The Glatstein Chronicles*, 286.

84. Mayzel, "Perets mit undz," 7.

85. Mayzel, 7.

86. Markish, *Farbaygeyendik*, 38–39.

87. *Badkhonim* are entertainers who combine melodies with invented rhymes, most notably in celebration of weddings.

88. Markish, *Farbaygeyendik*, 39–40.

89. Markish, 40.

90. Ogden, "The Impossible Peasant Voice in Russian Culture."

91. Ogden.

92. First published in 1921 in Kiev and again in Berlin in 1923 in the Yiddish avant-garde periodical *Albatros*, edited by Uri Zvi Grinberg.

93. The critique was reiterated by the Polish Jewish artist Henryk Berlewi, who coined the apt, if ungenerous, term "Chagallism" for this type of art. Berlewi, "Yidishe kinstler in der hayntiger rusisher kunst," 16.

94. Tshaykov, *Skulptur*, 14.

95. Ogden, "The Impossible Peasant Voice in Russian Culture," 532. The second is "metastylization—a styling of someone else's styling of reality," 521.

96. Ogden, 522.

97. Bois, "Kahnweiler's Lesson."

98. W. Rubin, *"Primitivism" in 20th Century Art.*

99. Goldwater, *Primitivism in Modern Art.*

100. Severi, "Primitivist Empathy."

101. Severi, 113. Severi is clearly addressing the visual arts here; I maintain that definitions of primitivism drawn from the visual arts are, as I argued in the Introduction, largely applicable to literature.

102. Severi, 111–12.

103. There is a case to be made for reading some works by Micha Yosef Berdichevsky as exemplifying this combination of primitivist themes with European aesthetics, and perhaps even going further toward Jewish primitivism than Peretz. Berdichevsky's anthologies restored what he saw as a subterranean, pagan, "Hebrew" genealogy of the Jewish people and religion, and some of his stories scraped the surface of eastern European Jewish life to reveal hidden vital forces below. For example, "Parah adumah" ("The Red Heifer") describes Jews throwing off millennia-old strictures to devour blood and uncooked flesh. The story describes such a scene literally, but its hopes are metaphoric: Europe's Jews freed of inhibition, rejecting religious rigidity and social timidity. Even though his objects and his aims diverged in their intensity from those of Peretz and the other exponents of folklorism, ultimately Berdichevsky expressed these hopes—in his stories and anthologies—in a formal idiom derived from his European context. Moreover, the stories that are arguably primitivist—for example, "Parah adumah" and "Hahafsakah" ("The Interlude")—stage the restoration to order and stasis at the end of the primitive eruptions they describe. In terms of their narrative content and their form, they revert to the European standard. This assimilation or negation of the primitive moment resembles the humanistic co-optation of Hasidism in Peretz's *Khsidish* stories. David Ohana frames Berdichevsky's project similarly, calling his focus on the ancient Hebrews as a model for Jewishness a form of Romantic primitivism (essentially what I call folklorism). Further exploration of Berdichevsky's primitivism in the light of the Nietzscheanism and Canaanism that Ohana puts at the center of his project is warranted. See Ohana, *The Origins of Israeli Mythology.*

104. Niger, *Shmuesn vegn bikher*, 73.

Chapter 2

1. Clifford, *Routes*; Clifford and Marcus, *Writing Culture*; Pratt, *Imperial Eyes.*

2. Niger, *Shmuesn vegn bikher*, 73.

3. Goldwater, *Primitivism in Modern Art*, 254–55.

4. Roth, "Döblin im Osten," 532–35. Originally *Frankfurter Zeitung*, January 31, 1926.

5. Solomon-Godeau, "Going Native."

6. In a 1917 article, the Austro-Hungarian (and later Israeli) engineer Markus Reiner emphasized the difficulty of such a transformation. He issued a blistering critique of the "Western" stereotype of eastern European Jews as primitive, and by extension a critique of modernity, by undertaking a reverse primitivism: "This is how the *Ostjude* sees his European brother. He perceives him as primitive. Because he knows: it is easy, so easy, for a yeshiva student to become a factory or bank director in West Berlin, if he cuts off his spirit from God (and we have examples enough); but he also knows that it is hard, so hard, for a bank or factory director from West Berlin to hear and understand God's voice." Reiner, "Modernität und Primitivität," 704.

7. See Halper, "Coming Out of the Hasidic Closet"; Shanes, "Ahron Marcus."

8. Safran, "Jews as Siberian Natives," 651.

9. Bhabha, *The Location of Culture*, 64.

10. Pratt, "Arts of the Contact Zone," 35.

11. Gourgouris, *Dream Nation*.

12. Zilcosky, *Uncanny Encounters*, 14.

13. Zilcosky, 12.

14. Zilcosky, 178.

15. Shmuel Trigano argues that a similar dynamic was at work during the French Revolution when a refiguring of the Jew as Noble Savage paved the way to granting Jews rights, but only according to the logic that "every Jew is a man, but all men are not Jews, therefore the Jew does not exist, or if he does exist, he *must* not stand out from other men." Trigano, "The French Revolution and the Jews," 172.

16. Brod, *Franz Kafka*.

17. Halper, "Coming Out of the Hasidic Closet"; Holtzman, "Langer, Jiří."

18. A typical example of such a work is Arnold Zweig's *Das ostjüdische Antlitz*, a German-language literary ethnography of eastern European Jews. For more on this work, see Chapter 6.

19. Döblin, *Reise in Polen*, 137.

20. Translated as *The Enemy at His Pleasure* by Joachim Neugroschel.

21. Safran and Zipperstein, *The Worlds of S. An-sky*, xxvi–xxviii.

22. Döblin, *Journey to Poland*, 75.

23. This interest played out in numerous articles and essays, a travelogue, and even a book-length study strongly flavored by anthropology, sociology, and philosophy. On Döblin's Jewish works, see Bayerdörfer, "'Ghettokunst'"; Hwang, "Not All Who Wander Are Lost"; Isermann, *Der Text und das Unsagbare*; Müller-Salget, "Döblin and Judaism"; Skolnik, "Yiddish, the Storyteller, and German-Jewish Modernism"; Sonino, "Eine andere Rationalität";

24. Jonathan Skolnik's article is a notable exception.

25. Döblin, *Reise in Polen*, 248. My translations from the original German are made with occasional reference to Joachim Neugroschel's English translation—Döblin's text is

full of idiosyncracies and a second opinion is helpful. In places I have deferred fully to his English edition (with slight modifications) and cite accordingly.

26. Döblin, *Reise in Polen*, 137.

27. Döblin, 250–51.

28. Döblin, 251.

29. Döblin, *Journey to Poland*, 68.

30. Döblin, 69.

31. Döblin, 158.

32. Döblin, 158.

33. Döblin, 159.

34. Döblin, 159.

35. Döblin, 159.

36. Döblin, *Reise in Polen*, 208.

37. Döblin, *Journey to Poland*, 190.

38. Hoyt, "The Reanimation of the Primitive."

39. Döblin, *Reise in Polen*, 326.

40. Döblin, 326. In addition to the Jewish primitivism of the text, Döblin expresses a medieval primitivism that was more typical of German modernism (featuring, for example, in *The Blaue Reiter Almanac*) or the works of Emil Nolde.

41. Döblin, *Journey to Poland*, 187.

42. Neugroschel, "Editor's Introduction," xxvi.

43. Döblin, *Journey to Poland*, 72.

44. Döblin, 74.

45. Döblin, 76. The centrality of the "urban crowd" to modernist conceptions of primitiveness makes this a doubly powerful assertion of the primitive nature of the crowds of Hasidim. See Nye, "Savage Crowds, Modernism, and Modern Politics."

46. Döblin, *Journey to Poland*, 75. I have changed the translation of the word *Art* from "breed" to "sort."

47. Döblin, 75.

48. Döblin, 77.

49. Döblin, 77.

50. Döblin, 77.

51. Döblin, 77.

52. Döblin, 77.

53. Döblin, 77.

54. Döblin, 99–100.

55. A booth used during the weeklong Jewish festival of Sukkot.

56. Döblin, 80.

57. Döblin, 80.

58. Döblin, 81.

59. This doctrine, a staple of anthropology in the latter part of the nineteenth century and into the twentieth, understood features of contemporary culture that seemed

inexplicable to be preserved remnants of earlier culture. On survivals, see Hodgen, "The Doctrine of Survivals" and "Survivals and Social Origins"; Kirshenblatt-Gimblett, "Folklore's Crisis"; Lowie, "Survivals and the Historical Method."

60. Döblin, *Journey to Poland*, 64–65.

61. Döblin, 66.

62. Döblin, 162.

63. Döblin, 66.

64. Sonino, "Eine andere Rationalität," 154.

65. Döblin, *Journey to Poland*, 251. Neugroschel's translation has "Strzegom"; I maintain the German "Strickow" because of its similarity to the Yiddish name of the town. The rebbe was Rabbi Saadia Chanoch Zhychlinski (b. 1885, murdered in the Holocaust), the Zhychliner Rebbe (Döblin spells the rebbe's name "Sadie" and identifies him as the grandson of the "Gichliner" Rebbe). He had lived in Strickow for a time, so was also known as the Strickower Rebbe, although there was a separate dynasty of Strickower Rebbes. See Fridenzon, "Mayn tatns rebe in varshever geto"; Unger, *Seyfer kedoyshim*, 175–78.

66. Döblin, *Journey to Poland*, 251.

67. Döblin, 251.

68. Döblin, 253.

69. Döblin, 253.

70. Döblin, 252.

71. Döblin, 253.

72. Döblin, 253.

73. Döblin, 254.

74. Döblin, 254.

75. Döblin, 254.

76. Mark Gelber sees the entire book as a polemic against Western civilization. Gelber, "'Juden auf Wanderschaft' und die Rhetorik der Ost-West-Debatte im Werk Joseph Roths."

77. For a general introduction, see Horrocks, "The Construction of Eastern Jewry in Joseph Roth's 'Juden auf Wanderschaft.'"

78. Kilcher, "Cold Order and the Eros of Storytelling," 85.

79. Sonino, "Eine andere Rationalität," 154.

80. Kilcher, "Cold Order and the Eros of Storytelling," 87.

81. Roth, *The Wandering Jews*, 32.

82. Roth, 31.

83. Roth, 13.

84. Roth, 32.

85. He was not alone—the Hasidic rebbe was a focal point of Jewish literature in the period in German and Yiddish. Depictions of Hasidic rebbes also appear in Fishl Schneersohn's *Grenadir-shtrase* (1935; a Yiddish novel about Jews in Berlin); Martin Beradt's *Beide Seiten einer Straße* (1940; a German novel on the same subject); Peretz's collection *Khsidish*; and S. An-sky's play *Der dibek* and his war memoir *Khurbn Galitsiye*,

to name only the most prominent examples. Martin Buber's collections of Hasidic stories, of course, also feature rebbes, as do other anthologies of Hasidic stories from the period.

86. Roth, *Wandering Jews*, 33–34.

87. Roth, 34.

88. Roth, 35.

89. Roth, 36.

90. Roth, 38.

91. Roth, 38.

92. Roth, 39.

93. Roth, 39.

94. The celebratory end of the holiday season, marking the conclusion of the annual cycle of communal Torah readings.

95. Roth, 40.

96. Roth, 40.

97. Roth, 40.

98. The final lines paraphrase Unetaneh tokef, a central prayer of the High Holiday liturgy. Roth, 41.

99. Mark Gelber comments that the entire work, in contrast to Döblin's *Reise in Polen*, lacks any scholarly or ethnographic apparatus or sources. Yet Roth does cite statistics here and there—as does Döblin—and his rhetoric at times takes on a tone of authority that lays claim to ethnographic substantiation. Gelber, "Juden auf Wanderschaft."

100. Roth, *Wandering Jews*, 42.

101. Roth, 48.

102. This despite the satirical depiction of performed identity in Kafka's "Ein Bericht für eine Akademie."

103. See Roskies, "S. Ansky and the Paradigm of Return."

104. Noy, "The Place of Sh. Ansky in Jewish Folkloristics"; Deutsch, *The Jewish Dark Continent*; Kugelmass, "The Father of Jewish Ethnography?"

105. Ivanov, "An-sky, Evgeny Vakhtangov, and 'The Dybbuk.'"

106. S. An-sky to Chaim Zhitlowsky, December 17, 1909, Zhitlowsky papers, YIVO Archives; qtd. in Benjamin Lukin, "'An Academy Where Folklore Will Be Studied,'" 287.

107. Deutsch, *The Jewish Dark Continent*; Safran, *Wandering Soul*.

108. An-sky, *Der yidisher khurbn fun Poyln, Galitsiye, un Bukovine, fun tog-bukh, 1914–1917*.

109. Qtd. in Roskies, *The Literature of Destruction*, 210. As this text makes clear, the boundaries between Jewish history and anthropology in the period were not clearly demarcated. The scholars of *Wissenschaft des Judentums* were often concerned with the study of Jewish folklore, and Jewish folklore studies and anthropology in Germany (under Max Grunwald) and in Russia (under An-sky) emerged out of the confluence of disciplines under the wide umbrella of *Wissenschaft des Judentums*.

110. An-sky, *The Enemy at His Pleasure*, 21. I have modified Neugroschel's translation in places.

111. An-sky, 246.

112. An-sky, 246.

113. An-sky, 246.

114. An-sky, 247.

115. An-sky, 247.

116. An-sky, 247.

117. An-sky, 249.

118. An-sky, 249.

119. An-sky, 248–49.

120. An-sky, 249.

121. See, e.g., *Shulḥan Arukh, Ḥoshen Mishpat* 427:8.

122. An-sky, *Enemy at His Pleasure*, 249.

123. An-sky, 249.

124. An-sky, 250.

125. See Roskies, "An-sky, Sholem Aleichem, and the Master Narrative of Russian Jewry," 42.

126. *Pesakhim* 87b. An-sky slightly misquotes the original as "Shivrei luḥot ve' otiyot porḥot"; it should read "Luḥot nishberu." An-sky, *Der yidisher khurbn*, 61.

127. *Avodah Zarah* 18a.

128. An-sky, *Enemy at His Pleasure*, 251.

129. The term is Ben Etherington's; see Etherington, *Literary Primitivism*.

130. Bayerdörfer, "'Ghettokunst'"; Isermann, *Der Text und das Unsagbare*, 147.

131. Skolnik, "Yiddish, the Storyteller, and German-Jewish Modernism: A New Look at Alfred Döblin in the 1920s," 216. Others have taken the opposite tack, arguing that the parables represent the narrative principles of the novel. See Bayerdörfer, "'Ghettokunst,'" 170; Isermann, *Der Text und das Unsagbare*, 146.

132. Döblin, *Berlin Alexanderplatz*, 25.

133. Döblin, 24.

134. Kilcher, "Cold Order and the Eros of Storytelling," 91.

135. Roth, *Job*, 204.

136. Ilse Josepha Lazaroms notes that despite the detailed and obvious elements of Jewish religion and culture in the novel, most critics have argued that a universalism transcends the Jewish specificity of the work, thus "silencing cultural differences." Lazaroms, *The Grace of Misery*, 74.

137. Roth, *Job*, 19.

138. Roth, 19–20.

139. Roth, 20.

140. Others have made similar observations about the rebbe's authority in the novel. Lazaroms, *Grace of Misery*, 81; Kilcher, "Cold Order and the Eros of Storytelling," 90; Ritchie Robertson, "Roth's *Hiob* and the Traditions of Ghetto Fiction," 196.

141. Robertson, "Roth's *Hiob* and the Traditions of Ghetto Fiction," 200.

142. The play was written in Russian in 1914 and published first in Hebrew translation in 1918 and then in a revised Yiddish version in 1919. On the complicated composi-

tion history of the various versions of the text, see Ivanov, introduction to "S. An-sky 'Between Two Worlds (The Dybbuk).'"

143. See, e.g., Horowitz, "Spiritual and Physical Strength in An-sky's Literary Imagination," 117; Deutsch, *The Jewish Dark Continent*, 33–37; Roskies, "S. Ansky and the Paradigm of Return"; Safran, "Dancing with Death and Salvaging Jewish Culture in *Austeria* and *The Dybbuk*," 768.

144. Safran, *Wandering Soul*, 193.

145. An-sky, *The Dybbuk and Other Writings by S. Ansky*, 29.

146. Qtd. in Safran, *Wandering Soul*, 214.

147. See M. Ungerfeld, "Tsum hundertstn geboyrn tog fun Sh. Anski (Sh. Rapaport)," 209.

148. See An-sky, "Jewish Ethnographic Program" and "Di yudishe folks-shafung."

149. Safran, "Jews as Siberian Natives," 639.

150. Safran, *Wandering Soul*, 214.

151. An-sky, *Dybbuk*, 14–16.

152. An-sky, 19–20.

153. Safran, "Dancing with Death and Salvaging Jewish Culture," 768.

154. I differ here from Safran, who argues that "An-sky had trouble portraying the rebbe as though he truly believed in his power; this problem reveals the ethnographer's real distance from his subjects." Safran, *Wandering Soul*, 219.

155. Safran, "Jews as Siberian Natives."

Chapter 3

A version of this chapter first appeared as "Plausible Primitives: Kafka and Jewish Primitivism," *German Quarterly* 89, no. 1 (2016): 17–35. Reprinted with permission.

1. Brod, *Franz Kafka*, 188.

2. Robertson, "Myth vs. Enlightenment in Kafka's *Das Schloß*," 389.

3. Thompson, *Kafka's Blues*, 5–6.

4. Thompson also notes (as have others, notably Sander Gilman) that Kafka thought about Jewishness in relation to blackness. See Thompson, 9–11, 40; Gilman, *Franz Kafka, the Jewish Patient*.

5. Honold, "Berichte von der Menschenschau"; Lemon, *Imperial Messages*; Zink, "Rotpeter als Bororo?"; Neumann, "Kafka als Ethnologe." None of these works deals with the Jewish aspect of Kafka's engagement with ethnography. Jürgen Zink more directly implicates Kafka in modernist primitivism, but his contention differs significantly in substance from mine. Zink sees Kafka's primitivism as an engagement with mythical thinking, which reflects a primitivist desire to resist logic and reason. This approach, in focusing strictly on conceptual forms, neglects the ethnographic encounter and sensitivity to performative elements of identity that are at the heart of Kafka's Jewish primitivism.

6. The rebbe was likely Rabbi Sholem Rokeach, a scion of the Belz dynasty. Grayding is the Yiddish name for Horodok (Ukrainian), or Gródek Jagielloński (Polish).

7. Noah Isenberg provides a useful overview of Kafka's engagement with Jewish identity, centered around a discussion of his interest in Yiddish. See Isenberg, *Between Redemption and Doom*, 19–50.

8. Kafka, *The Metamorphosis and Other Stories*, 123.

9. Kafka, "An Introductory Talk on the Yiddish Language," 266.

10. Perry, "Primitivism and the 'Modern,'" 8.

11. Alexander Honold identifies the *Völkerschau* as the critical historical context for "Ein Bericht für eine Akademie" but offers a historical overview of various ethnographic showcases rather than an interpretation of the story in light of such showcases.

12. Kafka was exposed to Yiddish literature through the theatrical performances of Löwy's troupe as well as through German translation of Yiddish texts, including classics by Y. L. Peretz, Sholem Aleichem, and Sh. Y. Abramovitsh. It should also be noted that Kafka read the autobiography of Solomon Maimon, perhaps the first *Ostjude* (to use the term anachronistically). Suggestively, Maimon—in an extended passage on the *Guide of the Perplexed*—extrapolates from Maimonides to describe Moors as being "less than humans but somewhat more than apes" (Maimon, *The Autobiography of Solomon Maimon*, 186). On Kafka's reading of Yiddish literature, see Born, *Kafkas Bibliothek*; on his reading of Maimon, see Suchoff, *Kafka's Jewish Languages*, 79. The volume of material on Kafka and Judaism, including his interest in Yiddish, is enormous. I list here several of the most apropos and important entries: Beck, *Kafka and the Yiddish Theater*; Bruce, *Kafka and Cultural Zionism*; Gilman, *Franz Kafka, the Jewish Patient* and *Jewish Self-Hatred*; Robertson, *Kafka*; Spector, *Prague Territories*; Suchoff, *Kafka's Jewish Languages*. These works engage many diverse aspects of Kafka's Jewish cultural, religious, and political world, including his engagement with the Yiddish theater, Yiddish language and literature, Zionist thought, Jewish folklore, and so on. His interest in *Ostjuden* is a frequent point of comment, but never in an effort to place it in the nexus of Jewish identity and ethnography at stake in my readings.

13. Bechtel, "Kafka, the 'Ostjuden,' and the Inscription of Identity." Delphine Bechtel sees Kafka's other descriptions of *Ostjuden* as governed by the contents of these two passages, namely, bodily inscription and ritual torture. I, on the contrary, understand Kafka's focus as largely on the ethnographic process of observation and description rather than on the specific ethnographic content of the episode.

14. For the original, see Kafka, *Tagebücher*, 316.

15. Franz Kafka, 317.

16. Halper, "Coming Out of the Hasidic Closet."

17. Kafka, *Tagebücher*, 733.

18. František Langer, "Foreword: My Brother Jiří," xvii.

19. Indeed, this nearness is evoked in *Letter to His Father*, where he describes his character as being nearer to his mother's family than his father's. He is, he writes, "a Löwy on a Kafka foundation," whereas his father is "a real Kafka." Kafka, *The Metamorphosis and Other Stories*, 101. One thinks of his friend Löwy, the Yiddish actor whom he mentions in the letter and throughout his diaries. Is it in fact this Löwy with whom he shares, or would have liked to share, the closer kinship?

20. Kafka, *Tagebücher*, 751–52.

21. Kafka, 752.

22. Kafka, 752.

23. Kafka, 752.

24. Kafka, 752.

25. Kafka, 622.

26. Brod, *Max Brod, Franz Kafka*, 179.

27. Brod, 179.

28. My thanks to Mark Anderson for helping me arrive at this interpretation.

29. Kafka, "Vor dem Gesetz."

30. Kafka, 1.

31. Kafka, 2.

32. Several scholars have based their interpretations on the doorkeeper's resemblance to an *Ostjude*, a resemblance that Hartmut Binder rejects out of hand. These interpretations are based largely on appearance, and Binder is able to refute them on those grounds. My interpretation is based on the dynamics of the exchange; I see the appearance of the doorkeeper merely as corroborating evidence. See Kafka, 77–76.

33. Kafka, *Tagebücher*, 622.

34. Spector, *Prague Territories*, 192.

35. Blanchard, *Human Zoos*; Corbey, "Ethnographic Showcases, 1870–1930."

36. Ames, *Carl Hagenbeck's Empire of Entertainments*.

37. This kind of historic specificity is unusual for Kafka and affirms the integrality of the ethnographic context to this story.

38. Similar observations about the reversal or combination of Rotpeter's position as subject and object have been made by several scholars. See Neumann, "Kafka als Ethnologe," 336; Geller, *The Other Jewish Question*, 272; Weiss, "Identity and Essentialism." I differ from them in seeing the text as a satire of European primitivism, which brings me closer to David Suchoff, who reads Rotpeter's performance as a parody of blackface minstrelsy (*Kafka's Jewish Languages*, 117). The American context, though resonant, seems to me quite distant from the text in light of its explicit references to European modes of ethnographic investigation and display.

39. Gilman, *Jewish Self-Hatred*, 285.

40. Gilman, 282–83.

41. Honold, "Berichte von der Menschenschau," 313.

42. Kafka, *Tagebücher*, 622.

43. Kafka, *The Metamorphosis and Other Stories*, 15.

Chapter 4

A shorter version of this chapter first appeared as "Else Lasker-Schüler and Uri Zvi Greenberg in 'The Society of Savage Jews': Art, Politics, and Primitivism," *Prooftexts* 38, no. 1 (2020): 60–93.

1. Grinberg's surname is often spelled Greenberg (as I did in the above-cited article). I have opted here to spell it Grinberg because that is the standard Yiddish transliteration

and is also the spelling that the poet himself preferred. My thanks to Tamar Wolf-Monzon for informing me of his opinion on the matter. As for the name Zvi: while Tsevi or Zevi are possible Hebrew transliterations and Tsvi is the standard Yiddish, almost all scholars of both the Greenberg and Grinberg camps spell it Zvi.

2. Khone Shmeruk points to several examples of Grinberg continuing to write in Yiddish after his shift to Hebrew; Shmeruk, "Yetsirato shel Uri Zvi Grinberg," 177.

3. Lasker-Schüler was born in Elberfeld, Grinberg in Bilyi Kamin.

4. Qtd. in Bauschinger, *Else Lasker-Schüler*, 400.

5. On Lasker-Schüler's politics, see, e.g., Miller, "Reading the Politics of Else Lasker-Schüler's 1914 Hebrew Ballads."

6. On Grinberg's politics and his place in the Jewish radical right, see Hever, "Shir hahod labiryon" and *Moledet hamavet yafah*; Kaplan, *The Jewish Radical Right*; Shindler, *The Rise of the Israeli Right*. For a general overview of Grinberg's life and works, see Miron, *Akdamut Le'Atsag* and "Introduction to the Poetry of Uri Zvi Greenberg."

7. Gitin 56a.

8. The essay was published in Hebrew and written during the period when Grinberg was in Berlin. Seelig, *Strangers in Berlin*, 116.

9. It is also, of course, related to the avant-garde Yiddish literary and artistic circle he joined in Warsaw in 1921, Di Khalyastre (the Gang). It was together with members of the Khalyastre circle that he first formulated his expressionist aesthetics. See Wolitz, "'Di Khalyastre.'"

10. On Lasker-Schüler's art, see Berman, *Orientalismus, Kolonialismus und Moderne*, 330–34; Dick and Schmetterling, *Else Lasker-Schüler*; Hedgepeth, "A Matter of Perspective"; Schmetterling, "'I Am Jussuf of Egypt'"; Shedletzky, "Bild als Text und Text als Bild".

11. Kirschnick argues that Lasker-Schüler's proposed journal *Die wilden Juden* exemplifies the parodistic manner in which the author opposes the nation-state to the "Künstlerstadtstaat." See Kirschnick, *Tausend und ein Zeichen*, 222.

12. Shavit, "Uri Zvi Greenberg," 66, 69. The influence of Spengler on Grinberg and his radical Zionist circle is treated in detail in Wolf-Monzon, "'Time for the Orient Has Come,'" 181–84.

13. On the connections between Jewish identity and orientalism, see Aschheim, *The Modern Jewish Experience and the Entangled Web of Orientalism*; Heschel, "German Jewish Scholarship on Islam as a Tool for De-orientalizing Judaism"; Kalmar and Penslar, *Orientalism and the Jews*; Peleg, *Orientalism and the Hebrew Imagination*; Wittler, "Orientalist Body Politics." On Lasker-Schüler's orientalism, see, e.g., Berman, *Orientalismus, Kolonialismus und Moderne*; Hallensleben, *Else Lasker-Schüler*; Hedgepeth, "Die Flucht ins Morgenland: Zum Orientalismus im Werk Else Lasker-Schülers"; Heizer, *Jewish-German Identity in the Orientalist Literature of Else Lasker-Schüler, Friedrich Wolf, and Franz Werfel*; Kirschnick, *Tausend und ein Zeichen*; Miller, *Cultures of Modernism*, 131–48; Robertson, *The "Jewish Question" in German Literature, 1749–1939*, 442–53; Schmetterling, "'I Am Jussuf of Egypt.'"

14. Abraham Nahum (Avrom Nokhem) Stencl's surname is sometimes spelled Shtentsl (the standard transliteration from Yiddish) and sometimes Stenzel (a Germanized version). I have opted for Stencl, the most common rendering.

15. Mendes-Flohr, "Fin-de-Siècle Orientalism, the Ostjuden and the Aesthetics of Jewish Self-Affirmation."

16. Micha Yosef Berdichevsky and Oskar Goldberg, for example, were contemporary exponents of a conception of Jewish identity inspired by an image of the robust and vital ancient Hebrews. This discourse later developed into a more concentrated (and radical) form centered on Canaanites rather than Hebrews. Ohana, *The Origins of Israeli Mythology* and *Modernism and Zionism*; Diamond, *Homeland or Holy Land?*; Hever, "Territoriality and Otherness in Hebrew Literature of the War of Independence"; Shavit, "Hebrews and Phoenicians" and *The New Hebrew Nation*.

17. Qtd. in Shedletzky, "Bild als Text und Text als Bild," 171.

18. Said, *Orientalism*, 234.

19. Robertson, *"Jewish Question" in German Literature*, 447.

20. Sigrid Bauschinger argues that Lasker-Schüler's distinction between wild Jew and Hebrew marks the author's transition from a diasporic conception of Jewish identity to one rooted in what Lasker-Schüler called the "Urboden" of the Jews, their culture and their language. See Bauschinger, "'Ich bin Jude. Gott sei Dank,'" 94.

21. See, e.g., Itta Shedletzky's articles, which, along with Jonathan Skolnik's chapter on Lasker-Schüler, laid the groundwork for my own approach to Lasker-Schüler's relation to Hebrew and to Jewish identity. Shedletzky, "Bild als Text und Text als Bild" and "'Überall hängt noch ein Fetzen Jerusalem'"; Skolnik, *Jewish Pasts, German Fictions*, 105–46; Spinner, "Lasker-Schüler's Languages."

22. If Lasker-Schüler's intersection of savage and Jewish identities is considered, it is only briefly; for example, Nina Berman offers the following gnomic assessment: "Ursprache and Jewish savagery metaphorically stand for the effort to redefine Jewish self-understanding in Germany." Berman, *Orientalismus, Kolonialismus und Moderne*, 329–30. Sylke Kirschnick likewise calls "die wilden Juden" a metaphor, but disagrees with Berman, claiming that the savage Jews "do not constitute a homogenous community." See Kirschnick, *Tausend und ein Zeichen*, 225. Jakob Hessing also comments that "the word 'Wildjude' is a poetic metaphor for [Lasker-Schüler's] longing for an 'originary' Judaism." See Hessing, *Else Lasker-Schüler*, 102. Astrid Schmetterling and Ritchie Robertson conflate the savage Jews with Hebrews; Robertson, *"Jewish Question" in German Literature*, 447; Schmetterling, "'I Am Jussuf of Egypt,'" 88. Uta Grossmann describes the wild Jews as a counterpoint to Lasker-Schüler's own negative stereotypes about Jews, whether businessmen or scholars, and also connects them to her interest in *Ostjuden*; Grossmann, *Fremdheit im Leben und in der Prosa Else Lasker-Schülers*, 45, 50. Bauschinger sees them as a counterpoint to both Jews and non-Jews; Bauschinger, "Ich bin Jude. Gott sei Dank," 89–91. See also Radde, *Else Lasker-Schülers Hebräische Balladen*, 255–61, 266–67. Donna Heizer notes that wild Jews are "a poetic metaphor for her longing to return to an ancient, original Jewish culture"; Heizer, *Jewish-German Identity*

in Orientalist Literature, 37, also 35, 38. See also Hallensleben, *Else Lasker-Schüler*, 68n4; Henneke-Weischer, *Poetisches Judentum: Die Bibel im Werk Else Lasker-Schülers*, 120–23. Henneke-Weischer maintains that the savage Jews form a part of Lasker-Schüler's "anti-bourgeois attitude" (121).

23. Qtd. in Fabian, "Culture, Time, and the Object of Anthropology," 9.

24. Lasker-Schüler, *Prosa: 1903–1920*, 306.

25. Lasker-Schüler, *Prosa: 1903–1920; Anmerkungen*, 270.

26. Lasker-Schüler, *Gedichte*, 145.

27. Lasker-Schüler, *Prosa: 1903–1920*, 333.

28. Lasker-Schüler, 325.

29. The article was paired with one titled "Die wilden Rußlands" (The savages of Russia), by David Burliuk, the futurist and neoprimitivist.

30. Kandinsky and Marc, *Der Blaue Reiter*, 5.

31. Doerte Bischoff notes the dominance of Jussuf and his identity as sovereign in this community. See Bischoff, *Ausgesetzte Schöpfung*, chap. 4.

32. Markus Hallensleben claims that Lasker-Schüler's depictions of Africans evince a desire to portray them with more "authenticity and dignity" than was typical in the period. Perhaps, but not by much. See Hallensleben, *Else Lasker-Schüler*, 51.

33. The essay appeared in the issue of February 26, 1926. Lasker-Schüler actually turned fifty-seven on February 11 of that year.

34. Pinthus, *Menschheitsdämmerung*, 294.

35. Seelig, *Strangers in Berlin*, 124.

36. Grinberg, *Kol ketavav*, 15:126.

37. Grinberg, 15:123.

38. Grinberg, 15:126.

39. Grinberg, 15:124.

40. Grinberg, 15:125.

41. Grinberg, 15:125.

42. A.S., "Der yidisher 'prints fun Teben': Di yubileyum-fayerung fun der barimter dikhterin Elze Lasker-Shiler," *Haynt*, February 19, 1926.

43. Grinberg, *Kol ketavav*, 15:126.

44. A.S., "Der yidisher 'prints fun Teben.'"

45. Jonathan Skolnik notes that Lasker-Schüler's Hebraisms in *Wunderrabbiner* include biblical-style paronomasia; Skolnik, *Jewish Pasts, German Fictions*, 132.

46. On expressiveness in primitivism, see, e.g., Severi, "Primitivist Empathy."

47. Grinberg, *Kol ketavav*, 15:123.

48. Grinberg, 15:127.

49. Although *tekheilet* is usually understood to be a kind of blue, its rarity and specialness are perhaps more suggestive of royal purple.

50. Grinberg, 15:126.

51. Grinberg, 15:127.

52. Grinberg, 15:128.

53. And ultimately in reality—she was unable to return to Europe from her 1939 trip to Palestine. She died in Jerusalem in 1945.

54. As Hannan Hever argues, this play between the spheres of the political and the aesthetic was a crucial element of Grinberg's poetics. In contrast to my argument here, Hever shows how Grinberg sometimes prioritized the aesthetic into which the political was subsumed. See especially Hever, "Shir hahod labiryon," 273.

55. Wolf-Monzon, "Uri Zvi Greenberg and the Pioneers of the Third Aliyah," 49–50. Wolf-Monzon shows how he expressed this choice most strikingly in his manifesto *Klapei tish 'im vetish 'ah* from 1928.

56. Wolf-Monzon, "'Mayn meshikhisher bruder shloyme,'" 262. Wolf-Monzon counts twenty-four uses of the pseudonym in the 1920s and 1930s. See her article for an extended analysis of Grinberg's wide-ranging use of the pseudonym throughout his oeuvre.

57. Miron, "Introduction to the Poetry of Uri Zvi Greenberg," 217–21. The question of what changed in Grinberg's aesthetics—even in his politics—and to what extent after his renunciation of Labor Zionism and official affiliation with Revisionism is often addressed in the scholarship, but inconclusively. Hever sees a shift, as does Miron, who directly correlates Grinberg's linguistic transition to his political one: "The poetic experiment [i.e., the shift from Yiddish to Hebrew] Greenberg was conducting amounted therefore to a spiritual equivalent of the Zionist experiment as a political and social Jewish revolution" (Miron, "Introduction to the Poetry of Uri Zvi Greenberg," 227). Others, however, argue that the continuities are much stronger. Dov Sadan plays with the idea of a consequential shift but concludes that the evidence tilts toward continuity; see Sadan, "Tsu di gvures (vegn Uri Zvi Grinberg)," esp. 26. Similarly, Khone Shmeruk argues that Grinberg's Hebrew and Yiddish works from the period were basically equivalent; moreover, he points to the particular example of a pair of Yiddish poems printed in 1929 in a Labor Zionist publication and reprinted in 1934 in a revisionist periodical as evidence of Grinberg's fundamental political continuity; see Shmeruk, "Yetsirato shel Uri Zvi Grinberg beYidish be 'Eretz Yisra 'el uvePolin," 184–86. Insofar as his primitivism offers more evidence in this debate, it would tend to reinforce the conclusion that Grinberg's institutional move from one Zionist faction to another did not correspond to a major change in the landscape of his politics and aesthetics—his primitivist works appear before and after his 1929 fault line and in Labor Zionist as well as revisionist publications.

58. Hever, "Shir hahod labiryon," 278.

59. My capsule history of Molcho is largely derived from Goldish, "Mystical Messianism," 121–23.

60. The purported flag and associated relics are housed at the Jewish Museum in Prague.

61. Wolf-Monzon, "Mayn meshikhisher bruder shloyme," 263–64. Wolf-Monzon places the heaviest weight on biographical and thematic analogies between Molcho and Yosef Lishansky, a spy for the NILI Jewish espionage group in Palestine during the First World War.

62. Shavit, "Realism and Messianism in Zionism and the Yishuv," 113.

63. Shmeruk, "Yetsirato shel Uri Zvi Grinberg," 191.

64. Grinberg, *Gezamlte Verk*, 2:502–7; *Di velt*, May 4, 1934, 9–12. Despite Grinberg's choice of Hebrew over Yiddish with his adoption of Zionism in 1923, and despite the assertion in the scholarship of the completeness of his linguistic transition (Miron, *The Prophetic Mode*, 205), Grinberg continued to write in Yiddish, albeit with greatly diminished frequency, until the end of his life. On his Yiddish works from the late 1920s and 1930s, see Shmeruk, "Yetsirato shel Uri Zvi Grinberg."

65. Messianism had a major presence in Jewish culture of the period, including in Zionism in Europe and Palestine. It played a significant role in Grinberg's aesthetics and ideology. On messianism in Grinberg, see Hever, "Shir hahod labiryon," esp. 267–68, 275–77; Wolf-Monzon, "Mayn meshikhisher bruder shloyme"; Belfer, "Shirat Uri Zvi Grinberg bein mamlaḥtiyut limeshiḥiyut"; Shavit, "Uri Zvi Greenberg." On messianism in Zionism and Hebrew culture, see Shavit, "Realism and Messianism in Zionism and the Yishuv"; Hever, *Beshevi ha'utopyah*. On messianism in Yiddish literature more broadly, see Novershtern, *Qesem hadimdumim*, esp. 253–78.

66. Grinberg, *Gezamlte verk*, 2:504; *Di velt*, May 4, 1934, 10.

67. Grinberg, 2:504; *Di velt*, 10.

68. This conflation of Zionism with messianism, as well as the grouping of Zvi, Molcho, and Reuveni, was part of the historical and spiritual argument of Grinberg's wider circle, including Yehoshua Heshel Yeivin, who directly connected Zionism with these early modern messianic movements. See Shavit, "Realism and Messianism in Zionism and the Yishuv," 120.

69. On expressionism in Grinberg's early work, including his typography and visual work, see Lipsker, "The Albatrosses of Young Yiddish Poetry" and "Hamuzah ha'asirit"; Novershtern, "Hama'avar el ha'ekspresionizm biyetsirat Uri Zvi Grinberg"; Seelig, *Strangers in Berlin*, 103; Weinfeld, "Shirat Uri Zvi Grinberg bishnot ha'esrim al reqa' ha'ekspresionizm."

70. Grinberg, *Kol ketavav*, 16:121–29. Individual poems from the cycle appeared in a number of Grinberg's collections, but not the entire cycle. See Dan Miron's editorial note, *Kol ketavav*, 16:153.

71. Grinberg, *Kol ketavav*, 16:127.

72. Grinberg, *Gezamlte verk*, 2:517–18; *Di velt*, September 7, 1934. Indeed, blood is an overwhelmingly frequent motif and word throughout Grinberg's works in both Yiddish and Hebrew. See Stahl, "'Man's Red Soup.'" Blood also appears very often in Lasker-Schüler's works. As Caspar Battegay points out, it is mostly in reference to erotic themes, but also contains strong resonances with Martin Buber's conception of blood and community, which itself was one of many engagements with the subject among German Jews and cultural Zionists in the period. See Battegay, "Das Gedächtnis des Bluts in Else Lasker-Schülers früher Lyrik." On Lasker-Schüler and cultural Zionism see, e.g., Gelber, "Jewish, Erotic, Female."

73. On the intersection of aesthetics and politics in Grinberg's oeuvre, see the works of Hannan Hever, esp. "Shir hahod labiryon" and *Moledet hamavet yafah*.

74. Grinberg, *Kol ketavav* 16:121.

75. Grinberg, *Gezamlte Verk*, 2:485–86; *Kapa'y yediyes*, January 31, 1929. The periodical was a Labor Zionist journal published in Yiddish in Tel Aviv exclusively for distribution outside of Palestine. See Shmeruk, "Yetsirato shel Uri Zvi Grinberg," 184.

76. Pinthus, *Menschheitsdämmerung*, 294.

77. Prelogical is the French anthropologist Lucien Lévy-Bruhl's characterization of the reasoning method of so-called primitive peoples. He understood them to think outside the Western norms of reasoning, specifically by ignoring logical contradictions, and thus called them not alogical but prelogical. This conception of "primitive" cognition has strong affinities with, and indeed was influential on, broader modernist notions of primitive peoples. See Lévy-Bruhl, *Primitive Mentality*.

78. Grinberg, *Gezamlte verk*, 2:485–86; *Kapa'y yediyes*, January 31, 1929.

79. His memoirs were published serially in *Loshn un lebn*, a periodical he edited and published in London from his immigration to his death. On their friendship and for extracts of the memoir (translated into German), see Valencia, *Else Lasker-Schüler und Abraham Nochem Stenzel*.

80. Valencia, 108. The translation is mine, from Valencia's German translation of the original Yiddish.

81. Had anything of note occurred, we might expect to have some evidence of it from one of the other writers present that evening, including Bergelson, Kvitko, and Der Nister.

82. Lasker-Schüler, *Briefe, 1914–1924*, 261.

83. Qtd. in Valencia, *Else Lasker-Schüler und Abraham Nochem Stenzel*, 85.

84. Qtd. in Valencia, 108. He similarly wrote in the article in *Haynt*: "Are not our dreams and fantasies more real than reality?" See A.S., "Der yidisher 'prints fun Teben.'" On the other hand, he could also turn the primitivizing gaze back onto her—in what seems to be a draft for the article he published in *Haynt*, he wrote: "The first poets were like [her]: simple and true like sheep at pasture, like in the first dreams of childhood." Qtd. in Valencia, 81.

85. She performs the same sudden shift in a letter to Grinberg from the same period, in which she castigates him colorfully and at length for a slight but ends by referring him to someone for help with arranging a visa for his mother. Lasker-Schüler, *Briefe, 1914–1924*, 262–63.

86. Lasker-Schüler, *Briefe, 1941–1945; Nachträge*, 360. The letter is undated.

87. It is not clear why she makes the request and refrains from naming Grinberg.

88. Lasker-Schüler, 360.

89. Lasker-Schüler, *Das Hebräerland*, 144.

90. Lasker-Schüler, *Briefe, 1941–1945*, 60.

91. See the letter of September 13, 1941: Lasker-Schüler, 60. It is unclear whether Grinberg accepted her invitation or not. The subsequent letter indicates that she assumed he would keep the appointment.

92. Lasker-Schüler, 60.

93. Abba Aḥimeir, a co-founder of the Berit habiryonim, was an avowed fascist. See, e.g., Shindler, *The Rise of the Israeli Right*, 84.

94. Lasker-Schüler, *Das Hebräerland*, 94.

95. Lasker-Schüler, 144.

96. Lasker-Schüler, 144, 94.

97. Grinberg cites this letter in "Devorah beshivyah" but ascribes to Lasker-Schüler the sentence she ascribes to his father: "Uri, Uri, you find salvation in the Promised Land while Abigail [i.e., Lasker-Schüler] cries in the dark world?" Lasker-Schüler, *Briefe, 1914–1924*, 17.

98. She seems to have been particularly attracted to those Yiddish writers with a Hasidic background—her close friend Stencl was from a Polish Hasidic family. Stencl's father was a rabbi, as was his brother, who went on to a distinguished career as a Torah scholar, judge of Jewish law, and local rabbi. Neither, however, was a rebbe.

99. It seems to me that the word exists solely in her oeuvre, first introduced with her story *Der Wunderrabbiner von Barcelona*.

100. It stands to reason that *-rabbi* was used rather than *-rabbiner* to more closely mimic the Yiddish usage of *rebbe*.

101. Skolnik, *Jewish Pasts, German Fictions*, 122. Skolnik's extended analysis of Lasker-Schüler's *Wunderrabbiner* and its cultural context is illuminating.

102. Lasker-Schüler, *Briefe, 1914–1924*, 224.

103. Grinberg, *Kol ketavav*, 15:124.

104. On more connections between Heine and Lasker-Schüler, see Shedletzky, "Bacherach and Barcelona"; Skolnik, *Jewish Pasts, German Fictions*, 105–7.

105. Robertson, *The German-Jewish Dialogue*, 229.

106. On the role of love in *Wunderrabbiner*, see Garloff, *Mixed Feelings*, 164–70.

107. Skolnik argues that Lasker-Schüler "problematizes the identity of [the] collective" in *Wunderrabbiner* but does not renounce it. Skolnik, *Jewish Pasts, German Fictions*, 146.

108. Hever, "Shir hahod labiryon."

109. See Kirschnick, *Tausend und ein Zeichen*.

110. Lasker-Schüler, *Das Hebräerland*, 212. "Will man die Urnachkommen Ismaels kennen lernen, gehe man vor die Stadt. Wilde Jsmaeliten leben eintächtig mit den wilden Juden; mir waren diese noch nicht mit der Kultur beleckten, pflanzlichen Asiaten fast die grösste Ueberraschung und Interessanteste aller der Einwohner Palästinas. Schliessliech fühlte ich mich auch befreit von jedem Widergefühl ihrer salopen Aeusserlichkeit. Genau wie der Gärtner Wurm und Schnecke und schlammige Erde an der Wurzel der Pflanze überwindet, sie sogar liebreich zwischen seine Hände nimmt, so betrachtete ich mein Urvolk und seinen Stiefbruder."

111. Lasker-Schüler, 212.

112. In the published edition of *Das Hebräerland*, she has similar assessments: "the savage Jews before Jerusalem's gate, unassuming and peaceful, with their Arab brothers in tents." A few lines further: "The Jew and Christian, Mohammedan and Buddhist go hand in hand here." Lasker-Schüler, 14.

113. Goethe, *Faust*, line 2495.

114. Lasker-Schüler, *Das Hebräerland*, 212.

115. Said, *Orientalism*, 27.

116. Bauschinger, *Else Lasker-Schüler*, 412.

Chapter Five

1. Der Nister, *Gedakht*, 62.

2. Caplan, "Performance Anxieties," 2.

3. Niger, "Nister 'Hekher fun der erd,' ferlag progres," *Der Fraynt*, May 6, 1910, 4.

4. From a 1909 letter to Charney, qtd. in Novershtern, "Igrotav shel Der Nister el Shmuel Niger," 181.

5. Roskies, "The Storyteller as High Priest".

6. Caplan, "Watch the Throne"; Boehlich, *"Nay-gayst."*

7. Sherman, "Der Nister and Symbolism in Yiddish Literature"; Roskies, "Storyteller as High Priest"; Bechtel, *Der Nister's Work, 1907–1929*; Garrett, *Journeys beyond the Pale*, 66–73.

8. Mantovan, "'Political' Writings of an 'Unpolitical' Yiddish Symbolist"; Mikhail Krutikov, *Der Nister's Soviet Years*; Shmeruk, "Der Nister's 'Under a Fence.'"

9. For example, Delphine Bechtel argues that his works are a form of "allegorical symbolism" which ultimately "collapses" under "an irreducible opposition between a distinctively allegorical system and the obscurity of its message, between the tendency to allegorize the world and the inability to find a meaning for the allegory." Bechtel, *Der Nister's Work*, 265.

10. Bechtel, 119–22.

11. Bechtel, 213.

12. Bechtel, 120.

13. Bechtel, 213.

14. Horn, "Der Nister's Symbolist Stories," 16. The dissertations by Daniela Mantovan and Delphine Bechtel describe various formal aspects of Nister's works but refrain from an in-depth consideration of the technique and purpose of Nister's form. Bechtel, *Der Nister's Work, 1907–1929*; Mantovan, "Der Nister and His Symbolist Short Stories (1913–1929)."

15. Lovejoy and Boas, *Primitivism and Related Ideas in Antiquity*.

16. Critics in the period used this term to describe Der Nister's works. For more on stylization, see Chapter 1. Moyshe Litvakov, *In umru*, 70.

17. Peterson, *A History of Russian Symbolism*; Bechtel, *Der Nister's Work*; Sherman, "Der Nister and Symbolism in Yiddish Literature."

18. Peterson, *A History of Russian Symbolism*; Pyman, *A History of Russian Symbolism*.

19. Gary L. Browning, "Russian Ornamental Prose"; Wolf Schmid, "Poetic or Ornamental Prose."

20. Shklovsky, *Theory of Prose*, 180.

21. Gary Browning enumerates the techniques of ornamental prose: "It is based above all on an artistic regulation of syntactic groups, on the element of repetition and syntactic parallelism. At the phonemic level, alliteration and assonance are prominent, while on the morphological plane paregmenon (repetition of a root with

various prefixes and suffixes), homoioptoton (rhyme of like grammatical forms), and paramoion (any word-beginning likeness of sound) are frequently encountered. Regarding syntax, anaphora and tautotes are common." Browning, "Russian Ornamental Prose," 348.

22. Wolf Schmid notes that "the restriction of narrativity can go so far that no eventful story is formed at all, so that the text merely denotes fragments of a story whose interrelations are no longer narrative-syntagmatic but only poetic-paradigmatic, produced in line with principles of association, similarity and contrast." Schmid, "Poetic or Ornamental Prose."

23. Der Nister, *Gedakht*, 80.

24. Krutikov, *Der Nister's Soviet Years*, 30.

25. It is worth noting that a related but more limited phenomenon is at play in the work of the Hebrew writer M. Y. Berdichevsky. Na'ama Rokem argues that "the underlying rhetorical logic of Berdichevsky's use of metaphors to describe Jewish multilingualism is visual." Rokem, "'With the Changing of Horizons Comes the Broadening of the Horizon,'" 237.

26. Der Nister, *Gedakht*, 62.

27. Ayzik Zaretski, "Nisters un."

28. Zaretski, 131.

29. Zaretski, 147.

30. Zaretski, 135–37.

31. Zaretski, 133.

32. Zaretski, 139.

33. Zaretski, 140.

34. Zaretski, 143.

35. Frank, *The Idea of Spatial Form*. Marcus Moseley has suggested that spatial form is the structuring principle of the Hebrew novel *Miriam* by M. Y. Berdichevsky. Moseley's suggestion together with Rokem's earlier-cited analysis of *Miriam* suggests that it might be fruitful to read the novel in the light of the view of Der Nister I put forward here. Moseley, *Being for Myself Alone*, 284.

36. Williams, "Wilhelm Worringer and the Historical Avant-Garde."

37. Worringer took the term from Alois Riegl. On Riegl's concept, see Olin, *Forms of Representation in Alois Riegl's Theory of Art*, 71–72, 148–53.

38. Worringer, *Abstraction and Empathy*, 14.

39. Worringer, 15.

40. Worringer, 23.

41. Frank, *The Idea of Spatial Form*, 61.

42. Donahue, *Forms of Disruption*, 28.

43. The letter is preserved only in Einstein's draft. Einstein, *Texte aus dem Nachlaß I*, 153.

44. Einstein, 153.

45. Einstein, 153.

46. Einstein, 154.

47. Einstein, 154.

48. Einstein, *Bebuquin or the Dilettantes of the Miracle*, 26.

49. Einstein, 27–28.

50. Einstein, *Texte aus dem Nachlaß I*, 154.

51. Other critics have argued that the stories are commensurate with Einstein's aesthetic aims, but these interpretations are based on analysis of the content of the stories, Einstein's editorial selections, or the stylistic effects of his prose. Formally the stories do not diverge significantly from the sources on which Einstein drew. See Pan, *Primitive Renaissance*; Pape, "Auf der Suche nach der dreidimensionalen Dichtung."

52. Fore, *Realism after Modernism*, 222.

53. Einstein, *A Mythology of Forms*, 236.

54. Einstein, *Werke: 1907–1918*, 191.

55. Einstein, *A Mythology of Forms*, 49.

56. Einstein, 50.

57. Einstein, 50–51.

58. Einstein, 51. The bas-relief, an intermediate ersatz proposed by Hildebrand, was also unacceptable to Einstein because it still depended on the illusionism of perspective.

59. Einstein, 53.

60. Einstein, 52.

61. Kahnweiler, *Der Weg zum Kubismus*, 27.

62. Einstein, *A Mythology of Forms*, 58.

63. Einstein, *Texte aus dem Nachlaß I*, 154. This is akin to Viktor Shklovsky's description of the process of removing an object "from the sphere of automatized perception." Shklovsky, *Theory of Prose*, 6.

64. Fore, *Realism after Modernism*, 222.

65. Fore, 223.

66. Fore, 224.

67. Qtd. in Fore, 224.

68. El Lissitzky, "K. und Pangeometrie."

69. Lodder, "Ideology and Identity"; Dmitrieva, "Traces of Transit"; Dukhan, "El Lissitzky"; Birnholz, "El Lissitzky and the Jewish Tradition."

70. El Lissitzky, "K. und Pangeometrie," 103.

71. El Lissitzky, 113.

72. Einstein, *A Mythology of Forms*, 63.

73. Krutikov, *Der Nister's Soviet Years*, 21–56.

74. Shmeruk, "Der Nister's 'Under a Fence.'"

75. Roskies, *A Bridge of Longing*, 217.

76. Mantovan, "'Political' Writings of an 'Unpolitical' Yiddish Symbolist," 80.

77. Mantovan, 85.

78. Qtd. in Shmeruk, "Der Nister's 'Under a Fence,'" 285.

79. Of course, primitivism afforded other political options, as in the works of Uri Zvi Grinberg. For a discussion of the tension between fascism and its alternatives in modernist primitivism, see Berman, "German Primitivism / Primitive Germany."

80. Mantovan, "'Political' Writings of an 'Unpolitical' Yiddish Symbolist," 85.

81. Bechtel, *Der Nister's Work*, 264–65.

82. An additional story features a character with the name "Pinkhes the son of Menakhem the priest." This name, from the story "Nay-gayst" (composed in 1920, first published in 1923 and republished in *Fun mayne giter*), is the name by which Der Nister would have been referred to in Jewish ritual contexts. His secular surname also means as much: Kahanovitch, that is, son of Kahan or Cohen, that is, priest. This is not to say that Der Nister does not experiment in *Gedakht* with first-person perspectives: "Muser," one of the latest stories in *Gedakht*, has an authorial stand-in identified as "a certain modern writer," and a number have first-person narrators not identified with the author or embedded narratives told from a first-person perspective. There is also a Nister character in the early story "Der letster mentsh" from *Gedankn un motivn*. But *Fun mayne giter* goes further, introducing a character named "Der Nister" in the primary diegetic level of two stories. On Der Nister's first-person personas, see Mantovan, "Der Nister and His Symbolist Short Stories (1913–1929)," 156–59.

83. Koenig, "The Mad Book," 208.

84. Koenig, 208; Mantovan, "'Political' Writings of an 'Unpolitical' Yiddish Symbolist," 84.

85. Koenig, "The Mad Book," 222; see also 218–19.

86. Mantovan, "'Political' Writings of an 'Unpolitical' Yiddish Symbolist," 84.

87. Der Nister, *Fun mayne giter*, 7.

88. Der Nister, 8.

89. Mantovan notes the conventional association of bears with Russia; Koenig, along the same lines, argues that the sacrifice of Der Nister's fingers is a form of sacrificing authorship. It is thus a sacrifice to the Soviet Union. Mantovan, "'Political' Writings of an 'Unpolitical' Yiddish Symbolist," 82; Koenig, "The Mad Book."

90. Der Nister, *Fun mayne giter*, 33.

91. Der Nister, 35.

92. Der Nister, 54.

93. Der Nister, 58–59.

94. Der Nister, 66.

95. Der Nister, 69.

96. Der Nister, 77.

97. Der Nister, 80.

98. First published in 1921 in Kiev and again in Berlin in 1923 in the Yiddish avant-garde periodical *Albatros*, edited by Uri Zvi Grinberg.

99. He refers specifically to "Egyptian and Negrito art." It is unclear why he uses the word Negrito (*negritanish*) instead of the typical "Negro"; he gives no indication of a functional difference between the two as far as art is concerned. Tshaykov, *Skulptur*, 7.

Chapter 6

A shorter version of this chapter was first published as "Avant-Garde Authenticity: M. Vorobeichic's Photographic Modernism and the East European Jew," in *Writing*

Jewish Culture: Paradoxes in Ethnography, edited by Andreas Kilcher and Gabriella Saf-ran (Bloomington: Indiana University Press, 2016), 208–32.

1. Berlewi, "Yidishe kinstler in der hayntiker rusisher kunst."

2. Berlewi, 16.

3. Berlewi, 16.

4. Berlewi, "El Lissitzky in Warschau," 61.

5. Zweig, "Dybuk Hebräisch," *Jüdische Rundschau*, October 5, 1926.

6. Ryback and Aronson, "Di vegn fun der yidisher moleray."

7. Ryback and Aronson, 123.

8. Ryback and Aronson, 122. Subsequent critics have similarly seen him in the light of modernist primitivism, but there are few explanations or extended considerations of the matter. This seems to indicate Chagall's primitivism is a kind of conventional wisdom rather than a fully justified critical assessment. For a sustained treatment of the subject, see Rajner, "The Origins of Neo-primitivism in Chagall's Work."

9. Tshaykov, *Skulptur*, 14.

10. Morris-Reich, *Race and Photography*; Edwards, "Anthropology and Photography"; Edwards, *Anthropology and Photography, 1860–1920*.

11. At least four scholars cite Chagall's use of the word "document" in this context, but none give an original source. Kiel, "A Twice Lost Legacy," 245; Harshav, *Marc Chagall on Art and Culture*, 12; Meyer, *Marc Chagall*, 217; Kamensky, *Chagall*, 153.

12. The story has been told exhaustively in the scholarship. See, e.g., Rubin, "Picasso." For critical revisions of this narrative, see Gikandi, "Picasso, Africa, and the Schemata of Difference"; Hay, "Primitivism Reconsidered (Part 1)" and "Primitivism Reconsidered (Part 2)."

13. Gluck, "Interpreting Primitivism, Mass Culture and Modernism."

14. Corbey, "Ethnographic Showcases, 1870–1930"; Ames, *Carl Hagenbeck's Empire of Entertainments*.

15. Luschan, *Kriegsgefangene*.

16. Luschan, 1–2.

17. Luschan, 6–7.

18. On these works, see Isenberg, *Between Redemption and Doom*; Edelmann-Ohler, "Exclusion and Inclusion."

19. Zweig, *The Face of East European Jewry*, 2.

20. Zweig, 1.

21. The book saw three bilingual editions in 1931: German/Hebrew, English/Hebrew, and German/Yiddish. The multilingualism pertains to the covers, titles, captions, and introductions, while the images and their layout are the same in all editions. The book's German title is *Ein Ghetto im Osten: Wilna* (A ghetto in the East: Vilna); the Hebrew title is *Reḥov hayehudim bevilna* (The Jewish street in Vilna); the Yiddish title is *Yidishe gas in Vilne* (The Jewish street in Vilna); and the English is *The Ghetto Lane in Vilna*. Since the book was published by a German-language Swiss press, I will refer to the book by its German title (or a direct translation of that title) but will specify from which edition all citations come.

22. On the publication of Vorobeichic's book and the entire Schaubücher series, see Jaeger, "Gegensatz zum Lesebuch 'Die Reihe Schaubücher' im Orell Füssli Verlag, Zürich."

23. The series also included books of a more conventionally popular orientation, including *Das schöne Tier* (Beautiful animals) and *Die Lüneburger Heide* (The Lüneburg heath).

24. The others were *Ein Ghetto im Osten*, *An den Höfen der Maharadschas* (The courts of the maharajas), *Von China und Chinesen* (On China and the Chinese), and *Frauenbilder des Morgenlandes* (Women of the Orient).

25. Its post-Holocaust reception (though limited) took a different trajectory, split between back-shadowed evaluations and a small number of scholarly treatments. Of the former, see Sapper, "Das Antlitz des ermordeten Volkes." There are few scholarly treatments of the book: Nelson positions Vorobeichic's book as a "new vision" configuration of the spaces of Vilna. Zemel and Washton Long contend in similar ways that Vorobeichic recasts the diaspora Jew as a modern subject. Finally, Dimitrieva sees *Ein Ghetto im Osten* as an example of Vilna modernity. See Rose-Carol Washton Long, "Modernity as Anti-Nostalgia"; Zemel, "Imaging the Shtetl"; Nelson, "Suspended Relationship"; Dmitrieva, "Die Wilna-Fotocollagen von Moshe Vorobeichic."

26. It is thus not as overtly political as some of its interpreters would have it, despite Vorobeichic's increasing dedication to Zionism and its cultural forms in the period. For such readings, see Zemel, "Imaging the Shtetl"; Washton Long, "Modernity as Anti-Nostalgia."

27. I assume that Shneour's essay was written in Hebrew, since he begins it by referring to his well-known Hebrew poem on Vilna. The distinction is important, since the versions do diverge sometimes, mostly owing to poor and occasionally erroneous translation. The translations I offer of Shneour's introduction are mine and are from the Hebrew version, unless otherwise specified.

28. Shneour, "Reḥov hayehudim be˙or vatsel," 4.

29. It is true that museums also loom large in the mythology of the origins of primitivism and the avant-garde. The story of Picasso's inspiration in the Musée d'ethnographie du Trocadéro in Paris and subsequent transformation of *Les Desmoiselles d'Avignon* from a brilliant protocubist work into a primitivist masterpiece—the "first modernist painting," as it is sometimes called—is exemplary of the avant-garde appropriation (or at least appreciation) of ethnographic museums. Yet by the late 1920s museums were no longer a site of uncomplicated inspiration but a focus for the subversive primitivism and critique of colonialism of the ethnographic surrealists.

On the avant-garde critique of colonialism, see Blake, "The Truth about the Colonies, 1931"; Mileaf, "Body to Politics." For further considerations of primitivism in avant-garde visual art, see Kelly, "Discipline and Indiscipline"; Krauss, "The Photographic Conditions of Surrealism"; Krauss, Livingston, and Ades, *L'amour fou*; Maurer, "In Quest of the Myth"; Tythacott, *Surrealism and the Exotic*; Walker, *City Gorged with Dreams*; Warehime, "'Vision Sauvage' and Images of Culture." For general

considerations of primitivism and art, see especially Goldwater, *Primitivism in Modern Art*; Lloyd, *German Expressionism*; Rubin, *"Primitivism" in 20th Century Art*.

30. Shneour refers to an "album," since at the time he wrote the essay (dated October 1929 in the text), Vorobeichic's book had not yet been published; this date is obviously, then, the terminus ad quem for the images that were ultimately published in 1931.

31. Clifford, "On Ethnographic Surrealism."

32. The image reproduced here is the Hebrew cover of the German/Hebrew edition.

33. These techniques are all typical of the avant-garde photography of Neues Sehen (New Vision), associated with the Bauhaus where Vorobeichic studied and first took up photography. His teacher, László Moholy-Nagy, was an important theorist and practitioner of Neues Sehen. On German avant-garde photography books of the period, see Heiting and Jaeger, *Autopsie*; Magilow, *The Photography of Crisis*; for examples of Moholy-Nagy's theoretical writings, see Phillips, *Photography in the Modern Era*.

34. There was clearly a strong demand throughout the diaspora for nostalgic images from the old country. Shneour's introduction and the publication and reception history of the book suggest that despite its striking modernism, Vorobeichic's book tapped that vein of sentimentality.

35. André Malraux suggested that he change his name, cautioning that no one would buy a book by someone named Vorobeichic. This was clearly not judged to be a problem for the Vilna book. Moyshe Vorobeichic to Moï Ver was not his only change of name. In 1951, he changed his name to Moshe Raviv, at the request of Ben Gurion. Vorobeichic's son Yossi Raviv shared with me the information about his father's names in a telephone conversation.

36. By contrast, painting, exemplified by Chagall's "shtetl" works as well as primitivist artists from Gauguin to Nolde, was more readily able to portray primitivist subjects in modernist forms. It seems to me that the relative belatedness of modernist primitivism in photography is due to the heavy influence of anthropology on photography, or to be more specific, of ethnographic and anthropological photography on the nonscientific photographic representation of primitivist subjects.

37. Clifford argued that the relationship of influence between ethnography and surrealism among the group around Georges Bataille and his journal *Documents* was not unidirectional (from ethnography to surrealism) but reciprocal, resulting in an ethnography that was, in essence, surrealist. This notion has been widely influential but also strongly criticized. See Hollier, "The Use-Value of the Impossible"; Jamin, "L'ethnographie mode d'inemploi" and "Anxious Science"; Richardson, "Encounter of Wise Men and Cyclops Women"; Slaney, "Psychoanalysis and Cycles of 'Subversion' in Modern Art and Anthropology."

38. Lastra, "Why Is This Absurd Picture Here?," 52.

39. Lastra, 53.

40. Lastra, 57.

41. Lastra, 58.

42. Lastra, 67.

43. Buñuel, "Land without Bread," 92.

44. See Lastra, "Why Is This Absurd Picture Here?" 66; Buñuel, "Land without Bread," 96.

45. Walker, *City Gorged with Dreams*, 5.

46. Richardson, *Georges Bataille*, 52.

47. Indeed, Jeffrey Shandler calls this representational mode "the time of Vishniac." His reading is based, however, mostly on the post-Holocaust reception of Vishniac's works and is premised on the mistaken contention that no photography books devoted to eastern European Jewry were published before the war. See Shandler, "The Time of Vishniac," 316.

48. A mistake unfortunately echoed in Rose-Carol Washton Long's mistranslation of the same caption as "Talmud Hours" ("Modernity as Anti-Nostalgia," 73).

49. In pointing out the simultaneity of visual puns on Yiddish expressions in Chagall, Seth Wolitz has called this phenomenon "Marranism," since the dual meanings exist in two separate worlds. See Wolitz, "Vitebsk versus Bezalel," 172. On visual puns in Chagall, see esp. Harshav, "The Role of Language in Modern Art."

50. Alternatively, the meaning could be based on the status of the letter *yud* as the smallest letter in the Hebrew alphabet—barely more than a "point" of ink but just as important as any other letter. The phrase is clearly an item of popular theology, but I have been unable to find any sources that clarify its origins. Mendel Piekarz associates the phrase with nineteenth- and twentieth-century Hasidic thought on the subject of Jewish chosenness and essential Jewishness, and traces this theological strand to Yehuda Halevi and the Maharal (Yehudah Leib ben Betsalel). This accounts for the theology of the phrase but does not clarify its rather peculiar imagery or its origins. See Piekarz, *Ḥasidut Polin*, chap. 5. Nevertheless, its meaning is clear, and both conjectural etymologies support my reading of Vorobeichic's word/image play.

For a summary of the phrase's appearance in literary works, see Hoffman, "From 'Pintele Yid to Racenjude,'" 66.

51. Krauss, "Photography in the Service of Surrealism," 124.

52. Vorobeichic, *Ein Ghetto im Osten (Wilna)*, 3 (in Yiddish).

53. Vorobeichic, 3.

54. "M. Vorobeichic: Das Ghetto von Wilna," 440.

55. Shneour, "Reḥov hayehudim be'or vatsel," 7.

56. Weinreich, "A bilder-bukh fun der yidisher Vilne," *Forverts*, September 20, 1931, sec. 2, 4.

57. This time the German caption retains the irony of the Hebrew and Yiddish, while the English elides it with a mistranslation: "The Material Wealth of Israel."

58. On the anticolonial exhibition, see Blake, "The Truth about the Colonies, 1931"; Mileaf, "Body to Politics"; Palermo, "L'Exposition Anticoloniale."

Conclusion

1. Gianni Cipriano, "In the Land of Black Coats," *New York Times*, March 9, 2008, available online at http://www.nytimes.com/2008/03/09/nyregion/thecity/09boro.html.

Interestingly, a correction is appended to the article, revising the estimate (in two separate articles) of the Jewish population of Borough Park from "a quarter of a million Orthodox Jews" to 75,000 Jews of varying denominations. The primitivist association of savages and mobs comes to mind.

2. Alan Feuer, "A Piece of Brooklyn Perhaps Lost to Time," *New York Times*, July 5, 2009, available online at http://www.nytimes.com/2009/07/05/nyregion/05stop.html.

3. James Poniewozik, "Review: 'Unorthodox,' a Stunning Escape from Brooklyn," *New York Times*, March 25, 2020, sec. Arts, https://www.nytimes.com/2020/03/25/arts/television/unorthodox-review-netflix.html.

4. Chabon, *The Yiddish Policemen's Union*.

5. Justin Rocket Silverman, "Students Get an Immersion in an Endangered Language, and Their Heritage, at the Yiddish Farm," *New York Daily News*, January 20, 2014, https://www.nydailynews.com/life-style/reconnecting-language-yiddish-farm-article-1.1583157.

6. For an overview in English of Kisch's life and career, see Harold B. Segel's introduction to Kisch, *Egon Erwin Kisch, the Raging Reporter*.

7. Kisch, *Der Rasende Reporter*; Kisch, *Geschichten aus sieben Ghettos*.

8. Mayer, *Golem*, 180.

9. Maya Barzilai has written a book on the connection of representations of the Golem to war. Unfortunately, her discussion of Kisch's story is very brief. Barzilai, *Golem*, 7, 232n34.

10. Kisch, *Geschichten aus sieben Ghettos*, 197.

11. Kisch, *Tales from Seven Ghettos*, 154. This translation is based on the earlier version of the article. I cite from it (with minor alterations) where it corresponds with "Den Golem wiederzuerwecken" (1934). Otherwise, the footnotes will indicate the German edition and the translations will be entirely my own.

12. Kisch incorrectly transliterates and translates the first words of the book's title; he renders *mayse funem* (story of) as *meisse punem* and translates the phrase as *seltsame Geschichten* (curious stories). Kisch, *Geschichten aus sieben Ghettos*, 199. On Rosenberg and his Golem book, see Leiman, "The Adventures of the Maharal of Prague in London"; Robinson, "Literary Forgery and Hasidic Judaism."

On the Golem story in modernity (including Rosenberg's book), see Baer, *The Golem Redux*; Barzilai, *Golem*; Gelbin, *The Golem Returns*.

13. Kisch, *Geschichten aus sieben Ghettos*, 198–99.

14. Kisch, 199.

15. Kisch, *Tales from Seven Ghettos*, 154.

16. Kisch, 158.

17. Kisch, *Geschichten aus sieben Ghettos*, 204.

18. Kisch, 210–11.

19. Kisch, *Tales from Seven Ghettos*, 164.

20. Kisch, *Geschichten aus sieben Ghettos*, 216.

21. The choice of the word "robot" is deliberate: it is of Czech etymology, just as the Golem was ascribed a Czech origin.

22. An-sky, "Blut-bilbulim in der yidisher folks-shafung."

23. Baudrillard, *Simulacra and Simulation*, 7.

24. Kisch, *Entdeckungen in Mexiko*.

25. Kisch, *Egon Erwin Kisch, the Raging Reporter*, 365–72.

26. Kisch, 365–66.

27. Kisch, 366.

28. Kisch, 366–67.

29. Kisch, 371.

30. It is unclear whether the prayer is the Kaddish or the El Maleh Rachamim. Kisch indicates that the prayer was recited in unison and at the end of the service, as in the former, but that individual names were supplied, as in the latter. It does not matter.

31. Kisch, *Egon Erwin Kisch, the Raging Reporter*, 371.

32. Kisch, 372.

BIBLIOGRAPHY

Aberbach, David. *Jewish Cultural Nationalism: Origins and Influences*. London: Routledge, 2007.

Agnon, Shmuel Yosef. *Me'atzmi el 'atzmi*. Jerusalem: Schocken Books, 1976.

Alt, Arthur Tilo. "The Berlin Milgroym Group and Modernism." *Yiddish* 6, no. 1 (1985): 33–44.

———. "A Survey of Literary Contributions to the Post-World War I Yiddish Journals of Berlin." *Yiddish* 7, no. 1 (1987): 42–52.

———. "Yiddish and Berlin's 'Scheunenviertel.'" *Shofar: An Interdisciplinary Journal of Jewish Studies* 9, no. 2 (1991): 29–43.

Ames, Eric. *Carl Hagenbeck's Empire of Entertainments*. Seattle: University of Washington Press, 2008.

An-sky [Ansky], S. "Blut-bilbulim in der yidisher folks-shafung." In *Gezamlte shriften*, 15:99–152. Vilna: Ferlag An-ski, 1925.

———. *Der yidisher khurbn fun Poyln, Galitsiye, un Bukovine, fun tog-bukh, 1914–1917*. Vols. 4–6 of *Gezamelte shriften*. Vilna: Ferlag An-ski, 1922–27.

———. "Di yudishe folks-shafung." In *Gezamlte shriften*, 15:29–95. Vilna: Ferlag An-ski, 1925.

———. *The Dybbuk and Other Writings by S. Ansky*. Edited by David G. Roskies. Translated by Golda Werman. New Haven, CT: Yale University Press, 2002.

———. *The Enemy at His Pleasure: A Journey through the Jewish Pale of Settlement during World War I*. Translated by Joachim Neugroschel. New York: Metropolitan Books / H. Holt, 2003.

———. "The Jewish Ethnographic Program." Translated by Nathaniel Deutsch. In *The Jewish Dark Continent: Life and Death in the Russian Pale of Settlement*. Cambridge, MA: Harvard University Press, 2011.

Arnold, Matthew. *Culture and Anarchy: An Essay in Political and Social Criticism.* London: Smith, Elder, 1869.

Aschheim, Steven E. *Brothers and Strangers: The East European Jew in German and German Jewish Consciousness, 1800–1923.* Madison: University of Wisconsin Press, 1982.

———. *The Modern Jewish Experience and the Entangled Web of Orientalism.* Amsterdam: Menasseh ben Israel Instituut, 2010.

Baer, Elizabeth Roberts. *The Golem Redux: From Prague to Post-Holocaust Fiction.* Detroit: Wayne State University Press, 2012.

Bal Makhshoves. "Bal Makhshoves vegn zikh aleyn." In *Geklibene verk*, 13–36. New York: Cyco Bicher-Farlag, 1953.

———. "Der yidisher mitos." *Bikher-velt* 1, no. 1 (1922): 7–10.

———. "Tsvey shprakhn—eyneyntsike literatur." In *Geklibene verk*, 112–23. New York: Cyco Bicher-Farlag, 1953.

Barnard, Frederick M. "Herder and Israel." *Jewish Social Studies* 28, no. 1 (1966): 25–33.

Bartal, Israel. "The Ingathering of Traditions: Zionism's Anthology Projects." *Prooftexts* 17, no. 1 (1997): 77–93.

———. "The *Kinnus* Project: *Wissenschaft des Judentums* and the Fashioning of a 'National Culture' in Palestine." In *Transmitting Jewish Traditions: Orality, Textuality, and Cultural Diffusion*, edited by Yaakov Elman and Israel Gershoni, 310–23. New Haven, CT: Yale University Press, 2000.

Barzilai, Maya. *Golem: Modern Wars and Their Monsters.* New York: NYU Press, 2016.

Battegay, Caspar. "Das Gedächtnis des Bluts in Else Lasker-Schülers früher Lyrik." In *Naturgeschichte, Körpergedächtnis: Erkundungen einer kulturanthropologischen Denkfigur*, edited by Andrea Bartl and Hans-Joachim Schott, 117–34. Würzburg: Königshausen & Neumann, 2014.

Baudrillard, Jean. *Simulacra and Simulation.* Ann Arbor: University of Michigan Press, 1994.

Bauman, Richard, and Charles L. Briggs. *Voices of Modernity: Language Ideologies and the Politics of Inequality.* Cambridge: Cambridge University Press, 2003.

Bauschinger, Sigrid. *Else Lasker-Schüler: Biographie.* Göttingen: Wallstein Verlag, 2004.

———. "'Ich bin Jude. Gott sei Dank': Else Lasker-Schüler." In *Im Zeichen Hiobs: Jüdische Schriftsteller und deutsche Literatur im 20. Jahrhundert*, edited by Gunter E. Grimm and Hans-Peter Bayerdörfer, 84–97. Königstein: Athenäum, 1985.

Bayerdörfer, Hans-Peter. "'Ghettokunst. Meinetwegen, aber hunderprozentig echt': Alfred Döblins Begegnung mit dem Ostjudentum." In *Im Zeichen Hiobs: Jüdische Schriftsteller und deutsche Literatur im 20. Jahrhundert*, edited by Gunter Grimm and Hans-Peter Bayerdörfer, 161–77. Königstein: Athenäum, 1985.

Bechtel, Delphine. "1922: *Milgroym*, a Yiddish Magazine of Arts and Letters, Is Founded in Berlin by Mark Wischnitzer." In *Yale Companion to Jewish Writing and Thought in German Culture, 1096–1996*, edited by Sander L. Gilman and Jack Zipes, 420–26. New Haven, CT: Yale University Press, 1997.

———. "Cultural Transfers between 'Ostjuden' and 'Westjuden' German-Jewish Intellectuals and Yiddish Culture 1897–1930." *Leo Baeck Institute Year Book* 42, no. 1 (1997): 67–83.

———. *Der Nister's Work, 1907–1929: A Study of a Yiddish Symbolist.* Bern: P. Lang, 1990.

———. "Kafka, the 'Ostjuden', and the Inscription of Identity." In *Kafka, Zionism and Beyond*, edited by Mark H. Gelber, 189–205. Tübingen: Max Niemeyer Verlag, 2004.

Beck, Evelyn Torton. *Kafka and the Yiddish Theater: Its Impact on His Work.* Madison: University of Wisconsin Press, 1971.

Belfer, Ella. "Shirat Uri Zvi Grinberg bein mamlaḥtiyut limshiḥiyut." In *Hamatkonet vehademut: meḥqarim ve'iyunim beshirat Uri Zvi Grinberg*, edited by Hillel Weiss, 297–325. Ramat Gan: Hotsa'at Universitat Bar Ilan, 2000.

Bell, Michael. *Primitivism.* The Critical Idiom 20. London: Methuen, 1972.

Ben-Amos, Dan. "The Idea of Folklore: An Essay." In *Studies in Aggadah and Jewish Folklore*, edited by Issachar Ben-Ami and Joseph Dan, 7:11–17. Folklore Research Centre Studies. Jerusalem: Magnes Press, 1983.

Bendix, Regina. *In Search of Authenticity: The Formation of Folklore Studies.* Madison: University of Wisconsin Press, 1997.

Berdichevsky, Micah Joseph. *Kitvei Mikhah Yosef Bin-Gorion (Berdichevsky).* Vol. 2, *Ma'amarim.* Tel Aviv: Dvir, 1964.

———. *Sefer ḥasidim: agadot, partsufim veḥezyonot.* Warsaw: Tushiya, 1900.

Bergelson, Dovid. "Y. L. Perets un di khsidishe ideologye." *Literarishe bleter*, April 10, 1925.

Berkowitz, Michael. *Nationalism, Zionism and Ethnic Mobilization of the Jews in 1900 and Beyond.* Leiden: Brill, 2004.

Berlewi, Henryk. "El Lissitzky in Warschau." In *El Lissitzky*, edited by J. Leering and Wieland Schmied, 61–63. Eindhoven: Stedelijk Van Abbemuseum; Hannover: Kestner-Gesellschaft, 1965.

———. "Yidishe kinstler in der hayntiker rusisher kunst: tsu der rusisher kunst-oysshtelung in Berlin 1922." *Milgroym: tsaytshrift far kunst un literatur* 3 (1923): 14–16.

Berman, Nina. *Orientalismus, Kolonialismus und Moderne: Zum Bild des Orients in der deutschsprachigen Kultur um 1900.* Stuttgart: M und P, Verlag für Wissenschaft und Forschung, 1997.

Berman, Russell A. "German Primitivism / Primitive Germany: The Case of Emil Nolde." In *Fascism, Aesthetics, and Culture*, edited by Richard J. Golsan, 56–66. Hanover, NH: University Press of New England, 1992.

Bhabha, Homi. *The Location of Culture.* London: Routledge, 1994.

Biale, David, David Assaf, Benjamin Brown, Uriel Gellman, Samuel Heilman, Moshe Rosman, Gadi Sagiv, and Marcin Wodziński. *Hasidism: A New History.* Princeton, NJ: Princeton University Press, 2017.

Birnholz, Alan C. "El Lissitzky and the Jewish Tradition." *Studio International* 186, no. 959 (1973): 133.

Bischoff, Doerte. *Ausgesetzte Schöpfung: Figuren der Souveränität und Ethik der Differenz in der Prosa Else Lasker-Schülers*. Tübingen: M. Niemeyer, 2002.

Blake, Jody. "The Truth about the Colonies, 1931: Art Indigène in Service of the Revolution." *Oxford Art Journal* 25, no. 1 (2002): 35–58.

Blanchard, Pascal, ed. *Human Zoos: Science and Spectacle in the Age of Colonial Empires*. Liverpool University Press, 2008.

Block, Nick. "The Dialectics of Jewish Author and Jewish Other in German-Jewish and Yiddish Literatures, 1886–1939." PhD diss., University of Michigan, 2013.

Boehlich, Sabine. *"Nay-gayst": Mystische Traditionen in einer symbolistischen Erzählung des jiddischen Autors "Der Nister" (Pinkhas Kahanovitsh)*. Wiesbaden: Harrassowitz Verlag, 2008.

Bois, Yve-Alain. "Kahnweiler's Lesson." Translated by Katharine Streip. *Representations*, no. 18 (1987): 33–68.

Born, Jürgen. *Kafkas Bibliothek: Ein beschreibendes Verzeichnis*. Frankfurt am Main: Fischer, 1990.

Bowlt, John E. "Neo-primitivism and Russian Painting." *Burlington Magazine* 116, no. 852 (1974): 133–40.

———, ed. *Russian Art of the Avant-Garde: Theory and Criticism, 1902–1934*. Translated by John E. Bowlt. New York: Viking Press, 1976.

Bowlt, John E., Nicoletta Misler, and Evgenija Petrova, eds. *The Russian Avant-Garde: Siberia and the East*. Milan: Skira, 2014.

Boyarin, Jonathan. "The Other Within and the Other Without." In *The Other in Jewish Thought and History*, edited by Laurence Silberstein, 424–52. New York: NYU Press, 1994.

Brenner, David. *Marketing Identities: The Invention of Jewish Ethnicity in "Ost und West."* Detroit: Wayne State University Press, 1998.

———. "Promoting East European Jewry: *Ost und West*, Ethnic Identity, and the German-Jewish Audience." *Prooftexts* 15, no. 1 (1995): 63–88.

Brenner, Michael. *The Renaissance of Jewish Culture in Weimar Germany*. New Haven, CT: Yale University Press, 1998.

Brenner, Naomi. *Lingering Bilingualism: Modern Hebrew and Yiddish Literatures in Contact*. Syracuse, NY: Syracuse University Press, 2016.

Brod, Max. *Franz Kafka: Eine Biographie*. Berlin: Fischer Verlag, 1954.

———. *Max Brod, Franz Kafka: Eine Freundschaft*. Edited by Malcolm Pasley and Hannelore Rodlauer. Vol. 2, *Briefwechsel*. S. Fischer, 1989.

Bromberg, Eli. "We Need to Talk about Shmuel Charney." *In Geveb*, October 2019. https://ingeveb.org/articles/we-need-to-talk-about-shmuel-charney.

Browning, Gary L. "Russian Ornamental Prose." *Slavic and East European Journal* 23, no. 3 (1979): 346–52.

Bruce, Iris. *Kafka and Cultural Zionism: Dates in Palestine*. University of Wisconsin Press, 2007.

Buber, Martin. *Der große Maggid und seine Nachfolge*. Frankfurt am Main: Rütten & Loening, 1922.

——. *Die chassidischen Bücher*. Hellerau: Hegner, 1928.

——. "Jüdische Renaissance." *Ost und West: Illustrierte Monatsschrift für modernes Judentum* 1, no. 1 (1901): 7–10.

——. *The Legend of the Baal-Shem*. Princeton, NJ: Princeton University Press, 1995.

Buñuel, Luis. "Land without Bread." In *F Is for Phony: Fake Documentary and Truth's Undoing*, edited by Alexandra Juhasz and Jesse Lerner, 91–98. Minneapolis: University of Minnesota Press, 2006.

Caplan, Marc. "Performance Anxieties: Carnival Spaces and Assemblages in Der Nister's 'Under a Fence.'" *Prooftexts* 18, no. 1 (1998): 1–18.

——. "Watch the Throne: Allegory, Kingship and Trauerspiel in the Stories of Der Nister and Reb Nakhman." In *Uncovering the Hidden: The Works and Life of Der Nister*, edited by Gennady Estraikh, Kerstin Hoge, and Mikhail Krutikov, 90–110. London: Legenda, 2014.

——. *Yiddish Writers in Weimar Berlin: A Fugitive Modernism*. Bloomington: Indiana University Press, 2021.

Castle, Gregory. *Modernism and the Celtic Revival*. Cambridge: Cambridge University Press, 2001.

Chabon, Michael. *The Yiddish Policemen's Union: A Novel*. New York: HarperCollins, 2007.

Chinitz, David. "Rejuvenation through Joy: Langston Hughes, Primitivism, and Jazz." *American Literary History* 9, no. 1 (1997): 60–78.

Chipp, Herschel Browning, ed. *Theories of Modern Art: A Source Book by Artists and Critics*. Berkeley: University of California Press, 1968.

Clifford, James. "On Ethnographic Surrealism." In *The Predicament of Culture: Twentieth-Century Ethnography, Literature, and Art*, 117–51. Cambridge, MA: Harvard University Press, 2002.

——. "The Others: Beyond the 'Salvage' Paradigm." *Third Text* 3, no. 6 (1989): 73–78.

——. *Routes: Travel and Translation in the Late Twentieth Century*. Cambridge, MA: Harvard University Press, 1997.

Clifford, James, and George E. Marcus, eds. *Writing Culture: The Poetics and Politics of Ethnography*. Berkeley: University of California Press, 1986.

Corbey, Raymond. "Ethnographic Showcases, 1870–1930." *Cultural Anthropology* 8, no. 3 (1993): 338–69.

Dan, Joseph. "A Bow to Frumkinian Hasidism." *Modern Judaism* 11, no. 2 (1991): 175–93.

Der Nister. *Fun mayne giter*. Kharkov: Melukhe-farlag fun Ukrayne, 1929.

——. *Gedakht*. Kiev: Kooperativer farlag "Kultur-lige," 1929.

Deutsch, Nathaniel. *The Jewish Dark Continent: Life and Death in the Russian Pale of Settlement*. Cambridge, MA: Harvard University Press, 2011.

Diamond, James S. *Homeland or Holy Land? The "Canaanite" Critique of Israel*. Bloomington: Indiana University Press, 1986.

Dick, Ricarda, and Astrid Schmetterling, eds. *Else Lasker-Schüler: Die Bilder*. Berlin: Jüdischer Verlag, 2010.

Dmitrieva, Marina. "Die Wilna-Fotocollagen von Moshe Vorobeichic." In *Jüdische Kultur(en) im Neuen Europa*, edited by Marina Dmitrieva and Heidemarie Petersen, 69–84. Jüdische Kultur: Studien zur Geistesgeschichte, Religion und Literatur 13. Wiesbaden: Harrasowitz Verlag, 2004.

———. "Traces of Transit: Jewish Artists from Eastern Europe in Berlin." Translated by Gerald Holden. *Osteuropa* 58, no. 8/10 (2008): 143–56.

Döblin, Alfred. *Berlin Alexanderplatz: Die Geschichte vom Franz Biberkopf.* Berlin: Suhrkamp, 2002.

———. *Journey to Poland.* Edited by Heinz Graber. Translated by Joachim Neugroschel. New York: Paragon House, 1991.

———. *Reise in Polen.* Munich: Deutscher Taschenbuch Verlag, 1987.

Donahue, Neil H. *Forms of Disruption: Abstraction in Modern German Prose.* Ann Arbor: University of Michigan Press, 1993.

Drews, Peter. *Herder und die Slaven: Materialien zur Wirkungsgeschichte bis zur Mitte des 19. Jahrhunderts.* Munich: O. Sagner, 1990.

Dukhan, Igor. "El Lissitzky: Jewish as Universal; From Jewish Style to Pangeometry." *Ars Judaica* 3 (2007): 1–20.

Dundes, Alan. "Nationalistic Inferiority Complexes and the Fabrication of Fakelore: A Reconsideration of Ossian, the Kinder- und Hausmärchen, the Kalevala, and Paul Bunyan." *Journal of Folklore Research* 22, no. 1 (1985): 5–18.

Edelmann-Ohler, Eva. "Exclusion and Inclusion: Ethnography of War in *Kriegsgefangene* (1916) and *Das ostjüdische Antlitz* (1920)." In *Writing Jewish Culture: Paradoxes in Ethnography*, edited by Andreas Kilcher and Gabriella Safran, 181–207. Bloomington: Indiana University Press, 2016.

Edwards, Elizabeth. *Anthropology and Photography, 1860–1920.* New Haven, CT: Yale University Press, 1992.

———. "Anthropology and Photography: A Long History of Knowledge and Affect." *Photographies* 8, no. 3 (2015): 235–52.

Einstein, Carl. *Afrikanische Legenden.* Berlin: E. Rowohlt, 1925.

———. *Bebuquin oder die Dilettanten des Wunders: Ein Roman.* Berlin: Die Aktion, 1912.

———. *Bebuquin or the Dilettantes of the Miracle.* Translated by Patrick Healy. Amsterdam: November Editions, 2017.

———. *A Mythology of Forms: Selected Writings on Art.* Edited by Charles W. Haxthausen. Chicago: University of Chicago Press, 2019.

———. *Texte aus dem Nachlaß I.* Edited by Hermann Haarmann and Klaus Siebenhaar. Vol. 4 of *Carl Einstein: Werke.* Berlin: Fannei & Walz, 1992.

———. *Werke: 1907–1918.* Edited by Hermann Haarmann and Klaus Siebenhaar. Vol. 1 of *Carl Einstein: Werke.* Berlin: Fannei & Walz, 1994.

Erlich, Rachel (Shoshke). "Vos iz taytsh folkstimlekh?" *Yidishe shprakh* 33, nos. 1–3 (1974): 51–52.

Estraikh, Gennady. "Vilna on the Spree: Yiddish in Weimar Berlin." *Aschkenas* 16, no. 1 (2007): 103–27.

Estraikh, Gennady, and Mikhail Krutikov, eds. *Yiddish in Weimar Berlin: At the Cross-roads of Diaspora Politics and Culture.* London: Legenda, 2010.

Etherington, Ben. *Literary Primitivism.* Stanford, CA: Stanford University Press, 2017.

Fabian, Johannes. "Culture, Time, and the Object of Anthropology." *Berkshire Review* 20 (1985).

———. *Time and the Other: How Anthropology Makes Its Object.* New York: Columbia University Press, 2002.

Fore, Devin. *Realism after Modernism: The Rehumanization of Art and Literature.* Cambridge, MA: MIT Press, 2012.

Foster, Hal. "The 'Primitive' Unconscious of Modern Art." *October* 34 (1985): 45–70.

Frank, Joseph. *The Idea of Spatial Form.* New Brunswick, NJ: Rutgers University Press, 1991.

Fridenzon, Yoysef. "Mayn tatns rebe in varshever geto." *Dos yidishe vort,* no. 310 (5753): 55–57.

Frieden, Ken. *Classic Yiddish Fiction: Abramovitsh, Sholem Aleichem, and Peretz.* Albany: SUNY Press, 2012.

Garloff, Katja. *Mixed Feelings: Tropes of Love in German Jewish Culture.* Ithaca, NY: Cornell University Press, 2016.

Garrett, Leah V. *Journeys beyond the Pale: Yiddish Travel Writing in the Modern World.* Madison: University of Wisconsin Press, 2003.

Garrigan Mattar, Sinéad. *Primitivism, Science, and the Irish Revival.* Oxford: Clarendon Press, 2004.

Gelber, Mark H. "Jewish, Erotic, Female: Else Lasker-Schüler in the Context of Cultural Zionism." In *Else Lasker-Schüler: Ansichten und Perspektiven,* edited by Ernst Schürer and Sonja Maria Hedgepeth, 27–43. Tübingen: Francke A. Verlag, 1999.

———. "'Juden auf Wanderschaft' und die Rhetorik der Ost-West-Debatte im Werk Joseph Roths." In *Joseph Roth: Interpretation, Rezeption, Kritik,* edited by Michael Kessler and Fritz Hackert, 127–35. Tübingen: Stauffenburg Verlag, 1990.

Gelbin, Cathy. *The Golem Returns: From German Romantic Literature to Global Jewish Culture, 1808–2008.* Ann Arbor: University of Michigan Press, 2010.

Geller, Jay. *The Other Jewish Question: Identifying the Jew and Making Sense of Modernity.* New York: Fordham University Press, 2011.

Gess, Nicola, ed. *Literarischer Primitivismus.* Untersuchungen zur deutschen Literaturgeschichte 143. Berlin: De Gruyter, 2013.

———. *Primitives Denken: Wilde, Kinder und Wahnsinnige in der literarischen Moderne (Müller, Musil, Benn, Benjamin).* Munich: Wilhelm Fink, 2013.

Gikandi, Simon. "Picasso, Africa, and the Schemata of Difference." *Modernism/Modernity* 10, no. 3 (2003): 455–80.

Gilman, Sander L. *Franz Kafka, the Jewish Patient.* London: Routledge, 1995.

———. *Jewish Self-Hatred: Anti-Semitism and the Hidden Language of the Jews.* Baltimore: Johns Hopkins University Press, 1990.

Glatstein, Jacob. *The Glatstein Chronicles.* Edited by Ruth R. Wisse. Translated by Maier Deshell and Norbert Guterman. New Haven, CT: Yale University Press, 2010.

Gluck, Mary. "Interpreting Primitivism, Mass Culture and Modernism: The Making of Wilhelm Worringer's Abstraction and Empathy." *New German Critique*, no. 80 (2000): 149–69.

Goldish, Matt. "Mystical Messianism: From the Renaissance to the Enlightenment." In *Jewish Mysticism and Kabbalah: New Insights and Scholarship*, edited by Frederick E. Greenspahn, 115–38. New York: NYU Press, 2011.

Goldsmith, Emanuel S. *Modern Yiddish Culture: The Story of the Yiddish Language Movement*. New York: Fordham University Press, 1997.

Goldwater, Robert. *Primitivism in Modern Art*. Cambridge, MA: Harvard University Press, 1986.

Gombocz, István. "The Reception of Herder in Central Europe: Idealization and Exaggeration." *Seminar: A Journal of Germanic Studies* 33, no. 2 (1997): 107–18.

Gordon-Mlotek, Khane. "Y. L. Peretses zamlung yidishe folkslider." *YIVO bleter*, n.s., 4 (2003): 9–14.

Gottesman, Itzik Nakhmen. *Defining the Yiddish Nation: The Jewish Folklorists of Poland*. Detroit: Wayne State University Press, 2003.

Gourgouris, Stathis. *Dream Nation: Enlightenment, Colonization, and the Institution of Modern Greece*. Stanford, CA: Stanford University Press, 1996.

Grinberg, Uri Zvi. *Gezamlte verk*. Edited by Chone Shmeruk. Vol. 2. Jerusalem: Hebrew University Magnes Press, 1979.

———. *Kol ketavav*. Edited by Dan Miron. Vol. 15. Jerusalem: Mosad Bialik, 2001.

———. *Kol ketavav*. Edited by Dan Miron. Vol. 16. Jerusalem: Mosad Bialik, 2004.

Grossman, Jeffrey. "From East to West: Translating Y. L. Perets in Early Twentieth-Century Germany." In *Transmitting Jewish Traditions: Orality, Textuality, and Cultural Diffusion*, edited by Yaakov Elman and Israel Gershoni, 278–309. New Haven, CT: Yale University Press, 2000.

———. "The Yiddish-German Connection: New Directions." *Poetics Today* 36, nos. 1–2 (2015): 59–110.

Grossmann, Uta. *Fremdheit im Leben und in der Prosa Else Lasker-Schülers*. Oldenburg: Igel Verlag, 2001.

Gruber, Jacob W. "Ethnographic Salvage and the Shaping of Anthropology." *American Anthropologist*, n.s., 72, no. 6 (1970): 1289–99.

Hallensleben, Markus. *Else Lasker-Schüler: Avantgardismus und Kunstinszenierung*. Tübingen: Francke, 2000.

Halper, Shaun Jacob. "Coming Out of the Hasidic Closet: Jiří Mordechai Langer (1894–1943) and the Fashioning of Homosexual-Jewish Identity." *Jewish Quarterly Review* 101, no. 2 (2011): 189–231.

Hansen-Löve, Aage A. *Über das Vorgestern ins Übermorgen: Neoprimitivismus in Wort- und Bildkunst der russischen Moderne*. Paderborn: Wilhelm Fink, 2016.

———. "Vom Vorgestern ins Übermorgen: Neoprimitivismus in der russischen Avantgarde." In *Literarischer Primitivismus*, edited by Nicola Gess, 269–314. Berlin: De Gruyter, 2013.

Harbsmeier, Michael. "Writing and the Other: Travellers' Literacy, or Towards an Archaeology of Orality." In *Literacy and Society*, edited by Karen Schousboe and Mogens Trolle Larsen, 197–228. Copenhagen: Akademisk Forlag, 1989.

Harshav, Benjamin, ed. *Marc Chagall on Art and Culture: Including the First Book on Chagall's Art by A. Efros and Ya. Tugendhold (Moscow, 1918)*. Stanford, CA: Stanford University Press, 2003.

———. "The Role of Language in Modern Art: On Texts and Subtexts in Chagall's Paintings." *Modernism/Modernity* 1, no. 2 (1994): 51–87.

Hauschild, Thomas. "Christians, Jews, and the Other in German Anthropology." *American Anthropologist* 99, no. 4 (1997): 746–53.

Hay, Jonathan. "Primitivism Reconsidered (Part 1): A Question of Attitude." *Res: Anthropology and Aesthetics* 67–68 (2016, 2017): 61–77.

———. "Primitivism Reconsidered (Part 2): Picasso and the Krumen." *Res: Anthropology and Aesthetics* 69–70 (2018): 227–50.

Hedgepeth, Sonja M. "Die Flucht ins Morgenland: Zum Orientalismus im Werk Else Lasker-Schülers." In *Kulturelle Wechselbeziehungen im Exil—Exile across Cultures*, edited by Helmut F. Pfanner, 190–201. Bonn: Bouvier Verlag Herbert Grundmann, 1986.

———. "A Matter of Perspective: Regarding Else Lasker-Schüler as a Visual Artist." In *Else Lasker-Schüler: Ansichten und Perspektiven*, edited by Ernst Schürer and Sonja M. Hedgepeth, 249–65. Tübingen: Francke A. Verlag, 1999.

Heiting, Manfred, and Roland Jaeger, eds. *Autopsie: Deutschsprachige Fotobücher 1918 bis 1945*. Göttingen: Steidl, 2012.

Heizer, Donna K. *Jewish-German Identity in the Orientalist Literature of Else Lasker-Schüler, Friedrich Wolf, and Franz Werfel*. Columbia, SC: Camden House, 1996.

Henneke-Weischer, Andrea. *Poetisches Judentum: Die Bibel im Werk Else Lasker-Schülers*. Mainz: Matthias-Grünewald-Verlag, 2003.

Herder, Johann Gottfried. *Schriften zur Ästhetik und Literatur 1767–1781*. Edited by Gunter E. Grimm. Vol. 2 of *Werke in Zehn Bänden*. Frankfurt: Deutscher Klassiker Verlag, 1993.

Heschel, Susannah. "German Jewish Scholarship on Islam as a Tool for De-orientalizing Judaism." *New German Critique*, no. 117 (2012): 91–107.

Hessing, Jakob. *Else Lasker-Schüler: Biographie einer deutsch-jüdischen Dichterin*. Karlsruhe: Loeper Verlag, 1985.

Hever, Hannan. *Beshevi ha'utopyah: masah al meshihiyut ufolitiqah bashirah ha'ivrit be'rets Yisra'el bein shtei milhamot ha'olam*. Qiryat Sdeh Boker: Hotsa'at Sefarim shel Ben Gurion Universtat beNegev, 1995.

———. *Moledet hamavet yafah: estetiqah ufolitiqah beshirat Uri Zvi Grinberg*. Tel Aviv: Am 'Oved, 2004.

———. "Shir hahod labiryon: Estetiqah, po'etiqah, politiqah, ve'alimut beshirat Atsag bishnot hashloshim." In *Hamatqonet vehademut: mehqarim ve'iyunim beshirat Uri Zvi Grinberg*, edited by Hillel Weiss, 263–96. Ramat Gan: Hotsa'at Universitat Bar Ilan, 2000.

———. "Territoriality and Otherness in Hebrew Literature of the War of Independence." In *The Other in Jewish Thought and History: Constructions of Jewish Culture and Identity*, edited by Laurence Jay Silberstein and Robert Leonard Cohn, 236–52. New York: NYU Press, 1994.

Hodgen, Margaret T. "The Doctrine of Survivals: The History of an Idea." *American Anthropologist*, n.s., 33, no. 3 (September 1931): 307–24.

———. "Survivals and Social Origins: The Pioneers." *American Journal of Sociology* 38, no. 4 (1933): 583–94.

Hoffman, Matthew. "From 'Pintele Yid' to Racenjude': Chaim Zhitlovsky and Racial Conceptions of Jewishness." *Jewish History* 19, no. 1 (2005): 65–78.

Hollier, Denis. "The Use-Value of the Impossible." Translated by Liesl Ollman. *October* 60 (1992): 3–24.

Holtzman, Avner. "Langer, Jiří." In *YIVO Encyclopedia of Jews in Eastern Europe*, October 27, 2010. https://yivoencyclopedia.org/article.aspx/Langer_Jiri.

Honold, Alexander. "Berichte von der Menschenschau: Kafka und die Ausstellung des Fremden." In *Odradeks Lachen: Fremdheit bei Kafka*, edited by Hansjörg Bay and Christof Hamann, 305–24. Freiburg: Rombach, 2006.

Horn, Dara. "Der Nister's Symbolist Stories: Adventures in Yiddish Storytelling and Their Consequences." In *Choosing Yiddish: New Frontiers of Language and Culture*, edited by Shiri Goren, Hannah S. Pressman, and Lara Rabinovitch, 15–28. Detroit: Wayne State University Press, 2013.

Horowitz, Brian. "Spiritual and Physical Strength in An-sky's Literary Imagination." In *The Worlds of S. An-sky: A Russian Jewish Intellectual at the Turn of the Century*, edited by Gabriella Safran and Steven J. Zipperstein, 103–18. Stanford, CA: Stanford University Press, 2006.

Horrocks, David. "The Construction of Eastern Jewry in Joseph Roth's 'Juden auf Wanderschaft.'" In *Ghetto Writing: Traditional and Eastern Jewry in German-Jewish Literature from Heine to Hilsenrath*, edited by Anne Fuchs and Florian Krobb, 126–139. Rochester, NY: Camden House, 1999.

Hoyt, David L. "The Reanimation of the Primitive: Fin-de-Siècle Ethnographic Discourse in Western Europe." *History of Science* 39 (2001): 331–54.

Huggins, Nathan Irvin. *Harlem Renaissance*. New York: Oxford University Press, 2007.

Hwang, June J. "Not All Who Wander Are Lost: Alfred Döblin's 'Reise in Polen' [Journey to Poland, 1925]." In *Spatial Turns: Space, Place, and Mobility in German Literary and Visual Culture*, edited by Jaimey Fisher and Barbara Mennel, 255–274. Amsterdam: Rodopi, 2010.

Isenberg, Noah. *Between Redemption and Doom: The Strains of German-Jewish Modernism*. Lincoln: University of Nebraska Press, 1999.

Isermann, Thomas. *Der Text und das Unsagbare: Studien zu Religionssuche und Werkpoetik bei Alfred Döblin*. Idstein: Schulz-Kirchner Verlag, 1989.

Ivanov, Vladislav. "An-sky, Evgeny Vakhtangov, and 'The Dybbuk.'" In *The Worlds of S. An-sky: A Russian Jewish Intellectual at the Turn of the Century*, edited by Gabriella

Safran and Steven J. Zipperstein, 252–65. Stanford, CA: Stanford University Press, 2006.

———. Introduction to "S. An-sky 'Between Two Worlds (The Dybbuk)': Censored Variant." In *The Worlds of S. An-sky: A Russian Jewish Intellectual at the Turn of the Century*, edited by Gabriella Safran and Steven J. Zipperstein, 361–72. Stanford, CA: Stanford University Press, 2006.

Jaeger, Roland. "Gegensatz zum Lesebuch 'Die Reihe Schaubücher' im Orell Füssli Verlag, Zürich." In *Autopsie: Deutschsprachige Fotobücher 1918 bis 1945*, edited by Manfred Heiting and Roland Jaeger, 314–31. Göttingen: Steidl, 2012.

Jamin, Jean. "Anxious Science: Ethnography as a Devil's Dictionary." *VAR: Visual Anthropology Review* 7, no. 1 (1991): 84–91.

———. "L'ethnographie mode d'inemploi: De quelques rapports de l'ethnologie avec le malaise dans la civilisation." In *Le mal et la douleur*, edited by Jacques Hainard and Roland Kaehr, 45–79. Neuchâtel: Musée d'ethnographie, 1986.

Kafka, Franz. "An Introductory Talk on the Yiddish Language." In *Reading Kafka: Prague, Politics, and the Fin de Siècle*, edited by Mark Anderson, 263–66. New York: Schocken Books, 1989.

———. *Letter to the Father / Brief an den Vater: Bilingual Edition*. Translated by Ernst Kaiser and Eithne Wilkins. New York: Schocken Books, 2015.

———. *The Metamorphosis and Other Stories*. Translated by Joyce Crick. Oxford: Oxford University Press, 2009.

———. *Tagebücher*. Edited by Hans-Gerd Koch, Michael Müller, and Malcolm Pasley. Frankfurt am Main: S. Fischer, 1990.

———. "Vor dem Gesetz." In *"Vor dem Gesetz": Einführung in Kafkas Welt*, edited by Hartmut Binder. Stuttgart: Metzler, 1993.

Kahnweiler, Daniel Henry. *Der Weg zum Kubismus*. Munich: Delphin-Verlag, 1920.

Kalmar, Ivan Davidson, and Derek J. Penslar, eds. *Orientalism and the Jews*. Waltham, MA: Brandeis University Press, 2005.

Kamensky, Aleksandr. *Chagall: The Russian Years 1907–1922*. New York: Rizzoli, 1989.

Kandinsky, Wassily, and Franz Marc, eds. *Der Blaue Reiter*. 2nd ed. Munich: Piper, 1914.

Kaplan, Eran. *The Jewish Radical Right: Revisionist Zionism and Its Ideological Legacy*. Madison: University of Wisconsin Press, 2005.

Katz, Dovid. *Words on Fire: The Unfinished Story of Yiddish*. New York: Basic Books, 2004.

Katz, Stephen. *Red, Black, and Jew: New Frontiers in Hebrew Literature*. Austin: University of Texas Press, 2009.

Kelly, Julia. "Discipline and Indiscipline: The Ethnographies of Documents." *Papers of Surrealism*, no. 7 (2007).

Kiefer, Klaus H. *Diskurswandel im Werk Carl Einsteins: Ein Beitrag zur Theorie und Geschichte der europäischen Avantgarde*. Tübingen: Max Niemeyer, 1994.

Kiel, Mark W. "A Twice Lost Legacy: Ideology, Culture and the Pursuit of Jewish Folklore in Russia until Stalinization (1930–1931)." PhD diss., Jewish Theological Seminary of America, 1991.

————. "Vox Populi, Vox Dei: The Centrality of Peretz in Jewish Folkloristics." *Polin* 7 (1992): 88–120.

Kilcher, Andreas. "The Cold Order and the Eros of Storytelling: Joseph Roth's 'Exotic Jews.'" In *Writing Jewish Culture: Paradoxes in Ethnography*, 68–93. Bloomington: Indiana University Press, 2016.

Kilcher, Andreas, and Gabriella Safran, eds. *Writing Jewish Culture: Paradoxes in Ethnography*. Bloomington: Indiana University Press, 2016.

Kirschnick, Sylke. *Tausend und ein Zeichen: Else Lasker-Schülers Orient und die Berliner Alltags- und Populärkultur um 1900*. Würzburg: Königshausen & Neumann, 2007.

Kirshenblatt-Gimblett, Barbara. "Di folkloristik: A Good Yiddish Word." *Journal of American Folklore* 98, no. 389 (1985): 331–34.

————. "Folklore's Crisis." *Journal of American Folklore* 111, no. 441 (1998): 281–327.

————. "Problems in the Early History of Jewish Folkloristics." In *Proceedings of the Tenth World Congress of Jewish Studies*, Division D, vol. 2: *Art, Folklore and Music*, 21–31. Jerusalem: World Union of Jewish Studies, 1990.

Kisch, Egon Erwin. *Der Rasende Reporter*. Berlin: Aufbau-Verlag, 1924.

————. *Egon Erwin Kisch, the Raging Reporter: A Bio-anthology*. Edited and translated by Harold B. Segel. West Lafayette, IN: Purdue University Press, 1997.

————. *Entdeckungen in Mexiko*. Mexico City: Editorial "El Libro libre," 1945.

————. *Geschichten aus sieben Ghettos*. Amsterdam: Allert de Lange, 1934.

————. *Tales from Seven Ghettos*. Translated by Edith Bone. London: Robert Anscombe, 1948.

Koenig, Raphael. "The Mad Book: Der Nister as Unreliable Author in 'From My Estate' (1929)." In *Jewish Aspects in Avant-Garde: Between Rebellion and Revelation*, edited by Mark H. Gelber and Sami Sjöberg, 207–25. Berlin: De Gruyter, 2017.

Koepke, Wulf. "Herder and the Sturm und Drang." In *Literature of the Sturm und Drang*, edited by David Hill, 69–94. Woodbridge, UK: Boydell & Brewer, 2003.

Koller, Sabine. "'A Mayse Mit a Hon. Dos Tsigele': Marc Chagall Illustrating Der Nister." In *Uncovering the Hidden: The Works and Life of Der Nister*, edited by Gennady Estraikh, Kerstin Hoge, and Mikhail Krutikov, 55–72. London: Legenda, 2014.

Krauss, Rosalind. "The Photographic Conditions of Surrealism." *October* 19 (1981): 3–34.

————. "Photography in the Service of Surrealism." In *Art of the Twentieth Century: A Reader*, edited by Jason Gaiger and Paul Wood, 114–32. New Haven, CT: Yale University Press, 2004.

Krauss, Rosalind E., Jane Livingston, and Dawn Ades. *L'amour fou: Photography and Surrealism*. Washington, DC: Corcoran Gallery of Art, 1985.

Kraut, Anthea. "Between Primitivism and Diaspora: The Dance Performances of Josephine Baker, Zora Neale Hurston, and Katherine Dunham." *Theatre Journal* 55, no. 3 (2003): 433–50.

Kronfeld, Chana. *On the Margins of Modernism: Decentering Literary Dynamics*. Berkeley: University of California Press, 1996.

Krutikov, Mikhail. *Der Nister's Soviet Years: Yiddish Writer as Witness to the People.* Bloomington: Indiana University Press, 2019.

———. "Slavishe erd vehapo'etiqah hamodernizm beYidish." *Ot: Ktav et lesifrut ulete'oriah* 5 (2015): 201–22.

Kugelmass, Jack. "The Father of Jewish Ethnography?" In *The Worlds of S. An-sky: A Russian Jewish Intellectual at the Turn of the Century*, edited by Gabriella Safran and Steven J. Zipperstein. Stanford, CA: Stanford University Press, 2006.

Langer, František. "My Brother Jiří." Forward to *Nine Gates to the Chasidic Mysteries*, by Jiří Langer, translated by Stephen Jolly, ix–xxxiv. Northvale, NJ: Jason Aronson, 1993.

Lasker-Schüler, Else. *Briefe, 1914–1924.* Vol. 7 of *Werke und Briefe.* Edited by Karl Jürgen Skrodzki. Frankfurt am Main: Jüdischer Verlag, 2004.

———. *Briefe, 1941–1945: Nachträge.* Vol. 11 of *Werke und Briefe.* Edited by Karl Jürgen Skrodzki and Andreas B. Kilcher. Frankfurt am Main: Jüdischer Verlag, 2010.

———. *Das Hebräerland.* Edited by Heinz Rölleke and Itta Shedletzky. Vol. 5 of *Werke und Briefe.* Frankfurt am Main: Jüdischer Verlag, 2002.

———. *Gedichte.* Edited by Karl Jürgen Skrodzki. Vol. 1.1 of *Werke und Briefe.* Frankfurt am Main: Jüdischer Verlag, 1996.

———. *Prosa: 1903–1920.* Edited by Ricarda Dick and Norbert Oellers. Vol. 3.1 of *Werke und Briefe.* Frankfurt am Main: Jüdischer Verlag, 1998.

———. *Prosa: 1903–1920; Anmerkungen.* Edited by Ricarda Dick and Norbert Oellers. Vol. 3.2 of *Werke und Briefe.* Frankfurt am Main: Jüdischer Verlag, 1998.

Lastra, James F. "Why Is This Absurd Picture Here? Ethnology/Equivocation/Buñuel." *October* 89 (1999): 51–68.

Lazaroms, Ilse Josepha. *The Grace of Misery: Joseph Roth and the Politics of Exile, 1919–1939.* Leiden: Brill, 2012.

Lehmann, Ulf, Helmut Grasshoff, and Gerhard Ziegengeist, eds. *Johann Gottfried Herder: Zur Herder-Rezeption in Ost- u. Südosteuropa.* Berlin: Akademie-Verlag, 1978.

Leiman, Shnayer. "The Adventures of the Maharal of Prague in London: R. Yudl Rosenberg and the Golem of Prague." *Tradition* 36, no. 1 (2002): 26–58.

Lemke, Sieglinde. *Primitivist Modernism: Black Culture and the Origins of Transatlantic Modernism.* New York: Oxford University Press, 1998.

Lemon, Robert. *Imperial Messages: Orientalism as Self-Critique in the Habsburg "Fin de Siècle."* Rochester, NY: Camden House, 2011.

Lévy-Bruhl, Lucien. *Primitive Mentality.* Translated by Lilian A. Clare. London: George Allen & Unwin, 1923.

Lipsker, Avidov. "The Albatrosses of Young Yiddish Poetry: An Idea and Its Visual Realization in Uri Zvi Greenberg's 'Albatros.'" *Prooftexts*, no. 15 (1995): 89–108.

———. "Hamuzah ha'asirit: musag programati leshiluv shirah, publitsistiqah, ve'omanut ḥazutit bikhtav-ha'et hayidi 'Albatros.'" In *Shir adom, shir kakhol: sheva masot 'al shirat Uri Zvi Grinberg ushetayim 'al shirat Else Lasker-Schüler*, 17–50. Ramat Gan: Bar Ilan University, 2010.

Lissitzky, El. "K. und Pangeometrie." In *Europa Almanach*, edited by Carl Einstein and Paul Westheim, 103–13. Potsdam: Gustav Kiepenheuer Verlag, 1924.

Litvakov, Moyshe. *In umru*. Vol. 2. Moscow: Shul un bukh, 1926.

Lloyd, Jill. *German Expressionism: Primitivism and Modernity*. New Haven, CT: Yale University Press, 1991.

Lodder, Christina. "Ideology and Identity: El Lissitzky in Berlin." In *The Russian Jewish Diaspora and European Culture, 1917–1937*, edited by Jörg Schulte, Olga Tabachnikova, and Peter Wagstaff, 339–64. Leiden: Brill, 2012.

Loeffler, James. "Do Zionists Read Music from Right to Left? Abraham Tsvi Idelsohn and the Invention of Israeli Music." *Jewish Quarterly Review* 100, no. 3 (2010): 385–416.

———. "From Biblical Antiquarianism to Revolutionary Modernism: Jewish Art Music, 1850–1925." In *The Cambridge Companion to Jewish Music*, edited by Joshua S. Walden, 167–86. Cambridge: Cambridge University Press, 2015.

———. *The Most Musical Nation: Jews and Culture in the Late Russian Empire*. New Haven, CT: Yale University Press, 2010.

Lovejoy, Arthur O., and George Boas. *Primitivism and Related Ideas in Antiquity*. Baltimore: Johns Hopkins University Press, 1935.

Lowie, Robert. "Survivals and the Historical Method." *American Journal of Sociology* 23, no. 4 (1918): 529–35.

Lukin, Benjamin. "'An Academy Where Folklore Will Be Studied': An-sky and the Jewish Museum." In *The Worlds of S. An-sky: A Russian Jewish Intellectual at the Turn of the Century*, edited by Gabriella Safran and Steven J. Zipperstein, 281–306. Stanford, CA: Stanford University Press, 2006.

Luschan, Felix von. *Kriegsgefangene: Ein Beitrag zur Völkerkunde im Weltkriege*. Berlin: D. Reimer, 1917.

"M. Vorobeichic: Das Ghetto von Wilna." *Menorah* 10, nos. 9–10 (1932): 440.

Magilow, Daniel H. *The Photography of Crisis: The Photo Essays of Weimar Germany*. University Park: Pennsylvania State University Press, 2012.

Maimon, Solomon. *The Autobiography of Solomon Maimon: The Complete Translation*. Edited by Yitzhak Y. Melamed and Abraham P. Socher. Translated by Paul Reitter. Princeton, NJ: Princeton University Press, 2018.

Mantovan, Daniela. "Der Nister and His Symbolist Short Stories (1913–1929): Patterns of Imagination." PhD diss., Columbia University, 1993.

———. "The 'Political' Writings of an 'Unpolitical' Yiddish Symbolist." In *Uncovering the Hidden: The Works and Life of Der Nister*, edited by Gennady Estraikh, Kerstin Hoge, and Mikhail Krutikov, 73–89. London: Legenda, 2014.

Markish, Peretz. *Farbaygeyendik: eseyen*. Vilna: Bikherlager bay der tsentraler yidisher shul-organizatsye in Vilne, 1921.

Mattenklott, Gert. "Ostjudentum und Exotismus." In *Die andere Welt: Studien zum Exotismus*, edited by Thomas Koebner and Gerhart Pickerodt, 291–306. Frankfurt am Main: Athenäum Verlag, 1987.

Maurer, Evan Maclyn. "In Quest of the Myth: An Investigation of the Relationships between Surrealism and Primitivism." PhD diss., University of Pennsylvania, 1974.

Mayer, Sigrid. *Golem: Die literarische Rezeption eines Stoffes*. Bern: H. Lang, 1975.

Mayzel, Nakhmen, ed. *Briv un redes fun Y. L. Perets*. New York: Ikuf, 1944.

———. "Perets mit undz." In *Tsum tsveytn yortsayt fun Y. L. Perets: Zamlung*, 6–8. Kiev, 1917.

———. *Y. L. Perets zayn lebn un shafn: Ophandlungen un materialn*. New York: Yidisher Kultur Farband, 1945.

McCabe, Tracy. "The Multifaceted Politics of Primitivism in Harlem Renaissance Writing." *Soundings: An Interdisciplinary Journal* 80, no. 4 (1997): 475–97.

McCrea, Barry. *Languages of the Night: Minor Languages and the Literary Imagination in Twentieth-Century Ireland and Europe*. New Haven, CT: Yale University Press, 2015.

Mendes-Flohr, Paul. "*Fin-de-Siècle* Orientalism, the *Ostjuden* and the Aesthetics of Jewish Self-Affirmation." *Studies in Contemporary Jewry* 1 (1984): 96–139.

Meyer, Franz. *Marc Chagall: Life and Work*. New York: Harry N. Abrams, 1963.

Micale, Mark S. *The Mind of Modernism: Medicine, Psychology, and the Cultural Arts in Europe and America, 1880–1940*. Stanford, CA: Stanford University Press, 2004.

Mileaf, Janine. "Body to Politics: Surrealist Exhibition of the Tribal and the Modern at the Anti-imperialist Exhibition and the Galerie Charles Ratton." *RES: Anthropology and Aesthetics*, no. 40 (2001): 239–55.

Miller, Cristanne. *Cultures of Modernism: Marianne Moore, Mina Loy, and Else Lasker-Schüler; Gender and Literary Community in New York and Berlin*. Ann Arbor: University of Michigan Press, 2005.

———. "Reading the Politics of Else Lasker-Schüler's 1914 Hebrew Ballads." *Modernism/Modernity* 6, no. 2 (1999): 135–59.

Miron, Dan. *Akdamut le Atsag*. Jerusalem: Mosad Bialik, 2002.

———. *Der imazh fun shtetl: Dray literarishe shtudyes*. Tel Aviv: I. L. Peretz Publishing House, 1981.

———. "Folklore and Antifolklore in the Yiddish Fiction of the Haskala." In *The Image of the Shtetl and Other Studies of Modern Jewish Literary Imagination*, 49–80. Syracuse, NY: Syracuse University Press, 2000.

———. "Introduction to the Poetry of Uri Zvi Greenberg." In *The Prophetic Mode in Modern Hebrew Poetry*, 191–307. Milford, CT: Toby Press, 2010.

———. "Literature as a Vehicle for a National Renaissance: The Model of Peretz versus That of Bialik." In *The Enduring Legacy of Yitzchok Leybush Peretz*, edited by Benny Kraut, 30–48. Flushing, NY: Center for Jewish Studies, Queens College, CUNY, 2006.

Móricz, Klára. *Jewish Identities: Nationalism, Racism, and Utopianism in Twentieth-Century Music*. Berkeley: University of California Press, 2008.

Morris-Reich, Amos. *Race and Photography: Racial Photography as Scientific Evidence, 1876–1980*. Chicago: University of Chicago Press, 2016.

Moseley, Marcus. *Being for Myself Alone: Origins of Jewish Autobiography*. Stanford Studies in Jewish History and Culture. Stanford, CA: Stanford University Press, 2006.

Moss, Kenneth B. *Jewish Renaissance in the Russian Revolution*. Cambridge, MA: Harvard University Press, 2009.

Müller-Salget, Klaus. "Döblin and Judaism." In *A Companion to the Works of Alfred Döblin*, edited by Roland Albert Dollinger, Wulf Köpke, and Heidi Thomann Tewarson, 233–46. Rochester, NY: Camden House, 2004.

Myers, David N. "'Distant Relatives Happening onto the Same Inn': The Meeting of East and West as Literary Theme and Cultural Ideal." *Jewish Social Studies* 1, no. 2 (1995): 75–100.

Nelson, Andrea. "Suspended Relationship: The Montage Photography Books of Moshe Raviv Vorobeichic." In *Time and Photography*, edited by Jan Baetens, Alexander Streitberger, and Hilde van Gelder, 141–64. Lieven Gevaert Series 10. Leuven: Leuven University Press, 2010.

Neugroschel, Joachim. "Editor's Introduction." In *Journey to Poland*, by Alfred Döblin, edited by Heinz Graber, ix–xxviii. New York: Paragon House, 1991.

Neumann, Gerhard. "Kafka als Ethnologe." In *Odradeks Lachen: Fremdheit bei Kafka*, edited by Hansjörg Bay and Christof Hamann, 325–45. Freiburg: Rombach, 2006.

Newall, Venetia J. "The Adaptation of Folklore and Tradition (Folklorismus)." *Folklore* 98, no. 2 (1987): 131–51.

Nichanian, Marc. *Mourning Philology: Art and Religion at the Margins of the Ottoman Empire*. New York: Fordham University Press, 2014.

Niger, Shmuel. *Shmuesn vegn bikher: ershter teyl*. New York: Farlag Yidish, 1922.

———. *Y. L. Perets: zayn lebn, zayn firndike perzenlekhkayt, zayne hebreishe un yidishe shriftn, zayn virkung*. Buenos Aires: Argentiner opteyl fun alveltlekhn yidishn kultur-kongres, 1952.

Nisbet, H. Barry. "Herder's Conception of Nationhood and its Influence in Eastern Europe." In *The German Lands and Eastern Europe: Essays on the History of Their Social, Cultural and Political Relations*, edited by Roger Bartlett and Karen Schönwälder, 115–35. Basingstoke, UK: Palgrave Macmillan, 1999.

Novershtern, Avraham. "Hama'avar el ha'ekspresionizm beyetsirat Uri Zvi Grinberg: hapo'emah 'Mefisto'—gilgulei 'emdot vedovrim." *Hasifrut* 35–36 (1986): 122–40.

———, ed. "Igrotav shel Der Nister el Shmuel Niger." *Khulyot*, no. 1 (Winter 1993): 159–244.

———. *Qesem hadimdumim: apoqalipsah umeshihiyut besifrut Yidish*. Jerusalem: Magnes Press, 2003.

Noy, Dov. "The Place of Sh. Ansky in Jewish Folkloristics." *Jerusalem Studies in Jewish Folklore* 2 (1982): 94–107.

Nye, Robert. "Savage Crowds, Modernism, and Modern Politics." In *Prehistories of the Future: The Primitivist Project and the Culture of Modernism*, edited by Elazar Barkan and Ronald Bush, 42–55. Stanford, CA: Stanford University Press, 1995.

Ogden, J. Alexander. "The Impossible Peasant Voice in Russian Culture: Stylization and Mimicry." *Slavic Review* 64, no. 3 (2005): 517–37.

Ohana, David. *Modernism and Zionism*. New York: Palgrave Macmillan, 2012.

———. *The Origins of Israeli Mythology: Neither Canaanites nor Crusaders*. Translated by David Maisel. New York: Cambridge University Press, 2012.

Olin, Margaret Rose. *Forms of Representation in Alois Riegl's Theory of Art*. University Park: Pennsylvania State University Press, 1992.

Olson, Jess. *Nathan Birnbaum and Jewish Modernity: Architect of Zionism, Yiddishism, and Orthodoxy*. Stanford, CA: Stanford University Press, 2013.

Oyslender, Nokhem. "Der Nister: shtrikhn." *Shtrom*, no. 1 (February 1922): 65–74.

Palermo, Lynn E. "L'Exposition Anticoloniale: Political or Aesthetic Protest?" *French Cultural Studies* 20, no. 1 (2009): 27–46.

Pan, David. "Erhard Schüttpelz: Die Moderne im Spiegel des Primitiven: Weltliteratur und Ethnologie (1870–1960), Fink, München 2005." *Zeitschrift für deutsche Philologie* 126, no. 4 (2007): 624–28.

———. *Primitive Renaissance: Rethinking German Expressionism*. Lincoln: University of Nebraska Press, 2001.

Pape, Marion. "Auf der Suche nach der dreidimensionalen Dichtung: Carl Einsteins *Afrikanische Legenden*." In *Wahlverwandtschaften: Eine Gedenkschrift / Elective Affinities: Tributes and Essays on Germanic and African Studies in Memory of Edith Ihekweazu (1941–1991)*, edited by Willfried Feuser, Marion Pape, and Elias O. Dunu, 125–44. Bayreuth: Boomerang Press N. Aas, 1993.

Peleg, Yaron. *Orientalism and the Hebrew Imagination*. Ithaca, NY: Cornell University Press, 2005.

Peppis, Paul. *Sciences of Modernism: Ethnography, Sexology, and Psychology*. Cambridge: Cambridge University Press, 2014.

Peretz, Yitskhok Leyb. "Bilder fun a provints rayze." In *Dertseylungen, mayselekh, bilder*. Vol. 2 of *Ale verk*. New York: Cyco Bicher-Farlag, 1947.

———. *Briv un redes fun Y. L. Perets*, edited by Nakhmen Mayzel. New York: Ikuf, 1944.

———. *Dramatishe verk*. Vol. 6 of *Ale verk*. New York: Cyco Bicher-Farlag, 1947.

———. "Gedanken in der velt arayn." In *Gedanken un ideyen*, vol. 9 of *Ale verk*, 151–56. New York: Cyco Bicher-Farlag, 1947.

———. *The I. L. Peretz Reader*. Edited by Ruth R. Wisse. New Haven, CT: Yale University Press, 2002.

———. "In folk arayn." In *Literatur un lebn*, vol. 7 of *Ale verk*, 158–61. New York: Cyco Bicher-Farlag, 1947.

———. *Khsidish*. Vol. 4 of *Ale verk*. New York: Cyco Bicher-Farlag, 1947.

———. "Mayses." In *Dertseylungen, mayselekh, bilder*, vol. 3 of *Ale verk*, 462–77. Ale verk. New York: Cyco Bicher-Farlag, 1947.

———. "Shtet un shtetlekh." In *Gedanken un ideyen*, vol. 8 of *Ale verk*, 161–363. New York: Cyco Bicher-Farlag, 1947.

———. "Tshernovitser shprakh konferents." In *Briv un redes fun Y. L. Perets*, edited by Nakhmen Mayzel, 369–76. New York: Ikuf, 1944.

———. "Vegn der yidisher literatur." In *Briv un redes fun Y. L. Perets*, edited by Nakhmen Mayzel, 377–81. New York: Ikuf, 1944.

———. "Vos felt undzer literatur." In *Literatur un lebn*, vol. 7 of *Ale verk*, 270–79. New York: Cyco Bicher-Farlag, 1947.

Perry, Gill. "Primitivism and the 'Modern.'" In *Primitivism, Cubism, Abstraction: The Early Twentieth Century*, 3–85. New Haven, CT: Yale University Press, 1993.

Peterson, Ronald E. *A History of Russian Symbolism*. Amsterdam: J. Benjamins, 1993.

Phillips, Christopher, ed. *Photography in the Modern Era: European Documents and Critical Writings, 1913–1940*. New York: Metropolitan Museum of Art / Aperture, 1989.

Piekarz, Mendel. *Ḥasidut Polin: megamot ra'ayoniyot ben shetei hamilḥamot uvegezerot 700–705 ("hasho'ah")*. Jerusalem: Mosad Bialik, 1990.

Pinthus, Kurt, ed. *Menschheitsdämmerung: Symphonie Jüngster Dichtung*. Berlin: Ernst Rowohlt, 1920.

Pratt, Mary Louise. "Arts of the Contact Zone." *Profession* (1991): 33–40.

———. *Imperial Eyes: Travel Writing and Transculturation*. London: Routledge, 2003.

Pyman, Avril. *A History of Russian Symbolism*. Cambridge: Cambridge University Press, 1994.

Radde, Christine. *Else Lasker-Schülers Hebräische Balladen*. Trier: Wissenschaftlicher Verlag Trier, 1998.

Rajner, Mirjam. "The Origins of Neo-primitivism in Chagall's Work." In *Chagall and the Russian Avant-Garde*, translated by Rose B. Champagne. Toronto: Art Gallery of Ontario, 2011. https://ago.ca/exhibitions/chagall-and-russian-avant-garde-masterpieces-collection-centre-pompidou-paris.

Reiner, Markus. "Modernität und Primitivität." *Der Jude*, no. 10 (January 1917): 702–4.

Richardson, Michael. "An Encounter of Wise Men and Cyclops Women: Considerations of Debates on Surrealism and Anthropology." *Critique of Anthropology* 13, no. 1 (1993): 57–75.

———. *Georges Bataille*. New York: Routledge, 1994.

Robertson, Ritchie, ed. *The German-Jewish Dialogue: An Anthology of Literary Texts, 1749–1993*. Oxford: Oxford University Press, 1999.

———. *The "Jewish Question" in German Literature, 1749–1939: Emancipation and Its Discontents*. Oxford: Oxford University Press, 1999.

———. *Kafka: Judaism, Politics, and Literature*. Oxford: Clarendon Press, 1985.

———. "Myth vs. Enlightenment in Kafka's *Das Schloß*." *Monatshefte* 103, no. 3 (2011): 385–95.

———. "Roth's *Hiob* and the Traditions of Ghetto Fiction." In *Co-existent Contradictions: Joseph Roth in Retrospect*, edited by Helen Chambers, 185–200. Riverside, CA: Ariadne Press, 1991.

Robinson, Ira. "Literary Forgery and Hasidic Judaism: The Case of Rabbi Yudel Rosenberg." *Judaism* 40, no. 1 (Winter 1991): 61–78.

Rokem, Na'ama. "'With the Changing of Horizons Comes the Broadening of the Horizon': Multilingual Narrative Modes in M. Y. Berdichevsky's *Miriam*." In *Languages of Modern Jewish Cultures: Comparative Perspectives*, edited by Joshua L. Miller and Anita Norich, 227–51. Ann Arbor: University of Michigan Press, 2016.

Roskies, David G. "An-sky, Sholem Aleichem, and the Master Narrative of Russian Jewry." In *The Worlds of S. An-sky: A Russian Jewish Intellectual at the Turn of the Century*, edited by Gabriella Safran and Steven J. Zipperstein, 31–43. Stanford, CA: Stanford University Press, 2006.

———. *A Bridge of Longing: The Lost Art of Yiddish Storytelling*. Cambridge, MA: Harvard University Press, 1995.

———. *The Literature of Destruction: Jewish Responses to Catastrophe*. Philadelphia: Jewish Publication Society, 1989.

———. "Rabbis, Rebbes and Other Humanists: The Search for a Usable Past in Modern Yiddish Literature." In *Literary Strategies: Jewish Texts and Contexts*, edited by Ezra Mendelsohn, 55–77. Studies in Contemporary Jewry 12. New York: Oxford University Press, 1996.

———. "S. Ansky and the Paradigm of Return." In *The Uses of Tradition: Jewish Continuity in the Modern Era*, edited by Jack Wertheimer, 243–60. New York: Jewish Theological Seminary of America, 1992.

———. "The Storyteller as High Priest: Der Nister." In *A Bridge of Longing: The Lost Art of Yiddish Storytelling*, 191–229. Cambridge, MA: Harvard University Press, 1995.

Roth, Joseph. "Döblin im Osten." In *Das journalistische Werk: 1924–1928*, vol. 2 of *Werke*, edited by Klaus Westermann, 532–35. Cologne: Kiepenheuer & Witsch, 1989.

———. *Job: The Story of a Simple Man*. Translated by Ross Benjamin. Brooklyn, NY: Archipelago, 2010.

———. *The Wandering Jews*. Translated by Michael Hofmann. New York: W. W. Norton, 2001.

Rubin, Adam. "Hebrew Folklore and the Problem of Exile." *Modern Judaism* 25, no. 1 (2005): 62–83.

Rubin, William. "Picasso." In *"Primitivism" in 20th Century Art: Affinity of the Tribal and the Modern*, edited by William Rubin, 1:241–343. New York: Museum of Modern Art, 1984.

———, ed. *"Primitivism" in 20th Century Art: Affinity of the Tribal and the Modern*. 2 vols. New York: Museum of Modern Art, 1984.

Rubinstein, Rachel. *Members of the Tribe: Native America in the Jewish Imagination*. Detroit: Wayne State University Press, 2010.

Ryback, Yisokher Ber, and Boris Aronson. "Di vegn fun der yidisher moleray." In *Oyfgang: ershter zamlbukh*, 99–124. Kiev: Kultur-lige, 1919.

Sadan, Dov. "Tsu di gvures (vegn Uri Zvi Grinberg)." *Di goldene keyt* 95/96 (1978): 19–29.

Safran, Gabriella. "Dancing with Death and Salvaging Jewish Culture in *Austeria* and *The Dybbuk*." *Slavic Review* 59, no. 4 (Winter 2000): 761–81.

———. "Jews as Siberian Natives: Primitivism and S. An-sky's *Dybbuk*." *Modernism/Modernity* 13, no. 4 (2006): 635–55.

———. *Wandering Soul: The Dybbuk's Creator, S. An-sky*. Cambridge, MA: Harvard University Press, 2010.

Safran, Gabriella, and Steven J. Zipperstein, eds. *The Worlds of S. An-sky: A Russian Jewish Intellectual at the Turn of the Century*. Stanford, CA: Stanford University Press, 2006.

Said, Edward W. *Orientalism*. New York: Knopf Doubleday, 2014.

Sapper, Manfred. "Das Antlitz des ermordeten Volkes: Anmerkungen zu den Fotos von M. Vorobeichic." *Osteuropa* 52, no. 9/10 (2002): 1338–45.

Schachter, Allison. *Diasporic Modernisms: Hebrew and Yiddish Literature in the Twentieth Century*. New York: Oxford University Press, 2011.

Schaechter, Mordkhe. "Folkish un poshet-folkish." *Yidishe shprakh* 33, nos. 1–3 (1974): 52–54.

Schmetterling, Astrid. "'I Am Jussuf of Egypt': Else Lasker-Schüler's Orientalist Drawings." *Ars Judaica* 8 (2012): 81–98.

Schmid, Wolf. "Poetic or Ornamental Prose." In *The Living Handbook of Narratology*, edited by Peter Hühn, Jan Christoph Meister, John Pier, and Wolf Schmid. https://www.lhn.uni-hamburg.de/node/62.html.

Scholem, Gershom. *From Berlin to Jerusalem: Memories of My Youth*. Translated by Harry Zohn. Philadelphia: Paul Dry Books, 2012.

Schulte, Christoph, ed. *Hebräische Poesie und jüdischer Volksgeist: Die Wirkungsgeschichte von Johann Gottfried Herder im Judentum Mittel- und Osteuropas*. Hildesheim: Olms, 2003.

Schüttpelz, Erhard. *Die Moderne im Spiegel des Primitiven: Weltliteratur und Ethnologie (1870–1960)*. Munich: Wilhelm Fink, 2005.

———. "Zur Definition des literarischen Primitivismus." In *Literarischer Primitivismus*, edited by Nicola Gess, 13–27. Untersuchungen zur deutschen Literaturgeschichte 143. Berlin: De Gruyter, 2013.

Schweid, Eliezer. *The Idea of Modern Jewish Culture*. Boston: Academic Studies Press, 2008.

Seelig, Rachel. *Strangers in Berlin: Modern Jewish Literature between East and West, 1919–1933*. Ann Arbor: University of Michigan Press, 2016.

Severi, Carlo. "Primitivist Empathy." Translated by Ramon Fonkoue and Joyce Suechun Cheng. *Art in Translation* 4, no. 1 (2012): 99–130.

Shandler, Jeffrey. "The Time of Vishniac: Photographs of Pre-war East European Jewry in Post-war Contexts." *Polin: Studies in Polish Jewry* 16 (2003): 313–33.

Shanes, Joshua. "Ahron Marcus: Portrait of a Zionist Hasid." *Jewish Social Studies* 16, no. 3 (2010): 116–60.

Shapira, Avraham. "Buber's Attachment to Herder and German 'Volkism.'" *Studies in Zionism* 14, no. 1 (1993): 1–30.

Shavit, Yaacov. "Hebrews and Phoenicians: An Ancient Historical Image and Its Usage." *Studies in Zionism* 5, no. 2 (1984): 157–80.

———. *The New Hebrew Nation: A Study in Israeli Heresy and Fantasy*. London: Frank Cass, 1987.

———. "Realism and Messianism in Zionism and the Yishuv." In *Modern Era: Metaphor and Meaning*, edited by Jonathan Frankel, 100–127. Studies in Contemporary Jewry 7. New York: Oxford University Press, 1991.

———. "Uri Zvi Greenberg: Conservative Revolutionarism and National Messianism." *Jerusalem Quarterly* 48 (1988): 63–72.

Shedletzky, Itta. "Bacherach and Barcelona: On Else Lasker-Schüler's Relation to Heinrich Heine." In *The Jewish Reception of Heinrich Heine*, edited by Mark H. Gelber, 113–26. Tübingen: Max Niemeyer Verlag, 1992.

———. "Bild als Text und Text als Bild: Hebräische Akzente bei Else Lasker-Schüler." In *Else Lasker-Schüler: Schrift, Bild, Schrift*, edited by Ricarda Dick, 171–84. Bonn: Verein August Macke Haus e.V., 2000.

———. "'Überall hängt noch ein Fetzen Jerusalem': Else Lasker-Schülers poetische und reale Präsenz in Jerusalem." *Israel & Palästina* 1 (2013): 64–72.

Sherman, Joseph. "Der Nister and Symbolism in Yiddish Literature." *Midstream* 51, no. 4 (2005): 33–35.

Shindler, Colin. *The Rise of the Israeli Right: From Odessa to Hebron*. Cambridge: Cambridge University Press, 2015.

Shklovsky, Viktor. *Theory of Prose*. Elmwood Park, IL: Dalkey Archive Press, 1991.

Shmeruk, Khone. "Der Nister's 'Under a Fence': Tribulations of a Soviet Yiddish Symbolist." In *The Field of Yiddish: Studies in Language, Folklore, and Literature; Second Collection*, edited by Uriel Weinreich, 263–87. London: Mouton, 1965.

———. "Yetsirato shel Uri Zvi Grinberg beYidish be'eretz Yisra'el uvePolin." In *Haqeri'ah lenavi: mehqerei historiyah vesifrut*, edited by Israel Bartal, 175–97. Jerusalem: Ha'universitah ha'ivrit biYerushalayim, 1999.

Shneour, Zalman. "Rehov hayehudim be'or vatsel." In M. Vorobeichic, *Rehov hayehudim beVilna*, 3–7. Schaubücher 27. Zurich: Orell Füssli Verlag, 1931.

Singer, Rüdiger. *"Nachgesang": Ein Konzept Herders, entwickelt an 'Ossian', der 'popular Ballad' und der frühen Kunstballade*. Würzburg: Königshausen & Neumann, 2006.

———. "'Wie es in uns übertönet': Zur Funktion des Übersetzens in Herders Übersetzungstheorie und -Praxis." In *Übersetzen bei Johann Gottfried Herder: Theorie und Praxis*, edited by Clémence Couturier-Heinrich, 99–112. Heidelberg: Synchron, 2012.

Skolnik, Jonathan. *Jewish Pasts, German Fictions: History, Memory, and Minority Culture in Germany, 1824–1955*. Stanford, CA: Stanford University Press, 2014.

———. "Yiddish, the Storyteller, and German-Jewish Modernism: A New Look at Alfred Döblin in the 1920s." In *Yiddish in Weimar Berlin: At the Crossroads of Diaspora Politics and Culture*, edited by Gennady Estraikh and Mikhail Krutikov, 215–23. Studies in Yiddish 8. London: Legenda, 2010.

Slaney, Frances M. "Psychoanalysis and Cycles of 'Subversion' in Modern Art and Anthropology." *Dialectical Anthropology* 14, no. 3 (1989): 213–34.

Solomon-Godeau, Abigail. "Going Native: Paul Gauguin and the Invention of Primitivist Modernism." In *The Expanding Discourse: Feminism and Art History*, edited by Norma Broude and Mary D. Garrard, 313–29. New York: Icon, 1992.

Sonino, Claudia. "Eine andere Rationalität: Döblins Begegnung mit den Ostjuden." In *Internationales Alfred-Döblin-Kolloquium, Bergamo 1999*, edited by Torsten Hahn, 141–56. Bern: Lang, 2002.

Spector, Scott. *Prague Territories: National Conflict and Cultural Innovation in Kafka's Fin de Siècle.* Berkeley: University of California Press, 2002.

Spinner, Samuel J. "Lasker-Schüler's Languages: Hebrew and Hieroglyphics." *MLN* 132, no. 3 (April 2017): 701–19.

Stahl, Neta. "'Man's Red Soup': Blood and the Art of Esau in the Poetry of Uri Zvi Greenberg." In *Jewish Blood: Reality and Metaphor in History, Religion, and Culture,* edited by Mitchell B. Hart, 160–71. London: Routledge, 2009.

Stewart, Susan. "Notes on Distressed Genres." *Journal of American Folklore* 104, no. 411 (Winter 1991): 5–31.

Suchoff, David Bruce. *Kafka's Jewish Languages: The Hidden Openness of Tradition.* Philadelphia: University of Pennsylvania Press, 2012.

Sundquist, Eric J. *Strangers in the Land: Blacks, Jews, Post-Holocaust America.* Cambridge, MA: Belknap Press, 2009.

Sweeney, Carole. *From Fetish to Subject: Race, Modernism, and Primitivism, 1919–1935.* Westport, CT: Praeger, 2004.

Thompson, Mark Christian. *Kafka's Blues: Figurations of Racial Blackness in the Construction of an Aesthetic.* Evanston, IL: Northwestern University Press, 2016.

Torgovnick, Marianna. *Gone Primitive: Savage Intellects, Modern Lives.* Chicago: University of Chicago Press, 1991.

Trachtenberg, Barry. *The Revolutionary Roots of Modern Yiddish, 1903–1917.* Syracuse, NY: Syracuse University Press, 2008.

Trigano, Shmuel. "The French Revolution and the Jews." *Modern Judaism* 10, no. 2 (1990): 171–90.

Tshaykov, Yoysef. *Skulptur.* Kiev: Melukhe farlag, 1921.

Tylor, Edward Burnett. *Primitive Culture: Researches into the Development of Mythology, Philosophy, Religion, Art, and Custom.* Vol. 1. London: J. Murray, 1871.

Tythacott, Louise. *Surrealism and the Exotic.* New York: Routledge, 2003.

Unger, Menashe. *Seyfer kedoyshim: Rebeyim oyf kidesh hashem.* New York: Shulsinger Brothers, 1967.

Ungerfeld, M. "Tsum hundertstn geboyrn tog fun Sh. Anski (Sh. Rapaport): Fuler brivoystoysh tsvishn Sh. Anski un Kh. N. Bialik." *Di goldene keyt* 48 (1968): 194–210.

Valencia, Heather. *Else Lasker-Schüler und Abraham Nochem Stenzel: Eine unbekannte Freunschaft.* Frankfurt am Main: Campus Verlag, 1995.

Vanvild, M. *Bay undz yidn: zamlbukh far folklor un filologye.* Warsaw: Pinkhes Graubard, 1923.

Volkov, Shulamit. "The Dynamics of Dissimilation: Ostjuden and German Jews." In *The Jewish Response to German Culture: From the Enlightenment to the Second World War,* edited by Jehuda Reinharz and Walter Schatzberg, 195–211. Hanover, NH: University Press of New England, 1985.

Vorobeichic, M. *Ein Ghetto im Osten (Wilna).* Schaubücher 27. Zurich: Orell Füssli Verlag, 1931.

Walden, Joshua S. "'An Essential Expression of the People': Interpretations of Hasidic Song in the Composition and Performance History of Ernest Bloch's *Baal Shem.*" *Journal of the American Musicological Society* 65, no. 3 (2012): 777–820.

———. *Sounding Authentic: The Rural Miniature and Musical Modernism.* AMS Studies in Music. New York: Oxford University Press, 2014.

Walker, Ian. *City Gorged with Dreams: Surrealism and Documentary Photography in Interwar Paris.* Manchester, UK: Manchester University Press, 2002.

Wallach, Kerry. *Passing Illusions: Jewish Visibility in Weimar Germany.* Ann Arbor: University of Michigan Press, 2017.

Warehime, Marja. "'Vision Sauvage' and Images of Culture: Georges Bataille, Editor of Documents." *French Review* 60, no. 1 (1986): 39–45.

Washton Long, Rose-Carol. "Modernity as Anti-Nostalgia: The Photographic Books of Tim Gidal and Moshe Vorobeichic and the Eastern European Shtetl." *Ars Judaica* 7 (2011): 67–81.

Weinfeld, David. "Shirat Uri Zvi Grinberg bishnot ha'esrim al reqa' ha'ekspresionizm." *Molad* 8, nos. 39–40 (1980): 65–72.

Weiser, Kalman. *Jewish People, Yiddish Nation: Noah Prylucki and the Folkists in Poland.* Toronto: University of Toronto Press, 2011.

Weiss, Peg. *Kandinsky and Old Russia: The Artist as Ethnographer and Shaman.* New Haven, CT: Yale University Press, 1995.

Weiss, Yfaat. "Identity and Essentialism: Race, Racism, and the Jews at the Fin de Siècle." In *German History from the Margins*, edited by Neil Gregor, Nils Roemer, and Mark Roseman, 49–68. Bloomington: Indiana University Press, 2006.

Werberger, Annette. "Ethnoliterary Modernity: Jewish Ethnography and Literature in the Russian Empire and Poland (1890–1930)." In *Writing Jewish Culture: Paradoxes in Ethnography*, edited by Andreas Kilcher and Gabriella Safran, 138–58. Bloomington: Indiana University Press, 2016.

Werkmeister, Sven. *Kulturen jenseits der Schrift: Zur Figur des Primitiven in Ethnologie, Kulturtheorie und Literatur um 1900.* Munich: Wilhelm Fink, 2010.

Wertheimer, Jack. "'The Unwanted Element': East European Jews in Imperial Germany." *Leo Baeck Institute Year Book* 26, no. 1 (1981): 23–46.

Williams, Rhys W. "Wilhelm Worringer and the Historical Avant-Garde." In *Avant-Garde/Neo-Avant-Garde*, edited by Dietrich Scheunemann, 49–62. Amsterdam: Rodopi, 2005.

Wilson, William A. "Herder, Folklore and Romantic Nationalism." *Journal of Popular Culture* 6, no. 4 (1973): 819–35.

Wittler, Kathrin. "Orientalist Body Politics: Intermedia Encounters between German and Polish Jews around 1800." *Central Europe* 17, no. 1 (2019): 34–53.

Wolf, Eric R. *Europe and the People without History.* Berkeley: University of California Press, 2010.

Wolf-Monzon, Tamar. "'Mayn meshikhisher bruder shloyme': leziqato hanefashit shel Uri Zvi Grinberg el Rabi Shlomo Molkho." *Meḥqarei Yerushalayim besifrut 'Ivrit* 18 (2001): 235–71.

———. "'Time for the Orient Has Come': The Orient as a Spiritual-Cultural Domain in the Work of Uri Zvi Grinberg." *Journal of Jewish Studies* 65, no. 1 (2014): 169–90.

———. "Uri Zvi Greenberg and the Pioneers of the Third Aliyah: A Case of Reception." *Prooftexts* 29, no. 1 (2009): 31–62.

Wolitz, Seth L. "'Di Khalyastre,' the Yiddish Modernist Movement in Poland: An Overview." *Yiddish* 3 (1981): 5–19.

———. "Vitebsk versus Bezalel: A Jewish 'Kulturkampf' in the Plastic Arts." In *The Emergence of Modern Jewish Politics: Bundism and Zionism in Eastern Europe*, edited by Zvi Y. Gitelman, 151–77. Pittsburgh: University of Pittsburgh Press, 2003.

Worringer, Wilhelm. *Abstraction and Empathy: A Contribution to the Psychology of Style.* Translated by Michael Bullock. Chicago: Ivan R. Dee, 1997.

Zaretski, Ayzik. "Nisters un." *Shriftn* 1 (1928): 130–47.

Zemel, Carol. "Imaging the Shtetl: Diaspora Culture, Photography and Eastern European Jews." In *Diaspora and Visual Culture: Representing Africans and Jews*, edited by Nicholas Mirzoeff, 193–206. New York: Routledge, 2000.

Zilcosky, John. *Uncanny Encounters: Literature, Psychoanalysis, and the End of Alterity.* Evanston, IL: Northwestern University Press, 2016.

Zink, Jürgen. "Rotpeter als Bororo?—Drei Erzählungen Franz Kafkas vor dem Hintergrund eines 'literarischen Primitivismus' um 1900." PhD diss., Julius-Maximilians-Universität Würzburg, 2005.

Zweig, Arnold. *Das ostjüdische Antlitz.* 2nd ed. Berlin: Welt-Verlag, 1922.

———. *The Face of East European Jewry.* Translated by Noah Isenberg. Berkeley: University of California Press, 2004.

INDEX

Page numbers in *italics* indicate illustrations. Titles of specific works will be found under the author's name.

Stanford Studies in Jewish History and Culture
David Biale and Sarah Abrevaya Stein, Editors

This series features novel approaches to examining the Jewish past in the form of innovative work that brings the field into productive dialogue with the newest scholarly concepts and methods. Open to a range of disciplinary and interdisciplinary approaches, from history to cultural studies, this series publishes exceptional scholarship balanced by an accessible tone, illustrating histories of difference and addressing issues of current urgency. Books in this list push the boundaries of Jewish Studies and speak compellingly to a wide audience of scholars and students.

Sonia Beth Gollance, *It Could Lead to Dancing:*
Mixed-Sex Dancing and Jewish Modernity
2021

Julia Elsky, *Writing Occupation: Jewish Émigré Voices*
in Wartime France
2020

Alma Rachel Heckman, *The Sultan's Communists:*
Moroccan Jews and the Politics of Belonging
2020

Golan Y. Moskowitz, *Queer Jewish Sendak: A Wild*
Visionary in Context
2020

Devi Mays, *Forging Ties, Forging Passports: Migration*
and the Modern Sephardi Diaspora
2020

For a complete listing of titles in this series, visit the Stanford University Press website, www.sup.org.

CPSIA information can be obtained
at www.ICGtesting.com
Printed in the USA
JSHW042330070621
15675JS00001B/2